CW01024758

Key Concepts in Public A

Key Concepts in Public Archaeology

Edited by Gabriel Moshenska

First published in 2017 by
UCL Press
University College London
Gower Street
London WC1E 6BT

Available to download free: www.ucl.ac.uk/ucl-press

ISBN: 978–1–911576–44–0 (Hbk.)
ISBN: 978–1–911576–43–3 (Pbk.)
ISBN: 978–1–911576–41–9 (PDF)
ISBN: 978–1–911576–40–2 (epub)
ISBN: 978–1–911576–42–6 (mobi)
ISBN: 978–1–787350–78–6 (html)
ISBN: 978–1–911307–71–6 (Apple app)
ISBN: 978–1–911307–72–3 (Android app)
DOI: https://doi.org/10.14324/111. 9781911576419

This publication was made possible by funding from Jisc as part of the 'Institution as e-textbook publisher' project:
https://www.jisc.ac.uk/rd/projects/institution-as-e-textbook-publisher.

This book is dedicated to Tim Schadla-Hall who has led the teaching and study of public archaeology at UCL for two decades, and inspired and supported a generation of public archaeologists.

Acknowledgements

This book has been a long time in the making, and I must first express my thanks to everybody involved for their formidable patience. The collection of papers originates in the MA Public Archaeology at UCL, devised and taught over many years by Tim Schadla-Hall and others. Most of the contributors to this volume have taught on the MA course and several are graduates, while others carried out doctoral research within what is becoming known as the 'London school' of public archaeology. This is the appropriate place to acknowledge the leadership and vision of the late Peter Ucko, whose understanding of archaeology as a politically engaged practice entangled in everyday life gave rise to the teaching programme in public archaeology at UCL Institute of Archaeology at both undergraduate and graduate level, as well as the creation of the journal *Public Archaeology*, still hosted in that department. The Ucko tradition of public archaeology as both scholarship and practice has been maintained over the last two decades by Tim Schadla-Hall, Neal Ascherson, Nick Merriman, Ulrike Sommer, Andrew Reid and many others in the Institute of Archaeology, and continues to this day. The publication of this volume has been guided with great patience and vision by Lara Speicher of UCL Press and her colleagues and I am grateful for their faith in the project. Public archaeology is founded upon the belief in breaking down divisions between professionals or academics and the wider world: UCL Press' commitment to Open Access publishing is a beacon in this broader campaign to share knowledge freely beyond the pay-walls and prohibitive prices of traditional elite academic publishing. Finally, my thanks to Maria Phelan and my family who have endured my moaning about this book for too long.

Funding for this publication was provided by Jisc as part of the 'Institution as e-textbook publisher project'.

Contents

List of figures and tables

Tables

Notes on contributors

Roger Bland was formerly Keeper of the Departments of Prehistory and Europe and Portable Antiquities and Treasure at the British Museum.

Chiara Bonacchi is Co-Investigator Researcher at the Institute of Archaeology, UCL. Her research and teaching are in the areas of public archaeology and digital heritage. She has worked on projects in the UK, Europe, the Middle East and America, and is Coordinator of the UCL Archaeology, Media and Communication Research Network.

Paul Burtenshaw received his PhD from the Institute of Archaeology, UCL. He has carried out economic impact and value assessments in Scotland and Jordan, and was a Research Fellow at the Council of British Research in the Levant, Amman, Jordan. He is now Director, Projects at the Sustainable Preservation Initiative.

David Gill is Professor of Archaeological Heritage and Director of Heritage Futures at the University of Suffolk.

Reuben Grima is a senior lecturer in the Department of Conservation and Built Heritage at the University of Malta, where he lectures in cultural heritage management.

Samuel Hardy is Adjunct Professor at the American University of Rome (AUR) and Honorary Research Associate at the UCL Institute of Archaeology. He focuses on the trafficking of antiquities from Cyprus and Syria, the history of conflict antiquities trafficking around the world, and open-source analysis of illicit trade.

Don Henson is an archaeologist who originally specialised in the study of prehistoric flint tools but eventually saw the light and moved into public archaeology and heritage education. He is now researching the narratives we create about prehistory, and realises the past is too important to be left to archaeologists.

Michael Lewis is Head of Portable Antiquities and Treasure at the British Museum and has worked as part of the Portable Antiquities Scheme since

2000, first as Finds Liaison Officer for Kent. He is a Fellow of the Society of Antiquaries of London and a Member of the Chartered Institute for Archaeologists.

Gabriel Moshenska is Senior Lecturer in Public Archaeology at UCL Institute of Archaeology, where he researches and teaches across a range of topics including the history of archaeology, the public understanding of the past, and the archaeology and heritage of modern conflict.

Daniel Pett is Senior Digital Humanities Manager at the British Museum, responsible for the Museum's digital activity in the research arena. He was the architect of the Portable Antiquities database for twelve years, a system which has been the foundation upon which the Portable Antiquities Scheme is built.

Ian Richardson is the Treasure Registrar in the department of Learning and National Partnerships at the British Museum. He heads a team which administers finds reported under the Treasure Act, facilitating their acquisition by public collections. He is an Associate of the Museums Association.

Katherine Robbins held a Leverhulme-funded post-doctoral fellowship at the British Museum working with the Portable Antiquities Scheme.

Suzie Thomas is University Lecturer in Museum Studies at the University of Helsinki, Finland. She has a PhD in Heritage Studies from Newcastle University (UK) and has previously worked as Community Archaeology Support Officer for the Council for British Archaeology. She is co-editor of the *Journal of Community Archaeology and Heritage*.

Rob Webley is a part-time doctoral student in Archaeology at the University of York. His thesis considers non-ferrous metalwork in the period around the Norman Conquest to examine changes and continuities, and their causes and effects. He is also a part-time Project Officer at the British Museum training Portable Antiquities Scheme volunteers.

Hilary Orange is a post-doctoral researcher at Ruhr-Universität Bochum studying post-industrial heritage. Her research interests include the archaeology of the contemporary world, industrial and post-industrial archaeology, heritage studies, and studies of landscape and memory.

Dominic Perring is Director of the Centre for Applied Archaeology at UCL Institute of Archaeology and of Archaeology South East.

Ulrike Sommer is Senior Lecturer in Prehistoric Archaeology at UCL Institute of Archaeology. Her research interests include the European Neolithic and the history of archaeology.

1
Introduction: public archaeology as practice and scholarship where archaeology meets the world

Gabriel Moshenska

> Public archaeology is all the New Territories, lying around the periphery of direct research into the remains of material culture … All of them are about the problems which arise when archaeology moves into the real world of economic conflicts and political struggle. In other words, they are about ethics.
>
> (Ascherson 2000: 2)

> any area of archaeological activity that interacted or had the potential to interact with the public – the vast majority of whom, for a variety of reasons, know little about archaeology as an academic subject.
>
> (Schadla-Hall 1999: 147)

> it studies the processes and outcomes whereby the discipline of archaeology becomes part of a wider public culture, where contestation and dissonance are inevitable. In being about ethics and identity, therefore, public archaeology is inevitably about negotiation and conflict over meaning.
>
> (Merriman 2004: 5)

public archaeology in the broadest sense is that part of the discipline concerned with studying and critiquing the processes of production and consumption of archaeological commodities.

(Moshenska 2009a: 47)

a subject that examines the relationship between archaeology and the public, and then seeks to improve it

(Matsuda and Okamura 2011: 4)

The aim of this book is to give the reader an overview of study and practice in the field of public archaeology. It offers a series of snapshots of important ideas and areas of work brought together as an introduction, albeit an inevitably brief and incomplete one, to one of the most challenging and rewarding parts of the wider archaeological discipline. Read the book from cover to cover and you will have a good working understanding of public archaeology as a complicated, rich and diverse field, as well as knowledge of some of the most significant and iconic examples of public archaeology in action. Dip into a specific chapter and you will find a concise and insightful introduction to one aspect of public archaeology with case studies and a list of readings to develop your understanding. However you use this book I am confident that you will emerge with a better understanding of what public archaeology is, why it matters and what you can do about it. First, it is necessary and useful, drawing on the quotes above, to ask what we mean by public archaeology, and to examine some of the different ways it has been defined.

The archaeologist and television personality Sir Mortimer Wheeler, one of the first prominent public archaeologists, stated

I was, and am, convinced of the moral and academic necessity of sharing scientific work to the fullest possible extent with the man in the street and in the field.

(1955: 104)

and that

It is the duty of the archaeologist, as of the scientist, to reach and impress the public, and to mould his words in the common clay of its forthright understanding.

(1956: 224)

Wheeler was an eloquent promoter of the ideals of public archaeology, but he was by no means the first or the only archaeologist of his time to look beyond the material remains of the past to consider the place of archaeology in the world (Moshenska and Schadla-Hall 2011). Public archaeology has remained at the core of archaeology throughout its history and into the present, touching upon every aspect of the discipline worldwide. Public archaeology straddles the great divides within archaeology between professional, academic and amateur; between the local and the global; between science and humanities: in fact, the study and critique of these disciplinary divisions is a vital part of what public archaeologists do.

One of the challenges of public archaeology is its all-encompassing nature: its study draws on fields as diverse as economics, international law and film studies, while its practice ranges from grassroots community activism to high-level international diplomacy. All of this makes public archaeology difficult to pin down and define. Public archaeology exists in a tangle of overlapping definitions and interpretations, many of them the result of different national, organisational and educational traditions: public archaeologists from Greece, Argentina, the UK and Japan will often find ourselves talking at cross-purposes, even with the best of intentions.

For now, I will offer a working definition for this chapter at least, as given in the title: 'practice and scholarship where archaeology meets the world'. This book is for people who want to better understand this point of contact between archaeology and the wider world, and for those who want to work at that interface. Within this definition of public archaeology, we can include a multitude of things: local communities campaigning to protect local heritage sites, archaeologists and producers collaborating to create television documentaries, metal detector users bringing their finds for identification and recording at local museums, archaeological heritage sites researching their visitor demographics, students studying the depiction of prehistoric women in comic books, and plenty more. The aim of this chapter is not to lay out the boundaries of the field; rather, it is to give an overview of the principles of public archaeology that underlie this book and to outline the values of studying and practising public archaeology.

Hybridity

The phrase 'practice and scholarship' in the brief definition above gives a hint of one of the challenges of understanding contemporary public archaeology; that is, its hybrid nature as a discipline. This hybridity and the resulting relation of public archaeology to archaeology as a whole is best understood by comparison with the sciences. The natural sciences are served by the two distinct fields of *science studies* and *science communication*. Science studies is the field of research into scientific practice in its contexts, whether those be economic, social, cultural, philosophical, legal and so on. It is a notably interdisciplinary area of scholarship drawing on elements of sociology, history, public policy, literary criticism and other fields (Sismondo 2010).

Science communication is a more practice-based field, focusing on the skills and techniques for sharing scientific knowledge and understanding as widely as possible within fields such as education and policymaking. Trained science communicators work in journalism, museums, universities and scientific industries, and employ skills as varied as technical writing and stand-up comedy (Brake and Weitkamp 2009).

Public archaeology fulfils the roles of both science studies and science communication within the wider field of archaeology, bridging critical academic scholarship and professional practice. Equally, public archaeology draws upon the literature, concepts and skills developed within these fields, as well as in analogous fields such as museum studies (Merriman 2004). This bringing together of scholarship and practice, and the blurred areas of overlap in between, makes public archaeology more complicated – and more interesting.

Origins

At this point some clarification is needed, or perhaps a confession. The model of public archaeology outlined in this introduction and in this book as a whole is neither universally agreed nor widely accepted. In fact, there are numerous narrow, overlapping and divergent definitions of the term in operation around the world, with the greatest variation being the transatlantic one between the UK and US (Fagan 2003; Jameson 2004; McDavid 2004). To be completely honest, the view of public archaeology offered in this book is based on more than two decades of work at University College London's Institute of Archaeology and the global diaspora of graduates who have emerged from what we

might call the 'London school' of public archaeology. This critical mass of scholarship, teaching and publishing was founded on the radical and iconoclastic work of Peter Ucko and driven by the teaching and writing of Tim Schadla-Hall, Nick Merriman and Neal Ascherson and the work of their students starting in the late 1990s (Ascherson 2000; Grima 2002; Matsuda 2004; Schadla-Hall 2006; Ucko 1987). Over the following decades this loose network has driven many of the most important developments in public archaeology, outlined in more detail in this volume, including the emerging study of digital media in public archaeology, the engagement with cultural economics, and concerns with heritage and human rights (Bonacchi 2013; Gould and Burtenshaw 2014; Hardy 2015; Richardson 2014). It is the breadth, inclusivity and global reach of this particular model of public archaeology that make it a suitable framework for this volume.

A typology

Over several years of teaching and research I found that the lack of an agreed definition of public archaeology was causing problems for students, scholars and practitioners across the field. The single greatest problem for me was the difference between the inclusive definition of public archaeology given above (practice and scholarship where archaeology meets the world) and its narrower definition within the wider field of archaeology as a synonym for public outreach by professional archaeologists. In response to these challenges I developed a simple seven-part typology presented in the form of a graphic, which I first published as an illustration in an open access paper (Bonacchi and Moshenska 2015). Entitled 'Some Common Types of Public Archaeology', this typology offers a good overview of the different and distinct elements of the field, detailed and expanded in Figure 1.1. While I have listed them as distinct categories there is obviously a considerable amount of overlap between them.

Archaeologists working with the public

This first category covers a great deal of what is generally referred to as public archaeology or, in many cases, community archaeology (Marshall 2002; Moshenska and Dhanjal 2012; Thomas 2014). It refers to archaeological work conducted by professionals which includes, by design, the provision of participation opportunities for members of

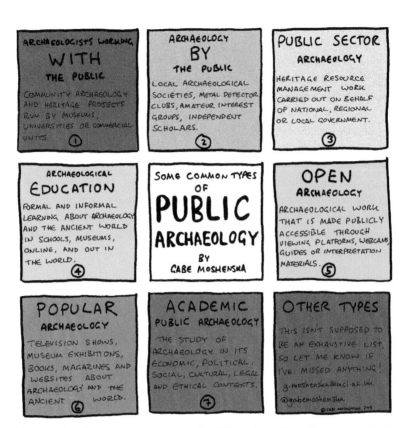

Figure 1.1: Some common types of public archaeology (Source: author).

the public or a specific community. Many projects of this kind are run under the auspices of museums, commercial archaeology units, university departments and local government bodies, and in the UK many are funded by the Heritage Lottery Fund (Bewley and Maeer 2014). While the specific forms of these events vary they tend to be time (and money) limited and aim to provide the public with experience of archaeological skills and methods, as well as insights into the heritage of their local area. Increasingly these opportunities for public involvement are moving away from excavations towards museum and archive archaeology, including outreach by archaeological archives and online crowd-sourcing of archaeological data (Bevan et al. 2014). The instigation and execution of projects of this kind are almost always in the hands of the professional archaeologists, sometimes working in partnership with organisations such as schools or community groups (Dhanjal et al. 2015; Nevell 2014; Simpson and Williams 2008).

Archaeology by the public

The second category of public archaeology is what is often called amateur archaeology: work carried out (often to the highest professional standards) by local archaeology societies and amateur interest groups (Manley 1999). The work of these groups long pre-dates the emergence of professional archaeology: in the UK many local societies date back to the early nineteenth century (Wetherall 1994). Alongside fieldwork and archive-based archaeological research many amateur archaeology societies organise programmes of talks or events often linked with formal educational organisations. The work of amateur archaeologists varies considerably around the world. In many countries there are licensing systems or legal restrictions on archaeological work by non-professionals, while in some places amateurs can only take part in projects run by professionals (Duineveld et al. 2013). One of the most controversial aspects of amateur archaeology is the work of metal-detector users and metal-detecting clubs (Thomas 2012). Again laws on metal detecting vary worldwide, between outright bans and complete freedom (Dobat 2013; Rasmussen 2014). Many archaeologists do not regard metal detecting as an archaeological activity, comparing it to treasure hunting: working standards and ethics are extremely variable, but at best metal-detector users produce valuable research that is incorporated into archaeological heritage databases (Bland 2005). The demographics of amateur archaeologists are of interest to public archaeology researchers: for example, most archaeology society members are older, white and middle class, while metal-detector users are overwhelmingly male. Amateur archaeology is the original form of public archaeology but it is increasingly under threat from restrictive laws and exclusionary professional practices.

Public sector archaeology

The first book entitled *Public Archaeology* was published by Charles McGimsey in 1972. McGimsey's meaning of 'public' refers to the state rather than to the people themselves: it can be best summarised as public sector archaeology. This broad category includes all the work of state-controlled or -funded bodies on national, regional and local scales to manage, preserve, study and communicate archaeological heritage. One of the largest such bodies is the US National Parks Service which employs a considerable number of archaeologists and heritage professionals (Jameson 2004). Over time it has become less common to refer to this work as public archaeology, with the rise of terms such as cultural

resource management or heritage management (King 2012). However, the significance of incorporating these practices within a wider public archaeology is to emphasise the power and the democratic accountability of taxpayer-funded bodies with responsibilities for vast archaeological resources. They may not work directly with the public or even in the public eye, but they are (in theory at least) answerable to the public.

Archaeological education

The idea of education underlies a great deal of work in public archaeology, based on the principle that experts have a responsibility to share their knowledge with those who can appreciate and use it. Archaeological education takes place in museums and heritage sites through visitor interaction with displays and archaeological materials, and through the work of curatorial staff and museum learning professionals (Corbishley 2011; Henson 2000). In public or community archaeology projects education can take many forms: sometimes visitors will get informal talks and guided tours; in other cases they will get basic training in archaeological skills. Many projects include field schools where amateur or student archaeologists can learn excavation, recording and surveying skills (Baxter 2009). In some cases, this training resembles formal teaching and learning, but in many cases archaeological skills are shared and developed through practice, with more experienced fieldworkers advising and assisting others. This fits within a wider model of archaeological knowledge as a 'craft' (Faulkner 2000; Shanks and McGuire 1996; Walker and Saitta 2002). Formal learning about archaeology is a marker of public interest in the subject: most archaeology classes in schools, colleges and universities are optional, taken out of personal interest (Henson 2004). Archaeology is a popular subject of lecture tours and cruises, online courses, adult education courses and evening classes: many prominent public archaeologists have worked extensively in these fields. Public archaeology has, in Merriman's view, long been based on the 'deficit model', a term taken from science communication that suggests that experts have a duty to remedy the deficit of scientific knowledge in the general public, who are viewed as empty vessels to be filled with information (Merriman 2004). Merriman's critique and suggested alternative, a 'multiple perspectives' approach, has advanced the understanding of education in public archaeology but in practice a wide variety of educational philosophies are employed, tacitly or explicitly, with greater or lesser success.

Open archaeology

One of the most interesting aspects of public archaeology is the degree to which archaeology can be made open: compared to many of the sciences and other scholarly fields, many of the processes and practices of archaeology (particularly around excavation) are visible and easily comprehensible to the public (Farid 2014; Moshenska 2009b; 2013; Tilley 1989). People watching an excavation can see artefacts, bodies and structures emerging from the earth before their eyes: this is part of what makes archaeology popular and successful on television. Throughout the history of archaeology this openness has been a factor in its popularity and success. Tourists visiting excavations frustrated Sir Flinders Petrie and delighted Sir Mortimer Wheeler, while many modern excavations, particularly in urban areas, provide a view of the site through viewing platforms or, more recently, webcams (Morgan and Eve 2012; Moshenska and Schadla-Hall 2011). In many cases visitors are able to tour the excavations and talk to the archaeologists, while in some cases dedicated tour guides are used. While excavation is only one aspect of archaeology this openness is a vital element in maintaining the public profile of archaeology and its democratic nature as something (at least potentially) participative and accessible to anybody. Open archaeology is part of what sets public archaeology aside as a distinct field within the wider fields of science communication and science studies.

Popular archaeology

This could equally be described as media archaeology or popular culture archaeology: the communication of archaeological research to the public through accessible and user-friendly media, rather than the more serious and detailed educational means described above. At the same time this is probably the largest field of public archaeology in terms of economics, employment and impact on the public understanding of archaeology and the human past. Public archaeologists often forget that the public, by and large, do not want to be archaeologists and nor do they want huge amounts of detailed archaeological knowledge (Merriman 1991). In fact, most people who engage with archaeology are antiquarians: they have a general, broad interest in the past that takes in local history, genealogy and family history, some military history, and a degree of interest in, perhaps, Ancient Rome or the lands of the Bible (Holtorf 2005, 2007). This hulking majority engage with antiquity through television documentaries such as *Time Team*, through museum

and gallery exhibitions, and through popular books and magazine articles by media-friendly scholars (Bonacchi 2013; Fagan 2005). A growing number engage with these sources through digital media of various kinds, researching heritage sites and museums online and downloading apps and videos, and public archaeology scholarship is increasingly taking this into account (Pett 2012). Archaeology relies on this shallow engagement by a wide audience to maintain popular interest and support for archaeological heritage in political, cultural and economic terms. They are our market and we ignore or mischaracterise them at our peril.

Academic public archaeology

Earlier I characterised public archaeology as a distinctive combination of practice and critique. The six categories described above are largely concerned with the practice of public archaeology: this last is focused on the critical aspects of scholarship in the discipline. The academic discipline of public archaeology is concerned with archaeology where it meets the world, but it draws upon and informs the practices described above: in the ivory tower it sits on the ground floor with a view of the rubbish bins (Flatman 2012). The study of archaeology in its economic contexts draws on the work of heritage organisations struggling to survive cuts, and of communities fighting to preserve their archaeological sites in the face of environmental threats (Gould and Burtenshaw 2014). The legal and political contexts of archaeology determine the survival of archaeological sites threatened by violent conflict, and the limits or opportunities for amateur archaeologists, scholars, looters and other interested parties (King 2013). Studying the social and cultural contexts of archaeology defines its role in the construction of individual and group identities amongst nation states and diasporas (Kohl 1998; Trigger 1984). Ultimately much of the scholarly critique of archaeology in these and similar contexts is an ethical critique, directed inward at the archaeological profession and the heritage sector more widely. The traditional concerns of archaeological ethics – including the nature of cultural property, dealing with descendent communities, and ensuring material and social sustainability – are core issues within the study and the practice of public archaeology (Carman 2005; Colwell-Chanthaphonh and Ferguson 2006; Tarlow 2006; Zimmerman et al. 2003).

This seven-part typology is meant to be descriptive rather than prescriptive, and any engagement with the world of public archaeology will quickly demonstrate the overlap and connections between these apparently distinct types. Crowd-sourced archaeology projects use digital media to connect members of the public with academic research projects, with the results of their work feeding into museum displays. A trip to see a working archaeological site might inspire visitors to get involved in a local archaeology or history society and begin to learn – and later, perhaps, to teach – archaeological skills of their own. A student inspired to study archaeology by television documentaries might go on to produce or work in media archaeology, or to become a researcher, or to work in the public end of the heritage sector. Ultimately this typology aims to make people aware of the breadth of possibilities within public archaeology, the range of approaches and methods that can be selected, honed and put into practice.

The future of public archaeology

In introductions of this kind one is obliged to reflect on the future of the discipline. This is actually a rather pleasant experience: public archaeology has seen a decade or more of growing mainstream acceptance and interest within academic archaeology, professional archaeology and heritage management, and in the wider world. The public interest and demand for documentaries, books, magazines and web-based media based on archaeology and archaeological themes seems to be as strong as ever, and there are even rumours of a new *Indiana Jones* movie in the works.

This general growth is pleasing and encouraging, but it is instructive to look at more narrowly defined areas of the field to examine trends and possibilities. Taking the chapters in this book as starting points offers a number of encouraging perspectives, with two areas in particular emerging as areas of growth:

1. interdisciplinarity
2. data.

Earlier in this chapter I drew a comparison between public archaeology and the related fields of science communication and science studies. As fields of study and practice these are older, larger and far better

developed in many respects than public archaeology: there is a great deal of benefit to be gained from drawing more explicitly and far more heavily upon these fields, as Merriman (2004) and others have already begun to do. From science communication we could gain a broader and richer skill-set, training public archaeologists in the abilities to write for different audiences, to create images, films and other media, to speak in public, and ultimately to create and manage an entire public engagement programme including working with media, professionals and a variety of public audiences. From science studies we might look for a different set of skills including archival, sociological and ethnographic research methods, and a richer engagement with archaeological epistemologies.

Another form of interdisciplinarity can be explored through an understanding of public archaeology as one component part of the 'public humanities', encompassing the public-facing and critical elements of other disciplines. These include public history, classical receptions, elements of digital humanities, museum studies and others. Here the possibilities lie not only in borrowing between disciplines but in forging a new broader-ranging discipline around principles such as the public understanding of the past. As discussed earlier, public archaeologists are well advised to restrain themselves from ramming the entirety of archaeology down the throats of any even slightly interested passer-by: we need to recognise that archaeology is, for the overwhelming majority of the interested public, just one amongst several historical and cultural interests in unique combinations. This can lead us to create new networks and collaborations to better understand – and respond to – public interest in the human past.

Data remains one of the most promising areas for growth and future development in public archaeology, due in part to the consistent and longstanding neglect of data-gathering within the discipline (Merriman 1991). For a public-facing field we know startlingly little about the public themselves: in any other industry such a neglect of market research would have long ago proven terminal. This is not to say that public archaeologists have not surveyed and studied public attitudes and interests to archaeology, heritage and museums: there has been and continues to be fantastic work carried out in these areas worldwide. Rather, it is the lack of larger-scale studies or systematic meta-analyses that poses the problem: we might know a great deal about what the visitors to a specific museum enjoy, but we have few insights into the archaeological interests of the people of Norway or Tanzania on a population level, including most importantly those who never visit museums and archaeological sites. Data of this kind

are expensive to gather, time-consuming and difficult to analyse, and have limited commercial or political uses beyond research. There are a variety of possible strategies including building research projects around large-scale market research studies, and carrying out systematic reviews of existing smaller datasets. For now, the paucity of data is probably the greatest single barrier to future developments in public archaeology.

The second area where data are needed is more straightforward: public archaeology projects need to become more proactive and consistent in gathering monitoring and evaluation data on themselves. As the discipline is constantly innovating and developing existing approaches it is vital that practitioners share their successes and failures, and have enough data to be able to point to what worked, what did not work, and – perhaps – why. There are a number of reasons for this deficit. In many projects public archaeology is regrettably treated as a luxury extra bolted onto a research or rescue project. In these circumstances detailed monitoring and evaluation would be a luxury upon a luxury, and over-stretched public archaeologists are likely to lack both the time and the skills to gather this data. However, this is not an inevitable state of affairs: many public archaeology projects collect excellent comprehensive data and use it to develop their own practices. The most successful impetus might come from funders: in the UK the Heritage Lottery Fund is the single greatest promoter of public archaeology projects and makes clear and stringent demands for evaluation throughout the timespans of the projects that they fund (Bewley and Maeer 2014). The most important development will be to add project evaluation and data-handling to the skill-sets that are taught in public archaeology courses and in professional development for practitioners.

Whether or not these specific concerns are addressed it is clear that public archaeology has a powerful momentum as a field of scholarship and an area of practice. The growth comes from within the discipline, as more graduates and experienced public archaeologists move into and up through the workforce; and it comes from the public, who maintain an interest in seeing, learning about and taking part in archaeology. Public archaeology is growing in profile, rigour, global reach and in the rich diversity of perspectives that it incorporates. Long may it continue.

2

Community archaeology

Suzie Thomas

Introduction

Community archaeology, like public archaeology, is a diverse and ever-growing field of study and practice that aims to connect archaeology with the wider world. Around the world community archaeologists engage with many different populations or sectors of society, employing a wide variety of methods, means, and conceptual frameworks. In this chapter it is impossible to cover community archaeology in its entirety: instead, my aim is to explore some of the definitional challenges of pinning down what community archaeology is, and then discuss examples of types of engagement from three different countries that fall under this broad church.*

Debates around definition

The concept of community archaeology, in a grassroots, community-led sense, has sometimes been elaborated as 'archaeology by the people for the people' (Reid 2012: 18). On the other hand, it is also sometimes the case that the wider public's role is as a recipient (but not necessarily a creator) of information, including not only as a visitor to museums and

* Acknowledgements: I would like to thank Sarah Dhanjal, Carol McDavid, Samantha Rowe, Tuija-Liisa Soininen, Elizabeth Stewart and Tara-Jane Sutcliffe for assisting with information for the case studies and/or providing images for this chapter.

heritage sites, but as a participant in hands-on opportunities that are nonetheless controlled (and limited) by parameters set out by professionals facilitating or providing the experience. In other cases, voluntary or amateur archaeologists are valued as historians and researchers and respected in their own right, as is their contribution to the academic discourse. Hence, what is now known as 'community archaeology' has developed to differing extents in different countries, often following quite different patterns depending on local traditions, economic realities and even legislation.

In recent years, at an international level, there appears to have been an increase both in opportunities for multiple publics to participate in archaeology, and in public demand for experiences of this kind. This is certainly the case in the UK, where the number of people involved as volunteers in archaeology has risen significantly in the past few decades (see Thomas 2010). This is perhaps assisted by the now-established theoretical strands within archaeology itself, such as post-processual frameworks, which encourage a plurality of interpretations and approaches to the past, and offer scope for archaeologists who wish to frame their scholarship and practice around public interests (e.g. McDavid 2002). It is also facilitated by popular media such as television programmes (see Piccini 2007 for a study of viewing figures in the UK) and social media outlets, both of which disseminate archaeological information in 'public-friendly' ways, and thus (it is hoped) engender enthusiasm about archaeology.

'Community archaeology' as a term has been both addressed and avoided by authors writing on the subject. Some, such as Marshall (2002) and Waterton and Smith (2010), have attempted to break the term down to focus on its component parts, inevitably giving more attention to 'community' than to 'archaeology'. For example, Smith and Waterton (2009: 11) have criticised the concept of 'community' as being too 'comfortable', stressing that the 'community of interest' of heritage professionals is only one of many possible communities. They also note that both 'community' and 'heritage' are terms which are dangerously assumed by many to be self-evident (12). Simpson (2010: 1) also acknowledges that 'the word community disguises the numerous communities that exist within a geographically constructed community'. However, in many of these publications the term 'archaeology' is itself not assumed to be contentious in its own right. Nonetheless archaeology is a term which can be interpreted in different ways, given the broad range of research methods, periods and activities that can constitute 'archaeology' and its research. Authors such as Simpson and Williams

(2008: 75) have suggested that excavation is an essential component for community archaeology, not least because it apparently fits the public perception of what 'archaeology' is (or should be). However, ignoring other archaeological activity such as survey (itself shown to have been an invaluable tool for community engagement in projects such as Scotland's Rural Past – see www.scotlandsruralpast.org.uk), or other pursuits that may also be described as 'heritage' in a wider sense, runs the risk of missing key opportunities for engagement and for generating community enthusiasm. Furthermore, research has indicated that the archaeological workforce, especially those actively involved in fieldwork, have a lower-than-average proportion of people with certain disabilities, although it was higher than previously estimated (Philips et al 2007: 10). This suggests that, unless particular care is taken, 'typical' work such as excavation may exclude people with disabilities.

This diversity of interpretation has, unsurprisingly, led to many definitions in the literature being accordingly broad. For example, Corbishley (2011: 104) says that: 'community archaeology is the term most often used to describe any outreach aspect of an archaeological project but it can mean a number of different types of project and involve a range of "publics"', and as such seemingly blends the boundaries between 'community archaeology' and 'public archaeology'. Moshenska and Dhanjal (2012: 1) state outright that they feel that there is little to be gained from attempting to define community archaeology too closely. Meanwhile Thomas (2010) – in producing a report aimed at capturing, for the first time, the full scale of community archaeology in a nationwide setting – deliberately left criteria and parameters broad so as not to exclude possible conceptions of 'community archaeology' from the study.

'Community archaeology' in practice is greatly affected by the social, cultural, economic and legislative settings in which it takes place. For example, the exclusion of non-professional archaeological intervention by law in Northern Ireland means that community archaeology in a Northern Irish setting is defined and carried out within a different framework from the rest of the UK. McDavid (2013), in her definition of 'community archaeology', identifies that not only does 'community archaeology' sit within a wider concept of 'public archaeology', but that the variant of community archaeology in the UK differs from how it is generally experienced in North America (for a US example, see case study 2.1). The theoretical frameworks that have been applied to community archaeology range widely, depending on the context of production – geographic, theoretical, temporal and otherwise.

Examples include community archaeology as post-processual reflexive methodology (Burke et al. 1994), community archaeology as part of the professional-dominant 'authorised heritage discourse' (Smith and Waterton 2009), and community archaeology as a way to empower disenfranchised descendant groups (Colwell-Chanthaphonh and Ferguson 2006; Gonzalez-Tennant 2010; McDavid 2002). What is clear is that the

Case study 2.1: Yates Community Archaeological Program (USA)

Where? Freedman's Town, Houston, Texas, USA.

When did it start? The Yates Community Archaeological Program (YCAP) began in 2001. Although the programme is ongoing, its activity varies depending on funding levels. This has raised questions, for the directors, about how community programmes such as this can be made sustainable over long periods (see McDavid 2011).

What do they do? The project involves a range of people within the local community, including school pupils and university students, from a variety of different ethnicities and social classes. The research strands of the programme focus on the impact of the African disapora, and engage with what are often difficult and painful histories, in a drive to better understand the impact of racism and other forms of oppression. It recognises that these oppressions often continue to have an impact in the present day.

Activities have included collecting oral histories from local residents, ethnographic research in the community, excavation, archival research (including parish records and personal archives of photographs and family mementoes), and various activities conducted to support the restoration of historical properties.

YCAP has also provided opportunities for educational fieldtrips and archaeological experience for students of all ages, from children (Figure 2.1) to university field-school students (Rice University, the University of Houston and Houston Community College).

Who organises it? YCAP is one programme of the Houston-based Community Archaeology Research Institute, Inc. (CARI), an organisation which provides resources, support and training for community-based and community-focused projects. CARI's primary collaborator (and client) for YCAP is the Rutherford B.H. Yates Museum, Inc., located in Freedmen's Town, Houston. CARI has also partnered with other organisations on specific community archaeology projects, including the Freedmen's Town Association, the City of Houston, the Texas Historical Commission and the Olivewood Cemetery Association.

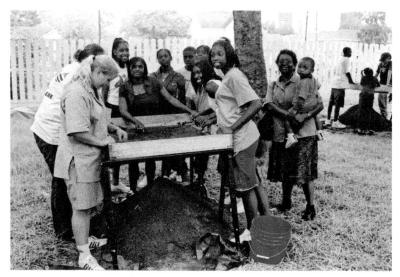

Figure 2.1: Children from New Zion Temple church in Freedmen's Town, Houston, learning to screen artefacts with university field-school students. *C. Mosheh Adamu 2003; courtesy Community Archaeology Research Institute, Inc.*

theoretical understanding and interpretation of community archaeology, like the community archaeology itself, are shaped to a large extent by the regional, national and local context in which they sit.

Community archaeology can be demonstrated to have its origins in anglophone settings such as the UK, where the term was first coined in the 1970s (Thomas 2014: 23; Schadla-Hall 2004), and in Australia where community-centred approaches first appeared in the 1980s (Greer 2014). In North America, similarly, McDavid (2013) suggests that the shift from 'public archaeology', as in archaeology practised by professionals with the public in mind (for example through providing

accessible interpretation material), to archaeology that actually involved the public, or community, began to occur in the 1980s and early 1990s. Peter Schmidt (2014: 39), an American professor with decades of experience of engaging with archaeology in Africa, has noted that, although not labelled as 'community archaeology' until relatively recently, archaeological practices that have engaged and involved the local and wider communities in numerous African nations have taken place for at least five decades through collaborative approaches. Therefore, among the understandings of community archaeology as a term, and indeed a trend, it is perhaps worth noting that what we might today identify as 'community archaeology' or 'community heritage' may not be as new an approach as practitioners sometimes believe.

Within Europe there is a demonstrable growth in awareness among the archaeological sector of the potential benefits and application of community archaeology. Interestingly, in some countries, it would seem that the development of community engagement in archaeology, for example providing opportunities to participate actively in archaeological projects, has not always been consistent. Van den Dries (2014) has noted that in the Netherlands, for example, while there is little community archaeology practised at present, 'community excavations' took place as far back as the 1960s. In the UK, too, some have noted the reduction in community and volunteer involvement in regular excavation work, especially through local societies, that came about with the professionalisation of archaeology from the 1970s onwards (e.g. Henson 2012: 124). Graduate-level research in the Netherlands has led to a set of recommendations for facilitating community archaeology once more (Lampe 2014), while targeted qualitative research in regions close to major archaeological projects in Estonia has demonstrated a desire in local communities to participate more closely (Kangert 2013). Whether this finding would be common in other social and cultural settings is an issue worth exploring more closely. For example, it is not uncommon for many community archaeology participants to be of, or close to, retirement age (Thomas 2010: 23), and this must be connected in no small way to the availability of free time required to become involved with an ongoing archaeological or heritage project.

In other parts of Europe, there have been and continue to be localised examples of community archaeology, such as in northern Norway (Brekmoe 2015). In the Pirkanmaa region of Finland, there is currently an 'Adopt-a-Monument' project (itself inspired by a similar programme in Scotland – see case study 2.2), essentially community stewardship, which seems to be producing positive outcomes for both participants

Case study 2.2: Adopt-a-Monument (Finland)

Where? Pirkanmaa, southern Finland.

When did it start? The first monuments were 'adopted' and the agreements signed in 2009. The project got under way after a series of exchange visits between Pirkanmaa Provincial Museum and Archaeology Scotland, who were already running a successful Adopt-a-Monument (AaM) programme across Scotland. The Finnish AaM scheme, although organised differently, openly acknowledges the influence of the Scottish AaM scheme in its own development (Nissinaho and Soininen 2014). At the time of writing, ten monuments have been 'adopted' in Pirkanmaa, with further 'adoptable' sites available. In addition, would-be participants are invited to suggest other sites and monuments that may be suitable for adoption.

What do they do? As stated on the project website, 'the purpose of the Adopt-a-Monument programme is to offer people who have an interest in their own home region an interesting hobby and an opportunity to participate in the maintenance of past values perceived as being important'.

Combining the relatively new (in the Finnish context) concept of community archaeology with the longer tradition of community conservation and locally run museums (see Nissinaho and Soininen 2014), AaM in the Pirkanmaa region aims to encourage community stewardship of local heritage sites. The archaeological sites involved in the scheme are all protected by law from interference or development, meaning that the community adopters also double as stewards, observing and reporting on signs of unauthorised disturbance. The adoptee sites range in date from the Bronze Age to the First World War, and can be anything from dry stone walls (Figure 2.2), to dwelling sites, to military fortifications. In addition, the museum won a grant in 2013 from the Ministry of Education and Culture for developing the project to include built heritage as well as archaeological. Would-be adopters have to enter into a formal agreement with the landowner and the Pirkanmaa Provincial Museum (and in collaboration with the museum staff draw up a maintenance plan, although in most cases the museum staff, with the National Board of Antiquities – NBA – have drawn up the plans to date). The adopter is then considered responsible for the maintenance of their adopted site.

Adopters can range from individuals to groups of people who may share a particular interest (including existing clubs and societies),

and they are offered training and advice to assist them with their conservation activities at their adopted site.

Adopt-a-Monument is currently only carried out in the Pirkanmaa region of Finland, rather than at a national level. The project has nonetheless been observed with interest by heritage professionals in other parts of the country.

Who organises it? It is organised by Pirkanmaa Provincial Museum, in consultation with the Finnish National Board of Antiquities.

How is it funded? Adopt-a-Monument is not grant-funded, but is supported and administered by Pirkanmaa Provincial Museum, which also obtained a grant from the Ministry of Education and Culture in 2013 to support and expand the project (see above).

Further information online: http://adoptoimonumentti.fi

The Pirkanmaa Provincial Museum website is available at: www.tampere.fi/vapriikki.html. And the NBA website is available at: www.nba.fi. Information about Archaeology Scotland's Adopt-a-Monument scheme is available at: http://archaeologyscotland.org.uk/our-projects/adopt-monument.

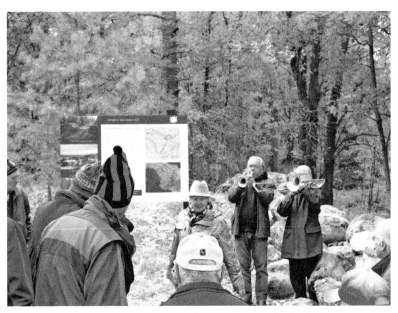

Figure 2.2: Revealing the new information panel of a dry stone wall in Pispala, 2013. *Courtesy of Miia Hinnerichsen, Pirkanmaan maakuntamuseo.*

and the once-vulnerable monuments themselves, where an active conservation programme has involved local groups in taking care of their 'adopted' monuments (Nissinaho and Soininen 2014).

Community archaeology and young people

Another common focus of community archaeology projects has been on young people. This mirrors wider public archaeology interests that have often targeted young people, particularly through their schools and teachers, as a priority for engagement (e.g. Corbishley 2011: 76–199; Jeppson and Brauer 2008; Smardz and Smith 2000).

Archaeology and politics are often inextricably linked, a point explored at length recently by Luke and Kersel (2013). Community encounters with archaeology are not immune from this, not even where young people are concerned. MacDonald and Burtness (2000: 45) have noted, for example, that 'education is very politicized in North American society'. Changes in government can directly impact the priorities and areas of emphasis within school curricula, meaning that the targets for education services change in tandem with political trends. However, MacDonald and Burtness note that this can also present an opportunity for archaeologists, if they are prepared to tailor curriculum suggestions and resources to fit school requirements, hence meeting 'directly the needs of the busy and overburdened classroom teacher' who may not have time themselves to create approaches that incorporate archaeology (2000: 45–6). There are other problematic examples where the governmental agendas can influence the interpretation of the past in school education. Badran (2011: 201) has noted an emphasis on tourism in primary school education in Jordan, which in turn has skewed the perception of the significance and indeed the 'value' of archaeological and heritage sites within the country. Reports stemming from archaeological work in the former Soviet republic of Turkmenistan have also noted the appropriation of the teaching of history to political agendas, with school education in general closely mapped to dictatorial viewpoints (Corbishley and Jorayev 2014; Corbishley 2011: 257–8).

Nonetheless, active advocates of archaeology in education such as Henson (e.g. 2000) have demonstrated that archaeology can be brought into the classroom, especially if it can be demonstrated to teachers and decision-makers that it is an interdisciplinary subject that can be applied to a number of subjects taught at school, such as history (most commonly), geography, mathematics and so on. This is not to say that

the application of archaeology into formal education for young people is commonplace.

In many ways, introducing archaeology to young people and children through formal school and college education may be more akin to 'outreach', or, as Hansen and Fowler (2008: 332) have termed it, 'outreach education', than 'community archaeology' due to the impetus for the participation coming from archaeologists and enthusiastic teachers, rather than from the young people themselves. However, young people can be engaged through informal channels as well. Perhaps one of the best-known groups through which young people are engaged outside of formal education is the UK's Young Archaeologists' Club (YAC – see www. yac-uk.org), which is overseen by the Council for British Archaeology (CBA) (and see Henry 2004 for a discussion of YAC positioned within informal education). At the time of writing YAC has seventy regional branches across the UK, local clubs for 8–16-year-olds, themselves run by volunteers (Figure 2.3).

While perhaps the most well known, certainly in the UK, YAC is not the only club providing opportunities to engage with archaeology for young people. For example, the Kids' Archaeology Programme

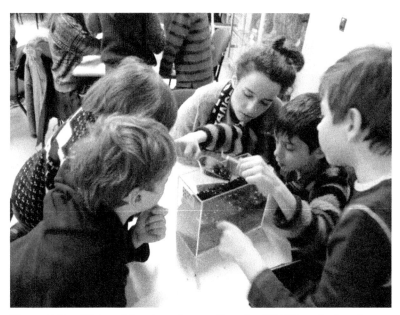

Figure 2.3: 'Fishtank' archaeology at Camden YAC Branch, London. *Courtesy of Sarah Dhanjal.*

(see www.fornleifaskoli.is), supported by the North Atlantic Biocultural Organisation and the Institute of Archaeology, Iceland, is a relatively new and still-expanding initiative, which is worthy of evaluation from a community archaeology perspective. It blends classroom-based activities with extracurricular opportunities such as summer schools, and involves a number of local community groups in Þingeyjarsýslur County, north-east Iceland, where the project is based (Jóhannesdóttir and Ingason 2009).

Community archaeology and marginalised communities

While some professional archaeologists, especially through online discussion portals, on occasion express negative comments about the concept of community archaeology (for example the relatively common misconception that allowing volunteers on-site somehow 'steals' employment from paid archaeologists), most discussion of outcomes of community archaeology remains positive, perhaps even taking these positive outcomes for granted at times. Certainly in the UK the understanding of outcomes is often driven by evaluative requirements of funding bodies (Clark 2004). This is not to say that community archaeology cannot also have negative consequences, especially if delivered poorly or with a 'tokenist' set of project goals (Doeser et al. 2012: 5). But while there are, perhaps inevitably, examples of more superficial engagements, sometimes driven by artificial targets imposed by grant-givers, there are also examples of community archaeology and heritage initiatives that have engaged successfully and meaningfully with sections of society that are often considered marginalised from mainstream activities.

Work by Kiddey and Schofield (2011) and Ainsworth (2009) has shown that, in at least a handful of cases, projects that engage with community members who are often the most excluded, such as the homeless in these cases, can nonetheless be carried out meaningfully and sensitively, with positive results. Similarly, a number of British archaeological organisations, such as the Hampshire and Wight Trust for Maritime Archaeology and the Surrey County Archaeology Unit, have experimented with involving young offenders and young people at risk of poor outcomes in their fieldwork.

Involvement and interaction with heritage, whether through an archaeological site or museum collections, is also being shown to have positive 'wellbeing' outcomes. A project involving University College London (UCL) Hospitals was able to demonstrate measurable increases

in how 'well' participants felt after engaging with objects from UCL Museums' collections (see Chatterjee et al. 2009). Similarly, archaeological projects that engage veterans and recovering soldiers, such as Operation Nightingale (www.wessexarch.co.uk/OperationNightingale) have seen fascinating results (see Winterton 2014 for a very personal account of this). An approach involving using archaeological survey to engage veterans of the Falklands War aims to see whether engagement with former sites of conflict through an archaeological lens can be used as a means to tackle war trauma (Williams 2013).

Another 'community' that has historically been viewed with suspicion by archaeologists has been hobbyist metal-detector users. There are ongoing concerns about the impact on archaeological sites of the criminal use of metal detectors (see for example Wilson and Harrison 2013), but at the same time, certainly in the UK, the uneasiness felt by archaeologists towards metal-detector users in general (and see Thomas 2012 for the history of this) has to some extent softened in more recent times. Initiatives such as the Portable Antiquities Scheme, which operates across England and Wales, have gone a long way to improve the situation, encouraging engagement between metal-detector users and archaeologists for the purpose of reporting and recording finds. It has even, in its own right, been described as 'the largest community archaeology project in the country' (Bland 2005: 257). Whether or not this is the case, metal-detector users have nonetheless become a common element of community archaeology projects, aiding the archaeological process with their particular skill-sets and equipment. This has particularly been the case in the area of battlefield archaeology, with observations that engaging with such relic hunters (as they are often called in the USA, for example) makes use of their local knowledge as well as their skills, resulting in a greater benefit for archaeological research (e.g. Espenshade et al. 2002).

Community archaeology and indigenous communities

Less common in much of Europe, but significant in other parts of the world, is the way in which community archaeology, and 'community-based approaches' (e.g. Greer 2010), have been utilised for encouraging indigenous communities to have an active involvement in the fate of their cultural heritage. As Greer et al. have noted (2002: 266), some of the tone of this engagement, for example with many archaeologists recognising a requirement to obtain 'consent' from indigenous communities

to carry out research, in many ways reflects the wider political developments in Australia and elsewhere to recognise indigenous rights.

The aftermath of colonialism has had an impact on archaeology in much of Africa as well. Chirikure et al. (2010) discuss how, due to some communities being moved away from their ancestral sites during the colonial period, this has led to special consideration of communities that are not necessarily geographically near to a particular heritage site any more. Ndlovu has noted also that traditional community connections to sites, for example connected to specific rituals, are sometimes compromised, or even stopped altogether when a site gains recognition as a national monument or other heritage-related label, as happened at Domboshava in Zimbabwe (2009: 66).

Another area where significant research has been carried out concerning collaboration in archaeology with indigenous communities is North America (e.g. Atalay 2006). As in Australia, some of these encounters can become politically charged, and at times can result in disagreements as well as in successful partnerships, especially where issues over human remains have been concerned (e.g. King 1983: 158). Since 1990, the Native American Graves Protection and Repatriation Act (NAGPRA – www.usbr.gov/nagpra) has enabled the greater involvement of Native American communities within the USA with the management of archaeological heritage (Banks et al. 2000: 35).

Training community archaeologists

Against the backdrop of community involvement and empowerment with regard to the archaeological heritage, it is important not to forget that the archaeology itself, as a finite and irreplaceable resource, still requires appropriate research and curation. Therefore, while the social outcomes from community archaeology are nonetheless important, it is also important to maintain acceptable standards within the archaeological work itself (Thomas 2015: 160). This is not intended to be dismissive of the many voluntary groups that have extensive experience of archaeological approaches, many of whom produce research of a high quality (e.g. Reid 2012). Nonetheless, it does reinforce that in many cases it is still advisable for trained archaeologists to be involved in a community archaeology project. In fact, there are numerous organisations in which posts actually called 'community archaeologist' exist (e.g. Guinness 2014).

Next to understanding archaeological processes themselves, a community archaeologist must also be able to communicate often

complex terminologies and processes to different age groups and abilities. Furthermore, they require what are referred to as 'soft skills', in order to handle different social situations, including becoming a mediator in instances of conflict or disagreement.

Interestingly, while archaeology itself (often taught as part of other disciplines such as anthropology, as is the case in the USA), is taught at many universities across the globe, special attention to community and public archaeology is relatively rare. Alongside masters programmes in Public Archaeology (UCL) and Heritage Education and Interpretation (Newcastle University), there is only one masters-level degree in the UK specifically named 'Community Archaeology', which is offered at Bishop Grosseteste University in Lincoln as a 'blended learning' course, incorporating distance learning alongside group sessions on site in order to accommodate students who may already be working. Therefore, while many archaeologists learn from experience, or perhaps find that they are naturally drawn to projects involving community engagement, few are equipped by the end of their formal education with actual training in this area.

This gap in training was also identified by the CBA (Thomas 2010: 44), and informed a funding application to the Heritage Lottery

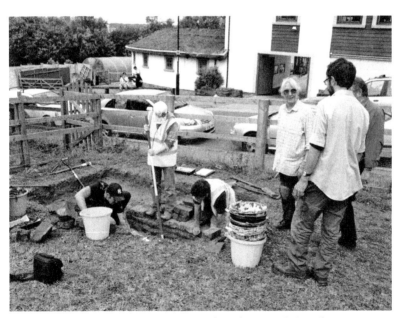

Figure 2.4: 2011–12 Community Archaeology Training Placement beneficiary Hannah Baxter (standing, in hat) with participants at Heeley City Farm, Sheffield. *Courtesy of Council for British Archaeology.*

Fund, through its Skills for the Future funding stream, to provide bespoke paid training placements to equip archaeologists with the skills and experience needed for successful engagement within community archaeology settings. The Community Archaeology Bursaries Project (see http://new.archaeologyuk.org/community-archaeology-bursaries-project) ran its first cohort of traineeships at host organisations across England, Wales and Scotland in 2011 (Figure 2.4), and by the completion of the project will have offered fifty-one different year-long placements (Sutcliffe 2014: 107). The legacy of the project will in part depend on the impacts of these bursaries on both the host organisations and the individual trainees, as well as the local communities who have interacted with them. Certainly, a long-term goal of the project is to assist the trainees to progress into careers in community archaeology, and the Rainford case study (case study 2.3) in this chapter illustrates one such example where this has happened.

Case study 2.3: Rainford's Roots (UK)

Where? Rainford, near St Helens, Merseyside, England, UK.

When did it start? Rainford's Roots began in January 2012, after a chance find of a near-complete post-medieval tyg (large pot mug) in a garden. It was developed as a community project after the success of a smaller grassroots project in 2011 investigating the area of the chance find, where significant remains associated with the post-medieval pottery industry were discovered. This small but exciting community excavation generated considerable local interest and enthusiasm, and involved the then CBA Community Archaeology Training Placement beneficiary based at National Museums Liverpool, which was later also involved with developing the application to the Heritage Lottery Fund to run Rainford's Roots.

What do they do? The project was set up to further explore the post-medieval pottery and clay-pipe manufacturing industries in the village. It engages members of Merseyside Archaeological Society, local residents, University of Liverpool students, and any other individuals who wish to become involved.

Activities to date have included garden test-pitting, building recording (Figure 2.5), larger community excavations, finds processing using the facilities of National Museums Liverpool, heritage walking tours, local exhibitions, handling sessions and participation in the annual Festival of Archaeology (a UK-wide fortnight of archaeology-related events open to the public, organised by a diverse range of organisations and groups, and coordinated annually by the CBA). Rainford's Roots also hosted

visits from other groups such as branches of the YAC. A dedicated blog featuring entries from different participants forms part of the project website, and among the outcomes of Rainford's Roots is a book about the project (Rowe and Stewart 2014). This and other aspects of the project mean that participation is not limited to excavation activities, and those who wish to be involved in other ways can also take part.

Who organises it? Rainford's Roots is organised by Merseyside Archaeological Society, a voluntary group based in the north-west of England that was founded in 1976. The project is carried out in partnership with National Museums Liverpool. Simultaneously with the launch of Rainford's Roots, the Rainford Heritage Society was formed in early 2012 for those interested in the history and archaeology of the village.

How is it funded? It is funded by a grant from the Heritage Lottery Fund, which as well as providing resources and equipment has paid for the employment of a project officer.

Further information available online: www.liverpoolmuseums. org.uk/mol/collections/archaeology/field/projects/rainfords-roots. aspx, with information about Merseyside Archaeological Society at: http://merseysidearchsoc.weebly.com.

Figure 2.5: Participants Martin and Liam recording a Rainford building in July 2013. *Courtesy of National Museums Liverpool.*

Conclusions

As this chapter has tried to demonstrate, while community archaeology has some defining features, the ways in which the term can be applied to different scenarios and projects, and the diversity of different communities (and individuals) that can become involved, are almost innumerable. There are still some facets of communities who remain less engaged, sometimes because they are hard to reach and sometimes because they are simply not interested. A key for successful engagement is to support genuine community empowerment and to avoid superficial involvements that are only driven by a need for obtaining impressive-sounding, but tokenistic, outcomes or statistics. As has been shown in many cases, for example with communities with a difficult history of oppression by more dominant sectors of society, or in cases where connections to school education programmes are sought, political impacts must also be considered and understood. Archaeology at a community-level has real potential to make significant impacts, but these can be negative as well as positive, and so care must always be taken.

3
Economics in public archaeology

Paul Burtenshaw

Introduction

Economics plays a significant role in the public's relationship with archae-
ology. It has been described as one of the chief reasons that archaeology
has relevance for governments or individuals today, and is often used to
justify why archaeology should be done, or given resources to be carried
out (Flatman 2012; Selvakumar 2010). Despite this, 'economics' and
'economic value' often sit uneasily within the archaeological discipline,
reflecting a general sense that issues of 'culture' and 'economics' are sep-
arate and indeed often opposed. This chapter explores what is meant by
economics in public archaeology, how archaeologists can think about
and measure economic value and how archaeology economically bene-
fits people. In doing so this chapter demonstrates that economics is vital
not only to understanding the public's relationship with archaeology but
also in the future sustainability of the discipline itself.

'Economics', and therefore 'economic value', in public archaeol-
ogy means two interrelated but separate things. These areas are often
confused and conflated, but care must be taken not to do this. The two
meanings reflect different definitions of 'economics' itself. On one hand,
economics means the purely financial costs and benefits of studying,
preserving and managing archaeological material. This can include
analysis of the commercial archaeological industry, heritage's contri-
bution to tourism revenue or aspects like urban heritage's contribution
to regeneration. On the other hand, the wider discipline of economics

concerns the efficient management of available resources to produce maximum welfare in a population. Therefore the 'economics of archaeology' also concerns the valuation and measurement of all the ways in which archaeology contributes to the wellbeing of the public, how these benefits (and costs) are measured, and how their analysis informs policy decisions about its management. However, the use of the term 'economics' in this regard can mean an assumption that the benefits being examined and considered are purely monetary, causing the second meaning to be associated purely with the first. It is important for public archaeology to understand these two meanings.

Archaeological economics

One definition of economics concerns a body of theory and practice which deals with the production, distribution and consumption of certain goods and services. Through this study it is hoped that the welfare that a good or service offers a population is maximised. Cultural resources, which include archaeology (and cultural heritage), are economic goods because they contribute to human 'wellbeing' or 'welfare' (Provins et al. 2008: 134). The field of cultural economics examines how to maximise the welfare cultural resources offer a population (Throsby 2001; Towse 2011). Cultural economics attempts to measure the 'economic value' of cultural heritage for the public: this 'value' is the measure of how important something is to the public.

> The economic value of cultural heritage can be defined as the
> amount of welfare that the heritage generates for society.
> (Ruijgrok 2006: 206)

The value of most goods provided to the public is set by the market (or rough versions of markets) and is reflected in the monetary price people are willing to pay for goods. This setting of value through supply and demand theoretically regulates the provision of that good to ensure optimal use of that good and resources to produce it (Kaul et al. 1999). For various reason most cultural goods, including cultural heritage, are not (usually) exchanged through a market. This means there is 'market failure', and other mechanisms and management approaches are required to establish value and regulate the provision of the good. Some of these mechanisms and policies will be familiar to archaeologists,

such as public designation, funding through taxation and philanthropy, and punishments for destruction of the resource.

The mechanisms to manage cultural heritage require ideas of value to inform them. Decision-makers need to understand which archaeological resources are of potentially higher value and therefore are a priority for protection and the investment of time and money. Within cultural heritage management various 'value' schemes have been developed to assess the importance of archaeological sites and materials (Mason 2008a). These schemes list attributes or 'values' that cultural heritage may have so that resources can be assessed against criteria. Various schemes have been suggested by archaeologists (e.g. Lipe 2009) and their differences highlight the difficulty in delineating the variety of ways in which archaeology benefits the public. Some are linked directly to legal protection, such as scheduling in the UK, or to designation, such as 'outstanding universal value' for World Heritage Sites. Few of these schemes list financial benefits as part of 'values' (Lipe 2009 being the exception), while some, like the Burra Charter (Australia ICOMOS 2000) purposefully exclude them. The application of the schemes share some characteristics, as resources tend to be assessed by expert opinion on behalf of the public, and produce qualitative assessments of value.

Cultural economics takes a different approach to assessing the value of cultural heritage. For economists the value of something is invested in the public (called consumer sovereignty) and the challenge is to measure the value they feel for different goods. Economists argue that this approach is more appropriate to maximising welfare as it serves the wishes of the public, rather than being guided by a small elite of decision-makers. Economists also seek to produce quantitative measurements of value, often expressed in monetary values. It is argued this form is more appropriate as it is the 'language' of value, and can therefore be compared to other uses for the money which may be committed to archaeology (Mason 2008b). The shortcomings of such an approach are argued to be deficiencies in the methodology of the valuation techniques (see below) and that a focus on public opinion in the short term harms long-term sustainability and benefits. However, it must be remembered that both approaches have their relative advantages and disadvantages and that both are ultimately designed to offer information on the value of cultural heritage.

To quantitatively assess the public's value, cultural economists divide value into two sorts: use and non-use value (Throsby 2012). Use value is the value people express for a good through the market. This may be through paying to visit places or buying objects. As these actions

have direct economic transactions attached to them the value can be measured directly. Non-use value is the value people feel for goods which they are unable to express through the market. This may be due to the fact that something is free to visit or appreciate, or that people value something but this value leaves no discernible trace; for example, someone may be glad that the world contains the Pyramids of Giza but never act on this through travelling there.

The methods to access this value can be broadly divided into two types – revealed preference and stated preference (Nijkamp 2012; O'Brien 2010). Revealed-preference methods, those that rely on people 'revealing' their value for heritage through their behaviour, include hedonic pricing and travel-cost method. Hedonic pricing primarily involves the analysis of house prices to understand the effect of historic characteristics, while travel-cost method analyses the amounts of time and money people are willing to spend to travel to heritage sites. Stated-preference techniques rely on directly asking the public to state the value that they feel for a certain resource. Techniques create hypothetical situations – for example, that a certain cultural resource will be destroyed, or that extra visitor services or conservation projects will be developed – and ask people's 'willingness to pay' for a positive change, or to prevent a negative change occurring. Contingent-valuation methodologies ask respondents for financial values using a variety of techniques. Choice modelling (or experiment) is slightly different in that it creates a variety of scenarios and asks respondents to choose between combinations of these to assess value for multiple facets of a cultural resource. The value expressed by the sample for both techniques is then extrapolated to the population thought to be affected by any change in the cultural resource.

The problems associated with such techniques have been well documented (McLoughlin et al. 2006). These revolve around practical issues in survey design, and fundamental critiques that results are invalid as they elicit little more than hypothetical answers and that people are unused to valuing resources in this way. The techniques have been popular in the assessment of environmental goods, and have been used in some important studies for cultural heritage (see case study 3.1) but remain largely marginal in value assessments of cultural heritage (Nijkamp 2012). However, cultural economics concepts have heavily influenced theories on the value of archaeology (Carman 2002; Carver 1996; Darvill 1995); and major heritage organisations have conducted research into the economics of archaeology and flirted with cultural economic theory (eftec 2005; Mason 1999; Ost and Van Droogenbroeck 1998).

Case study 3.1: Measuring the value of archaeology

An early example of a contingent valuation survey applied to archaeology is Maddison and Mourato's (2001) study valuing different road options for Stonehenge. The sample for the survey consisted of UK households from across the country and on-site visitors to Stonehenge. Respondents were presented with two options for Stonehenge: keeping the (then) current layout of roads with its associated ability to see the site from the road, or the construction of the 2km tunnel for the larger A303 and removal of the closer A344, with the associated reduction of noise and visual intrusion. Respondents were asked to select their preferred option of the two, and then asked their maximum willingness-to-pay in order to secure their preferred option, in the form of an increase in tax. While significant amounts of people valued viewing Stonehenge from the road, the mean bid per household for the tunnel options was £8.90 per household, as compared to £2.69 for maintaining the current scenario. When spread out to the UK population (taking into account background support for the project) the net heritage benefit of constructing the tunnel was found to be £144 million. However, it was also noted that many individuals did not really care which option went ahead.

A choice-modelling approach has been applied to the public value of the Roman fort of Vindolanda on Hadrian's Wall (Kinghorn and Willis 2008). This method was chosen for its advantages in obtaining values for various tourism attributes of the site, which could then be used to inform their management. The survey asked visitors their opinions of the presence of on-site research and excavation, interpretation, reconstructions, the museum and display of artefacts from the sites, general visitor facilities and the price of entry. A total of 149 visitors were offered different options for each element to change or remain the same. The study found that the presence of excavation and research at the site was the most important element to visitors, followed by the on-site display of artefacts from the site. Research and excavations were considered twenty-seven times more important to visitors than reducing the entrance fee, nineteen times more important than providing an audio guide, four times more important than creating more reconstructions, and one-and-a-half times more important than ensuring artefacts are displayed on the site. Willingness-to-pay estimates from visitors showed that the on-site excavations were valued at £27.18 per individual, while preventing objects moving to other museums was £18.65. The research also showed that the creation of a play area on the site would actually decrease the average visitor's willingness-to-pay to come to the fort.

The different approaches to the economics of archaeology highlight a fundamental problem of how the value of cultural heritage is represented and communicated. Throsby (2012: 51–2) describes this issue of representation as 'an all-pervading problem'. The history of efforts by the heritage sector to communicate with the government in the UK (case study 3.2) has shown the difficulties in expressing value in a form which both fits into wider value and policy assessment, yet does justice to the complex and varied public attitudes and relationships with archaeology. Success in doing so will come from the successful marrying of approaches and interdisciplinary perspectives rather than adherence to any one school of thought.

Case study 3.2: Representing archaeology and heritage economics in the UK

A battle about how the value of archaeology is demonstrated and communicated has been keenly fought between the UK government and the heritage sector over the past few decades. A shift in the relationship between government and the 'cultural sector' occurred in the late 1970s and early 1980s when what has been come to be labelled 'instrumental' justifications of state support came to the fore (Belfiore 2012; Gray 2007; Selwood 2002). 'Instrumental' benefits are usually characterised as those which are ancillary to culture, such as economic and social benefits. Political ideas at the time called for the application of market philosophies to public services, and the cultural sector was expected to contribute to wider economic and social policies, backing up such claims with data. Some of the first studies into economic contribution of culture, in terms of finances, date from this period (e.g. Myerscough 1988).

The focus on data and target-led cultural policy continued in the 1990s; however, by the new millennium criticism gathered that the focus on targets was unhealthy and the evidence provided for it was flawed and a 'spurious exercise' (Selwood 2002: 13). Along with broader changes in political philosophy (such as the introduction of 'public value') a more holistic account of cultural value was sought. This led to the 'Valuing Culture' conference in 2003 to 'articulate the non-monetary benefits' of culture (Hewison 2012: 209). As a result heritage organisations attempted to develop an array of methodologies to account for cultural heritage which could, however, also fit

in with the requirements of government mechanisms to judge policy (Cooper 2012; O'Brien 2010). Suggested methods included contingent valuation, social return on investment, subjective wellbeing analysis and public value framework, while conceptual models proposed include the influential 'cultural value triangle' (Holden 2004, 2006), which splits value into intrinsic, instrumental and institutional types. However, none of the suggested approaches has gained significant traction as yet, and commentators note that under the economic crisis from 2008 onwards there was a distinct return to instrumental values, principally economic, to justify government spending (Belfiore 2012), and some have judged the 'Valuing Culture' debate to have largely failed in its objective (Bakhshi 2012; Hewison 2012).

Archaeology as an economic asset

Archaeological materials generate jobs, revenue and money for people in a variety of ways, including:

- tourism
- urban regeneration
- direct sale of material (antiquities trading)
- marketing and branding
- jobs created by archaeological research and conservation.

These areas can overlap: for example, the regeneration of heritage properties, or the establishment of museums, can both improve urban spaces for residents as well as attract tourists.

All of these areas produce real financial flows in the economy which can be measured. The assessment of economic impacts is usually expressed in terms of revenue or employment: for example, place X generates £X million to the UK economic annually, or place Y provides so many full-time equivalent (FTE) jobs. However, it is also important to understand the nature of any economic impact, along with its distribution and knock-on effects. The initial impact of the money earned through, for example, a visitor buying a ticket is called the 'direct' impact (Bowitz and Ibenholt 2009; Stynes 1997). However, this money is re-spent in the economy, for example by a destination employing staff or buying supplies. Those people and suppliers in turn spend money on the goods and services they need. The 'indirect' effect of an economic impact is the effect of this re-spending by suppliers, while the 'induced'

effect is the result of the re-spending of wages earned by employees. This chain of re-spending in an economy is known as the 'multiplier effect'. 'Multipliers' are the amount direct economic impacts can be increased to reflect these effects. Associated with multipliers is the concept of 'leakage'. Although economic activity generated by an archaeological site or attraction may occur at a certain location, subsequent re-spending may occur within a local economy, but may also go outside that area due to aspects like employment of 'foreign' workers, taxes or payments to suppliers based outside that area.

The economic impact of archaeology (or economic value in the strictly financial sense) can therefore be assessed through the understanding of its magnitude, multiplication and distribution within a certain area. While the basic method of economic impact assessments is common, the range of factors and data involved mean there is ample opportunity for error, either mistaken or deliberate for political ends (Crompton 2006; Snowball 2008). Common sources of error include the blunt application of inappropriate multipliers (which can be hard to calculate in the first place), and lack of basic data, like visitor numbers and spending, to inform calculations.

The economic activity most associated with archaeological materials is tourism. Economic impacts are generated by people spending money directly at archaeological places – such as on tickets, refreshments, guides and souvenirs – or on the services such as transportation, accommodation and food for their trip. Relevant tourism occurs at archaeological sites, to objects in museums or even to representations of archaeology such as heritage parks. Heritage is a major driver of tourism globally and generates significant funds. It is estimated that about 40 per cent of international travel is motivated by heritage (Timothy and Boyd 2003), while over 40 per cent of all visitors to the United States said they planned to visit historical places (Office of Travel and Tourism Industries 2012: 10). In the UK, the Heritage Lottery Fund commissioned research which established that heritage tourism contributed £14 billion to the gross domestic product (GDP) of the UK (including multipliers), generating 393,000 jobs (Oxford Economics 2013) (see case study 3.3). The Global Heritage Fund calculated that tourism to 500 heritage sites in the developing world was worth US$24.6 billion in 2010, which would increase to over US$100 billion in 2025 (Global Heritage Fund 2010).

Archaeological resources have been the focus of major tourism projects to generate wealth and economic development for regions or countries, and their use as an economic asset in this regard is well recognised (e.g. World Bank 2001). Following ideas pioneered in eco-tourism, many

Case study 3.3: Investing in success

In the UK the Heritage Lottery Fund (HLF), which redistributes money generated by the National Lottery for heritage projects, has often led efforts to account for the economic impact of its activities and of heritage in the country in general. Between 2006 and 2010 it conducted a thorough study of its own projects, taking a sample each year and collecting data on their economic impacts. It also commissioned dedicated research to establish the value of heritage tourism to the UK. Both sets of data formed the basis of *Investing in Success* (Heritage Lottery Fund 2010), a policy document designed to advocate for and outline the economic benefit of continuing to support heritage in the UK.

The report concludes that visitor numbers typically increase by 50 per cent following an HLF-funded project, while every £1 million of HLF funding generates an increase in tourist revenues of £4.2 million over a ten-year period. A very important aspect of these studies was that they considered where economic impacts from the projects took place, trying to understand who it was that benefited. For example, in 2010 it was found that just less than 40 per cent of expenditure was leaked from regional economies (within fifty miles).

The report also detailed the value of heritage tourism to the UK economy by attempting to understand how much of tourism to the UK to general could be attributed to heritage. The amount of tourism that can be 'allocated' to heritage differs for different types of tourists. The initial report concluded that out of a total of £86.4 billion of tourist expenditure about £7.2 billion was due to cultural heritage (excluding natural heritage). If multipliers are added this becomes £11.9 billion. A more recent version of the study increased these values to £8.5 billion and £14 billion respectively (Oxford Economics 2013).

The figures in the first report, principally the general tourism figures, were heavily featured in policy and popular documents following its release (e.g. Reynolds 2011). Members of the HLF have commented that: 'The report has probably been the most successful advocacy document produced by HLF, and quite possibly by the heritage sector as a whole in the UK' (Bewley and Maeer 2014: 243).

projects seek to use archaeological tourism to benefit local communities, including using it as an economic incentive to stop looting, or developing archaeological sites for other uses (McEwan et al. 2006 and the activities of the Global Heritage Fund and Sustainable Preservation Initiative). However, these projects can be difficult to implement. Tourism in general can suffer from the poor quality of employment offered and is fragile to political disturbances in destinations, as well as having potentially negative social and cultural consequences (Schveyvens 2002). Leakages away from sites can be a major problem due to the entrenched power of suppliers or the level of local capacities (Adams 2010; Hampton 2005). Consistent reporting and analysis of the economic, and wider social and preservation, impacts of tourism are lacking in archaeology (Adams 2010; Parks 2010).

Archaeological sites, as well as cultural institutions such as museums and galleries, are used as assets in revitalising or enhancing urban areas (Bassett 1993; Selwood 2006). As well as attracting tourists, it is argued, the presence of heritage and culture makes places more attractive to live in, persuading businesses and skilled people to locate there, increasing the economic output of locations. The conservation and development of urban areas form a major theme for government and international funders (World Bank 2001), and have received significant academic attention concerning the relationship between heritage and sustainable development (Girard and Nijkamp 2009; Graham et al. 2000; Labadi 2008). In the UK, heritage organisations have conducted specialised research advocating re-use of historic properties (English Heritage 2013). One report claims that the economic impact of the maintenance and repair of historic buildings in the UK is worth £11 billion in GDP (ECORYS 2012).

Archaeology generates a great variety of jobs. This may be through employment in tourism, in archaeological conservation, in research, or in organisations (public or private) charged to manage archaeology (Aitchison 2012). The amount of people employed can be considerable – for example, a report focusing on Scotland found that the historic environment sector supported in excess of 60,000 FTE employees (ECOTEC 2008). The Association of Independent Museums found that their attractions provided at minimum 5800 FTE jobs (AIM 2010). Outside this more formal employment, archaeology creates work for people who live in the area around the excavations. Especially in developing countries, the benefits of this employment can be considerable (Boynter 2014), and for many their main relationship with archaeology is dominated by this economic relationship (Parks 2010).

The trade of archaeological objects can also raise significant revenue. Estimates for the legal and illicit trade in antiquities are hard to establish but are likely to be considerable. While looting sites can be an alternative source of revenue for communities (Parks 2010), studies have highlighted the fact that it is often middlemen and dealers in market countries who benefit most, financially, from the trade (Brodie et al. 2006). Some have suggested legal trades in antiquities (Wilkening and Kremer 2007), arguing that regulated market forces based around long-term leases would generate revenues to protect antiquities and decrease the black market.

Archaeological sites and objects also have commercial value for private interests through branding and marketing (Starr 2010). A variety of businesses will use images of, or associations with, archaeological remains to show connections with certain places or perceived values. Companies may also wish to sponsor archaeological research or conservation, or use heritage locations for advertising or for commercial events. While some of these arrangements are formal and result in revenue for archaeology, archaeological sites and symbols are often used informally due to the difficulties in maintaining formal image and rights management for archaeological places and objects.

Economics in public archaeology

The use of archaeology as an economic asset can have negative aspects. As is well known, the commercialisation of archaeology for tourism can have negative effects on the physical fabric of sites and objects, and can impact the other values of archaeology through restricted access or 'Disneyfication' of cultural values, amongst other aspects (see Timothy and Nyaupane 2009: 56–69). Looting motivated by economic gain destroys sites and the information they contain, while the use of archaeological resources for branding and marketing can promote values at odds with other public values (Starr 2010). The use of archaeology for economic gain can also promote short-term benefits over long-term preservation. Due in part to these reasons, economics has been traditionally thought of as separate from, or in opposition to, 'cultural' values, preferred by archaeologists (Graham et al. 2000).

However, there are also positive aspects. Economic impacts can interact well with other values, for example through urban regeneration. Economic incentives are used to halt more destructive processes, such as the use of tourism to prevent looting – the jobs and revenue

that archaeology provides to people can be a powerful motivation to preserve sites and materials. The ability of archaeology to act as an economic asset is one of the reasons people are willing to preserve it and give resources to it (Mason 2008b). For many people it is what gives archaeology 'value'. It should also be remembered that the undue promotion of any of archaeology's values, such as the promotion of nationalist readings of history, can also harm long-term preservation and other values. Archaeologists must be open to and perceptive of the importance of archaeology's 'economic value' for the public.

Economics is a major part of the relationship between the public and archaeology, and must be carefully observed and understood if it is to be managed successfully. However, research into the conceptual approaches to archaeological economics has been recognised as under-developed (Hodder 2010; Lafrenz Samuels 2008). Equally, large-scale literature reviews of economics and cultural heritage have noted a general lack of research and data on archaeology as an economic asset (Rypkema et al. 2011) although recent studies suggest some increased activity (Dümcke and Gnedovsky 2013). Skills within archaeology to measure, present and analyse economic value have also been high-lighted as lacking (Hodder 2010; Pyburn 2009). It is important that every public archaeologist, and every archaeologist, has a basic under-standing of both archaeological economics and how archaeology oper-ates as an economic asset.

Further reading

Archaeology and Economic Development. 2014. Special issue of *Public Archaeology Journal* 13(1–3).

Hutter, M. and Rizzo, I. (eds.) 1997. *Economic Perspectives on Cultural Heritage*. Basingstoke: Macmillan.

Licciardi, G. and Amirtahmasebi, R. 2012. *The Economic of Uniqueness: Investing in Historic City Cores and Cultural Heritage Assets for Sustainable Development*. Washington, DC: The World Bank.

4
Archaeology and education

Don Henson

Introduction

Why should archaeologists involve themselves in education? Education here means the formal education system through schools, colleges and universities. To do so is to reach out beyond our own discipline to young people and adults who are not necessarily intending to become archaeologists. In this chapter I examine some of the main themes in archaeology and education, focusing primarily on the UK. These themes include the value of archaeology in education, different theoretical approaches to learning, and the place of archaeology within formal learning. Three short case studies present examples of archaeological education in different forums.

The Council for British Archaeology as one of its first acts at its foundation in 1944 set up a committee to look at the place of archaeology in education. This committee produced a report which included the following:

> Furthermore it may be urged that unless a larger section of the British public is brought to take an intelligent interest in archaeology, our science will continue to be handicapped by ignorance, apathy and obstructionism in the post-war world and to find difficulty in obtaining state or other financial assistance for research. It is therefore of the utmost importance to the Council to promote archaeological studies in general education.
>
> (Dobson et al. 1944)

This presented a self-serving but highly important reason for archaeologists to concern themselves with education. Archaeology depends on public support for the funding it needs, and that public support would be greatly facilitated by having a populace who were educated in archaeology. Of course, in 1944, education was the major conduit for communication between archaeologists and a mass audience. Nowadays, we have television and the Internet as media, but the argument still stands. Formal education can still reach a wider audience, potentially the whole of society.

A more altruistic reason for engaging with education was presented by John Evans in 1975 in his inaugural lecture as Director of the Institute of Archaeology.

> Despite its great and growing popularity it seems to me that archaeology is still a widely misunderstood subject (not least by some of its friends, and even of its practitioners), and as a result of this it is still far from having achieved the place, either in formal education or in the general consciousness of society, to which its achievements, and its relevance to our human condition, entitle it.
>
> (Evans 1975: 2)

Archaeology has important things to say about the human condition and about the human experience across the ages. Education needs archaeology if society is to have access to our knowledge and ideas. Yet only a few writers have explored archaeology in education (Corbishley et al. 2008, 2012; Cracknell and Corbishley 1986; Henson et al. 2004, 2006; Jameson 2003; Planel 1996; Stone and MacKenzie 1990).

What archaeology offers

But what is it about archaeology that we can place at the service of education? We need to examine what archaeology is to be able to see how we can engage with education in a fruitful way.

The processes of archaeology are twofold: discovery and interpretation. That is, we discover (recover, record etc.) the physical remains of human activity, and we develop histories of past human life based on these remains. These processes can be seen as a reaching back from the present into the past, and a creation of a past in the minds of the present. Archaeology is a bridging discipline between past and present. Much of modern archaeology as a profession is concerned with managing the

remains of the past. The past has become reified, embodied in a category we identify as heritage (English Heritage 2006, 2007; National Trust and Accenture 2006).

As a practice carried out in the present, there must be some aim behind what we do. Archaeology is more than the mere collection of antiques. Archaeology as practised seems to have four basic aims:

- to learn about the past
- to learn from the past
- to manage the heritage of the past
- to enable public engagement with the past.

If we are to ensure that archaeology has a presence within formal education, at whatever level, then these four aims need to be included in what is taught. Educating people about archaeology is complex; it involves far more than simply saying 'this happened then'. We can give people the knowledge and skills of archaeological practice, and help them to make links between past and present and to see the value and complexity of heritage. Archaeology offers both intellectual challenge and emotional connection, so it can be a mental exercise as well as a set of technical craft skills. Because of its wide subject domain and practice, it can appeal to a very wide variety of learners.

Our relationship with the past depends on us seeing the connections and resonances between past and present. There are three dimensions of archaeology which have particular relevance for the present: time, place and people. Through our understanding of time, we can learn about the origins of our present-day world and its features, how human society is not static but develops through time, and we can focus on analogies in the past for present situations and issues. Our understanding of places in the past helps us to appreciate the enormous cultural variety and ways of expression of human societies. We also begin to understand the interactive relationship we have with our changing physical environment, landscapes and climate. Our investigations of human behaviour can lead us towards a feeling of common humanity with others and a more empathetic understanding of human experience (Henson 2005). All these have relevance for issues of the present, such as:

- identity: the popularity of family and local history, issues such as immigration
- environment: climate change, genetically modified foods, conservation of animals and landscapes

- warfare and oppression: our common origins and the futility of war
- economics: the benefits (and problems) of heritage tourism
- politics: the importance of remains such as Elgin marbles, the Bhamiyan Buddhas, or the mosque and temple at Ayodhya.

The learning context

Firstly, a word of warning: although educational theory is widely developed and used, it is academically contentious. There are many who see the growth of child-centred learning theories since the 1960s as based on little more than untested supposition and un-evidenced, unverifiable claims (Matthews 2003; Tobias and Duffy 2009). On the other hand, much learning theory provides a framework that educators have found useful and makes empirical sense within the multi-sensory setting of heritage sites and museums (Hein 1995; Hooper-Greenhill 2007; Jeffery-Clay 1998). There are various learning theories that have been developed. Many of these are often grouped under the label of constructivism, to signal the idea that learning is a process whereby pupils construct their own understandings with the help and support of the teacher rather than having knowledge imparted to them by instruction. Only a few theoretical models of learning will be discussed below.

An early theory was the taxonomy of learning developed by Benjamin Bloom and others in the 1950s (Bloom et al. 1964). This identified three main objectives of learning: cognitive (thinking), affective (feeling) and psycho-motor (doing). These domains do not refer to learners but to objectives in teaching; good teaching was meant to develop skills in all three areas. The domains have been widely used within the United States. Archaeology offers educators who use the domains a way of easily teaching all three: the analysis of remains involves high-order cognitive skills; to engage with a heritage of past peoples is to make a strong affective connection across the ages from person to person; and the practices of archaeology are highly physical and technical, so they are well-developed psycho-motor skills.

Another theoretical model, widely used in adult learning, was developed in the 1980s by David Kolb (1984). Kolb's ideas are a thinking-through of the learning that takes place through experience: experiential learning. Concrete experiences provide a basis for observation and reflection, which lead to the creation of abstract concepts and the testing of those concepts through a process of testing in new experiences. This cycle of learning involves a creative tension

between two poles of preferred learning methods: thinking (developing abstract concepts) or feeling (concrete experiences), and doing (experimenting) or watching (reflective observation). Each learner has their own combination of these methods. The development of Kolb's model by Honey and Mumford (1982) uses the following description of learning styles:

- activist (doing and feeling)
- reflector (feeling and watching)
- theorist (watching and thinking)
- pragmatist (doing and thinking).

Archaeology again has much to offer each of these categories. Activist learners are represented by experimental archaeology and re-enactment. Reflectors are perhaps to be found in heritage interpretation, where the details of the past and of its remains are integrated into bigger narratives. Theorists predominate in in academia, where high-level concepts are used to develop the analysis of the details. The fieldworker and finds analyst are good examples of the pragmatist.

A commonly used theoretical model in heritage education as well as schools is the multiple intelligences model of Howard Gardner (1983, 1999). Gardner proposed that, rather than there being a single measure of intelligence, there were eight possible ways in which the brain processes and makes sense of information or experiences. Every person will have their own mix of these eight, with around three being more dominant than the others. The intelligences are:

- linguistic: good with words and language
- logical-mathematical: good at reasoning, deduction and calculation
- spatial: good at visual perception and expression
- naturalist: good at classifying, seeing patterns and relationships
- musical: can easily recognise tone and rhythm, associates sound and feeling
- bodily-kinaesthetic: good at manual dexterity and agility
- interpersonal: empathises and communicates well with others
- intrapersonal: has a good self-awareness of own needs and characteristics.

Once again, archaeology has much to offer these intelligences: see Table 4.1.

Table 4.1: Archaeological correlations with Gardner's multiple intelligences

Intelligences	Archaeological or heritage activity
Linguistic	Writing site reports and interpretation panels
Logical-mathematical	Puzzling out the stratigraphy of a site, undertaking analytical tasks such as lithic refitting
Spatial	Creating site plans, landscape exploration, undertaking field survey
Musical	Using sound within heritage displays
Bodily-kinaesthetic	The physicality of excavation, experimental archaeology, developing interactive displays
Naturalist	Interpreting the patterns in data, classifying artefacts, regional site analysis
Interpersonal	Team working, bringing to life the people behind the site
Intrapersonal	Individual research, providing space for reflection on heritage sites

Archaeological and heritage educators

If archaeology has much to offer educators, and has a real purpose in incorporating itself in formal education, then we are fortunate in having many organisations in the UK which offer opportunities for schools and colleges. National heritage organisations – both those that are state run and independent charities – have in their charge many heritage sites open to the public and education services to provide opportunities to schools and others - for example, Stanley Mills, run by Historic Scotland and described in case study 4.1.

Likewise, museums have long had a remit for public education and catered for schools and colleges, although resources for education have

Case study 4.1: Education at heritage sites

Stanley Mills is an eighteenth-century cotton mill north of Perth, built in 1785 and working until 1989. It is now a property of Historic Scotland and in many ways is typical of hundreds of heritage sites in the United Kingdom. Like many such sites, it has a teaching room for schools, a resources pack for teachers, replica costumes and a handling collection, interactive displays and site interpretation that schools can use on visits to the mill and its surrounds. The schools' pack provides support for teachers who want to run their own visit to the mill. Facilitated visits for schools at Stanley Mills cover the obvious historical topics of Victorian millworkers, Highland clearances, the Industrial Revolution and the Second World War, but also other subject areas such as science workshops on waterwheels, water and electricity, and power transmission. Archaeology is also included directly, which is rare at a heritage site such as this, with workshops on archaeologists at work. As is common to this kind of venture, courses for teachers are also offered for training in how to make best use of the site. Historic Scotland runs a free educational visits scheme – where visits for learning are free to almost all properties – which covers not only schools but the University of the Third Age (U3A), Young Archaeologists' Club groups and after-school clubs. Schools can also claim a subsidy from the Scottish government to cover the costs of their travel, especially if they are in an area with high indicators of deprivation. The subsidy covers visits to Historic Scotland or some key National Trust for Scotland properties and the New Lanark World Heritage Site. Subsidies cover 75 per cent of transport costs, up to a maximum of £250.

traditionally been more forthcoming in the national and regional museums than in the smaller, local or independent museums.

Commercial archaeological units have a mixed record of working with schools. Not all units have charitable status but even those that do find that funding for education is hard to come by through developer funding. The lack of funding for working with schools is only the most obvious of the barriers to archaeological organisations engaging with schools. There is also a relative dearth of archaeological staff with training in, or knowledge of, education – either educational practice or learning theory. Education staff do exist in museums and there is a thriving

support network for them in the Group for Education in Museums (GEM). For archaeological educators, the Council for British Archaeology used to organise an archaeology and education conference every two years. A more troubling barrier lies in the attitudes of archaeologists themselves, many of whom regard engaging with education as completely beyond their remit or, at best, as an optional extra to be undertaken when funding allows.

Formal education in the United Kingdom

Almost all professional archaeologists will have at least an undergraduate degree, and many also have a postgraduate degree in archaeology. But, not all university archaeology students will become professional archaeologists. For most students, it is an interesting degree which gives a range of easily transferable skills that can be applied in a wide range of employment. This is fortunate since art and humanities subjects in the UK are now competing in the marketplace for the attention of students who are all too aware of the fees they will have to pay back after they have graduated. Archaeology has to learn to market itself as a worthwhile subject rather than simply an interesting pastime.

The total number of archaeology students graduating from university is small in comparison with many other subjects. If we are to embed a knowledge of archaeology more widely within society as a whole then we need to focus our attention on education before university to reach a wider number of students. Until recently, with changes in funding pursued by governments of all political complexions since the early 2000s, universities provided a wide range of part-time opportunities for adults to learn about a variety of different archaeological topics (Speight 2002, 2003). Archaeology and local history courses can be traced back to 1934, led by W.G. Hoskins (the father of landscape studies). By the year 2000, there were around 1300 such courses all over the UK. Many universities ran summer field schools (such as that begun by Maurice Beresford at Wharram Percy in 1949), engaging in new research. Now only a few universities support such courses. There are other adult education providers and these often welcome input into their courses from archaeologists. The WEA began in 1903 as the Workers' Educational Association and provides courses for adults of all backgrounds across the whole UK. The University of the Third Age (U3A) is a group for older people who are no longer in full-time employment and may regard themselves as

Case study 4.2: Taking archaeology into schools

Canterbury Archaeological Trust (CAT) is a professional field unit with its own education service, led by its Education Officer, Marion Green. One of its major services is to support teachers in the classroom. It secured Heritage Lottery funding to develop its successful CAT KITs. These are boxes of original archaeological finds, and the first phase of kits were for schools in the Canterbury district. Teachers borrowing the kits attended a training day in how to make best use of them. Each kit has pottery, animal bone and other materials from Roman to post-medieval times along with guidance and back-up materials. The kits support active enquiry-based learning, and were developed with the support of a history adviser who was part of the Schools History Project. Funding from Kent Archaeological Society and Kent County Council resulted in a second phase of kits for use across the county, with some going as far afield as Lancashire. More recently, the Trust has developed its CAT BOX loans, supported by the Friends of Canterbury Archaeological Trust, which are also available through Kent. These contain some original historical objects and also high-quality replicas and models covering prehistory up to modern times. Schools have to pay to borrow the CAT BOX loans but the fees are set at an affordable level. CAT is working with archaeologists and educators in Kent, northern France and Flanders in Belgium to produce new kits with a Bronze Age focus. A set of these kits will be held in each of the three countries for use by schools. These resources are part of an extensive EU-funded project, 'Boat 1550 BC', set up to illustrate the cultural links between the three regions over 3000 years ago through experimental archaeology, a travelling exhibition and the handling kits. The project has resulted from the discovery by CAT of a rare Bronze Age wooden boat in Dover, in 1992. The Trust also has an extensive Learning About the Past section on its website (www.canterburytrust.co.uk/learning).

retired, and also organises courses for its members. Archaeology has been slow to develop online opportunities for engaging with students. Rare exceptions include the University of the Highlands and Islands, and the University of Aberdeen, which both have to cover a large geographical area with a highly dispersed population.

In both England and Scotland, archaeology is also part of classical studies or classical civilisation qualifications at 14–18. There is also one history qualification, the Certificate in Applied History (of equivalent standard to a GCSE), which includes archaeology and heritage management options.

By far the best chance to get archaeology known by a wider public through education is in schools among pupils under the age of 14. As education is a devolved responsibility in the UK there are different school curricula in England, Scotland, Wales and Northern Ireland. Curricula are determined by government, and therefore subject to political pressures in terms of their shape and content. They therefore change regularly, and archaeology has to negotiate its presence within a shifting sand of content and learning objectives. There are, though, certain constant or common factors to be aware of. Archaeology does not appear in its own right as a subject in the curriculum, but has to be placed within other subjects. While archaeology can be used within any subject, it is used most often within history, and to a much lesser degree in geography and science. Each of the countries of the United Kingdom has special features in its history curriculum. The history curriculum in England places more stress on ancient foreign civilisations like ancient Greece or Rome and ancient Egypt. The curriculum in Scotland tends to be more aware of the cultural importance of history as part of heritage and identity. In Wales, history is seen as an unbroken succession from prehistoric into medieval times and there tends to be a greater interest in prehistory, especially the Iron Age and the notion of the Celts. In Northern Ireland, there is more awareness of the social and political context of history within the media, tourism and current affairs. Behind the changes in terminology from earlier to later versions of the curriculum, and the differences between the four countries, there are common elements of teaching in history:

- understanding historical chronology
- knowledge of the main people, societies, events and features of the past
- understanding the causes and effects of change and/or events over time
- understanding the nature of our evidence for the past
- knowing how historians use evidence to develop different interpretations of the past
- being able to construct historical arguments and descriptions.

So, how can we persuade history teachers to include some archaeology in their lessons? We have to change our mindset. Rather than try to fit archaeology into the above list, we can examine what archaeology has to offer and we will find that this will naturally fit into history teaching.

There are two aspects of archaeology that can be used by teachers: our knowledge of the past, and archaeological enquiry skills.

Using Table 4.2, we can begin to see where archaeology can fit into different curriculum subjects. Technology obviously fits into design and technology, but also sciences. Economy and society can contribute to our knowledge of particular periods in history, and can help to correct an imbalance towards political history and the deeds of the wealthy that results from an over-reliance on documentary evidence and traditional historical narratives.

Table 4.2: Archaeological knowledge of the past

Period	Technology	Economy	Society	Arts	Religion
Hominid evolution	Making and using stone tools	Use of fire and types of food	Evolution of family structure	N/a?	N/a?
Earlier prehistory	Use of wood, bone and antler	Hunting and gathering	Simple social organisation	Cave paintings and figurines	Burial practices
Later prehistory	Methods of pottery and metalworking	Introduction of farming	Evidence for social hierarchy	Interpretations of rock art	Changes in religious practice
Roman	Road building	Trade with the continent	Military and civilian relations	Classical realism	Pagan and Christian practices
Medieval	Timber house construction	Strip field farming	Differences in standards of living	Christian iconography	Monastic life
Post-medieval	New industrial technology	Urbanisation	Use of servants	Reuse of earlier artistic styles	Architecture of places of worship

There is another way of looking at archaeological knowledge. This is to look at the bigger diachronic themes that archaeology tells us about ourselves as a species. Archaeology has important things to say about the human condition. Instead of asking what we know about the past, we can ask, 'What can we learn about ourselves by studying the past?' In this way, we can offer archaeology as having relevance not only for history but for a range of other subjects (see Table 4.3).

Understanding what makes us human provides an ethical content that can be brought into subject like citizenship (Henson 2008), social studies and religious studies. Our other understandings can provide more specific links to curriculum subjects.

Table 4.3: Archaeological knowledge related to the present

Understanding	Details
What makes us human	Humans as primates Notions of race and species The nature of human social behaviour
Change through time	Sudden and gradual change Characteristics of different periods Reasons for change
Cultural variety	Characteristics of different societies Reasons for differences Overlapping cultural differences
How we interact with our environment	Settlement location Travel Subsistence Climate
Tracing origins and making analogies	The origins of the present Analogies in the past for current issues
How we use the heritage of the past today	Cultural identity Sense of place Economic value Articulating attitudes

Being able to examine change through time can support not only history through developing chronology as well as understanding why events happened in the past, but also geography, music and even physical education. Understanding the variety of human cultural expression and practices since prehistory can help both the humanities and arts subjects develop a wider breadth, contributing to teaching and learning in citizenship, art and religious education. Knowing how people have exploited and been shaped by their environments has obvious utility for a range of subjects, and connects with many issues of concern for today, such as the role and impact of GM crops, the nature and importance of immigration, the impact of climate change, challenging notions of identity and nationhood and so on. The validity of our contributions depends on our being able to trace origins and causes from the past directly into the present, or on finding good, robust analogies between the past and present.

It is not only our understandings of the past that are useful, of course, but also the remains of the past. Tangible cultural heritage is an important part of Britain's urban and rural landscape and identity (English Heritage 2000). Visits to heritage sites contribute large amounts of income to local economies as well as the national economy. Schools visit such sites in large numbers and they are an important educational resource. Yet the nature of the sites is seldom included in the visit. A visit to a local authority art gallery, for example, is a visit to collections owned on behalf of the residents. The art that the pupils see does, in a sense, belong to them, and the gallery is their space.

So much for archaeological knowledge and understanding. What about archaeological enquiry skills? It will help if we organise archaeological processes into four basic (and admittedly simplistic) stages (see Table 4.4).

Discovering and defining archaeological evidence clearly supports the history curriculum, especially where archaeological and documentary evidence can be compared. Archaeological analysis involves clarity of thought, logical reasoning and the ability to visualise in three dimensions. There is much in this that is applicable to maths and elements of geography such as mapping, and using coordinates and scales. Communicating results involves not only the historical skill of creating convincing narratives but also the practical application of English language and of art and design, as well as ICT. Management of heritage can also be studied as part of citizenship.

Table 4.4: Archaeological enquiry skills

Process stages	Examples	Specific cases
Discovering and defining the archaeo-logical evidence	Understanding the differences between kinds of evidence	Comparison of artefactual and documentary sources
carrying out archae-ological investiga-tion by recording an analysis	Analysing the structure of an archaeological site	Determining the relationship between contexts
Communicating results to others	Using different media to convey the results of archaeological investigation	Arranging museum displays or devising a website
Managing the archaeological heritage	Protecting sites against looting or visitor erosion	Seeking local com-munity support for protection of sites

The author freely admits to being a history nerd at school who could recite all the kings and queens of England since Alfred the Great, with their dates, and draw their family tree. Yet, most cannot - and nonetheless lead fulfilling lives! To know these kings and queens is not to know history, and does not produce the inquiring mind able to dis-criminate between different kinds of evidence that is one of the major benefits of studying the subject. Historical facts are simply the scaffold-ing, the framework, upon which interesting questions and enquiry can be fitted. Knowledge and skills go together, although this not how the debate is usually framed between overly polarised opinions (Tobias and Duffy 2009).

The beauty of archaeology is that its use of non-documentary evi-dence brings into sharp focus the necessity for enquiry and analysis. But it also covers large sweeps of time, exotic civilisations and a very differ-ent prehistoric past. It has knowledge and narratives, therefore, which can excite and enthral.

Positive opportunities for archaeology

We have seen that archaeology has many strengths for use within schools. Fortunately, there are various positive factors that support

this position. There is an increasing number of professional archaeologists with an interest in working in public engagement and education, many of whom are graduating from the masters courses which cover this area of archaeological practice. Within schools, there are many adventurous, high-quality teachers with a real interest in what archaeology can provide. Constructivist education theory is of great help to archaeology (Henson 2004), in that we can help learners of all kinds, with activities that range from the intellectual to the physical, from the rational to the emotive. Archaeology really has something for all pupils (Henson 2009).

Moreover, there are various networks of educational practice and initiatives of recent years that archaeology can be part of. There is a long-standing network of museum educators, GEM, which has provided a great deal of support for educators in museums and heritage sites, both nationally through its annual conference, its journal (*Journal of Education in Museums*), email discussion list and its regional workshops. The Council for British Archaeology has done a lot to support individual archaeologists working with schools; to publish guidance on archaeology in education, beginning under its first education officer, Mike Corbishley (e.g. Cracknell and Corbishley 1986; Henson 1997; Howell 1994; Pearson 2001); and, in recent years, to campaign for archaeology to be included in various government-led education initiatives. Government has been lobbied by the heritage sector to be more aware of the benefits that management of the historic environment can bring to society (English Heritage 1999, 2000; DCMS 2001).

Particular initiatives involving heritage have been Engaging Places, now run by Open City, and Learning Outside the Classroom, now run as an independent charity. Both aimed to encourage and support teachers to deliver good learning experiences using the resources available in the natural and cultural environment.

Conclusion

Archaeology has important things to say about the human condition. It also depends on public support for its funding and for its place in modern development and planning. Its best way of ensuring that its insights can be spread through society, and that society continues to support it, is to have a presence in formal education where most pupils in school can have at least some exposure to it. For archaeologists to embed themselves in education, they must understand the practical

Case study 4.3: Universities supporting young people

The Department of Archaeology at the University of Cambridge has its own outreach unit, Access Cambridge Archaeology, directed by Carenza Lewis, one of the original presenters of *Time Team* on Channel 4. The unit runs archaeological activities for the public, including schools. It sees its mission as being to use archaeology to enhance people's educational, economic and social wellbeing. Archaeological activities help to develop new skills and self-confidence, which can lead to increasing academic performance. Young people learn to raise their educational aspirations and enjoy learning for its own sake. At the same time the activities are genuine archaeological excavations and part of archaeological research. Specific Field Academies and Discovery Days are designed for both young people of secondary and primary school age, adapted for each age group. There are also community excavations which anybody can get involved in. The Discovery Days consist of multi-disciplinary challenges linked to subject-specific concepts in the curriculum and take place at the university. The Higher Education Field Academy involves young people running their own small test pit excavation over two days as part of research into the development of villages. The programme is run by a network of beacon schools, and pupils can only attend as part of an organised school group. Recruitment is coordinated by beacon schools with nearby partner schools. Excavation sites can be found throughout the United Kingdom. Pupils work in schools before and after their excavation and learn how to place their own discoveries with other historical sources to reconstruct the historic development of the site. These activities are designed to link with the Schools History Project GCSE History unit, History Around Us. Tailor-made sessions for schools can also be arranged. Activities enable thousands of members of the public to take part in inspiring university-linked archaeological programmes, and offer university students and staff the chance to gain experience in public engagement and community heritage. Feedback shows these to be very popular and very effective in achieving their wide range of educational, social and archaeological objectives.

and theoretical contexts of teaching and learning. Archaeological educators are dispersed widely through professional archaeology and heritage services but not in great numbers nor in financially secure positions. They need to become more self-aware, more aware of exactly what their subject offers (Archaeology Forum 2005) and be more organised in order to punch above their weight in campaigning for the place of archaeology in formal education. The education systems throughout the United Kingdom offer many opportunities for teaching archaeology. For pupils under the age of 14, archaeology is not available as a subject in its own right, but is most often included as elements of history, a subject that is not without its problems given that its teaching is constantly debated and redefined. In spite of this and other barriers, there are many opportunities and positive feature that archaeologists can build on to make sure that archaeology finds its rightful place in the consciousness of society.

5
Digital media in public archaeology

Chiara Bonacchi

Introduction

The twenty years following the mid-1990s witnessed a step change in the communication landscape, which can be summarised under the label of new digital media. In this period, the popularity of the Internet and mobile technologies has become more widespread, and previously distinct media forms have been progressively converging into fewer and 'newer' ones (Casey et al. 2008: 57–8; Castells 2010; Castells and Cardoso 2005; Lister et al. 2009: 420; Livingstone and Das 2009). An additional development since the early 2000s has been the shift from a straightforwardly informative World Wide Web to a more dramatically interactive Web 2.0 and 3.0, better equipped to support collaboration (e.g. O'Reilly 2005). This chapter will discuss the transformative roles of new digital media in public archaeology. It will focus on addressing key aspects relating to digital engagement, and thereafter explore possible applications of 'media-as-data' (Housley et al. 2014: 7) for public archaeology research.

The expression 'new media' has been used since the 1960s to describe the restructuring of 'media production, distribution and use' that follows the invention of new technologies (Bonacchi 2012a: xv). However, today, the term 'new media' is usually called upon jointly to refer specifically to communications that are increasingly digital, interactive, hypertextual, virtual, networked, simulated, ubiquitous and delocated (Lister et al. 2009: 13; McQuail 2005: 38). These transformed

(and ever transforming) communications may result in 'new textual experiences', 'new ways of representing the world', 'new relationships between subjects and media technologies', 'new experiences of the relationship between embodiment, identity and community', 'new conceptions of the biological body's relationship to technological media' and 'new patterns of organization and production' (Lister et al. 2009: 12–3). To understand the nature and pace of some of the recent changes that have been mentioned, it will be useful to recall the 'media ecology' view first proposed by the theorist Neil Postman (Naughton 2006: 43; see also Bonacchi 2012a). According to Postman, media can be regarded as organisms that inhabit an environment. Every new event (or invention) that is introduced in the media environment causes a series of ecological adaptations, as a result of which most of the pre-existing media practices, forms or content tend to adjust and survive in novel ways, rather then disappear suddenly. Following this idea, the chapter hopes to provide initial answers for two main questions. How have recent transformations in the communication landscape been affecting (or how may they affect) the practice of public archaeology? How can they support research concerned with the manifold facets of the relationship between archaeology and society (Matsuda and Okamura 2011; Schadla-Hall 1999, 2006)?

Digital engagement with archaeology

Bitgood described 'engagement' occurring in museum contexts as any 'deep sensory-perceptual, mental and/or affective involvement with exhibit content' which might lead to 'personal interpretation', 'meaning making' or a 'deep, emotional response' (Bitgood 2010). Despite its roots in the field of museology, the definition can be invoked for different kinds of digitally- and non digitally- enabled interactions with cultural content and institutions (see also Ridge 2013). It seems thus entirely appropriate to adopt it here as well, when referring to digital engagement with archaeology as a discipline, and as the process and outcomes of undertaking research via archaeological methods. Such engagement may result from one or indeed a mix of two possible approaches to communication, which we will call, respectively, 'broadcasting' and 'participatory'. Whether one or the other is ultimately implemented is largely a consequence of the types of human relationships that those initiating the communication are willing to establish with other citizens and institutions (Bevan 2012).

Before turning to examine broadcasting and participatory modes of digital engagement, it is useful to review some of the key factors and dynamics that influence both of these two modes. As already noted by several commentators (e.g. Morgan and Eve 2012; Perry and Beale 2015; Richardson 2014a, 2014b), in archaeology, as in other subject domains, the democratising powers of new digital media are hindered by the unequal possession of the physical means, skills and knowledge that are needed to get involved. Poor connection is still a barrier in many parts of the world, including more rural or remote regions in countries where, on the whole, Internet use is relatively high (see e.g. Enterprise LSE 2010: 7; Ofcom 2010: 227). The social geographies of digital literacy are equally uneven (Hargittai 2002). Having classified 'online skills' into operational, formal, information and strategic, Van Deursen and Van Dijk (2010)[1] discovered that education influences all of these four categories, whereas age is a determinant of operational and formal skills only. Additional studies have then demonstrated the role of cultural background and parental education in particular (Gui and Argentin 2011). In turn, different levels of digital skills can potentially unlock different kinds of engagements, as shown, amongst other published works, by nation-scale research enquiring about the 'composition' of online audiences of arts and culture in Britain (Arts & Business et al. 2011). The study identified and profiled three main 'audiences', highlighting how only 11 per cent of the surveyed population (the 'leading edge') enjoyed creating as well as accessing, learning, experiencing and sharing content online. The majority of respondents were instead found to use the Internet to access, learn, experience and share existing resources, without contributing personally to generate new ones. Far from being specific to the UK, these results portray a general trend in digital cultural engagement, even though creative uses of the Internet are becoming increasingly more popular, and especially so amongst younger people aged 16 to 24 years old (European Commission 2011).

These considerations urge us to reflect critically upon how expectations to open up archaeological practice via digital media relate to the fact that social change is often slower than technical innovations and that, at least at an early stage, new media are likely to reproduce, in a different wrapping, some if not all of the barriers and social divides that

1 Operational Internet skills: 'operating an Internet browser'; formal Internet skills: 'navigating the Internet'; information Internet skills: 'locating required information'; strategic Internet skills: 'taking advantage of the Internet by: developing an orientation towards a particular goal; taking the right actions to reach this goal; making the right decisions to reach this goal; gaining the benefits that result from this goal' (Van Deursen and Van Dijk 2010: 4).

characterise the analogue world (e.g. see Bonacchi 2012a; Richardson 2013). For instance, one of the drivers behind the eagerness of galleries, libraries, archives and museums to embark on the design of digital engagement programmes is frequently that of reaching out to younger people, who are today (as they have been for decades) under-represented amongst heritage audiences (Bonacchi 2012b, 2014; Merriman 1991; Piccini 2007; Swain 2007). These efforts have proved to be entirely achievable on a substantial number of occasions (e.g. Jeater 2012), but not equally across different social groups. Another example is that of archaeological volunteer societies established offline, whose members are usually in older age bands, and therefore tend to commit less enthusiastically to activities that entail the use digital technologies (see e.g. Bonacchi et al. 2015b; Thomas 2010: 23).

Finally, digital engagement with archaeology may bring along new and particular ethical issues that should be adequately pondered and weighed up front in so far as this is possible. By means of example, some forms of digital engagement that rely strongly on voluntarism and on the donation of time, skills and knowledge in support of activities proposed by archaeological organisations have been criticised as

Case study 5.1: Crowdsourcing and crowdfunding archaeology

Crowdsourcing is a method for collecting information, services or funds in small amounts, from large groups of people, over the Internet (e.g. Dunn and Hedges 2012). This practice emerged in the commercial sector in the first decade of the twenty-first century, when it started to be used by companies to outsource labour to interested workers around the world, as in the case of the Amazon Mechanical Turk (www.mturk.com/mturk/welcome; Howe 2006). In recent years, however, crowdsourcing has received growing attention also from scholars and practitioners in the cultural heritage sector, who are exploring it as a method for managing heritage resources, curating collections and undertaking research in collaboration with members of the public (see e.g. Dunn and Hedges 2012; Ridge 2014). In archaeology, crowdsourcing has been sought to create data or raise funding to support individual projects, although virtually no research has been published until now about the ways in which 'crowds' have been leveraged to pursue archaeological agendas (some initial work: Bonacchi et al. 2015a, 2015b).

Crowdsourcing applications aiming to produce archaeological information and knowledge have usually taken a contributory approach (Simon 2010), asking volunteers to help with research that had already been designed by archaeologists working in bespoke institutions. In some cases, these applications were powered by multi-subject platforms such as Zooniverse (e.g. the Ancient Lives project), whereas, in others, new websites were developed ad hoc (e.g. the Portable Antiquities Scheme). The tasks that the online public have been asked to complete so far tend to be mechanical (Dunn and Hedges 2012), and to vary from the interpretation of digital imagery (e.g. Yu-Min Lin et al. 2014), to the geo-referencing of finds, the transcription of artefact records and 3D modelling. Another characteristic shared by archaeological (and more generally heritage) crowd-sourcing projects is their tendency to involve groups of people that are certainly smaller than what a 'crowd' might be pictured as being. If these groups of participants are interconnected and have similar goals, norms and values, they are usually referred to as online communities (Haythornthwaite 2009). A kind of crowdsourcing that is worth a separate mention is crowdfunding, a form of web-based micro-financing where contributors make small monetary donations in support of certain ventures. Archaeological crowdfunding relies either on generalist platforms that already have high public visibility (e.g. Kickstarter or Indiegogo) or on thematic websites dedicated to heritage (e.g. CommonSites, DigVentures and MicroPasts). MicroPasts has been the first to experiment jointly with the crowdsourcing of archaeological data, forum discussions about the uses of such data to fuel novel research and the crowdfunding of community archaeology initiatives (Bevan et al. 2014).

exploiting free labour and contributing to neo-liberalist economies (Perry and Beale 2015). The outcomes of heritage crowdsourcing practices (see case study 5.1) have also been critiqued for affirming 'truths' constructed by majorities, and often excluding the alternative views of minorities (e.g. Harrison 2010). Furthermore, open geographic information can pose ethical challenges related to its potential use by looters to feed illicit trades of antiquities (Bevan 2012), and citizens taking part in heritage monitoring via web or mobile crowdsourcing (e.g. Cultural Heritage Monitor) may incur risks to their personal security. Building on prior work published in the couple of years before their study (e.g. Colley 2014; Richardson 2013; Walker 2014a, 2014b; but also Huggett

2012), Perry and Beale (2015) remind us of these potential issues and stress how little is known and researched about the impacts of the 'archaeology-themed' or 'archaeology-relevant' social web on the self-representations of users/producers, on the discipline of archaeology, on institutional workflows and on societal structures.

Case study 5.2: Social media engagement with archaeological sites

A pilot study undertaken in 2013 contributed to further our under-standing of how social media, and Facebook particularly, are used to engage with archaeological content and institutions (Bonacchi and Galani 2013*). As part of this research, a survey was conducted with 533 users of the Facebook pages of fifteen museums, galleries and heritage sites in the north-east of England. Amongst them, there were two archaeological sites (Arbeia Roman Fort and Museum and Segedunum Roman Fort) and an open-air museum (Beamish). Two hundred and twenty-five survey responses pertained to the Facebook pages of these three institutions specifically, showing that Facebook was used primarily by people who had already been to the venues in person (81 per cent), most of whom had also visited the sites at least three times in the previous twelve months. Consistently, the major-ity of respondents lived locally, as demonstrated by the fact that 159 postcodes (of the 221 collected in all) were from the north-east of England, with an additional thirty-five from other UK regions.

Survey respondents had 'liked' the Facebook pages of the three institutions principally in order to support and promote them, or to obtain information about the events and activities 'on offer' (these options were selected, respectively, by 81 per cent and 76 per cent of the total). Motivations related to other people, such as existing friends or fellow Facebook 'fans', were instead less frequent (e.g. 'like their online friends to know they are cultured', 'some friends had also liked the page', 'wanted to connect with other people who "liked" the institution' were answer categories chosen only by 9–11 per cent

* A brief synthesis of a small part of the results of the pilot study is reported in this chapter. The pilot project was conducted by the author from February to June 2013, with funding from the Cultural Engagement Fund of the UK Arts and Humanities Research Council. The project was led by Dr Areti Galani at Newcastle University, and undertaken in collaboration with Tyne & Wear Archives & Museums.

of survey participants). Ultimately, institutional Facebook pages proved useful to: (a) maintain the 'loyalty' of local audiences from a strictly marketing perspective (34 per cent of respondents could actually claim to have increased their visitation frequency as a result of their interaction with the pages); (b) guide and inform other cultural engagement decisions made by these audiences; and, to a lesser extent, (c) provide an opportunity to expand one's own knowledge about the sites, or relevant archaeological and historical content (for 41 per cent of respondents).[†]

The 'broadcasting' approach

The expression 'broadcasting mode of digital engagement' is used here in its widest possible meaning to describe one-way forms of communication. So far, this mode has been the most frequently implemented by archaeological organisations in the UK (e.g. Pett 2012; Richardson 2014a, 2014b; see also case study 5.2), and is accompanied by a view of communication as the transmission of messages from a sender, to a receiver, over a medium. When a response is invited from the 'receiver', through a feedback mechanism, this is mainly to provide comments and information that might be useful to improve a service or the communication itself in future, rather than for the collaborative construction of meanings.

In a commercial setting, the online broadcasting of archaeological content tends to remain subject to quite a few of the rules that were in place in the pre-digital world. In a well-known article published in *Wired* (Anderson 2004; see also Anderson 2006), it was argued that entertainment markets are increasingly catering for niche tastes as a result of the fact that digital technologies are progressively transforming a 'world of scarcity' into one of 'saturation', where space is no more an issue and audiences can be international. As already pointed out (see e.g. discussion in Bonacchi et al. 2012), although inspirational, this view does not accurately describe the current reality of things. Even online space can have costs, and it is more easily remunerative to use the Internet for offering fewer 'pop' products that appeal to high numbers of people than more niche products for a 'long tail' of individuals scattered around the

† More in-depth, qualitative research would be needed to triangulate and ground this last claim (c).

world (see Bonacchi 2012a, for further discussion on this topic). Thus, a number of traditional constraints to the sale of archaeological documentaries reappear also on digital platforms. Additionally, the online provision from institutional broadcasters is still tightly linked to (if not coinciding with) their offline schedules (see Bonacchi et al. 2012). This means that only seldom and with difficulty are digital technologies able to open effectively new spaces for a subject like archaeology through the operations of media institutions. Nevertheless, the 'provision' of archaeology via television and radio broadcast remains worthy of consideration and scrutiny for its function of 'agenda setting', its long-lasting societal impacts (e.g. see Bonacchi 2013), and its more democratic reach amongst audiences with different levels of formal education if compared, for instance, to museum or heritage site visitation (Bonacchi 2014; Piccini 2007).

A broadcasting approach to digital engagement can also be embraced directly by heritage organisations and archaeologists. A notable case is that of *A History of the World in 100 Objects*, a radio series produced in 2010 by the British Museum in partnership with BBC Radio 4 (Cock et al. 2011). Episodes were released as podcasts and downloaded in very high numbers worldwide (Cock et al. 2011). This success led the director of the British Museum to stress the value of the initiative in enabling the Museum to act not only as a 'producer' but also a 'broadcaster' of cultural content (Bonacchi et al. 2012). A further example is that of the Streetmuseum applications (apps) developed by the Museum of London's marketing team, in collaboration with – amongst others – the History Channel (Jeater 2012). These smartphone apps offer information about some of the Museum's collections and link artefacts with their context of discovery. A similar concept is at the basis of the Archaeology Britain app, which combines resources from the British Library and the UK Archaeological Data Service to provide insights into a number of British archaeological sites. Here again, all of the content originates from institutions and is passed on to audiences, expressing an authority-ranking model of human relationships (Bevan 2012; Fiske 1991). Vlogging (video blogging) and blogging are also, in themselves, forms of broadcast digital engagement, unless they give rise to conversations through comment threads. Perhaps the largest initiative of this kind in archaeology is currently the Day of Archaeology, a yearly endeavour that involves hundreds of archaeologists worldwide posting about their work (Richardson 2014c). In other cases, instead, the production and publication of audio-visual logs has been explored to offer

updates on the progress of excavations, such as those at the site of the Pillar of Eliseg, in Wales, UK (Tong et al. 2015).

Organisational capacity has a huge impact on the efficacy of digital broadcasting, but not every museum has the size and resources of the British Museum or the Museum of London. If outsourced, smartphone applications, for instance, can have rather high development costs for the budgets of most GLAMs (galleries, libraries, archives and museums) – let alone archaeological societies – especially considering that their visibility online and actual use by people beyond the simple act of downloading them is often very limited (Richardson 2014a). As a response to issues of scalability and sustainability and in order to reduce 'capacity gaps', new projects have arisen that try to offer open source platforms, tools and intelligence to assist in the development of apps for the public interpretation of heritage sites (e.g. Mbira). The visibility of applications remains instead a more difficult cliff to climb, since it is strongly linked to institutional branding. In this regard, it will be sufficient to point out the significantly lower number of downloads achieved by the Archaeocast podcast series, produced by the UK-based archaeological commercial company Wessex Archaeology (Goskar 2012), compared to *A History of the World in 100 Objects*.

Participatory practices

Apart from the broadcasting mode, participatory kinds of digital engagement invite direct input from organisations and citizens other than those accountable for starting the activity. Four main levels of participation can be identified (Simon 2010), spanning a spectrum from contributory, to collaborative, co-creative and hosted. In contributory participation, individuals or groups within society assist archaeologists with the completion of tasks as part of research or work programmes that have already been defined and set up. This is the case for that kind of crowdsourcing where citizens are asked to help with the recording and digitisation of data (see case study 5.1). Examples are the Portable Antiquities Scheme, which was set up to document metal finds collected by members of the public (often via metal detecting) in England and Wales (Pett 2010, 2014); or Pleiades, where online contributors help to match 'attested names' of places from the Greek and Roman past with 'measured locations' (Harris 2012: 586).

Collaborative ways of participating entail involvement in aspects of archaeological research that relate to the analysis and

interpretation of data, and potentially to the development of new working methods and procedures. Digital technologies have super-charged opportunities for collaborative participation; the take-up of open-source software, open data and access (e.g. Bevan 2012; Hole 2012; Lake 2012) is in fact fostering synergies amongst people who operate in archaeology and neighbouring subjects in different capacities all around the world. The term 'open' refers to the philosophical standing of those 'promoting open redistribution and access to the data, processes and syntheses generated within the archaeological domain' (Beck and Neylon 2012: 479–80). Such approaches encourage moving from traditional distinctions of 'professionals' and 'amateurs' to a discourse where more value is attributed to the possession of relevant skills than to institutional affiliation. Examples of collaborative participation are those of the recent UK-based Heritage Together and ACCORD projects, which involved the public in choosing sites and archaeological features to be recorded via 3D modelling. The aims of both initiatives were those of creating resources of value to both researchers and members of local communities. A further example is TrowelBlazers, whose contributors conduct historical research to uncover the lives of women in archaeology, geology and palaeontology across the centuries.

Co-creative participation moves a step further and requires that the activities to be undertaken are planned and developed jointly by all those involved. Together with hosted participation (see below) this is possibly the most challenging type of engagement to initiate, not least because of the traditional structure of heritage and research financing. Very few are the grant funding schemes where initiatives not entirely driven by organisations can be proposed. So far, the most substantial co-creative work in public archaeology has perhaps been the one related to community archaeology, material culture and digital repatriation. A number of projects in this realm have explored the ways in which new digital media can facilitate local communities' connection with and interpretation of their material culture alongside the work conducted by archaeologists and anthropologists. This is the case in The Sq'éwlets: A Stó:lo-Coast Salish community in the Fraser River Valley project in Canada, which also critically and usefully highlighted how open Creative Commons licences do not suit the restricted nature of traditional knowledge in the Stó:lo-Coast Salish community and are thus not advisable to use without adaptations (Hennessy 2015).

Most digital participation starts in a contributory form, and only subsequently, and in a minority of cases, proceeds towards

collaborative and co-creative engagements. Hosted participation is even more rare and presupposes that an institution provides space, expertise and infrastructure to facilitate the implementation of a project designed and undertaken by 'members of the public'. This kind of participation is enabled by the crowdfunding platforms of MicroPasts and DigVentures, two websites created to host community heritage teams in search of funding. And finally there is a number of wholly grassroots initiatives that have been thought of and taken forward by citizens whose main job is not related to archaeology. In this group are websites such as The Megalithic Portal or Pompeii in Pictures, as well as a plethora of generative practices (e.g. photosharing via Flickr) that contribute to the emergence of 'non-sanctioned' meanings linked to archaeological sites or objects (see Garduño Freeman 2010 for a discussion of the topic linked to built heritage). These activities are conveniently mentioned in this section, but they may also follow broadcasting modes of digital engagement, if the communication they embrace is predominantly one-way.

Digital media-as-data

At least some of the traces left by our internet-based interactions with archaeological content and organisations can be freely extracted, tidied up and analysed. For example, data mined from publicly accessible fora and blog posts, Facebook pages, tweets, and comments to videos shared via YouTube or Vimeo can support studies into attitudes and behaviour towards the human past and its archaeological investigation, while newspaper, magazine, television and radio content can help discover how and why archaeology has received 'institutional' media exposure in different geo-political, social and cultural contexts. Following comparable experiments in the social sciences, it is even possible to design applications that, via crowdsourcing and gamification, question contributors directly about their understanding of, interest in or engagement with the subject area that we are here examining.

The information contained in these 'web archives' can be aggregated to form very large if not 'big' sets of data able to open up novel analytical pathways. Big data is characterised not only by its impressive volume, but also by sheer variety and velocity, a fine-grained and relational nature, and great flexibility (e.g. Housley et al. 2014; Kitchin 2013, 2014). For research that leverages social science theory and methods, such as that in public archaeology, this deluge of data allows

a move from traditionally sharp divisions between quantitative and qualitative approaches to much more fluid and integrated quali-quantitative mindsets and methodologies (Venturini and Latour 2010). In a pre-digital world, there would be two main kinds of research strategies, extensive and intensive, as suggested by Housley et al. (2014; see Table 5.1). The extensive kind would be looking to collect larger amounts of data for quantitative types of analyses, which, however, could not also be 'locomotive' and examine in a continued way the effect of time passing. Surveys, for example, are helpful to gather information from multiple cases at one point in time, and even if the same human subject is questioned more than once, the method of investigation remains punctiform (the measurement occurs on specific days and at particular times). Ethnography permits locomotive research designs, but only as part of 'intensive' strategies of investigation. The latter are helpful to study 'micro-interactions' as they unfold (Venturini and Latour 2010), but disconnect them from an understanding of 'macro-structures'. Digital media makes it possible to bridge the divide that has been described, enabling both extensive and locomotive research: 'big' web data can be inspected quantitatively while not preventing as many close-up observations as needed across a potentially continuous temporal spectrum.

There are, however, at least three main issues which can limit the potential use of web archives. The first is their accessibility, since it is not always possible to mine, free of cost, all the data that is available. The second issue is ethics. For example, institutions can mine users' personal data through social logins, but whether and how this can be ethically done is still the subject to heated debate. The third issue is

Table 5.1: Types of research strategy

| | | Research data/design | |
		Locomotive	Punctiform
Research strategy	Intensive	E.g. ethonography/observational studies	E.g. cross-sectional qualitative interviewing
	Extensive	E.g. new social media analysis: population level, naturally occurring data in real/useful time	E.g. surveys (cross-sectional, longitudinal); experimental studies

Source: Edwards et al. 2013: 248, discussed in Housley et al. 2014.

usability. Data harvested via web platforms is often decontextualised, as it happens in the case of posts, for example, which cannot be easily linked with insights relating to the personal, social or physical 'niches' in which they were generated. It is therefore very difficult to understand who is expressing certain views or manifesting a given behaviour. To bridge this gap, it might be helpful to consider triangulating or integrating analyses of 'big' or 'very large' data with the inspection of smaller data (e.g. Kitchin 2013, 2014). Public archaeology research using digital methods is just beginning and, if adequately informed by theory and directed at the resolution of problems, its potential could be enormous.

6
Presenting archaeological sites to the public

Reuben Grima

Introduction

The presentation of archaeological sites to the public, broadly considered, encompasses a vast and bewildering array of encounters between a cacophony of audiences, each with their very different needs, and an equally cacophonous variety of archaeological contexts, each of which presents its own problems and challenges. Two short examples will underline this point.

On the south-eastern tip on the island of Malta, the remains of a megalithic structure dating from the Neolithic, and excavated a century ago, stand perched on an eroding cliff-edge, and are gradually but inexorably falling into the sea. The occasional visitor that is persistent enough to locate the remains is met by warning signs to keep away from the site and the treacherously crumbling cliff-edge.

At the heart of one of the great cities of the ancient Mediterranean, the church of Santa Sophia in modern-day Istanbul is not only the most sublime monument of the Byzantine world, but also incorporates works of Ottoman as well as ancient Greek civilisation. Of the three and a half million people that thronged through the site in 2014, probably only a minuscule proportion realised that they had walked past a bronze door created in the second century BC for a Hellenistic temple in Tarsus, and only installed in the church by a Byzantine emperor a millennium later.

These two quick vignettes may begin to give a sense of the infinite variety of challenges that may be gathered under the rubric of 'presentation of archaeological sites to the public'. This chapter will attempt to give some semblance of order to this variety by examining a selection of the more prevalent challenges. The terms 'archaeological site', 'the public' and 'presentation' are discussed and defined first. Some of the issues surrounding the presentation of archaeological sites are then discussed, using the concept of accessibility and its different forms as a set of pegs to structure the discussion.

Definitions

The presentation of archaeological sites to the public encompasses a wide range of issues and scenarios, which may vary dramatically according to the site and to the different public audiences that may have an interest in that site. A useful point to start the discussion is to examine what may be meant by each of these terms.

Defining 'archaeological sites'

The very idea of an 'archaeological site' is a modern creation, which only took the shape familiar to us today during the course of the nineteenth century. The same idea continues to shape present-day ideas of how members of the public should engage with archaeology, and therefore deserves to be looked at more closely. During the nineteenth century, a great increase in public awareness of archaeological remains was witnessed across Western Europe, closely followed by a heightened awareness of the responsibilities of the state to safeguard such remains in the public interest (Murray 1990; Diaz-Andreu 2007). The most widely adopted solution was to identify what were considered to be the more significant archaeological remains, and to bring them into public ownership, often through the acquisition by the state of an arbitrary rectangle or circle of land. The transformation from being a component of the inhabited landscape to become an 'archaeological site' or 'archaeological monument' was often completed by surrounding the expropriated land with a fence and, in some cases, adding a brief explanation of the name, date, nature and purpose of the monument.

This transformation has had far-reaching effects on how archaeological remains treated this way are encountered and experienced by

the public. Firstly, they are turned into a place apart, divorced from life in the present day, purportedly frozen in time, to serve as a window into the past. Secondly, wherever a gated enclosure is created, access becomes a controlled commodity, often accompanied by fixed opening hours and even entrance fees. Thirdly, the way people are expected, or even allowed, to behave around these remains is also transformed. They have now become visitors and consumers, who follow pre-ordained routes while diligently admiring the remains, with the minimum of direct physical contact.

The nineteenth-century paradigm that has just been outlined has come under considerable fire since the 1990s. Archaeological theory has conducted extensive critiques of the very concept of a 'site' as a useful analytical tool, emphasising instead the importance of taking in the scale and context of the landscape as a continuum, of which any site can only be an arbitrarily defined part (see Lock and Molyneaux 2006 for reviews of earlier work). This profound shift in emphasis has reflected itself in the prevailing paradigms for the management and presentation of archaeological sites and landscapes, with reverberations ranging from international documents such as the Australia ICOMOS *Burra Charter* (ICOMOS 2013) and the *Operational Guidelines for the Implementation of the World Heritage Convention* (UNESCO 2013), down to individual site management decisions at the local scale. Since the 1990s, several of the fences that had been installed over the previous century and a half have been dismantled and removed, facilitating the reading of archaeological structures in their landscape setting. For instance, the Ħaġar Qim Neolithic Temples on Malta, which form part of a UNESCO Word Heritage Site, were enclosed by such a rectangular boundary during the 1960s, which was pulled down in the late 1990s. The same happened at the Ġgantija Temples on nearby Gozo.

For the purpose of the present discussion, therefore, it may be useful to follow a broad definition of an 'archaeological site' as any place where in-situ archaeological remains may be encountered. It may range from a sprawling landscape, through the more conventional ruin with gated access, to the archaeological fragments that survive on the busy streets of many of our cities. Each of these scenarios presents unique challenges, and will be kept in mind in the following discussion.

Defining 'the public'

'The public' is of course a no less problematic term. In practice, it encompasses a wide diversity of audiences, with a bewildering variety of needs, aspirations, interests, concerns, and attitudes, which inevitably shape their perception and experience of 'archaeological sites' and how they are presented. These needs and expectations may vary with linguistic, ethnic, cultural, social and religious affiliations, as well as age and level of education. Audiences that live in the area where a feature is located may have different needs and expectations from visitors from another part of the country, which are likely be different again from those of visitors from other countries. A further distinction is that between people actually crossing the threshold of a gated site, and those that have not done so, but who nevertheless have a perception and an understanding of the site, which still forms part of their reality.

The range and breadth of audiences and needs, as just outlined, must be kept in mind in the following discussion on some of the issues surrounding the presentation of archaeological sites.

Interpretation and presentation

A final point regarding definitions concerns the terms 'interpretation' and 'presentation', which are sometimes used interchangeably. For simplicity, the definitions used in the ICOMOS *Charter for the Interpretation and Presentation of Cultural Heritage Sites* (ICOMOS 2008) are followed here. 'Interpretation' is given a wider definition that includes the full range of activities to raise public awareness and understanding of a site, be it on or off site, while 'presentation' is limited to the narrower definition of 'the carefully planned communication of interpretive content through the arrangement of interpretive information, physical access, and interpretative infrastructure at a cultural heritage site' (ICOMOS 2008). The two are of course inseparable, and this chapter makes reference to both.

Sustainability

Archaeological monuments have a long history of interventions aimed at their preservation, stretching back at least to the early nineteenth century. More recently, these efforts have been guided by a succession of international charters dedicated to principles of good practice in the

conservation of architectural and archaeological monuments. In the face of the global rise of tourism, the debate about the conservation of archaeological monuments has sometimes taken the form of a struggle between preservation and enjoyment of the resource, in which the only ethically responsible choice is to give priority to conservation, even at the expense of limiting public access.

Global debates that have taken place since the 1990s allow this issue to be presented in a different way. A cardinal consideration in the management of any non-renewable resource is its sustainability. Against the backdrop of concerns over climate change and environmental sustainability (WCED 1987), the concept of safeguarding the rights of future generations has entered the mainstream. The same principle may be applied to cultural heritage and, more specifically, to archaeological sites. Future generations have a right to enjoy these archaeological resources; conservation is the only way to safeguard that right. So rather than being diametrically opposed to access and enjoyment, and an end in itself, conservation is an integral part of a strategy to ensure long-term, sustainable enjoyment of archaeological resources. The reciprocity of conservation and interpretation has been further underlined in the ICOMOS *Charter for the Interpretation and Presentation of Cultural Heritage Sites* (ICOMOS 2008). In the following discussion on accessibility, conservation will be referred to in this perspective.

Accessibility

A central theme that runs through the presentation and public enjoyment of archaeological resources is that of accessibility, which encompasses a wide range of considerations, the most familiar of which are physical, intellectual and financial accessibility.

Physical accessibility

Physical access to an archaeological site is a prerequisite for it to be enjoyed at first hand. The very nature of archaeological sites and their management history may, however, pose a long list of difficulties. To begin with, the very setting of an archaeological site in the landscape, which is an intrinsic component of the site's values, may be remote and difficult to access (see Figure 6.1).

Protective measures such as reburial or fencing may create further limitations to physical access for the general public. In the case of

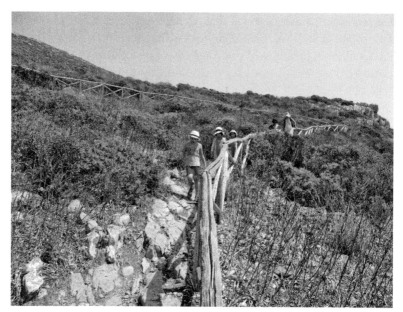

Figure 6.1:　Footpath leading to Grotta del Genovese, Levanzo, Egadi Islands. The cave houses contain an extraordinary assemblage of rock-art, ranging from Upper Palaeolithic to Neolithic in date. It is located in a pristine stretch of coastline that may only be reached by boat in calm weather. The only other way to reach the site is down a steep and rugged footpath over 700m long (Source: author).

small and remote sites that are enclosed, it may be difficult to deploy the human resources needed to have regular opening times for the public. Even within major archaeological sites such as Pompeii, which is among the most visited sites in Europe, substantial sectors of the city are off limits for conservation or safety reasons, or are only accessible by appointment. A related difficulty stems from the simple fact that archaeological sites were not usually designed to accommodate a flow of visitors, let alone to conform with modern-day accessibility guidelines. Low doorways, steep staircases and narrow corridors abound, severely restricting access to the less mobile and the less nimble. As a result, the encounter between the visitor and the archaeology often runs the risk of being limited and fragmentary, as well as cluttered by the very infrastructure required to make the visit possible in the first place. Managing these issues is one of the primary challenges in the presentation of any archaeological site, and will be discussed next.

The principle that any public facility must provide access for all, without discriminating against persons with any form of disability, is now firmly entrenched and widely embraced. The design of any new visitor facility needs to take this principle into account from the very earliest stages of concept development, through to detailed specification and final implementation. Gradients and floor levels in visitor welcoming areas, or on pathways through a site, need to conform with or improve upon the national standards to minimise discomfort to people using pushchairs and wheelchairs. Beyond the obvious that is usually spelt out in such regulations, the devil is often in the detail. Outdoor paved areas that leave gaps between the paving slabs or use egg-crate matrices to allow grass to grow through the pathway, for instance, do not only present an obstacle to a person in high heels, but are also challenging to anyone using a walking-stick. In any written signage or interpretation, the type and size of font, colour scheme and sentence structure need to be carefully orchestrated to maximise their accessibility to people with visual or cognitive impairments. Any facility which includes an audio component, from screened videos to portable guides, needs to include a closed-loop option for people using hearing aids.

While meeting such requirements in a visitor centre or in the approaches to a site is generally straightforward, doing so within a complex archaeological structure may become nightmarishly difficult, presenting challenging dilemmas. Several archaeological structures are characterised by steps, sharp changes in level, restricted doorways or fragile surfaces. In some instances, these obstacles may be bypassed, for instance by providing a bird's-eye view from a fully accessible walkway (see Figure 6.2). In other instances, however, creating access without a severe impact on the archaeology is well-nigh impossible. In such instances, providing more information about the inaccessible part – through videos, models and other media – may help mitigate the problem.

The insertion of walkways is itself a source of new challenges. Walkways may need to be inserted to provide access for all, as already noted, or even to manage visitor flow, to protect the site from the visitor and, in some instances, to protect the visitor from hazards on site. In all these situations, the very insertion of a walkway, or even any barrier or interpretative tool, alters the relationship between the visitor and the archaeology. The way a volume or layout is experienced is dramatically different, if it is divided into an 'accessible' and an 'inaccessible' area. Furthermore, a risk with walkways is that they change the point of view, usually by raising it above the original ground level. In some cases, such

Figure 6.2: Villa del Tellaro, south-east Sicily. A raised walkway allows visitors a bird's-eye view of an extensive cycle of Roman mosaic floors, without threading on the fragile floor surfaces at any point. It also creates a completely new relationship between visitor and site (Source: author).

a shift may interfere with the visitor's understanding of the site. Bearing in mind the archaeological literature on the importance of bodily experience and phenomenology in understanding how space, particularly architectural space, was organised and perceived in the past (e.g. Tilley 2004), every effort should be made to keep such distortions to the absolute minimum necessary, from concept through to realisation.

The physical relationship between people and place is being reshaped by virtual reality (VR) and augmented reality (AR) technologies, which are making rapid inroads into the mass market. VR headsets developed primarily for gaming now make it possible for users to interact with a virtual space, and may be used to simulate the experience of being in an archaeological site or even a reconstruction of a past landscape or streetscape, without ever leaving one's home. Meanwhile AR and 'mixed reality' technologies are making it possible to introduce digital imagery to augment the user's experience of a real physical space. Applications that may be installed on a smartphone make it possible to overlay virtual reconstructions or historic images of a space even as one walks through it. These emerging technologies have far-reaching implications for the

Case study 6.1: The Ħal Saflieni Hypogeum, Paola, Malta

The Ħal Saflieni Hypogeum is a rock-cut funerary complex created on the island of Malta, in the central Mediterranean, during the late Neolithic period (c.3600–c.2500 BC). In 1980, the site was inscribed on the UNESCO World Heritage List.

The complex has three main levels. The upper level lies just below the upper surface of bedrock, while the lower level reaches a maximum depth of over 10m below ground level. The chambers forming each level were hollowed out of the soft limestone, making extensive use of the faults and bedding planes that characterise it. Chamber walls were decorated with red ochre paintings and highly finished sculptures imitating the architecture of megalithic buildings above ground (Pace 2000).

The main entrance to the middle and lower levels was blocked at some point by roof collapse, and the site lay undisturbed for centuries, if not millennia, until its accidental discovery in 1902. The opening of the site to visitors shortly after, and the progressive increase in visitors up to around 1990, contributed to a number of serious conservation problems which were threatening the very existence of the site and its fragile paintings. Light fixtures, which were of course concentrated in the areas most interesting for visitors, encouraged the growth of algae on the walls, hiding the painted decoration. The carbon dioxide emitted by the large numbers of visitors was a further damaging factor, as well as the constant contact between visitors and archaeological surfaces.

With the support of UNESCO, a project was developed between the late 1980s and the early 1990s for the conservation and sustainable enjoyment of the site. A number of measures were undertaken during the implementation of the project. The number of visitors was limited to ten at a time, and visits strictly timed, to make their impact on the microclimate of the site more manageable. Walkways were installed to better manage visitor flow, reduce physical impact of visitors on site, and improve visitor safety. Visitor lights were programmed to light up one chamber after another, leading visitors through the site.

Apart from the primary purpose of the light programme, which was to control light levels for conservation reasons, this solution also presented some interesting challenges and opportunities in terms of the presentation of the site to visitors. The lighting system was not simply a constraint intended to control light levels as well as the

length of time visitors spent in each area, but could also be used as a tool to direct their attention and to shape their experience. Very little is known about how the site was illuminated during prehistory. Some form of artificial lighting must have been used in the deeper chambers, but no soot marks have been recorded. The changing light emitted by the light programme helps to demonstrate how different the site may look when illuminated in different ways, and to prompt visitors to think about how it may have been lit originally.

way archaeological sites are encountered. Firstly, they present opportunities to offer an ever-wider audience a glimpse of sites that are not physically accessible because of their sensitivity, or because they no longer exist, or simply because they are difficult to reach. Secondly, they offer exciting opportunities to enrich the experience of visitors who are actually physically present on a site, by complementing the material evidence with reconstructions and archival material. As the availability of these tools on the mass market gathers momentum, it is also posing new questions for archaeological site interpretation. What are the qualities of a first-hand encounter with an archaeological site, which *cannot* be conveyed through VR? And what kind of content do we want to include when augmenting a visit to an actual site, in order to enhance its intellectual accessibility?

Recent technological developments have given rise to another significant change in the relationship between archaeological sites and their visitors. It is now possible to create a 3D model of an object from multiple 2D images. The 3D recreation of an archaeological site may also be achieved using holiday snapshots crowdsourced from the general public. In the wake of the destruction of museum collections and sites taking place in Iraq, Project Mosul was set up in 2015, appealing to members of the public who had visited any of the affected sites to send in their pictures, which were then successfully used to virtually recreate the sites. The project has since widened its scope to other sites around the globe (https://projectmosul.org).

Intellectual accessibility

A second, subtler pillar of accessibility is intellectual. Physical hurdles having being overcome, how is the experience of the site being interpreted, understood and retained by different members of the public? To

what extent do archaeological sites make sense to these different audiences, and how may the presentation of those sites help this process of making sense?

The process of presenting archaeological remains to different audiences begins long before the design of interpretation facilities. It is rooted in the very discovery, excavation and study of the archaeology and, secondly, in the decisions taken about how to preserve those remains. These two points will be considered in turn.

The first point is that the research questions that are posed during and after an excavation inevitably condition the narratives and interpretations that will be produced by that research. It will eventually be those same narratives that an archaeologist is likely to draw upon to explain and present that site to other audiences. This lays the responsibility firmly on the archaeologist to pose questions that are meaningful and relevant to the communities that they serve. An interpretation of a site that is based solely on chronology, phasing and artefact typology is unlikely to make for a riveting and memorable encounter. An engagement with themes of enduring concern is much more likely to do so. Survival, solidarity and conflict, taste, wealth and power, intimacy, discovery and disease are but a few examples that may provoke empathy in a wide range of audiences, a spark of recognition of some fragment of their own preoccupations. Such moments of empathy allow us glimpses of how different, or similar, a life in the past may have been.

The second point concerns decisions about what to preserve of the archaeological remains and how to do this. A well-established principle in conservation practice is that conservation interventions must remain legible to the viewer, so that the remains themselves are an enduring document of their own life history (ICOMOS 1964; Jokilehto 2007: 7). Good practice requires that restorations and reconstructions, used here in the sense defined in the *Burra Charter*, are readily distinguishable. The distinction between what survives in situ and any new materials that are introduced to reconstruct missing components should be evident not only to a specialist, but also to the lay visitor. This may be achieved in a variety of ways, such as the use of different materials (Figure 6.3), different surface textures, or the insertion of a boundary marker.

The selection of what to retain and preserve of an archaeological site may be equally thorny, particularly in multi-period sites where the traces of one cultural episode may obscure those of the ones before. In such situations, it is vital that the research agenda for any significant excavation or conservation project sets out some clear guiding principles on how the site should or should not be modified by the project,

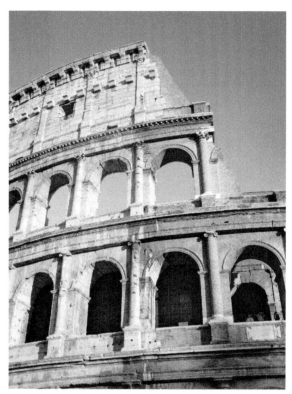

Figure 6.3: Valadier's early nineteenth-century restoration of the Colosseum in Rome. The use of brick, although in this case motivated by economic considerations, makes it very easy for the visitor to distinguish the restoration from the original travertine structure (Jokilehto 1999: 85–7).

what kind of document it will become, and how it will be presented. Throughout the lifetime of such projects, it is equally vital to maintain a debate on the values of different components of the site as they are revealed, and how these values may vary with different audiences. Faced with the ruins of a Hellenistic monumental building demolished by an earthquake, for example, a specialist in classical architecture may be keen to perform anastylosis to reassemble the architectural composition to its former grandeur. On the other hand, it may be persuasively argued that the collapsed masonry may, if preserved where it fell at the moment of the earthquake, remain an eloquent testimony of a traumatic event that played a decisive role in the destiny of that site. Such dilemmas underline the need for an approach that is informed by values, also

Case study 6.2: Segedunum Roman Fort, Baths and Museum, Wallsend, Tyne and Wear, United Kingdom

The fort of Segedunum was a Roman stronghold built to protect the eastern end of Hadrian's Wall, the northernmost frontier of the Roman Empire, and remained in use from the second to the fourth century AD. During the course of the nineteenth century, the area of the fort was built over by modern housing and industrial buildings.

Since the 1970s, many of the modern buildings that lay over the fort have been removed, extensive archaeological investigations have been conducted, and the site has been made accessible to the public. The fort suffered from a problem that is very common on sites from the ancient world, in that it is not preserved above the level of its foundations; it is therefore often very difficult for the casual visitor to appreciate the colossal scale and volume that many of these sites had originally. At Segedunum, extensive works initiated in the 1990s have successfully addressed these challenges. The first challenge is to give the modern visitor a sense of the scale, layout and extent of the fort. Although it covered an area larger than two football fields (about 120m by about 140m), so little was preserved above ground that it is difficult to get any sense of the layout of the fort from ground level. This was addressed with a daring and innovative solution. A modernist structure looking very much like an airport control tower was installed, equipped with lifts and a viewing platform. The backfill protecting the archaeological remains was picked out in a different colour to highlight the footprint of the walls and buildings of the fort. From the vantage point of the viewing platform, the plan of the fort is therefore very legible, as is its relationship to the surrounding modern streets and buildings that still cover part of the fort. The tower has also become a landmark that announces the presence of the fort, which would otherwise be lost in the rather anonymous urban streetscape.

Another significant decision taken at Segedunum was to fully reconstruct a selection of the original buildings, complete with their internal decoration. One of the most popular of these reconstructions is the bath house. The elegantly decorated interior and fittings of the fully functional bath house allow an intimate and human glimpse of the Roman garrison's concerns for their creature comforts, totally altering the way most visitors think about life on a Roman fort, and

serving as an antidote to the aridity of the surviving archaeological remains themselves.

Re-enactments of garrison life that are carefully informed by the archaeological evidence are also an important component of the interpretation and educational programme at Segedunum, as is an on-site visitor centre that is widely praised in visitor reviews for its interactive displays.

taking into account which characteristics of a site may set it apart from comparable sites.

As noted above, the process of discovery, excavation, research and preservation of archaeological remains has major implications for the way a site is presented to and experienced by the public, with the concomitant responsibility to keep the public interest in view throughout the entire process. In practice, however, the detail of a 'how and what' is communicated to the public is usually developed after the archaeological research process has been concluded. This stage raises a series of fresh challenges. To begin with, there is the question of what to communicate. What narratives will be told to the public? Or, to use the more fashionable jargon, what story boards will underpin the visitor experience? In more useful terminology, what are the facts, issues, problems and relationships that are witnessed by the site, and that may be interesting and relevant to different audiences today? The answers may vary dramatically from site to site. Some common underlying themes will be considered in turn.

The first theme that may be noted is people. Narratives that allow some insight into the beliefs and worldviews, the aspirations and fears, that shaped an individual's life in the past have the potential to resonate with the attitudes of people today, not necessarily because of their similarities, but even more so because of their differences. Archaeological evidence abounds in insights into the intimate and the personal. Graffiti on the walls of a prison-cell. A toy buried with a child. Skeletal evidence of a painful ailment caused by decades of toil. A treasured necklace made of some highly prized material. Such evidence provides opportunities for encounters between the experiences of people today and those of people from the past, and lends itself to a more engaging and memorable presentation of any archaeological site.

Another recurring theme is place. The relationship of people to the landscapes they inhabit is an inescapable and universal component of human experience. The issues of subsistence, cosmology, war, ownership, exchange, statehood and identity resonate across time, and are embodied in the landscapes where human dramas were, and are, played out. The presentation of an archaeological site may draw on a rich seam of themes here. The availability of natural resources, and how they were exploited across time. The textures of the different raw materials that were available, and the sensations of working them with the technologies of the day. The constraints and opportunities presented by the climate in different seasons, and strategies to cope with and take advantage of these factors in the past. The issues of environmental exploitation, over-exploitation, and response to climate change.

Another point that may be noted, closely tied to the themes of people and place already discussed, is that of multi-sensory experience. As has been noted in the wider debates on archaeological interpretations more generally, the visual has often dominated our narratives at the expense of the other senses. Since the 1990s, the importance of the full range of phenomenological experience has been recognised (see Skeates 2010 for a succinct review of earlier work). This development presents another range of opportunities and challenges for the presentation of archaeological sites in ways that are more engaging and meaningful to the public today. The sounds and smells experienced in the everyday lives of the past – in industry, commerce, ritual, cuisine and war – are some of the more obvious examples, and may be powerful triggers of memories and associations, engaging audiences with an intimacy and empathy that would be difficult to achieve through other means (Silberman 2015). The experience of landscapes and buildings may be enriched by multi-sensory accounts of how they would have been experienced. Reconstructing the quality of the lighting that may have prevailed in a place of worship in a different period, or the dank, cold conditions that had to be endured in a prison cell, or the kinaesthetic experience as one follows a processional way to a monumental climax, are all ways of allowing glimpses of past experience that are likely to leave an indelible impression (see Figure 6.4).

The need for multi-vocality in the presentation of archaeological sites is another theme that has been widely debated since the 1990s (Bender 1998). The *Framework Convention on the Value of Cultural Heritage for Society* (Council of Europe 2005), also referred to as the Faro Convention, lays down explicit and coherent principles on this issue.

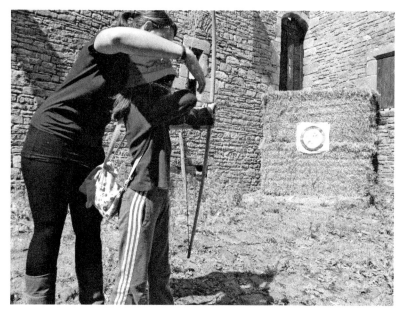

Figure 6.4: A young visitor being introduced to archery in the court-yard of Bolton Castle, Yorkshire. Such multi-sensory engagement with traditional materials, skills and practices is often the most captivating and memorable part of a visit (Source: author).

Article 7, which deals with 'cultural heritage and dialogue', requires countries that have ratified the convention, inter alia, to:

1. encourage reflection on the ethics and methods of presentation of the cultural heritage, as well as respect for diversity of interpretations
2. establish processes for conciliation to deal equitably with situations where contradictory values are placed on the same cultural heritage by different communities
3. develop knowledge of cultural heritage as a resource to facilitate peaceful co-existence by promoting trust and mutual understanding with a view to resolution and prevention of conflicts.

This ambitious agenda should inspire approaches to the presentation of archaeological sites, even beyond the frontiers of the countries that have signed up to the Convention. This is particularly relevant in situations characterised by long-standing contestation over territory. Archaeological sites often feature prominently in such discourse, with

major implications for their presentation to the public. One risk is to offer a partial narrative skewed by a partisan agenda. Another, no less problematic approach is to offer anodyne narratives that ignore or skirt the burning issues of the day. Wherever multiple points of view are present, the presentation of an archaeological site has the potential to engage with, map out and explore these divergent views in an equitable manner, creating a space for more constructive debate, and even perhaps contributing to resolution and reconciliation.

The debate over multi-vocality is by no means restricted to the problems of territorial contestation. A 'diversity of interpretations' and even 'contradictory values' such as those referred to in Article 7 of the Faro Convention may be placed on archaeological sites in many shapes and forms. The Goddess, New Age, Druid and Wicca movements are but four examples present on the contemporary European scene (Rountree 2002, 2003; Schadla-Hall 2004). Their interpretations of archaeological (particularly prehistoric) sites are often wildly divergent from mainstream archaeological interpretations, posing a rather thorny problem to a site manager trying to live up to the spirit of the Faro Convention. At which point does the multi-vocal inclusion of these alternative narratives cross the line to become public misinformation? The ICOMOS (2008) *Charter for the Interpretation and Presentation of Cultural Heritage Sites* gives some more detailed guidance here. Principle 2 of the Charter, while recognising that 'interpretation should be based on a well-researched, multidisciplinary study', goes on to say 'meaningful interpretation necessarily includes reflection on alternative historical hypotheses, local traditions, and stories'. Alternative narratives, regardless of whether they are consistent with archaeological orthodoxy, form part of the rich tapestry of human responses and values built around an archaeological site. Their inclusion in the presentation of a site is therefore desirable. The responsibility not to mislead the visitor may be addressed with suitable signposting on the context and origin of these alternative interpretations and, crucially, the evidence on which they are based.

The presentation of alternative narratives is tied not only to alternative interpretations of a site, but also to the challenge posed by a wide range of audience needs. Schoolchildren, adults with different levels of education, individuals with learning disabilities, locals and foreigners, will all have different needs and expectations, which need to be addressed if the goal of intellectual accessibility is to be met. Any robust strategy to meet this spectrum of needs on an archaeological site is bound to include alternative modes of communication, where each

audience may find a level of complexity and detail that it is comfortable with. Even a presentation tool as simple as a printed panel may have different text boxes with two or three different levels of complexity, distinguished by their fonts and format, allowing a viewer to choose what to focus on and what to glide over. Audio tours may likewise have two alternative narratives, pitched at different audiences.

A final point concerning the presentation facilities required to make an archaeological site intellectually accessible is the question of where to put them. Fixed signage along a visitor itinerary is a popular solution. One limitation of such information panels is that of space, which limits the number of languages that may be included. Another problem is that of clutter on an archaeological site, as too many panels may become visually intrusive. The alternatives include portable solutions, such as low-tech information sheets or guide books in a wider range of languages, or, where the resources are available, multi-lingual audio guides or interactive programmes on portable electronic devices. Portable devices may themselves become a distraction of a different kind, which ends up hindering rather than helping visitors from making the most of their brief, first-hand encounter with an archaeological monument. Downloadable audio tours that may be played on the visitor's own mobile phone or tablet have the advantage of doing away with the fuss and clutter of being issued with an audio wand and having to learn how to operate it there and then. A further advantage is that they may be heard even prior to the visit, lessening the risk of their becoming too distracting during the visit itself.

Another approach is that of the on-site visitor centre, which allows visitors to engage with information immediately before and after a visit, without cluttering the experience of the site itself. An added advantage of a visitor centre is that it makes it possible to display artefacts from the site, rather than in some distant museum, making the connection between site and artefact much more meaningful and tangible. Visitor centres may also create a space for other activities targeting specific audiences such as school groups.

Financial, attitudinal and cultural barriers to accessibility

Perhaps a less obvious dimension of accessibility is that tied to socio-economic factors, which may also result in considerable obstacles to the enjoyment of an archaeological site by the public (Lang 2000). The financial component is straightforward enough: the cost of travelling to

and entering a site may prove prohibitive to certain groups. In Britain, the debate on social inclusion that took off in the 1990s led to the reduction or removal of entrance fees to several national museums. The evaluation of the impact of these measures makes sobering reading. Contrary to the hopes and expectations that inspired the measures, the socio-economic profile of visitors did not change appreciably, despite an increase in visitor numbers (Appleyard 2013; Bailey and Falconer 1998). The fact that the removal of the financial barrier was not enough to draw in under-represented groups underlines the fact that there are other, perhaps even more challenging, obstacles preventing certain groups from enjoying cultural heritage resources. Attitudinal and social obstacles include the perception that an archaeological site has nothing to offer them, or that it is there only for foreign visitors, or that they will not be welcome, or that it is a waste of time they cannot afford. The manner in which an archaeological site is presented, and the range of activities on offer, has a crucial role to play in any strategy to surmount such barriers. Many of the Greek and Roman theatres that are dotted across the Mediterranean world have enjoyed a new lease of life as spaces for theatrical performances, ranging from ancient Greek tragedies to contemporary and experimental theatre. While the conservation concerns raised by such re-use require careful attention, it is difficult to think of a more appropriate, more appealing or more memorable way to draw the public into experiencing an ancient theatre, and to make it relevant to people's lives today.

The integration of narratives that are meaningful and relevant to contemporary publics is one solution that has already been mentioned. Another is the embracing of alternative narratives, which will reduce the risk of any particular group feeling disenfranchised. Complementing efforts within the site with outreach activities in the community, partnerships with local organisations and with events aimed expressly at under-represented communities may all help correct such imbalances. The adaptation of site presentation facilities to reflect and convey components of the national curriculum for different disciplines is another recipe for increasing the relevance and enjoyment of the archaeological resource.

The challenges posed by social and attitudinal barriers bring us back to the paradigm of the gated site, discussed at the beginning of this chapter. The divorcing of a site from its spatial context by means of a fenced enclosure often had direct consequences for the alienation of local communities. A very different approach to the conservation, management and presentation of archaeological remains is their full

integration into the fabric of everyday life. This approach has a particularly long pedigree in the history of cities, where the sheer density of land-use, often combined with an abundance of archaeological remains, makes it difficult to separate and cordon off the archaeology from the rest of the living fabric of the city. Ancient cities such as Rome and Istanbul are perhaps the archetypal examples of this happy co-existence, where the daily encounter with archaeology is as inevitable as the urban traffic. The model of integration of archaeology into the daily life of the city has made a vibrant return, with a number of innovative solutions aimed at preserving archaeology side by side with newly installed infrastructure. The underground transport systems of London, Rome and Athens all have elements of archaeology presented to commuters, usually in situ or, in the case of portable objects, near to the location where they were discovered. The challenge for the future is to explore how this model may be applied even beyond the confines of the city, in places where the integration of archaeology with the contemporary is not imposed by necessity, but becomes an end in itself.

Conclusions

This overview of some key issues in the presentation of archaeological sites is by no means intended to be exhaustive, but is rather intended to convey the range and complexity of the issues at stake, and to question some of the more prevalent assumptions about the nature of archaeological site interpretation. A cardinal rule which the present writer has learnt to follow is that each site will present unique scenarios, challenges and opportunities, and that no solution may be imported wholesale and applied without careful development to suit the specific situation. In order to achieve and maintain creative engagement between any archaeological resource and its manifold audiences, any interpretation strategy must remain as alive and dynamic as those audiences themselves.

7
The archaeological profession and human rights

Samuel Hardy

Introduction

Human rights intertwine with archaeology around the work that is done, the material on which the work is done, the material that the work produces, the labourers who do the work and the communities amongst whom the work is done; equally, they intersect over the work that is not done, the material that is neglected, the narratives that are untold and the people who are marginalised.

Insofar as it generates scientific data, cultural material and social understanding, archaeology produces, conserves, develops and diffuses objects of human rights – science and culture – and contributes to community life. Since they are acts of participation in and contributions to the cultural life of the community, archaeological practices themselves are objects of human rights claims. Furthermore, through its use in community development and social education, and through its use in mass grave excavations and other criminal investigations, archaeology can be an instrument for the realisation and enforcement of human rights.

Due to the conditions in which it is practised, and due to the nature and uses of its products, archaeology is also bound up with and set against other objects of human rights. It can be used to clear and claim territory. It can be used to consolidate structures of power and inequality. Professionals' scientific practices can infringe upon communities' cultural practices and cultural beliefs can interfere with scientific analyses. The provision and

division of archaeological labour can exploit or exclude professionals for economic or political reasons, while the conduct of archaeological work can disadvantage communities. So, *ethical* archaeology requires a sensitive responsiveness to the civil and political, environmental, economic, social and cultural circumstances in which it is conducted.

This chapter will highlight historical interrelations between archaeology and human rights – the use of archaeology in struggles over rights and the assertion of rights over archaeology – then consider intersections between archaeology and affected people's civil and political, social, cultural and economic rights. It will focus on the messy situations in which people's access to their rights is impeded or prevented. A number of its examples come from the eastern Mediterranean, partly because of the author's research area, but largely because there is such a wealth of public evidence of both the violation of professionals' and communities' rights and those professionals' and communities' resistance in this area. By the end, the reader will have an overview of flash points in the ethical and political history of archaeology, a deepened understanding of ethical concerns regarding archaeological practice, and a greater ability to assess and manage the ethical challenges that are present in different circumstances.

Human rights

Human rights are the goods to which all humans are entitled by virtue of their humanity, from the most tangible right to food to the most intangible right to freedom of thought. They were initially declared to be universal and inalienable, as all people were entitled to all rights (UN 1948).

Then, they were divided into civil and political rights (UN 1966a) and economic, social and cultural rights (UN 1966b), as they were prioritised by the respective capitalist and communist powers of the Cold War. This division was reinforced through the assertion that civil and political rights were primary concerns that should be implemented in law, whereas economic, social and cultural rights were secondary concerns that should be achieved through policy (Goonesekere 1998: Para. 45).

Hence, after the Cold War, they were reaffirmed as indivisible, interdependent and interrelated, insofar as they were all necessary to human dignity, and deprivation of one right affected access to others, so they all had to be treated in an 'equal' way (UNWCHR 1993: Art. 5). This principle has been stated more explicitly – 'all human rights have

equal status, and cannot be positioned in a hierarchical order' (UNFPA 2005) – and has recently been reasserted in the context of cultural rights (UNSRCR 2016: Ch. II, Para. 4).

However, this directly contradicts (or is contradicted by) the judgement that 'the right to life … forms the supreme value in the hierarchy of human rights' (ECtHR 2001: Para. 94; cf. Gewirth 1978: 213). If the right to life is the most fundamental right, as the right without which no other action may be performed, then the hierarchy of human rights may be determined by how fundamental each right is to any person's capacity to act (Beyleveld 1991: 163–241; Gewirth 1982: 139).

The hierarchy would progress from the right to life, without which no action would be possible; to the rights to adequate water and food, without which no action would be sustainable; to the rights to adequate medical care, shelter and physical security – or the right to physical health; to the right to freedom from discrimination; to the rights to freedom of belief, freedom of expression and freedom to participate in cultural life – or the right to mental health (Gewirth 1978: 52–5; 110–11). Each person could waive their own rights and others' duties, but not others' rights or their own duties. The question, then, would be how to respect and realise those rights in and through archaeological practice.

The role of archaeological theory in human rights struggles

Archaeology developed into a profession within an imperialist context. Until surprisingly recently, many within the archaeological profession at least did not *demonstrate* a recognition of responsibilities towards publics as stakeholding communities as well as curious audiences (Knudson 1984: 251). Sometimes, cultural heritage workers self-censored politically challenging work, for example socialist and feminist archaeology in the anti-Communist bloc during the Cold War (Pauketat and Loren 2005: 11; see also Patterson 1995: 104–5). Yet archaeologists have considered and debated questions of ethics and responsibility since the emergence of the profession (e.g. Dixon 1913: 563–4; cf. Wylie 2002: 28–9), including the politics of interpretation (e.g. Childe 1933), and the relationship between archaeology and the state (e.g. Jacquetta Hawkes and Grahame Clark in the Conference on the Future of Archaeology 1943: 64; 70; cf. Evans 1995: 315; Moshenska 2013: 135–7).

And archaeologists have intervened directly at some critical moments. For example, in 1933, when Nazi leader Adolf Hitler became

chancellor of, then dictator over, Germany, British archaeologist Vere Gordon Childe (1933: 410) warned colleagues that, '[i]n the name of these theories men [sic] are being exiled from public life and shut up in concentration camps, books are being burned and expression of opinions stifled'. In 1943, while the Second World War raged, Grahame Clark argued that archaeologists should 'bring to the common man [sic] everywhere a realization of his inheritance as a citizen of the world … an overriding sense of human solidarity such as can come only from

Case study 7.1: Great Zimbabwe

The history of the indigenous peoples of Zimbabwe was destroyed, denied, recognised and reclaimed through antiquarianism and archaeology between the late nineteenth and the late twentieth century. Sometimes, denialist interpretations were inadvertently produced by racist thought; sometimes, even while they recognised indigenous history, scientific examinations still involved and promoted racist thought; and, sometimes, denialist interpretations were politically imposed, through the violation of cultural heritage workers' economic rights, in order to perpetuate discrimination against indigenous people and denial of their civil and political rights.

In 1871, German geographer Karl Gottlieb Mauch identified the remains of the eleventh- to fourteenth-century capital of the (Bantu) Shona kingdom as Ophir, the site of King Solomon's mines and the seat of the legendary Queen of Sheba. The British South Africa Company (BSAC) occupied Mashonaland in 1890 and annexed it as a protectorate in 1891. The BSAC, the Royal Geographic Society (RGS) and the British Association for the Advancement of Science (BAAS) immediately funded an excavation of the exceptional *zimbabwe* – 'houses of stone' (*dzimba dza mabwe*) or 'honoured houses' (*dzimba woye*) – by antiquarian James Theodore Bent. The site manifested Britons' self-perceived inheritance of the Phoenicians' legacy, and its excavation manifested the 're-establishment' of 'civilisation'. Unsurprisingly, the colonialist dig declared that Great Zimbabwe had been built by 'a northern race coming from Arabia', which had 'eventually develop[ed] into the more civilised races of the ancient world', then had been 'inhabited by Kaffirs' – a racist term for black people – and 'destroyed' (Bent 1892: 1–2, 164). Initially, it was the only site protected by the BSAC between 1895 and 1901. In return for 20 per cent of its finds and BSAC director Cecil Rhodes' right to the first offer

on the remaining 80 per cent, the Ancient Ruins Company (ARC) was licensed to pillage any other site (Kuklick 1991: 142).

Between 1902 and 1904, white settler journalist Richard N. Hall 'restored' the site by removing 'the filth and decadence of the Kaffir occupation' (quoted by Trigger 2006: 199), through which he affirmed the city's builders' Near Eastern origins. Yet, in 1905, the BAAS dispatched professional archaeologist David Randall-McIver to re-excavate the site. Randall-McIver attributed the site to ancient indigenous people, rather than an ancient colony, and the imported artefacts to the indigenous people's inter-continental trade networks, rather than the settlers' colonisation. His findings thus implied that the land itself was the inheritance of the local Shona. This 'so angered local [settler] whites' that scientific archaeologists were not able to return to Great Zimbabwe until 1929 (Trigger 1984: 362), the year when the racist state-building National Party was elected.

When archaeologists eventually returned, they repeated the offence. Notably, though, the offence was a very technical disagreement (see M. Hall 1995: 35–8; Trigger 2006: 196–200): the settlers believed *the Bantu were not sufficiently intelligent* to have been able to build the site (R.N. Hall 1909: 13); while they acknowledged 'national organisation, originality, and amazing industry' (Caton-Thompson quoted in the *Sydney Morning Herald* 1929: 11), the archaeologists believed that *the architecture was sufficiently 'infantile' and 'pre-logical'* for the Bantu to have been able to build it (Caton-Thompson 1931: 103). Even that was too much for some: when Caton-Thompson presented the team's findings in South Africa, immediately after the election of the National Party, palaeoanatomist Raymond Dart complained aggressively and stormed out (*Sydney Morning Herald* 1929: 11).

That was just a few years before Childe's stark warning, but it was only decades later that black Zimbabweans were legally recognised as the equals of white Zimbabweans. After (by then Southern) Rhodesia made a Unilateral Declaration of Independence from the British Empire in 1965, it censored factually correct archaeological guides and warned cultural heritage workers at Great Zimbabwe that 'they would lose their jobs if they credited "black people" with the monuments' (Kuklick 1991: 159). When, in 1980, black resistance to white supremacy secured the establishment of an independent, biracial democracy, they asserted their right to self-determination by identifying themselves with the archaeological evidence of their historic independence and achievement – as Zimbabwe.

consciousness of common origins' (Clark, quoted by Evans 1995: 316). His wish foreshadowed the expectation in the UN's *Universal Declaration of Human Rights* that education should foster 'understanding, tolerance and friendship among all nations, racial or religious groups' and 'the maintenance of peace' (UN 1948: Art. 26). Whether or not archaeologists used their work politically, whether or not they were aware that their work was being used politically, it was used nonetheless.

Cultural rights and property rights

In certain delicate struggles over cultural property, now, shows of respect for victimised communities can be so theatrical as to give the impression that such respect can be taken for granted. But in some of those cases, the performance of respect for the victimised community is used to display the goodwill and generosity of the performer, precisely to avoid any recognition of the victimised community's human rights and the performer's moral responsibilities, and especially to prevent the opening or conclusion of a court case that would establish legal obligations. In other cases, the threat of a human rights court case is used to publicise precisely a moral claim for which there is no usable human rights law.

Thus, possessors and handlers of illicit cultural property may be publicly or privately convinced to confer their ostensible right to the property in return for not being named and shamed or otherwise punished. They may even be praised and rewarded for their sensitive or dutiful behaviour, despite the fact that it consisted of negligent or wilful handling or possession of stolen goods, and despite the fact that it required the rightful owners, who had already been deprived of their cultural assets, to spend time, energy and money to get back what was theirs in the first place.

Since investigations and trials for illicit antiquities trading are exceptionally difficult, even within law enforcement, there is a tendency to accept repatriation without prosecution; the policy options have been characterised as 'seize and send v. investigate and indict' (St Hilaire 2012a; 2012b). A policy of seizure and repatriation without investigation and punishment fosters a feeling of impunity amongst offenders, so they continue to offend; and it prevents the development of intelligence and policing, which would recover more stolen goods and reduce the frequency and scale of the crime. Thus, such a policy maintains a fiction of illicit possessors' private property rights that deprives victim

communities of the capacity to protect themselves from further violations of their cultural rights.

Once professionals, agencies, institutions and/or states have invested perhaps years in the tracing and verification of illicit antiquities in collections, galleries and museums, those bodies may renounce and repatriate insecurely sourced antiquities one by one, but acknowledge only 'misfortunes' or 'mistakes' in the acquisition process, not negligence or wilful wrongdoing. Thus, they may avoid, or even get a guarantee against, criminal liability for their actions; by turning their PR-conscious minimisation of embarrassment into an act of generosity, they may avoid setting a precedent; and they may refuse or ignore any responsibility to conduct genuine due diligence on other insecurely sourced materials in their collections. And the rightful owners may not even get the assets back. Whether by design to secure political leverage, or in resignation to the practical impossibility of a more just conclusion, the owners may allow the receivers of the stolen goods to keep them.

Egypt, Greece, Italy and Turkey, for instance, have sufficient leverage that they can press for restitution of looted antiquities from 'encyclopaedic', 'universal' museums in the West. Nigeria, however, has felt compelled to restrain its campaign for restitution of looted antiquities in order not to jeopardise Western technical and financial support for capacity-building to prevent further plunder (Opoku 2011, 2012). Thus, it has been forced to waive its right to already-stolen cultural property in order to have an opportunity to secure its right to not-yet-stolen cultural goods.

The right to property and the right to work

In pursuit of restitution, Turkey uses such intense pressure that the President of the Prussian Cultural Heritage Foundation (Stiftung Preußischer Kulturbesitz (SPK)), Hermann Parzinger, and an anonymous museum curator have categorised it as 'blackmail' (Letsch and Connolly 2013; Matthews 2012). The 'blackmail' secures cultural property rights through threats to or violations of cultural heritage workers' labour rights. The director of excavations at Troy, Ernst Pernicka, has identified himself and others as 'hostages', who have been asked – privately, but by those with the power to bestow or withhold work permits – to demand the restitution of antiquities from cultural heritage institutions in their home state (Kasiske 2013).

In 2011, Turkey's Ministry of Culture and Tourism banned French projects, because the Louvre Museum did not return its desired objects (Letsch and Connolly 2013) and threatened to withhold work permits from German projects until the Pergamon Museum returned the Hattusa Sphinx (Jones 2012). SPK president Parzinger insisted that Germany's restitution to Turkey was 'a gesture of goodwill' that was made 'despite being under no legal obligation to do so' (paraphrased by Letsch and Connolly 2013). Following that, the Ministry demanded another three, then yet another two, antiquities from Germany, and still other artefacts from other 'universal' museums around the world (Çelik with Evers and Knöfel 2013; *Economist* 2012). In 2012, it 'halt[ed]' any loan to the Metropolitan Museum of Art (Bilefsky 2012: A1) and 'vetoed' any loan to the British Museum (Jones 2012) until they had returned certain artefacts. Furthermore, though no case has ever been heard, Turkey has repeatedly threatened to take the British Museum to the European Court of Human Rights (ECHR) to recover sculptures from the Mausoleum of Halicarnassus (Acar 2005; Alberge 2012; Yeğinsu 2013); and Greece has hinted that it might take the same action against the same institution to recover the sculptures from the Parthenon (O'Donnell 2014).

Freedom of opinion and expression and the right to just conditions of work

While exhibition agreements between looted states and recipient institutions may seem to be as good solutions as possible, which respect the source communities' right to culture (and thus to dispose of their cultural property as they wish), such agreements can create altogether new moral hazards for cultural heritage professionals. Under the guise of raising awareness of the violation of a community's cultural rights, authorities and activists can exert influence over cultural heritage professionals' freedom of expression and thus over the production of knowledge.

Whether the understanding is express or implicit, states and institutions with interests and leverage will not provide artefacts or funds for displays that do not communicate more or less their own narrative of history or consolidate their desired perspective on politics. They may even provide selected data and directly or indirectly prohibit contrary sources, by which practice they can ensure public education that benefits their cause. And they will not provide artefacts or funds, either, for institutions that host dissidents, however loosely defined. Even if such

understandings are implicit, there are enough privately discussed experiences that everyone knows that a line exists and where it is.

It might be argued that the affected individuals' and institutions' right to freedom of expression was not infringed, because the professionals were still able to express themselves as citizens, but that neglects the impact on their right and duty to act as professionals and, more fundamentally, their audiences' right to access to information.

On a far larger scale and with a far graver social impact than interstate politicking through disruption of cultural heritage work, certain states manipulate access to and the conduct of cultural heritage work in order to manage dissent and advance political and economic projects. For instance, in Istanbul, Taksim Square was built over an Armenian graveyard, with the remains of that graveyard. When it was redeveloped, archaeologists were excluded, seemingly so that they did not document evidence of the graveyard and its treatment (see Hardy 2013). (This is also discussed as a matter of *freedom of assembly and association and the right to just conditions of work*.)

In contentious areas, the rights violations become so expected that they are no longer managed as rights violations, but rather as working conditions. Self-censorship becomes a part of the pursuit of work – or underemployment and unemployment become facts of working life. For example, 'many' young cultural heritage professionals in Turkey research the Armenian Genocide, but very few publish their research and none publish interpretations that counter state denial (Hürriyet Daily News 2013), because they will be deprived of work.

The Higher Education Board maintains a database of such activity and 'suggests' to universities – most of which are state-funded – that they support research that supports the state narrative (Özgül 2013); and the Board shares its data with the ultranationalist Turkish Historical Society, which will not fund researchers who do not support the state narrative (Cengiz 2013; Ertani 2013).

Archaeological work can also become a site of struggle for individual and collective rights against more local political and economic interests. The Head of Archaeology at Mardin Artuklu University, Güner Coşkunsu, strove to protect the multicultural inheritance of the historic city against looting and reckless development and to support democratic and meritocratic practices within the university. Coşkunsu was persecuted through 'mobbing' (emotional abuse in the workplace) – which ranged from being disfavoured by networks of corruption and nepotism to being subjected to personal abuse and death threats – and finally unfair dismissal (Erbil 2014a, 2014b).

And, while it is difficult to comment on whether the consequences are intentional or unintentional, some struggles over cultural rights can have significant consequences for archaeological work and archaeological workers. For example, due to a Greek Cypriot law against the alteration of historic place-names on Cyprus, which is intended to counter the ethnic cleansing of the historic environment in Turkish military-occupied territory, it is illegal to publish, import, acquire, circulate, offer, distribute or sell (physical or digital) documents that include new names for places (KD 2013: Paragraph 6, Sub-paragraph 1). So, when documenting historic environments or analysing the prehistoric archaeology of the island, cultural heritage professionals must choose between not publishing systematic data and breaking the law, not addressing vulnerable communities by their name and breaking the law, and not citing their sources and breaking the law.

Case study 7.2: Apartheid

The eleventh Congress of the International Union of Prehistoric and Protohistoric Sciences (IUPPS) was due to be held in Southampton in England in 1986, but as the struggle against apartheid in South Africa and Namibia intensified, trade unions, activists and archaeologists got involved to prevent the participation of South African and Namibian cultural heritage workers, in order not to appear as if they recognised the regime or accepted its practices.

The local council insisted upon a boycott of the apartheid regimes and the local archaeologists agreed, but the IUPPS and other archaeological organisations, such as the Society for American Archaeology (SAA), denounced the boycott for denying academic freedom (Gero 2000). As American Archaeologists Against Apartheid pointed out, their colleagues' objections to the boycott were illogical, because apartheid denied academic freedom both within and outside South Africa and Namibia (Patterson and Kohl 1986: 319). The local archaeologists proceeded to hold the first World Archaeological Congress (WAC).

Conference organiser Peter Ucko (1987: 5) insisted that 'to discuss the issue of academic free speech [was] almost an obscenity in the context of South Africa, where the majority of the population lack[ed] far more fundamental freedoms than that of discussion'. This was an argument for a political, ethical archaeology grounded in human

rights, with an understanding that human rights frequently con-
flicted, but that they could not be considered equal and relativised,
that there was a hierarchy of human rights, determined from human
need, and that some civil, political, economic, social and cultural
freedoms were more fundamental than others.

While it was still often referred to as 'politics', the actual substance
of the debate was manifestly ethics, 'the weight given to … academic
freedom vis-à-vis other human rights', 'the principle of human rights
in an institutionally racist society versus the principle of academic
free speech' (Ucko 1987: 224, 226), 'the social responsibility of the
profession' (Neal Ascherson, quoted by Ucko 1987: 239).

Freedom of assembly and association and the right to just conditions of work

The somewhat peculiar framework within which archaeology functions
can enable political and economic struggles to be waged through the
archaeological labour market. When Coşkunsu was dismissed, she was
initially substituted with a historian, but eventually replaced with a
theologian (Erbil 2014c), as the Rector of the University was replaced
with the Dean of Theology (Alphan 2015). And they were not isolated
incidents: the majority of recent faculty appointments across the social
sciences at that university (Erbil 2014c), and numerous other (inap-
propriate) appointments elsewhere (Alphan 2015), had been of theolo-
gians, as Islamist political networks struggled with secularist political
networks for control of public education. These incidents provide fur-
ther evidence of political networks and state structures that work to
undermine and suppress the academic freedom of non-conformist
archaeologists.

One of the 'public secret' motives for Turkey to find reasons to take
excavation licences away from foreign teams is to give them out to local
teams, as it transferred Xanthos from Bordeaux University to Akdeniz
University (see Matthews 2012). Yet licences are also transferred or
withheld internally, for instance at Allianoi, ahead of its flooding for a
hydroelectric dam project. There, the registry office denied excavation
director Ahmet Yaraş and ceramicist Candan Yaraş the right to name
their child after the site (Yaraş and Aşkın 2010); in a contemporaneous,
shadowy campaign of intimidation, the dig's mascot dog Geronimo was
poisoned, crippled and killed on site (Akdemir 2008); and, in the end,

the state withdrew funding for the excavation then, when donations and volunteer labour enabled the work to continue, the state withheld the licence (Akdemir 2008); professionals and community members alike were denied access to the excavated site (Yapı 2010). Director Yaraş was 'punished by the Turkish government' for years afterwards, by being denied any excavation permit (cited in Letsch and Connolly 2013). Since the Gezi Park uprising for human rights and democracy in Turkey, at least one archaeologist who held a teach-in at the occupation has found their long-standing excavation licence inexplicably impossible to renew.

Freedom of belief and freedom from discrimination

And beyond politics, as such, certain ethical considerations challenge the foundations of archaeological responsibility. The management of archaeological sites and cultural artefacts can produce clashes with communities of belief. Certain communities' religious beliefs, for example, require that archaeological sites are not 'polluted' by the presence of a menstruating woman or her partner, that archaeological materials are not 'polluted' by handling by a menstruating woman or her partner, and/or that neither sites nor materials are 'polluted' by their contemplation by a menstruating woman or her partner (see Dowdall and Parrish 2002: 113–4; Meighan 1994). Such rules have even been imposed in cases where the studied community's beliefs were not known and the believers' connections to the studied community were not known or were known not to exist, while the wishes of connected non-believers were discounted (Meighan 1994).

How should such conflicts in rights be managed? Should female archaeologists and male archaeologists with female partners be excluded, in order to prevent both violations of the community's rules and invasion of the archaeologists' and their partners' privacy? Should female archaeologists and male and female archaeologists' female partners be tested continuously to guarantee the 'purity' of the site without denying the right to work of non-menstruating women and their partners? Should female archaeologists and male and female archaeologists with female partners be contractually obliged to absent themselves from work for the duration of menstruation? Or should the community's right to freedom of religion be disregarded insofar as it impinges on non-believers' right to privacy and work?

For the excavation of CA-SON-1661, the California Department of Transportation agreed to honour the Kashaya community's rules and

guaranteed that 'no one would lose their job if they did not participate' (Dowdall and Parrish 2002: 118–9). Such strictures on an excavation are manageable for a limited project by a public organisation with a large, permanent workforce that can be redeployed as convenient. But they may be far more difficult as recurring or long-term conditions for a private contractor with a small, precarious workforce, which would then be incentivised not to employ women who would not be allowed to work up to 20 per cent of the time (up to four working days out of twenty a month) or women with female partners who would not be allowed to work up to 40 per cent of the time. And such strictures are exceptionally difficult for the precarious workers themselves, who may be professionally or financially induced to agree to abide by religious law, or more likely to exclude themselves from participation. So, they have serious implications for women's employment. (They have implications for men too, but men who have female partners can obstruct knowledge of their relationship status in a way that women cannot generally obstruct knowledge of their gender.)

The right to work, physical health and mental health

More broadly and more basically, cultural rights can infringe upon or violate economic rights where cultural property is protected while economically vulnerable communities are neglected, whether by exclusion from cultural heritage work and sustainable cultural heritage economies or by prosecution for cultural property crime that is committed in the course of subsistence. Though the economic wellbeing of local communities is increasingly being built into archaeological projects, unless the archaeology is conducted in a colonial settler society in which its indigenous peoples have led somewhat successful resistance to their marginalisation, it is technically possible to conduct an 'ethical' archaeological project in which outsiders enter a deprived area, excavate a site to bedrock and remove all of the archaeological materials to a cultural and economic powerhouse (such as a regional or national capital), leaving the local community without economic, social or cultural benefits.

Respecting human rights in archaeological work

Beyond its generic potential to teach respect for human rights, whether by professional design or public use, through its impact on

professionals and publics, archaeology plays a significant role in struggles for and against the rights to self-determination and participation in public affairs; freedom from discrimination; life and freedom from persecution; education; belief, association, assembly and expression; work and just conditions of work; the highest attainable physical and mental health and an adequate standard of living; and conservation of, access to and participation in science and culture. However, the archaeologists themselves are commonly vulnerable and may struggle to secure their own rights sufficiently to be able to advance those of affected communities.

8
The Treasure Act and Portable Antiquities Scheme in England and Wales

Roger Bland, Michael Lewis, Daniel Pett, Ian Richardson, Katherine Robbins and Rob Webley

Introduction

This chapter describes the solution adopted in England and Wales to the universal problem of how to deal with objects of archaeological, historical or cultural importance found in the soil by members of the public (portable antiquities): the Treasure Act 1996 and the Portable Antiquities Scheme. All countries have legal frameworks and other systems intended to protect such objects found by members of the public in their territory either by chance or as a result of deliberate searching. While these approaches vary widely, in most countries there is a legal requirement to report all objects of archaeological importance and normally the state claims ownership of them; there are mechanisms for paying rewards to the finders (although these usually fall short of the full market value) and there is usually protection for archaeological sites and controls over the use of metal detectors (Bland 1998). England and Wales have adopted a different approach to this problem, in the Treasure Act and Portable Antiquities Scheme.

Background: Treasure Trove

Until 1996 England and Wales very unusually had no legislation governing portable antiquities. The old feudal right to Treasure Trove

(under which the king claimed all finds of gold or silver that had been deliberately buried in the ground) had been adapted as an antiquities law in 1886 when the government started paying finders rewards for finds of Treasure Trove that museums wished to acquire, but this was just an administrative act and no law setting out a sensible definition of Treasure Trove was ever passed; instead the definition was based on case law going back to the seventeenth century and beyond (Hill 1936). So only finds made of gold and silver that had been deliberately buried qualified as Treasure Trove. In practice most Treasure Trove cases were coin hoards, but not all hoards were covered, as small groups that could have been lost did not qualify, nor did hoards of bronze or base metal coins (Bland 1996; Palmer 1993).

Archaeologists pressed for reform throughout the twentieth century but could never agree on what form that reform should take (Bland 2005a, 2005b). The availability of cheap metal detectors in the 1970s suddenly lent a new urgency to the need to reform the law, as the number of objects being found suddenly rocketed, but, with a few exceptions, museums and archaeologists failed to respond adequately. A part of the archaeological establishment responded by trying to introduce controls on metal detecting – the STOP (Stop Taking Our Past) campaign – but this failed to gain political support and simply led to a climate of distrust between archaeologists and detector users (Bland 2008). In 1979 the Ancient Monuments and Archaeological Areas Act included a provision that banned metal detecting on Scheduled Monuments (of which there are some 20,000) without the written permission of English Heritage but, this apart, it is completely legal to use a metal detector with the permission of the owner of the land in England and Wales. This is in contrast to most European countries, where a licence is needed to search for archaeological objects (Bland 1998). In a few parts of England far-seeing archaeologists, notably in the East Anglian counties of Norfolk and Suffolk, pioneered a system of liaison with detector users (Addyman 2001; Green and Gregory 1978).

Treasure Act

Thanks to the efforts of Lord Perth and others, the UK Parliament finally passed the Treasure Act in 1996 (it came into effect the following year) and this provided a significant, but incremental change (Bland 2008). The Act came into effect in 1997 and applies only to objects found since September 1997 (DCMS 2008). It has effect in England, Wales and

Northern Ireland but not Scotland, which has a completely separate legal framework governing finds: in Scotland there is, in effect, a legal requirement to report all finds (Campbell 2013; Saville 2000).

Under the Treasure Act the following finds are Treasure, provided they were found after 24 September 1997:

1. objects other than coins at least 300 years old with a minimum precious metal content of 10 per cent
2. all groups of coins from the same find at least 300 years old (if the coins have a precious metal content of less than 10 per cent then the hoard must consist of at least ten coins) and
3. objects found in association with Treasure.

Objects belonging to their original owner or his heirs are excluded, as are unworked natural objects (such as fossils) and wreck. The Act also contained a provision that allows for regular reviews, following which the definition can be extended. The first review in 2003 led to adding hoards of prehistoric base-metal objects to the categories of Treasure. A second review is now overdue.

Rewards and valuations

Although some Treasure cases are found during the course of archaeo-logical investigations, the great majority (95 per cent) are found by ama-teur metal-detector users, of whom there are believed to be about 10,000 (Robbins 2014: 13–4). Any object that a museum wishes to acquire is valued by a committee of independent experts, the Treasure Valuation Committee, and their remit is to determine the full market value of the object in question; the current chairman is Professor Lord Renfrew of Kaimsthorn, an eminent archaeologist and member of the House of Lords. The reward is normally divided equally between the finder and landowner. The Committee is advised by a panel of valuers drawn from the trade, and interested parties can commission their own valuations which the committee will consider. The reward can be reduced or not paid at all if there is evidence of wrongdoing on the part of the finder or the landowner. Once a valuation has been agreed, museums have up to four months to raise money. Archaeologists are not eligible for rewards. Not all finds reported as Treasure are acquired by museums and indeed about 60 per cent of all cases are now disclaimed and returned to the finders, who are free to dispose of them as they wish.

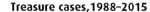

Treasure cases,1988–2015

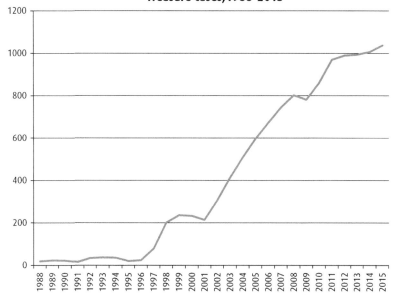

Figure 8.1: Finds reported as Treasure Trove (1988–97) and Treasure (since 1997)

Impact of the Treasure Act

The impact of the Act has been dramatic: before 1997, an average of twenty-six finds a year were Treasure Trove and offered to museums to acquire; in 2015, 1038 cases were reported as Treasure, 95 per cent of these found by amateur metal-detector users (see Figure 8.1). Since most of the finds that were Treasure Trove before 1997 were coin hoards, it might have been thought that the Act would only have a limited impact on the number of hoards being reported, but in fact the average number of coin hoards since 1997 is sixty-seven a year (half of these are Roman hoards), more than twice the twenty-six a year logged in the ten years before the change in the law. Since that figure of twenty-six a year included hoards of bronze coins and small groups of coins that were not Treasure Trove, this increase must reflect a greater willingness by metal-detector users to report their finds.

Case study 8.1: The Staffordshire Hoard: archaeology captures the public imagination

When metal-detecting on farmland in central Staffordshire in July 2009, Terry Herbert discovered a series of early medieval gold and garnet artefacts. He carefully boxed these up and then contacted his local finds liaison officer of the Portable Antiquities Scheme, Duncan Slarke, who drove to Mr Herbert's house to see the items. Mr Slarke was astounded at their number and quality, and immediately contacted colleagues at the British Museum and the Staffordshire Historic Environment Record. Mr Slarke also contacted the Coroner and reported the find as potential Treasure. Archaeologists from Staffordshire County Council investigated the site of the find, and a team from Birmingham University undertook a limited excavation, assisted by Mr Herbert. They recovered hundreds of further artefacts revealing the vast scale of what would come to be called the Staffordshire Hoard.

Dr Kevin Leahy, National Finds Advisor for the Portable Antiquities Scheme, and his wife, Diane Leahy, undertook the immense task of cataloguing the finds made by Mr Herbert and the archaeologists. Over 1500 items and fragments of items were initially identified, including intricately filigreed sword pommels, sword hilts, crosses, a helmet cheek piece and other helmet fragments, and a large gold strip inscribed in Latin with a quotation from the Bible – 'rise up, O Lord, and may thy enemies be scattered and those who hate thee be driven from thy face'. It was the largest collection of Anglo-Saxon gold material ever found.

From the start, there was immense interest among the academics who knew about the find, as well as concern that news of the discovery would break before archaeologists had the opportunity to recover all of the items from the dispersed hoard. Workers on the site were careful not to reveal the true nature of their investigation to curious onlookers. When the work was complete and Dr Leahy had finished his report on the finds for the coroner, the inquest was scheduled for 24 September 2009. On this date, when the coroner declared the hoard to be 'Treasure', Birmingham Museums and the Potteries Museum & Art Gallery in Stoke-on-Trent, who hoped to jointly acquire the hoard, issued a press release with the British Museum, announcing the discovery. Daniel Pett of the Portable Antiquities Scheme and Kate Kelland from the British Museum (Pett 2010) built

a unique website about the hoard, which received more than 175,000 page views within five days of going online; it linked to a Flickr website of photos taken by Birmingham Museums which saw 500,000 views over the same period. The find was extensively covered in the British and overseas media, and the hoard captured public interest, with references to the discovery appearing in cartoons and television adverts. There was even a local beer variety that was named 'The Hoard' and featured a photograph of the star artefacts on its label.

A quickly arranged display in Birmingham Museum and Art Gallery found members of the public eager to view the major pieces in the hoard. As the valuation for the reward payment requires the items to be assessed 'in the condition in which they were found', the artefacts had the dull patina of the fresh earth from which they had come. Despite this, people queued for more than three hours and in the rain for a chance to see the hoard. After two weeks the artefacts were transported to London for eventual valuation by the Treasure Valuation Committee. In the meantime, a selection of the finds were also put in specially sourced cases and installed in the prominent location of the Central Saloon at the British Museum.

Sensing the popular interest in the spectacular discovery, several media companies put forward plans for a television programme. The cultural institutions were in the advantageous position of being able to ask the companies to tender for the short-term exclusive rights to access to the hoard, and a team from the British Museum, Birmingham Museums and the Potteries Museum & Art Gallery chose National Geographic as the preferred partner. In due course this was to lead to a television documentary broadcast on Channel 4 and a cover article in *National Geographic Magazine*, in addition to an access fee which would assist in conservation costs of the hoard.

As part of the valuation process, several different experts in the antiquities trade provided reports on the hoard's value. The Treasure Valuation Committee then met to consider these and after a day-long meeting, recommended a value of £3,285,000 for the items. In order to acquire the hoard, Birmingham Museums and the Potteries Museum & Art Gallery had to raise this money, which would form the reward paid to the finder and landowner. The Art Fund led a national fundraising campaign to support the hoard's acquisition and gave £300,000, with the National Heritage Memorial Fund contributing £1,285,000. Many politicians gave their support to the campaign to

'save the Staffordshire Hoard', with Baron Corbett of Castle Vale hosting a fundraising event in the House of Lords. The Potteries Museum & Art Gallery and Birmingham Museums 'loaned' some of the star items for temporary shows to encourage local donations. In all, a staggering number of organisations and private individuals contributed to the campaign, and in May 2010 the target had been reached and the Staffordshire Hoard was acquired by the Midlands museums.

This was only the beginning of the public's widespread fascination. Whilst conservators started cleaning up the thousands of items and making discoveries about how many of the mystery items would have looked and been used, academics were already using the hoard in their works. Indeed, before the find had even been valued, a symposium had been organised at the British Museum which drew experts from around the world and across disciplines to discuss the implications of the hoard's discovery. Most subsequently published their work at www.finds.org.uk/staffshoardsymposium. On the popular front, more appearances were made in nationally broadcast television programmes, from BBC's *Digging for Britain* to ITV's *Britain's Secret Treasures*.

The acquisition of the Staffordshire Hoard fuelled the development of bespoke displays in both Birmingham and Stoke-on-Trent. The hoard went on tour to several venues in Britain and was the subject of a special exhibition at the National Geographic Museum in Washington, DC in 2011/12. Elements of the hoard continue to tour various locations, and it retains its own website (www.staffordshire-hoard.org.uk), which includes information on how the hoard can be used in education. Continuing research, conservation and development are actively managed by the acquiring museums. This has led to further investigations on the site of the discovery, and in 2012 a survey assisted by volunteer metal-detector users and organised by Archaeology Warwickshire uncovered an additional ninety items belonging to the original hoard, news which again made the front page of many national newspapers.

The Staffordshire Hoard has proven so popular and become so well known that it has become symbolic of the material culture of early medieval Britain. Like the famous burial at Sutton Hoo, the Staffordshire Hoard has gone beyond specialist interest in archaeology and appeals to a wide and diverse audience, both in Britain and beyond.

Portable Antiquities Scheme

Of course Treasure finds are only part of the picture: the great majority of archaeological objects found do not qualify as Treasure, but the information they provide can be just as important for our understanding of the past (DNH 1996). The Portable Antiquities Scheme (PAS) was established in parallel with the Treasure Act to encourage amateur finders to report – voluntarily – all the coins and other archaeological objects that they find. This works through a network of thirty-eight locally based finds liaison officers, who between them cover the whole of England and Wales. Their main remit is to record finds offered for recording; they also have very important responsibilities for archaeological outreach and disseminating good practice to metal-detector users (for examples see British Museum 2014: 8–12). They have to cope with all types of archaeological finds and so are supported by five specialists, national finds advisers. All the finds are recorded onto an online database (https://finds.org.uk), which is now the largest resource of its kind in the world and which, as of September 2016, contains details of more than 1.2 million objects reported by over 14,000 metal detector users and others. These finds are returned to their finders after recording.

It is a priority to record find spots as accurately as possible, so 90 per cent of all finds are recorded to an area 100m square. When finds are recorded in this way, and the data is integrated with other archaeological finds together with the local archaeological records, the information has huge potential for revealing new sites. Brindle has shown that in ten years the data recorded by PAS had increased the number of Roman sites from two counties (Warwickshire and Worcestershire) by 30 per cent (Brindle 2014). Most archaeology in Britain takes place in advance of building development and, as sites brought to light by detector finds are mostly rural, most of them are unlikely to have been discovered through the normal archaeological process. Ninety per cent of all finds recorded by PAS come from cultivated land where the archaeological contexts have already been disturbed by the plough: when metal detecting is carried out properly on such land, with all finds being carefully recorded, it can be seen as a form of rescue archaeology.

Perhaps the biggest problem for PAS is its own success: it perpetually struggles to record all the finds that it can. Although 82,975 finds were added to the database in 2015 (see Figure 8.2), there will never be enough staff to record all the finds they would like to, and so in March 2010 a new facility was added to the database to allow amateurs to

record their own finds, under supervision, and at the time of writing over 270 individuals had recorded over 40,000 finds. Persuading the individuals who make finds to take responsibility for ensuring that they are recorded must underlie the scheme's future direction, as the flow of new discoveries shows no signs of diminishing.

It has sometimes been said as a criticism of PAS that it has not stopped illegal metal detecting in England and Wales, but this is for the simple fact that it was not intended to. This is an enduring problem and PAS staff are working closely with English Heritage's Heritage Crime Initiative, which is run by a police inspector on secondment. This has had considerable success in targeting illegal detector users, known as 'nighthawks'. However, it is important to put nighthawking in perspective: a survey commissioned by English Heritage in 2008 found that on two measures (the numbers of scheduled sites attacked by illegal detector users and the number of archaeological units that reported nighthawking incidences on their excavations), the number of cases has declined since 1995, when a previous survey was carried out (Dobinson and Denison 1995; Oxford Archaeology 2009).

Another way of tackling the problem of illegal metal detecting is to make it harder for the thieves to sell their finds. At present, it is too easy for the 'nighthawks' to sell their finds to dealers who are happy

Figure 8.2: Numbers of finds recorded on http://finds.org.uk

to purchase such objects without checking that the vendors are acting legally, with the agreement of the landowners. Many items of potential Treasure are openly offered for sale, especially on the eBay website. In October 2006 PAS signed a memorandum of understanding with eBay whereby eBay will take such items down from its website when notified by PAS and the police; PAS has been monitoring eBay as time allows since then. For the first time, eBay has published comprehensive guidance on buying and selling antiquities on its website, while PAS has also developed its own guidance. In addition, PAS has followed up several hundred cases of potential Treasure offered for sale on eBay. Although there have not yet been any criminal prosecutions as a result of this monitoring of eBay, there have been a number of cases where vendors have voluntarily agreed to report the finds they were selling as Treasure. However, monitoring eBay on a daily basis, which is what is needed, is a time-consuming process. More resources are needed in order to pursue this work; arguably these should come from eBay and similar sites which profit from the sale of antiquities.

It might have been expected that the government's accession to the 1970 UNESCO Convention in 2002 and the Dealing in Cultural Objects (Offences) Act, which came into force on 30 December 2003, would suppress the market in finds illegally recovered from the UK but no prosecutions have been brought under this Act, nor have any been brought under the Treasure Act.

Case study 8.2: Research using the Portable Antiquities Scheme data

With over 1.1 million archaeological finds recorded on the PAS database (https://finds.org.uk) and many more being added every day, its potential as a research tool is increasingly powerful. This was highlighted at PAS's tenth anniversary conference – 'A Decade of Discovery' – in 2007, which provided a platform for twenty scholars to discuss their work using PAS data (Worrell et al. 2010). The PAS website is continually updated (Pett 2010) with details of those using the scheme's data, with access provided via a tiered model allowing for various roles to consume these data. Upon registration, users are given limited access to the information collated; find-spot data is reserved for those who have higher-level access (which is granted upon application and receipt of references). At the time of writing,

433 researchers have full access to find-spot data, whilst a further 292 have finds liaison officer access. These data have been used in over 450 research projects, including seventeen pieces of large-scale research and ninety-three PhDs. Over 7000 people have registered as users, and if they are associated with personal details recorded by PAS staff, they are able to interrogate the database for their own discoveries.

Useful insights into the value of PAS data for researchers have recently been provided by a research project by Katherine Robbins (2013), funded by the Leverhulme Trust, which seeks to understand the factors that underlie the data generated by the scheme. This project builds upon her PhD research (Robbins 2012), which analysed data gathered by PAS in Hampshire, the Isle of Wight and Northamptonshire. The new research uses statistical techniques within a geographic information system to analyse the spatial distribution of the data and various classes of finds and compare it with other datasets such as relevant Historic Environment Records. Of particular value are the analyses that explain the wide variations in the frequency of finds recorded across England and Wales: is this an archaeological reality or due to other factors, such as the attitude of detectorists towards finds recording or where they search? It is hoped that this research will offer a baseline for all researchers using PAS data, enabling the rapidly growing PAS database to be exploited to the full: it has been noted that PAS data is currently not being used to its full potential because there has been little detailed research on the nature of the data, and some archaeologists may not use it for this reason.

There are a number of examples of research benefiting from this approach, including a body of PhDs using PAS data. In recent years the Arts and Humanities Research Council (AHRC) has funded several Collaborative Doctoral Awards (CDAs) with the British Museum/ PAS as a co-partner. These have covered a range of periods from the Iron Age to Anglo-Norman England. Rob Webley's research on portable metalwork in Late Saxon and Anglo-Norman England is particularly notable, not least since most analysis using PAS data has explored artefacts of earlier periods.

The Norman Conquest of England (1066) brought huge social and political change in England, most visible in the elite architecture of the period immediately after it, particularly castle and church building, but also in manuscript art and stone sculpture, for example. Webley's

research will explore whether or not these shifts can be seen in the portable material culture of the time. As noted already, the PAS database provides an unprecedentedly large dataset with which to study different regional responses to a 'national' socio-political event of the magnitude of the Norman Conquest. While it is generally thought that there are few portable metal artefacts dateable to the eleventh and twelfth centuries, this project aims to critically re-examine the dating of such objects over the wider period between AD 900 and AD 1250. This work builds on the scholarship of others who have studied (in isolation) particular artefact types, such as stirrup-strap mounts (Williams 1997) and strap-ends (Thomas 2001). Now that a better profiling of relevant non-ferrous dress accessories, equestrian equipment and weaponry has been achieved, interesting questions can be asked of the cultural effects (or relative lack) of the Norman Conquest, and by extension of perceived turning points in history. The findings will be promoted widely to achieve a better understanding of Anglo-Norman metalwork within both academic and public realms. Further, they hope to inform a wider debate on how metalwork fits into the wider phenomenon of the Norman Conquest, and to what extent it was mostly an event affecting the elite rather than everyday people.

An increasingly number of people are considering PAS material in approaches to medieval and post-medieval metalwork (e.g. Lewis 2012), and this is to be welcomed, thus demonstrating the important contribution metal-detected finds (if responsibly recovered and properly recorded) can make to the archaeology and history of Britain.

Proposed amendments to the Treasure Act

In 2009 Parliament passed a number of significant amendments to the Treasure Act in the Coroners and Justice Act:

1. Establishing the post of Coroner for Treasure, who would deal with all Treasure cases from across England and Wales (at present many coroners give Treasure cases low priority and delays of a year or more in their holding an inquest on a find are not uncommon).
2. Extending the obligation to report Treasure: currently there is only an obligation for 'finders' of Treasure to report such finds. This amendment would require that anyone who 'acquires property in

an object' that he 'believes or has reasonable grounds for believing … is treasure' report it. This would help frustrate the illicit trade in Treasure finds.

3. In conjunction with this there would be a 'reverse presumption' that an object was found on/after 24 September 1997 unless there is evidence otherwise: currently some finders state that an object was found before the Act, and therefore it is declared not Treasure Trove (under the old common law). This amendment would tighten up this loophole in the legislation. Coroners declare objects Treasure (or not) on the balance of probability.

4. Extending the time limit for prosecutions for non-reporting: this would increase the *statute of limitation* (currently six months) up to three years, so that police have more time to pursue a prosecution of failure to report Treasure. Prosecution cases have failed because time has run out – even before a coroner has declared a find to be Treasure.

5. Allowing the secretary of state to designate officers to whom Treasure can be reported: the Act states that Treasure should be reported to the coroner in the district in which it was found, but it is normal practice (since it is convenient for finders) for finders to report (and hand over) Treasure to their local finds liaison officer (at their local metal-detecting club), and this amendment would normalise that practice.

6. Obligation to hand over treasure: currently finders only have a legal obligation to report Treasure, not hand it over. This amendment will ensure that the obligations of finders (who are intransigent) are clear.

All of the amendments would help the Act work better, and the second and third ones would make it much harder for dealers to sell unreported Treasure finds. Unfortunately, the coalition government did not implement these amendments (there is a cost, albeit a low one, to establishing the post of Coroner for Treasure). In addition, a second review of the Act is overdue: on its agenda will be the possibility of extending the Act, and single finds of Roman and Anglo-Saxon gold coins, as well as Roman base-metal hoards, have been discussed as possible candidates for adding to the definition of Treasure. It remains to be seen whether the Act will be extended in this way.

Case study 8.3: Portable Antiquities on the web

The PAS website has been online now for over a decade and has been delivering data dynamically to the public since 2003 via its database (Pett 2010). Since 2007, this dissemination platform has been developed entirely in-house and allows an agile deployment of a high-technology environment for people to research discoveries of portable antiquities. This system has been recognised internationally as an exemplar for the recording of archaeological data and is now employing new techniques for enabling research: for example, the production and consumption of linked open data (Gruber et al. 2013) to enrich numismatic records and through the visualisation of coin finds (Pett 2014).

The PAS website has seen substantial usage since 2007, with over half a million unique visitors to all PAS web resources over several years. This total, whilst a small detail in the greater picture, is particularly significant as PAS's contributor base is estimated at around 8000–10,000 metal-detector users (Bland 2013). Therefore, the PAS online presence is now reaching an audience 50 times its constituent base. The material that the PAS site disseminates is reaching a worldwide mass audience and bringing best practice and freely available data to places that traditional means would not have reached.

PAS strives to innovate within the archaeological sector; the database is consistently cited as the largest archaeological small-finds database in existence (at the time of writing, and commented on above, over one million objects have been recorded). The reach of PAS on the web has been further supplemented with dissemination of the data (licensed under a Creative Commons By-Attribution Share-Alike licence) into mass consumer platforms such as Wikipedia. The PAS site has developed large sections for the teaching of numismatics to a non-specialist audience, and this is proving to be an area with rich development potential. As a partner in the Nomisma project (with the American Numismatic Society and Deutsches Archäologisches Institut, amongst others), the PAS site is now supplementing its coin guides with a wide array of resources (some multi-lingual), through the use of Linked Open Data (Pett 2014).

PAS has actively developed a social media presence, maintaining identities on mainstream platforms such as Flickr (which was used to great effect for dissemination of the Staffordshire Hoard images

in 2009), Facebook and Twitter. Producing output for these media is relatively straightforward, and a strategy has been implemented in line with the British Museum's general approach to the use of social media (Pett 2012). Whilst follower numbers are relatively small, they are growing at a reasonable rate and reflect the limited time devoted to this facet of PAS engagement. However, PAS is now receiving a reasonable volume of referrals via these platforms, and this will no doubt increase as people start to share more information in this way.

PAS's web presence is constantly evolving; it tries to stay on the edge of technological innovation and this drives its delivery of archaeological data to the public. A recently conducted survey that will inform a Heritage Lottery Fund bid has shown that many respondents requested a mobile device application to be constructed. This is one area which PAS could develop in the future, but the data can also easily contribute to third-party developed applications. The window of opportunity to the digital super highway that Schadla-Hall (1996) referred to in the late 1990s is still there. He posed the question: 'how ready is our collections information for the information super highway? I suspect the answer is that a lot of it is not ready for the mud track or even the occasionally trodden grassy path!' PAS is ready and has been for a while.

Conclusion

Although the Act could be improved and the PAS could benefit from more funding, it has had a major impact. The finds recorded by the scheme are available at the PAS website for all to see (case study 8.3). This is a major tool for research (case study 8.2). The Treasure Act and PAS may be a particularly English response to the situation that exists in this country, but they are undoubtedly transforming our understanding of the past of England and Wales.

9
Alternative archaeologies

Gabriel Moshenska

Introduction

You might have seen books on the 'archaeology' shelves in bookstores with brightly printed covers with pyramids, standing stones and crystal skulls. More likely you will have seen television shows where enthusiastic explorers find traces of ghosts, aliens or mythical monsters at archaeological sites around the world. Welcome to the world of alternative archaeology where up is down, old is new, and nothing is what it seems – except for the surprisingly large pay cheques. In this chapter I want to explore the world of alternative archaeologies (sometimes called fringe, bad or pseudo-archaeology), looking at their different themes and characteristics, at how archaeologists have responded to them, and at their impact in the real world. This chapter can be read as an accompaniment to Schadla-Hall's (2004) detailed analysis of the topic.

What is alternative archaeology – or perhaps given their number and diversity I should ask what *are* alternative archaeolog*ies*? The term refers to the practices, products and views of the ancient world that exist beyond the margins of the professional, scholarly and intellectual mainstreams – outsider knowledge of the past, some of it the result of painstaking if misguided scholarship, some of it 'truths' revealed to initiates by prophets and conmen and the voices in their heads. Alternative archaeologies pose hypotheses and narratives of the human past that deviate from the mainstream consensuses in a variety of ways. They present a challenge to archaeologists who must decide if – and how – we

should respond to them, but they also exist in the real world (like mainstream archaeology) and must be understood (again, like mainstream archaeology) in their specific political, economic, cultural, social and intellectual contexts.

Academic and professional archaeologists have long taken an interest in alternative archaeologies, and there are a number of good studies of the subject. The majority of these are by US-based scholars and focus on US archaeology, such as the works of Williams (1991), Feder (1984, 2002) and Harrold and Eve (1995). Archaeologists' responses to alternative archaeologies can be seen as part of a movement – again largely US-based – against pseudoscience in general, such as the widely read works of Michael Shermer (1997) and Carl Sagan (1997). The lively debates around the teaching of biblical creationism in the US – often referred to as a 'culture war' – have endured for more than a century, and this more than any other factor is arguably responsible for the relative strength and diversity of US scholars' responses to pseudoscience in general, as well as pseudo-archaeology.

There are number of factors that make alternative archaeologies alternative. One common feature is their epistemology: in other words, the way they deal with knowledge, often by a rejection of scholarly rigour and the scientific method. For example, rather than critically evaluating all available evidence, some alternative archaeologists work by gathering only the evidence that fits their theories – even if some bits contradict others. Another is their outsider status: some archaeologists are deemed 'alternative' because they disregard widely accepted conventions and practices, while other more conspiracy-minded alternative archaeologists cultivate their 'outsider' persona as a badge of rebelliousness, independence and authenticity. In practice the boundaries between alternative and mainstream archaeology are not so clear, and they change over time. For example, the druidic origins of Stonehenge are viewed as pseudo-archaeology today, but in the past this has been the dominant, mainstream view (Schadla-Hall 2004). Many alternative archaeologists like to claim that their ideas – though mocked in the present – will one day be regarded as a long-neglected truth.

Themes in alternative archaeologies

Alternative archaeologies are a very diverse group, ranging from religious fundamentalist ideologies to romantic nationalism to alien conspiracy theories to New Age beliefs. However, there are a number of themes that

turn up again and again in different alternative archaeologies around the world, and these are worth looking at in a little more depth (for a more detailed analysis of these themes see Schadla-Hall 2004).

Origins

Many alternative archaeologies are focused on the search for origins: whether it's the origins of a national, linguistic or ethnic community, or the birthplace of a specific practice like metalworking, agriculture or pyramid building. Alternative archaeologists want the origins of their favoured groups or things to be glorious (or at least respectable) and they want them to be simple and unambiguous. Unfortunately for them, archaeology is really not very useful for writing 'just so' stories. If you really look into it, the origin of a particular group of people probably involves groups joining and dividing over and over again over time; the story will have gaps, and the point of origin – if you can find it – is likely to be mundane, unimpressive and probably not where you hoped or expected it to be. As for technologies and other practices, most of them seem to have had multiple points of origin – no one person is the father or mother of, say, the bow and arrow – but for alternative archaeologists this is too complicated. A good example of this is pyramids: some alternative archaeologists claim that pyramids could only have been invented once (probably in Egypt), and that every other pyramid-like structure in the world, from Mexico to Silbury Hill, is part of the same continuous lineage (e.g. Picknett and Prince 2003). This type of belief in single, identifiable origins is referred to as 'hyperdiffusionism', a variation on the more respectable 'diffusionism' or the spread of ideas through cultural transmission.

Ancient knowledge

Another common theme in alternative archaeologies is the idea that people or civilisations in the past possessed spiritual, technological or ecological knowledge that far surpasses modern thought in complexity or purity. This sort of romantic nostalgia for a lost, more perfect world is part of many New Age alternative archaeologies as well as ideas of Atlantis, Mu and other lost continents. Writers and leaders in alternative archaeology like to talk about lost, ancient knowledge, holding out the promise that if you buy their book, watch their show or join their sinister little cult you can enjoy exclusive access to the wisdom of the ancients.

The existence of occult (literally 'hidden') knowledge in the archaeological record of past civilisations and cultures is an alluring idea, and one that has influenced literature and popular culture as well as the more literal beliefs of alternative archaeologists. Again, pyramids are a good example (they seem to have a supernatural ability to attract odd theories). Pyramids have been interpreted as ancient refrigerators, radio beacons, and timelines that predict the future destiny of entire peoples (Jackson and Stamp 2002; Moshenska 2008). The revival of ancient knowledge is a popular theme in alternative archaeologies because it claims to offer the consumer wisdom, enlightenment and superiority – in particular, superiority to successful academic scholars – without requiring much if any work.

Religious truth

One of the largest and best-funded strands of alternative archaeology is devoted to proving the truth of one religion or another. Archaeological evidence is often invoked to demonstrate the literal truth of the Bible, and wealthy fundamentalist Christians have lavished funding on expeditions to find the resting place of Noah's ark and other biblical sites. The influence of religiously inspired work on middle-eastern archaeology has been a powerful one, and not altogether negative: the disputes between biblical literalists and less dogmatic Christians in the nineteenth and early twentieth century led to a large amount of work taking place on important middle-eastern sites, only a relatively small amount of it by truly crazed fundamentalists.

Mainstream religions are not alone in seeking reinforcement in archaeology. The 'Vedic archaeologist' Michael Cremo is a Hare Krishna creationist: his widely read book *Forbidden Archeology* (*sic*) claims that anatomically modern humans have existed on earth for hundreds of millions of years, in accordance with Hare Krishna beliefs (Cremo and Thompson 1993). Furthermore, he claims that archaeologists have conspired to hide this fact behind the invented idea of human evolution. Cremo and his co-author marshal a large amount of evidence in support of his claims: like many alternative archaeologists they favour early archaeological material that pre-dates accurate relative or absolute dating, and which has often been conclusively refuted or subsequently reinterpreted. They also cherry-pick materials and quotes without sufficient regard for context. Overall their approach is characterised by confirmation bias: the search for supporting evidence only, rather than the

rigorous evaluation of a hypothesis against both supporting and opposing evidence.

Another area of religiously inspired alternative archaeology lies within the New Age movement, and in particular around the idea that ancient societies worshipped a Mother Goddess whose likenesses and traces can be found spread across Europe and beyond. The idea of the Mother Goddess was powerfully reinforced by the work of archaeologist Marija Gimbutas (1974, 1989), whose work has been widely accused of going beyond the boundaries of scholarship into pseudoscientific speculation and imagination. Gimbutas's vision of a peaceful prehistoric matriarchal religion found a great deal of support and sympathy within parts of the feminist movement in the 1980s and 90s, particularly in the US. This in turn led to a growing number of contemporary feminists identifying themselves as followers or worshippers of the ancient Mother Goddess, a movement that continues into the present and claims to be a revival of ancient beliefs and practices. However, Gimbutas' interpretations of much of her material were questioned by archaeologists such as Peter Ucko (1968), while Lynn Meskell has criticised her work from a feminist archaeological perspective, arguing that 'fantasy' views of the past are an impediment to feminism in archaeology and in society (1995: 83).

Aliens

The idea that extra-terrestrial beings have visited earth in the past and guided human development and/or evolution is a staple of science fiction, from *2001: A Space Odyssey* (1968) to *Prometheus* (2012). These views were most effectively popularised by the works of Erich von Däniken, discussed in more detail below, and by the more recent television series *Ancient Aliens*. The belief in extra-terrestrial influences on the human past is arguably an extreme version of hyperdiffusionism discussed earlier: the idea that all advances in human culture have a single origin (in this case an external one) from which they were spread and disseminated. Like most hyperdiffusionist beliefs, these beliefs are based in part on a derogatory view of past human societies that emphasises or exaggerates their primitive nature and lack of technological or intellectual abilities, often within an implicitly racist framework. Other arguments for early human contact with extra-terrestrials focus on artistic and iconographic analysis of figurines and other representations, in particular of large-scale artworks such as the Nazca Lines

Case study 9.1: Erich von Däniken's Chariots of the Gods?

Probably the single most successful work of alternative archaeology was published in 1968 by Swiss hotel manager and convicted fraudster Erich von Däniken: *Chariots of the Gods?* presented what the author claimed to be a raft of evidence showing extra-terrestrial influence on human societies throughout prehistory. *Chariots of the Gods?* sold tens of millions of copies around the world, was adapted into documentaries, and formed the basis of a theme park in Switzerland opened by von Däniken in 2003.

The premise of the book is that there is abundant evidence in art, artefacts, mythology and religion for numerous visits to earth by extra-terrestrials in spaceships. In defence of this theory von Däniken shows images of rock carvings such as the sarcophagus of the Maya Pacal the Great, arguing that it shows the complex internal structure of a rocket ship; he also claimed that the Nazca Lines in Peru are landing strips for spaceships. Turning to the Bible, von Däniken suggested that Ezekiel's vision of fire was in fact a spaceship, and that Lot's encounter with angels was in fact a close encounter with aliens.

The success of von Däniken's book spawned a host of imitators and followers, but also a number of attempts to debunk his work. One of the most amusing of these is *Some Trust in Chariots*, published a few years after *Chariots of the Gods?* (Thiering and Castle 1972). This short edited collection takes a tongue-in-cheek approach to von Däniken's claims, with a cover describing it as 'The bombshell book that goes far beyond *Chariots of the Gods?* to reveal the startling, irrefutable truth about ancient marvels!'. The contributors include an archaeologist, an engineer, a theologian, a philosopher and an ancient historian. The title, taken from the psalms, highlights the slightly religious tinge to the work although the editors point out the contributors include 'Christians of several kinds, a member of the Jewish community, and at least one agnostic. But they are closely united in believing that truth is hard-won and precious, and that *Chariots of the Gods?* requires a counter-attack' (Thiering and Castle 1972: 1).

It is worth noting that von Däniken's tone in his writing is (at least superficially) questioning rather than declaiming. This is a common rhetorical device in alternative archaeology to protect the writer or speaker from being required to justify their argument: they can claim semi-truthfully that they never made the claims suggested; they merely posed difficult questions and suggested possible solutions.

When various parts of his work have been debunked von Däniken has often acknowledged the fact, but without ever amending subsequent editions of his books.

Chariots of the Gods?, its sequels and subsequent films and publicity brought von Däniken considerable wealth. In 2003 he opened the Mystery Park in Switzerland, a theme park based on the ideas promoted in his books. The park was made up of different pavilions displaying various aspects of von Däniken's theories, and included extensive merchandising and sales points for his books. At one point it included a trail where visitors could go to see von Däniken at work at his desk. The park closed due to poor visitor numbers and subsequently reopened and closed several times.

which are most clearly visible from a high altitude. The 'aliens' view of the origins of humanity is closely linked to other pseudoscientific beliefs about extra-terrestrial contact and related conspiracy theories.

Characteristics of alternative archaeologies

Despite the global spread and thematic variations of alternative archaeologies, there are some characteristics that are common to many or most of them. These are worth examining and knowing about, as they can be used as the basis of an archaeological 'bullshit detector'.

Fallacies

If you examine the arguments presented by alternative archaeologists, you find a number of recurring themes in the methods of presenting information and drawing conclusions. Very often these means of arguing seem flimsy or misleading, but it is not always easy to pin down precisely why. It helps to have an understanding of logical fallacies – formal and informal – to get a clearer view of how these arguments aim to mislead. The full range of fallacies is beyond the scope of this chapter, but some of the most common in alternative archaeology include either–or fallacies, confirmation bias, and proof by assertion.

Either–or fallacies present a false dichotomy, and are commonly used by creationist alternative archaeologists: they claim that a mainstream argument is invalidated by a minor or invented problem (for

example, the imprecision of radiocarbon dating), and assert that therefore their preferred faith-based viewpoint is correct, excluding the myriad other possible interpretations. This is particularly common in creationist arguments, which tend to be constructed in primary opposition to mainstream scientific research, not to – for example – the many other very different religious creation stories.

Confirmation bias, mentioned earlier, is the gathering of information in support of a theory, rather than critically evaluating it by seeking and including evidence that contradicts or disproves it. This is often done unconsciously and is by no means restricted to alternative archaeologies: some prominent archaeologists are known to have ignored or discarded evidence which did not conform to their preferred interpretations of sites.

Proof by assertion is the crude method of repeating a claim over and over until it is embedded in the minds of credulous viewers, listeners or readers. This method, derived from rhetoric, is surprisingly successful and is often used in the form of 'Just Asking Questions' (also known as JAQing off), popularised by Erich von Däniken and more recently on the television series *Ancient Aliens*. Here the proponent of an alternative archaeological theory can claim that they are not in fact promoting a particular view, but merely asking awkward questions that highlight flaws in the mainstream view. In fact, the questions are likely to be posed as claims, worded misleadingly, or piled up one after another so as to overwhelm. Crude and bullying rhetoric of this kind is surprisingly effective, particularly if the audience is already broadly sympathetic to the questioner's views.

These are just a few of the many logical fallacies employed by alternative archaeologists, and it can be fun to try to spot them 'in the wild' in television programmes, books and discussions.

Linguistic and stylistic similarities

One of the most important longstanding research methods in archaeology is the establishment of typologies and type-series of artefacts and other material things showing how tools, technologies, buildings, decorative designs and other features developed over time and moved through space, either by the movement of people or the spread of ideas. Similarly, related fields such as historical linguistics chart the spread of languages, dialects, language families and even specific words through time and space, revealing movements and connections between people,

whether based on migration, trade, conquest or other factors. Similarities between languages and designs are a valid form of data in archaeology, but with well-understood limits: individual similarities are not treated as proofs of connection, rather they contribute small pieces to an overall weight and diversity of evidence. In alternative archaeologies, in contrast, even very minor or isolated similarities can be treated as conclusive proof of connection: in these breathless, uncritical searches for meaning there is no room for coincidence.

One example with a long and disreputable history is the idea popularised by the American anthropologist Thomas Wilson (1894) that the swastika design is a distinctive symbol, perhaps the first to be deliberately designed, and that its spread around the world coincided with the movement of spindle whorls and bronze working. The idea of the swastika as the distinctive symbol of an advanced race was taken up by the hyperdiffusionist anthropologist Grafton Elliot Smith (1929), amongst others, becoming associated with the notion of a Nordic or Aryan race.

Case study 9.2: The curious theories of John Hooper Harvey

John Hooper Harvey (1911–97) is best known as a reputable and respected British architectural historian, who published extensively in scholarly journals and lectured in conservation at University College London. In his other life, as revealed in his early writings and in research by historian Graham Macklin (2008), Harvey was a Nazi-sympathiser, a rabid anti-Semite and a virulent fascist, regarded as extreme even within the British fascist groups of the 1930s and 40s. Harvey's interest for the purpose of this case study lies in his ability both to work within the academic system producing reputable research, and also to publish fantastical and wildly racist writings that seem (to modern eyes) utterly deranged.

As a student in London Harvey became a member of the Imperial Fascist League, and a friend of its leader Arnold Leese. He gave lectures to members of the League on topics relating to the history of the Nordic race, and wrote articles for their magazine *The Fascist*. During the 1930s Harvey became an ardent admirer of the alternative archaeologist Laurence Austine Waddell, a retired doctor in the Indian army and former professor of Tibetan. Throughout the 1920s and 30s Waddell authored a series of ever-more bizarre history books claiming inter alia that the Britons, Scots and Anglo-Saxons were

Phoenician; that the Phoenicians were Egyptian; that the Egyptians were Sumerian; and that the Sumerians were (of course) Aryans from India. Waddell had directed archaeological excavations in India in the 1890s, and his books employed the full range of alternative archaeological techniques including the alleged decipherment of ancient texts, the misinterpretation of monuments, the conflation of stylistic and linguistic elements, and the use of rhetoric and bombast in place of evidence. A recent and extremely odd biography shows that Waddell's ability to command adherence to his views has extended far beyond the grave. Harvey's uses of Waddell's works are best seen in his book *The Heritage of Britain,* published in 1940, in which he notes that

> One of the greatest real advantages of the modern age has been its ability to recover past history by scientific archaeology. But so specialized has archaeology become that the results achieved are for the most part sealed books to the ordinary man … Violent conflicts of opinion among the scientists themselves are frequent, and entirely erroneous ideas have been upheld in order to buttress some political or religious theory.
>
> (Harvey 1940: 5)

In place of these erroneous ideas, Harvey promises a history that 'can yet save the British nation from the downfall which awaits those who lose race-consciousness, and who mix their blood with that of lesser breeds' (Harvey 1940: 5).

Building on Waddell's ideas, Harvey asserted that the biblical Adam was a real man, a king of the 'Gothic Sumerians', and identical with King Arthur, Thor and St Andrew. He draws uncritically on the medieval writings of Geoffrey of Monmouth to argue that the Trojan king Brutus travelled to Britain and gave it its name, and that the Scots were really 'S'Goths' (Harvey 1940: 60). His short bibliography includes the works of the proto-Nazi race theorist Hans Günther, and Alfred Watkins, inventor of ley lines. Harvey's combination of outdated sources, weak arguments and racist ramblings are not in themselves unusual, but it is remarkable that he went on to become the respected author of several scholarly works on architectural history and conservation. It is very important to note that the line between the mainstream and the lunatic fringe is in no way identical with the lines between amateur and professional or academic and layman.

Writer George Herbert Cooper (1921) found a swastika within the layout of Stonehenge, while fringe archaeologist Laurence Austine Waddell (1924) traced the swastika from India to Scotland, both taking this as proof of the Aryan origins of the British.

Amongst the most ambitious attempts to prove linguistic connections comes in the work of well-known alternative archaeologist Barry Fell, whose book *America B.C.* (1976) claimed that many ancient civilisations of the Old World made contact with the Americas in prehistory. Much of Fell's evidence comes from tenuous linguistic connections, claiming to have found words in Native American languages that are identical or very similar to words in other ancient languages. Fell's analysis was examined in depth by researchers from the Smithsonian Institute, who concluded rather damningly that

> No prehistoric loanwords of Old World origin have been found in any North American Indian language. The contention is made in *America B.C.* that there are words of Egyptian, Semitic, Celtic, and Norse origin in certain Indian languages of the Algonquian family, but the alleged evidence is seriously flawed. The discussion does not distinguish clearly among the separate Algonquian languages; ignores basic facts of Algonquian grammar, linguistic history, and etymology; makes many errors on specific facts; miscopies and misinterprets words (or impossible fragments of words) and their translations; and shows no awareness of the basic scientific linguistic procedures that have been used by specialists for over a hundred years to study the history of languages.
>
> (Goddard and Fitzhugh 1978: 86).

This catalogue of intellectual sins is typical of alternative archaeological approaches to historical linguistics.

Misinterpreting geological phenomena

One of the most interesting features that links alternative archaeologies with the world of conspiracy theories is the capacity – some might say compulsion – to find evidence of human agency behind what might otherwise be regarded as natural processes. Nowhere is this more common than in the interpretation of geological phenomena as evidence of often colossal megalithic architecture. Many of these sites are underwater, and link in with theories of sunken continents such as Mu and Atlantis.

The alternative archaeologist behind many of these claims is the journalist Graham Hancock, whose work covers a wide range of fringe beliefs including pyramidology and astro-archaeology (e.g. Hancock 1995). Hancock's explorations of underwater pseudo-architecture includes the island of Yonaguni in Japan (2005), where formations of sedimentary rock probably shaped by tectonic activity have been interpreted as a pyramid, a vast stadium, castles, roads and other structures. Few artefacts have been recovered from the site and most are strangely shaped rocks, not the advanced technologies one might expect to find in a vast city. In 1997 Hancock was involved in the early exploration of this site, which has been claimed to date from as early as 6000 years ago although geologist Robert Schoch, an alternative archaeologist also involved in the study, has argued for a natural origin for the site. Schoch is best known for his theory that the Sphinx is much older than commonly supposed, based on a tendentious analysis of its erosion patterns. The Yonaguni site has been linked with the mythical lost civilisation of Mu. Perhaps the best-known example of a geological phenomenon interpreted as manmade is the Bosnian Pyramid, discussed in more detail in Case study 9.3.

Case study 9.3: The Bosnian pyramid

The Bosnian pyramid is a good example of nationalist-driven alternative archaeology: a vaguely pyramidal (from some angles) hill near the town of Visoko in Bosnia and Herzegovina, which is claimed to be a 12,000-year-old human-made structure. The pyramid theory was instigated and promoted by Semir Osmanagić, a Bosnian businessman and author of several alternative history books. Osmanagić's works include claims that the Maya people are descended from aliens in Atlantis, and that Hitler survived the Second World War and escaped to the Antarctic. In 2005 Osmanagić visited Visoko and discovered the pointed hills, which he decided were pyramids. He conducted surveys and excavations, and published a book describing the monumental landscape, which he claimed included several pyramids and other important sites. Scientists who have examined the site have found that it is a fairly common form of geological formation found across Europe, Asia and North America.

While claims such as Osmanagić's are not unusual in alternative archaeology, the response from politicians and the public is far from

typical. The Bosnian pyramids have been embraced by local and national politicians, given state funding for research, and promoted as a heritage attraction. Local stores sell pyramid-themed food and souvenirs, while hundreds of thousands of domestic and foreign tourists have flocked to the site since its discovery. Visoko is a stronghold of Bosnian Muslim nationalism, and the pyramids have become symbols of the historic strength and significance of the area and its people. Like most nationalist alternative archaeologies this comes with a violent dimension, in this case directed as the small number of Bosnian scholars willing to question what is increasingly an orthodoxy:

> The belief that Visoko was a cradle of European civilization and that the Bosniaks' ancestors were master builders who surpassed even the ancient Egyptians has become a matter of ethnic pride. 'The pyramids have been turned into a place of Bosniak identification,' says historian Dubravko Lovrenovic of the Bosnia and Herzegovina Commission to Preserve National Monuments. 'If you are not for the pyramids, you are accused of being an enemy of the Bosniaks.'
>
> (Woodward 2009)

Numerous archaeologists and even the European Association of Archaeologists have spoken out against the pyramid theory, highlighting the destruction of real archaeological material that has been carried out in investigating the pyramid, and the waste of resources in a country whose rich archaeological heritage receives little state support and protection. But money continues to roll in to the town of Visoko, and no politician will risk denouncing such a popular nationalist delusion.

How have archaeologists approached alternative archaeologies?

One of the most interesting things about alternative archaeologies is what they tell us about the 'mainstream' or establishment world of archaeology. This is particularly the case when we observe the many different ways in which professional and academic archaeologists have approached or responded to the work of alternative archaeologists,

revealing much about their own ideologies, beliefs and approaches to the ancient world.

Cornelius Holtorf has highlighted what he regards as the absolutism of many critics of alternative archaeologies, suggesting that they hold to an unrealistic view of archaeology as a bounded, professional enterprise. He points out that many of these critical responses are unduly censorious and high-handed, noting that 'Archaeologists do not serve as a special state police force dedicated to eradicating interpretations that are considered false or inappropriate by a self-selected jury' (Holtorf 2005: 549). Holtorf's criticism is focused on the more strident critics of alternative archaeologies:

> Readers are addressed by dismissive rhetoric and seemingly arbitrary value judgements reflecting personal preferences. What exactly is a 'distortion' of archaeological interpretation or 'bogus archaeology', as opposed to one based on the 'proper' study of archaeological remains? Which criteria are to be applied to judge TV archaeology? On what authority is anybody entitled to divide up their fellow citizens into categories such as 'charlatans' and 'misdirected hobbyists'? Surely such judgements, as they are socially negotiable and subject to change over time, tell us more about the person making them than about the people addressed or should I say insulted.
>
> (Holtorf 2005: 545)

It is worth noting that some of the subjects of Holtorf's ire have been known to combine attacks on alternative archaeologies with criticisms of aspects of post-processual public archaeology such as multivocality in archaeological interpretation. Some of the key texts on alternative archaeologies, such as Feder's highly influential *Frauds, Myths, and Mysteries* (2002) explicitly align themselves with a model of archaeological reasoning tied to an increasingly anachronistic notion of scientific objectivity, as Holtorf notes.

One common approach to alternative archaeologies is to attempt to debunk their claims, providing evidence to contradict their arguments and pointing out gaps, misinterpretations or deliberate distortions. Given the rate at which alternative archaeologies are created and spread, particularly in the age of the Internet, this is a near-impossible task and requires a large investment of time and intellectual effort. Websites such as *Bad Archaeology* and *The Hall of Maat* provide resources and information to contradict specific

alternative archaeological narratives, often with painstaking detail and at considerable length. Sometimes debunking is combined with humour: *Some Trust in Chariots*, a collection of papers attacking von Däniken's *Chariots of the Gods?*, includes a paper entitled 'Was Santa a Spaceman?' by an anonymous author described as 'a used car sales-man for many years [who] has recently devoted himself to full-time studies in esoteric anthropology and occult archaeology' (Thiering and Castle 1972: 123).

Perhaps the most constructive approach to alternative archae-ologies is to treat them as a phenomenon worth studying: something that we can examine, evaluate, critique and deconstruct. Whether you believe that alternative archaeologies are harmful intellectual patholo-gies or valid ways of approaching the past, it is surely worth approach-ing them with a clearer understanding of their nature, their appeal and their possible harms.

Discussion

Why should public archaeologists take an interest in alternative archae-ologies? Alternative, fringe or pseudo-archaeologies have enormous popular appeal, and reach a far wider audience than mainstream archae-ology. Thus if we want to understand the public interest in archaeology then we need to appreciate the degree to which it has been shaped by these alternative narratives, and shape our messages and our media accordingly.

At the same time, it is important to understand alternative archae-ologies in their wider social and political contexts as well as the purely intellectual. Compared to mainstream archaeology (never innocent, of course) the narratives generated within alternative archaeological frameworks are far more likely to be embedded within frameworks of nationalism, imperialism, and religious and ethnic supremacism. All too often the claim 'Aliens built X' is built upon the assumption that 'Non-white indigenous people Y could not possibly have built X', while many 'lost civilisation' narratives posit white-skinned settlers who pre-date and/or were wiped out by the apparently indigenous populations in countries such as New Zealand and the United States. These narratives provide the blueprints or more commonly post hoc justifications for colonialism and genocide. Even apparently 'harm-less' alternative archaeologies such as the Pagan campaigners for the reburial of archaeological human remains in the UK can encode strongly

nationalist and white-supremacist assumptions within their mythologies. Archaeologists as scholars and intellectuals can, if they wish, choose to challenge potentially harmful interpretations or presentations of the ancient world. But alternative perspectives on the past, the earth and the universe have been compared to unsinkable rubber ducks: you can submerge them with arguments but they will almost always bob up again.

The phenomenon of alternative archaeologies is global, with a long and interesting history. In this short chapter I have only been able to cover a few of the most notable examples and significant themes, but there is a great deal of potential for research in this field including sociological, anthropological, historical and philosophical perspectives, all of which will strengthen our understanding of the world of archaeology in general, and public archaeology in particular. Alternative archaeologies matter – and they are very much part of archaeology.

10

Commercial archaeology in the UK: public interest, benefit and engagement

Hilary Orange, Dominic Perring

Introduction

Commercial archaeology in the UK involves the contracting of profes-
sional archaeological services primarily to the construction industry.
Since 1990, the sector has operated within the framework of an evolving
UK government planning policy that has adhered to broad principles of
sustainable development set out in EU directives and international con-
ventions. The relationship between the commercial sector and planning
is predicated on the notion that archaeology serves the public interest
by providing key benefits. The sector supports the construction indus-
try in discharging its regulatory duties as it responds to public demand
for new housing and infrastructure (Aitchison 2012), and mitigates the
impact of development by conserving and interpreting a record of the
heritage asset and advancing understanding of its significance (DCLG
2010, 2012). This chapter presents an overview of commercial archaeol-
ogy in the UK and outlines the relationship between the sector and the
public realm. Alongside some general concepts, a brief history of com-
mercial archaeology is presented before common factors that encourage
and impede engagement and outreach services are outlined. Two case
studies illustrate recent practice in this area.

A brief history of commercial archaeology

Before 1990 most investigations undertaken ahead of new construction were considered rescue excavations, aimed at recovering scientific evidence from the jaws of the bulldozer. Important rescue projects took place in rebuilding after the Second World War, but work increased massively from the 1970s onwards when a patchwork of local and regional teams, or field units, was established (Jones 1984). Various local solutions emerged from arrangements that had previously relied on volunteers coordinated by museums, university departments and ad hoc excavation committees. Although these rescue units were grant-aided by central government, they remained independent organisations, often structured as charitable trusts committed to community benefit (Thomas 2007; Schofield et al. 2011). Several district and county authorities appointed archaeologists to support the rescue programme. These posts were often located within local museum services, but local authority archaeologists soon forged links with planning departments, initially to anticipate where rescue excavations might be necessary and subsequently to arrange for the protection of important sites.

The risk of a conflict between development and archaeology was instrumental in the introduction of new planning guidance in 1990 (DoE 1990). This guidance established the need to consider the interests of archaeological conservation before development could proceed, drawing on the practice of cultural resource management developed in the USA (King 2004: 23). Local planning authorities were encouraged to require developers to record and advance understanding of the significance of any heritage assets at risk of being damaged, in a manner proportionate to their importance and the impact, and to make evidence of significance publicly accessible (DCLG 2012).

The planning reforms encouraged a separation between the decision-making that obliged developers to support archaeological works and the undertaking of those works, formalising a division between 'curator' (engaged in cultural resource management) and 'contractor' (undertaking excavation and research for development clients). Public funds were directed towards supporting 'curatorial' posts within planning departments, whilst field units came to depend on commercial income as grant aid diminished. This accelerated a move towards developer funding, as construction companies responded to the need to provide information on the archaeological and historical landscape in order to secure planning permission. In turn, consultancies found a profitable role mediating between the

interests of the different parties involved and helping commercial clients manage their archaeological work programmes. The expansion of archaeological employment was accompanied by the establishment in 1982 of a professional body, now the Chartered Institute for Archaeologists (CIFA), with a remit to promote standards and regulate professional archaeology in the UK. According to CIFA (2010), the duty of the profession is to realise the full potential of archaeological resources 'for education and research, the improvement of our environment and the enrichment of people's lives'.

The scale of commercial archaeology

Development-led archaeology is an established business, drawing on project-management practices found in the construction industry. It is estimated that around 90 per cent of all archaeological investigations are undertaken by commercial organisations (Fulford 2011: 33) and therefore the sector's potential to contribute to public understanding of archaeology has long been recognised (Flatman 2011: 30–1, 90–1). In busy years, some 5000 developer-funded investigations can be undertaken, at an estimated cost to developers of approximately £150 million (Aitchison 2010: 26). By 2015, this platform of funded work meant that commercially funded organisations employed over 3000 people, representing some 60 per cent of all those working in British archaeology. The work is, however, vulnerable to the fluctuating fortunes of the construction industry, resulting in considerable variations in volumes of work and employment opportunities.

Approximately 80 per cent of development-led archaeological work falls within the orbit of professional audit and regulation, where the public interest of archaeological work is addressed (Perring 2016: 96). CIFA maintains a list of registered organisations that have been subject to peer review and have successfully demonstrated their adherence to professional standards (CIFA 2015). There are about seventy such organisations operating in England, 46 of which undertake developer-funded archaeological excavations, employing some 2200 staff. The sector remains dominated by business practices that were established in the 1970s as regional rescue units. These remain not-for-profit organisations structured to meet research and charitable objectives, retaining specialist knowledge of regions within which they have worked for many decades. A smaller group of more recently established companies do not trace their origins to the public sector provision of the 1970s,

but many have also inherited the research culture and commitment to local community engagement that characterises the longer-established archaeological companies.

Typical services

Archaeological contractors provide a wide range of specialist services, including site evaluation, survey, excavation, and areas of work such as historic building recording, forensic archaeology (including scene-of-crime work), geo-archaeology, heritage site management and interpretation, and maritime archaeology. Most archaeological investigations are small-scale evaluation exercises undertaken to establish whether important and vulnerable remains are present; sometimes following on from earlier desk-based research and environmental impact assessment that has identified that this might be the case. A typical archaeological evaluation will involve the machine excavation of a few trial trenches or test pits down to the horizons where archaeology might be present, but will not entail the detailed investigation of the remains uncovered, since these may warrant preservation in situ. Sometimes non-invasive techniques, such as geophysical and topographic survey, will also be deployed, although not routinely. Evaluation exercises are usually arranged at short notice and completed within a matter of days, offering little opportunity for public engagement or access. Since the purpose of these works is to inform a planning decision, the results are generally summarised in a technical report submitted to a planning committee, and this kind of 'grey literature' can be difficult to find or use for other purposes (Bradley 2006). Summary information is more readily available through local Historic Environment Records held by the planning authorities concerned.

Where significant finds are made during an evaluation exercise, the planning decision will usually require the conservation of the remains in situ or for an archaeological excavation to take place ahead of construction (see case study 10.1). These investigations are intended to mitigate the physical loss of archaeological resources by identifying some form of compensatory public benefit, such as a research value or use value. Such benefits could include, for instance, interpretation panels, historical information and public open days, the repair of a heritage asset or public access to archives (Historic England 2015b: 7). Such programmes of mitigation are structured by a research design, usually described as a 'written scheme of investigation' (WSI), prepared by the archaeological

Case study 10.1: Volunteers and outreach at the Pococks Field excavation

Archaeology South-East (ASE) operates as an independent cost-centre within the UCL Institute of Archaeology (IoA) and has offices in Brighton, London and Witham. ASE started life as the IoA's Field Archaeology Unit in the early 1970s before becoming increasingly involved in commercial work in the 1990s. Employing approximately 100 permanent staff, the company tenders for nearly 1000 projects annually and has an annual operating turnover of around £4 million (Perring 2015b: 192). ASE offers services in excavation, building survey, maritime archaeology, forensic archaeology, academic publication, specialist illustration and computer modelling (UCL 2015).

In 2014, ASE completed a seven-month-long excavation and associated outreach programme ahead of development on behalf of Bovis Homes at Pococks Field, Eastbourne, East Sussex. Previous small-scale investigations on the site, especially work by the Eastbourne Natural History and Archaeological Society, had already uncovered prehistoric, Roman and medieval settlement. The excavation and outreach in 2014 were funded by Bovis Homes, following recommendations from East Sussex County Council, acting as advisors to Eastbourne District Council, and were undertaken in accordance with a written scheme of investigation prepared by ASE to meet the requirements of planning conditions.

ASE opened the excavation to volunteers, with training and supervision provided by staff. Over eighty volunteers took part, including students, retired people, unemployed people and some with declared disabilities, with the vast majority of volunteers living locally. The excavation was opened to the public who could see the work in progress and visit an on-site exhibition. Guided tours were offered on a weekly basis and two large-scale family open days were held (Dawkes 2015). The outreach programme also included visits to the site by local schools (over 200 pupils attended), which entailed site tours and handling sessions with finds and environmental materials. Feedback from a visitor survey indicated that people appreciated the opportunity to visit the site and learn more about the depth of history on their doorstep, and developed a deeper understanding of the process and complexity of archaeological investigation (L. Rayner, pers. comm.).

The excavation revealed settlement from the prehistoric to the Tudor period, including an Iron Age enclosed settlement, the first evidence of the Saxon settlement of Eastbourne, medieval occupation and an impressive large stone-built Tudor Hall. Following post-excavation analysis of 6000 excavated contexts, 500 registered finds and 250 environmental samples (Dawkes 2015), an academic monograph will be published on the findings of the excavation set in their local and regional context.

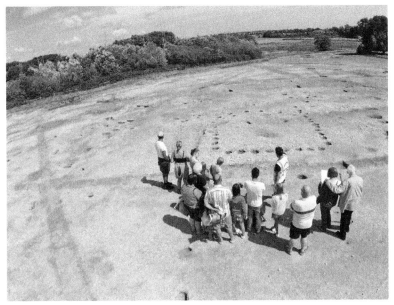

Figure 10.1: Visitors to an open day being shown the post-built Saxon building. Photo reproduced with kind permission of Archaeology South-East.

contractor and consultant on behalf of the client for approval by the local planning authority drawing on appropriate archaeological advice (CIFA 2014). These documents set out the research objectives of the exercise and define the methodologies that need to be employed (and hence help to set the timetable and budget). It is at this point that some larger, longer-running archaeological projects are designed to include opportunities for public engagement and outreach, particularly where the public value of an engagement programme can be demonstrated

or is felt to be self-evident. Although most work is closely restricted to the boundaries of an individual development project, there is also some scope for project work to embrace wider research goals on larger infrastructure projects where whole landscapes are explored. In the case of projects that cross authority borders, planning conditions are set by the government's Planning Inspectorate.

On completion of fieldwork, a programme of analysis is prepared. An initial review of the quality, quantity and significance of the archaeological data recovered is set out in a 'post-excavation assessment' (PXA), which the local planning authority will use as the basis for agreeing on the final analytical works required to secure the discharge of any planning restrictions placed on the site (English Heritage 1991; Historic England 2015a). Post-excavation work, usually aimed at providing a descriptive narrative of landscape change, informed by the evidence of the artefacts (pottery, building material, small finds and coins), and ecofacts (human and animal bone, palaeobotanical remains, etc.), is time-consuming and can often take several years to complete. Depending on the complexity of the remains encountered, the post-excavation work can cost as much again as the field investigations, and may draw on a range of external specialist contributions (such as scientific dating). The ultimate goal of post-excavation work is the academic publication of the results and the deposition of the fieldwork archive in a local museum. Owing to their complexity, archaeologists struggle to keep these complicated work programmes on track, and a significant proportion of the work undertaken in development-led archaeology generates little in the way of publicly accessible results and materials. The greater public interest engendered by the more significant discoveries helps, however, to ensure that these are given the attention they merit.

Public engagement and outreach

Although more recent planning reforms have explored ways of adding to the range of public benefit obtained from developer-funded archaeological work (Southport Group 2011), these planning reforms have had little direct impact on the nature of commercial practice. This remains dominated by the needs of resource management, where the benefits of knowledge gain and social engagement are valued but often remain subordinate (Carver 2011). The financing and organisation of public engagement or outreach activities are hampered by several factors. The prevalence of short-duration projects resulting in ephemeral features and

finds has already been noted above. Low profit margins can lead to reluctance to fund staff training in 'peripheral' areas, such as public engagement (Aitchison 2012; Flatman 2011: 92; Southport Group 2011: 12). Clients may request confidentiality or control the release of information. For instance, confidentiality is common with 'pre-determination' works prior to a decision on planning and when construction is contested by the local community (Orange 2013). Site access may be restricted when there is heavy plant operating, demolition in progress or requirements to undergo formal inductions into safety regimes. Access may also be complicated by the shared use of a site by contractors. Unsympathetic working systems and poorly designed or non-existent public engagement strategies (Perring 2015a: 169–71) can lead to a lack of confidence in developing outreach services. Moreover, a desire to maintain professional standards can contribute to a reluctance to communicate interim findings to the public and the media before the post-excavation assessment and reporting stages of a project are concluded.

Clients may see public engagement as an unnecessary delay and expense that comes without certain outcomes. However, some clients may request outreach services; for example, the Environment Agency, the National Trust and the RSPB place a particular emphasis on engagement as part of their charitable or public sector remit. Private sector clients – for instance, those behind large-scale public utility projects and housing schemes – may view public engagement favourably for public relations reasons. In addition, some commercial companies develop their own programmes of outreach and community engagement by attracting small-scale funding from trusts and learned societies. Importantly, since 1994, National Lottery funding has provided more substantive funding that has enabled cross-sector organisations and voluntary groups to work in partnership with, and to commission, commercial firms to carry out archaeological services (see case study 10.2). It is important to note that not all public engagement work in commercial archaeology is driven by developer funding.

Not surprisingly, the number of archaeologists employed in designated engagement posts within commercial archaeological firms remains relatively small, but recently has been boosted by the Council for British Archaeology (CBA) work-based placements in community archaeology scheme, funded from the HLF's *Skills for the Future* programme from 2011 to 2015 (Bradley et al. 2015). The five-yearly survey of the archaeological profession, *Archaeology Labour Market Intelligence: Profiling the Profession*, recorded fifteen education and outreach posts in the latest report covering the period 2012–13. Females held 67 per cent of posts

Case study 10.2: The restoration of Carwynnen Quoit Project

In 2012, the Sustainable Trust, an educational charity based in Cornwall, contracted the Cornwall Archaeological Unit (CAU), Cornwall Council, to deliver a series of excavations at the site of a collapsed prehistoric monument known as Carwynnen Quoit. The monument is a Scheduled Ancient Monument (no. 396) comprising three granite uprights and a 9.8-tonne granite capstone, and belongs to a type of monument known as a portal dolmen, dating to the Early Neolithic. With a grant from the Heritage Lottery Fund (HLF), the Trust purchased the land surrounding the quoit in 2009. With further funding from HLF, local trusts, societies and private bequests, the Trust formed a partnership with the Cornwall Heritage Trust and the Cornwall Archaeological Society to restore the monument (Sustainable Trust 2014).

CAU was established as a charity in 1975 and became part of the local authority in 1988. With about twenty staff and an annual turnover of projects worth on average £1 million per year (J. Nowakowski, pers. comm.), the unit has responsibility for recording, conserving, presenting and interpreting the historic environment across Cornwall and the Isles of Scilly. CAU carries out a wide variety of archaeological projects including conservation management, aerial mapping, heritage audits, heritage assessments, historic building recording, excavations, evaluations, interpretation and research (CAU 2017). Over the last seven years, the unit has been actively developing community archaeology, which forms an increasingly significant part of its project portfolio (J. Nowakowski pers. comm.).

On this project, CAU's role was to develop and direct a series of community training excavations in order to establish how the monument should be reassembled – a requirement of the restoration licence from English Heritage (now Historic England). In 2012, CAU ran a test-pitting exercise as part of preliminary investigations followed by an open-area excavation. Up to forty-five people, with varying levels of experience, were given training in excavation, recording, illustration, finds processing and cataloguing. The excavations uncovered the partial survival of a granite stone and quartz pavement on the footprint of the original monument, the socket holes for the granite uprights, Neolithic and later pottery, many burnt and broken flint tools, a partially finished greenstone axe, some other worked stones items, a quern fragment and a hammerstone. The objects ranged in date from the Early Neolithic to the Bronze Age and later, showing

a long history of engagement and interest throughout prehistory (Sustainable Trust 2014: 7, 9).

The restoration work was completed in June 2014 when the capstone was lowered into position onto the three reinstated uprights by a large crane – an event that was watched by a crowd of over 600 people (see www.giantsquoit.org). In 2014, the project won the Council for British Archaeology's Marsh Award for Community Archaeology.

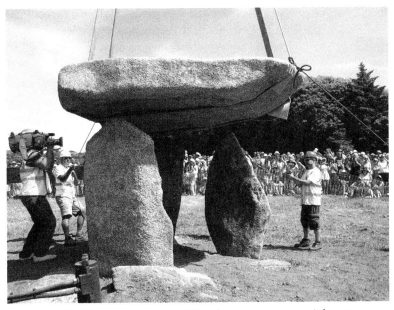

Figure 10.2: The capstone in position hovering over uprights on Midsummer Day 2014. Photo reproduced with the kind permission of Jacky Nowakowski.

and 93 per cent of posts were funded through established income. Salaries ranged from £15,000 to £40,500 and the average salary was £21,559. Job titles included variations on the words 'Community', 'Education', 'Outreach', 'Interpret', 'Access', 'Exploring' and 'Heritage' (Aitchison and Rocks-Macqueen 2013: 54, 179). The small number of designated outreach staff means that public engagement services are regularly carried out by staff whose main specialism(s) or focus of work lies in other areas. In consequence, engagement is an area that many

professional archaeologists have had ad hoc experience in, but it is perceived by some to be a non-archaeological skill (Orange 2013).

The types of outreach and engagement activities that commercial firms deliver cover a 'spectrum of public involvement' (Kador 2014: 35), and could include informal conversations that take place when members of the public walk past a team conducting fieldwork, as well as multifaceted community archaeology programmes where members of the public can gain experience by working alongside trained archaeologists. A survey of commercial archaeology in the UK by Orange (2013) found that common engagement activities included giving talks to societies and other groups, publishing, hosting open days, communicating with the media, working with the media and facilitating work with volunteers and work experience placements. It should be noted that many professional archaeologists give up their own time to deliver public engagement outside of working hours.

Digital public engagement is also a burgeoning area of practice (Richardson 2013) and the use of web technology and social media has provided a valuable mechanism for distributing news and project updates to different public audiences. Archaeologists working in the commercial sector have contributed to the successful annual blogging carnival Day of Archaeology (Richardson 2014) and some archaeologists share details of their work informally on their personal social media platforms. The posting of project updates on company platforms has become increasingly common, but may be constrained by client confidentiality and a lack of staff time; however, digital archaeology is also seen as a useful marketing tool for archaeological firms seeking to establish new business and contacts (Orange 2013). Furthermore, digital archaeology can help to create and maintain relationships between commercial companies and public audiences. Commercial projects operate within communities on a time-limited basis and the formulation of exit strategies at project end are easily omitted from project designs. The identification and digital dissemination of information on different opportunities at local, regional and national levels can help to create progression routes that redirect and maintain public interest in archaeological participation.

Data and evaluation

Public engagement is usually well intentioned but is it always effective? Does it offer long-lived impact and meaningful collaboration with professional archaeologists? In one study, Simpson and Williams suggested

that the 'ideals of community archaeology programmes, both in the US and the UK, often do not match expectations for the practical and perceived benefits for the communities' (2008: 86). To better understand the contribution of the commercial sector to public life further data is needed, including empirical data on the types of audiences that stand to benefit most from interaction with commercial firms, and the engagement activities that are most valued by different public audiences. With such data, commercial companies will be better positioned to advocate for public engagement during discussions with clients and will be able to draw on evidence when seeking to shape regional and national policies. Standardised recording of public engagement is lacking across the sector and a competitive instinct perhaps hinders the sharing of public engagement failures, and hence the opportunity to learn lessons (Heaton 2014: 256).

Conclusion

The commercial sector provides a direct link between development and community and its potential to serve public interest is clear. The sector's foremost concern, however, is the delivery of tangible, closely defined and measurable outcomes that enable developers to comply with the conditions set on a grant of planning permission. These stand in contrast to more indistinct aspirations that enter debate on social engagement, as Perring notes, 'the politically fashionable goals of social cohesion and environmental wellbeing, adding values to our understanding and use of space and place' (2015b: 193). As such, the margin between professional practice and the public realm undergoes intermittent, rather than regular, permeation. When contractual stars align, public engagement can be given fuller reign (as our case studies illustrate), but it otherwise continues to be small-scale or incumbent on the goodwill of archaeologists to give their own time to it.

Too frequently public engagement and outreach are pushed to the margins of practice, treated as 'add-on' aspects, rather than central to, and embedded within, professional services. There is a disciplinary tension between archaeologists as managers of a resource (Fowler 2006: 1), as technicians providing a pre-construction service to developers (Lucas 2006: 21), and as translators and communicators striving to convert discovery into understanding through original research and accessible forms of presentation (Perring 2016: 95). The gulf between vision and reality is not new. In 2006, Parker Pearson and Pryor drew

attention to the fact that 'What we would like to do and what we end up doing are often two different things, because of pressures of time and limits of funds' (2006: 316). It is important to remember, however, that commercial archaeology depends on the idea that development-led investigations provide some form of public benefit. In many cases, outreach and social engagement can provide clearer and more tangible benefit than the marginal knowledge gain that might emerge from the academic publication of findings.

Acknowledgements

We extend our gratitude to Archaeology South-East, Cornwall Archaeological Unit and the Sustainable Trust for permitting us to publish details and images of their projects as case studies, with particular thanks to Giles Dawkes, Jacky Nowakowski and Louise Rayner.

Abbreviations

ASE: Archaeology South-East
CAU: Cornwall Archaeological Unit
CBA: Council for British Archaeology
CIFA: Chartered Institute for Archaeologists
DCLG: Department for Communities and Local Government
DoE: Department of the Environment
HLF: Heritage Lottery Fund

11
Archaeologists in popular culture

Gabriel Moshenska

Introduction

On the occasion of his retirement in 1981, the distinguished archaeologist Glyn Daniel was presented with a Festschrift entitled *Antiquity and Man*, with papers ranging across the subjects that had occupied his career. These recognised his contributions to the study of megaliths and the history of archaeology, but also his work as a television presenter, popular writer and author of murder mysteries featuring an archaeologist-detective. One paper by Latin American archaeologist Warwick Bray reflected on humour in archaeology, and the idea that

> there are two kinds of archaeology: archaeology as perceived by archaeologists, and archaeology as perceived by the man in the street. Each of these archaeologies has its own history…The unofficial history of archaeology as perceived by the outsider at the time, and without benefit of hindsight, has yet to receive the attention it deserves, though the raw materials exist in the form of ephemera of all kinds: newspaper cartoons, television programmes, magazine articles, pulp fiction, advertisements and even pop songs. (Bray 1981: 221)

Bray goes on to suggest that the disparities between the archaeologists' and the public's view of archaeological work should be a cause for concern and study. This field of study has remained one of the most

enjoyable and intriguing strands within public archaeology for some time, represented in the work of Holtorf (2005, 2007), Evans (1989, 2006), Russell (2002), Hall (2004) and others.

The reality of popular culture archaeology is more complicated than Bray suggests: most if not all archaeologists are just as aware as anybody of popular representations of archaeology, if not more so. Some will have become archaeologists based at least in part on a fascination with these representations, and a few might even have consciously constructed their professional identity in relation to the archaeological tropes found in popular culture, most cringe-inspiringly through the acquisition of an *Indiana Jones* hat. This is the same set of commonly understood archaeological themes that form the basis for most popular culture archaeology, including a set of actions such as journeying to remote places and excavating; a set of settings based primarily around Egypt and the Mediterranean; and a set of personal characteristics of the archaeologist themselves as mostly physically tough, and socially, intellectually and economically elite white men. These themes have evolved and changed over time: to an older generation in Britain archaeology is epitomised by Mortimer Wheeler on television (he was awarded Television Personality of the Year in 1954) (Hawkes 1982). For most British adults the twenty-year run of *Time Team* on television from 1994 to 2014 has provided a new set of characteristics for identifying archaeologists and archaeology, and no doubt the younger generation have their own that I know nothing about (Paynton 2002).

It is fair and useful to regard these simplistic views of archaeology and archaeologists as stereotypes, in the technical sense of a simplified, generalised or exaggerated view of a group of people: often, but not always, with negative connotations or implications. Miles Russell has explored the ideas underlying archaeologist stereotypes, noting that archaeologists are just one professional stereotype that abounds in popular culture alongside stereotyped doctors, teachers, police officers, accountants and so on (Russell 2002: 53). However, he points out that unlike the majority of these more common professions, most people are unlikely to know or to encounter real-life archaeologists to contradict or correct any stereotypical views that they might hold. Russell raises the question of how archaeologists ought to respond to this situation. One option is to embrace our popular perception as 'treasure hunting hero/gun toting psychopath/doom-bringing villain' and use it as a starting point for education and engagement (Russell 2002: 53). Another option would be to vocally reject these perceptions and try to spread better awareness of what 'real' archaeologists do. Finally, Russell

acknowledges that most archaeologists will simply continue to bemoan or ignore popular culture archaeology as an annoying irrelevance. Most usefully in his discussion of stereotypes, Russell introduces some of the key themes that recur throughout popular culture archaeology over time and across media and genres. These (discussed in more detail below) include the notions of archaeologists as 'adventurers', 'explorers', 'tomb-raiders' and 'eccentrics'. Archaeologists are typically and contradictorily portrayed as one or more of the following: obsessive to the point of madness, crazed by greed or ideology, suspiciously heavily-armed, unworldly bookworms and/or globetrotting polyglots. Often they are murdered or at least kidnapped.

My aim in this chapter is to examine the nature and sources of some of these stereotypes of the archaeologist in popular culture, and to consider their significance within both archaeology and in the wider world in general. Finally, I will consider the popular culture archaeologist in the revealing light of their opponent, the popular culture anti-archaeologist.

Background

Popular culture archaeology is as old as archaeology itself, if not older: many of the themes of discovery of ancient relics can be traced back into earlier antiquarian, religious and more broadly humanistic scholarship. In Britain Schwyzer (2007) has traced these themes back to the Renaissance, while Duesterberg (2015) has found them to be firmly embedded in popular culture by the early nineteenth century. They are also widespread across different media, ranging from computer games and board games to blockbuster movies, and to virtually every genre of literature from Victorian murder mysteries to contemporary dystopian science fiction (e.g. Miéville 2009). I believe that the impact of this cultural universality has been broadly positive for the field of archaeology, raising its profile and popularity while exacting a cost in respectability and accuracy. Finally, in popular culture we commonly see the endurance of the nineteenth-century model of the archaeologist as agent and foot soldier of European nationalism and colonialism: an unpleasant reflection if not an altogether unreasonable one.

Some of the most significant recent work on popular culture archaeology has been Cornelius Holtorf's studies *From Stonehenge to Las Vegas* (2005) and *Archaeology is a Brand!* (2007). Holtorf's wide-ranging and playful research has drawn out many of the most significant

concepts underlying popular culture archaeology, looking beyond the more straightforward tropes discussed below to consider the purposes and meanings that they serve in contemporary late-capitalist society. In this sense his work, strongly infused by contemporary heritage studies, is unapologetically presentist (Holtorf 2005: 15).

One of the most important innovations in Holtorf's work is the concept of 'archaeo-appeal', his answer to the question, 'what is it that makes archaeology so extraordinary and appealing in our society?' (2005: 150). Holtorf argues convincingly that the attraction of popular culture archaeology is deeper than the popularity of the media that it inhabits, residing instead in aesthetics and metaphors that draw upon archaeology's dual nature as a field of practice and as a means of experiencing the human past: he uses the term 'magic' (of archaeology) (2005: 156). Holtorf's conception of archaeo-appeal is a straightforwardly positive one, combining the popular interest in the archaeological process with the more general interest in imagining life in the deeper human past. So embedded is 'archaeo-appeal' in popular culture, that Holtorf argues it is usually evoked or deployed without explicit reference to archaeology, as a theme in marketing and communication.

Holtorf's 2007 *Archaeology is a Brand!* further develops his argument for a systematic but inclusive understanding of archaeology in, for, and as popular culture. However, by necessity his work can only touch upon a small part of popular culture. One notable characteristic of Holtorf's concept is its general positivity: archaeo-appeal is found in theme parks and other visitor attractions, shopping malls, video games and so on. In part as a response to this, some archaeologists have begun to explore the more psychologically complex archaeo-appeal of creepy, uncanny, transgressive or just plain nasty pasts: the archaeology found in ghost stories, 'dungeon' museums and horror movies (Moshenska 2006, 2012). As we shall see, there is plenty of popular culture archaeology to analyse in these and other ways.

Why does it matter?

As good critical thinkers as well as public archaeologists we should of course ask: why does popular culture archaeology matter? There are several answers to this question. One is that popular culture in all its diverse forms is likely to be the means by which the vast majority of people encounter archaeological themes and ideas for the first time. Like the museum, popular culture is a point of contact and connection between the public

and the human past, and one that we should therefore take care to understand as best we can. This leads to a second reason: that popular culture archaeology more than probably any other factor shapes the popular perceptions of archaeology and archaeologists, both positive and negative. If archaeologists are to be effective educators, communicators and advocates for archaeological heritage then it matters more than a little whether we are regarded as serious scholars, bumbling antiquaries, reckless adventurers, bunny-hugging hippies or ivory-tower elitists. These are the stereotypes that pre-exist in the minds of planners, developers, politicians and policy-makers when they meet with archaeologists.

Another reason to take it seriously is that popular culture archaeology has already blossomed into a lively, exciting and increasingly rigorous field of research within public archaeology. This includes Gardner's (2012) studies of strategy games, Holtorf (2007) on stereotypical archaeological clothing, Noble (2007) on archaeology in Hollywood movies and Evans (1989) on archaeologists in fiction. Alongside these works, many of them narrowly focused on specific media, there are more general studies of the 'archaeological imagination', most notably by Shanks (1992, 2012). It is interesting and instructive to compare the studies cited above, most of them by archaeologists, with the work of scholars from outside the field. These external views tend to have a less subtle understanding of archaeological practice but a more sophisticated approach to the wider social and cultural contexts of the phenomenon that they study. For example, Jennifer Wallace's (2004) study of the archaeological imagination ranges from Freud to fundamentalisms; Kitty Hauser (2007) explores archaeology as a historically situated viewpoint or way of approaching the British landscape; Cathy Gere (2009) has explored the enduring cultural impacts of Arthur Evans' work at Knossos, Crete; and a study by Susanne Duesterberg (2015) takes a sweeping view of British popular culture archaeology across the nineteenth and early twentieth centuries. Most importantly, several of these studies distinguish clearly between archaeology as *process*, archaeological materials as *product* and archaeologists as *individuals*. For the sake of simplicity, it is the last of these that I will focus on in the remainder of this chapter.

The fictional archaeologist

Where do we find the fictional archaeologist? He or she moves between media, skipping from a comic book to a film, or from a film to a video game. Some are thinly veiled portraits of specific, often well-known

scholars; others are inventions of pure fantasy. Some are explicitly described as archaeologists and are seen to practise as such; others we can identify only (and with problematic circularity) through the common tropes of the archaeological stereotype.

By far the most plentiful fictional archaeologists are found in books, and these have made some of the most popular and enduring characters. Elizabeth Peters created the nineteenth-century Egyptologists Amelia Peabody and her husband Radcliffe Emerson, who appeared in a series of novels published since 1975 (Hoppenstand 2000). British Egyptology forms the background to these novels and the characters themselves embody many of the stereotypes of the British colonialist-archaeologist: armed and adventurous. Their adventures, which include battling antiquities smugglers, are entertainingly placed within the context of European scholarship in late nineteenth-century Egypt. Like Peters (the pen name of Egyptologist Barbara Mertz), E.F. Benson had some practical experience of Egyptology before adopting it as a setting for several of his popular pre-war ghost stories, such as *Monkeys* and *At Abdul Ali's Grave*. Benson's archaeologists are, like Peters', independently wealthy and effortlessly chauvinistic (Benson 2012).

The figure of the archaeologist-abroad offers writers a great deal: exotic locations, foreign villains and all sorts of adventurous exploits. In contrast, the archaeologist at home in, say, Britain has to find other sources of interest. Peter Ackroyd's novel *First Light* is unusual in depicting a contemporary archaeological excavation in some detail (Ackroyd 1989). The site in question is a megalithic monument near Lyme Regis in the southwest of England, and the novel focuses on the relationships between the archaeologists, the farmer, visiting hippies and a government inspector. Ackroyd's archaeologists are stereotypes but not altogether inaccurate ones, such as the high-minded theorist and the more materialist fieldworker, and he evokes the odd environment of the remote excavation team rather well.

While Ackroyd's characters explore a prehistoric site and reach some sort of spiritual state, a number of fictional archaeologists have found themselves more firmly grounded in contemporary murders. The archaeologist as detective is an enduring theme in popular culture: after all, both collect evidence in small bags and derive momentous results from it. Forensic anthropologist Kathy Reichs created the extremely successful Temperance Brennan novels, with the titular heroine (an anthropologist who occasionally works as an archaeologist) consulting with police forces in the United States and Canada on a series of complicated murder mysteries (Reichs 1997). Brennan's British counterpart is Ruth

Galloway, lecturer in archaeology at a fictional Norfolk university and the creation of novelist Elly Griffiths (Griffiths 2009). Like Brennan, Galloway frequently finds herself in peril during her investigations, as her archaeological and police forensic careers overlap and collide. Galloway is a well-observed and believable character: a single mother and moderately successful academic with a passion for ancient landscapes. While Brennan and Galloway represent the archaeologist-detective in modern novels, Glyn Daniel's Richard Cherrington represents an older era of amateur detective in the Agatha Christie tradition. Daniel based his character in a fictional Cambridge college and *The Cambridge Murders* abounds with in-jokes, but Cherrington himself is the perfect ivory-tower academic archaeologist that mid-century audiences would have recognised from their tiny television screens (Daniel 1965).

Murderers are not the only peril that popular culture archaeologists have traditionally faced: the dead (or rather the undead) are a far more formidable threat. The mummy's curse is an enduring and very widely known phenomenon, studied in some detail by Roger Luckhurst (2012). The idea that unearthing the dead might annoy their spectral revenants is a long-standing one, but the mummy's curse has popularised the notion that archaeologists routinely bring horrors upon themselves, and wreak far wider destruction in the process. Beyond ancient Egypt, the 'antiquarian ghost story' has a long and rich history in gothic literature, and is widely considered to have been perfected by the academic and museum curator Montague Rhodes James. The antiquarians in James' stories, and in those of his many imitators, are distinctively stale, pale and male, but the population of archaeologists in popular fiction is somewhat more representative of the modern discipline (James 2007; Moshenska 2012).

In contrast to novels where oddities and eccentricities can more comfortably be housed, the big budgets of feature films mean that archaeological characters are generally required to conform more closely to public expectation and stereotype. In his extensive study of 'reel archaeology' Day (1997) traces the first cinematic depiction of archaeology to 1915, and lists an impressive array of actors who have portrayed archaeologists, including Sharon Stone, Charlton Heston, Sean Connery, Susannah York and Burt Reynolds.

One of the most common themes in film archaeology (or 'reel' archaeology) that Day notes is the 'MacGuffin', a concept popularised by director Alfred Hitchcock. MacGuffins are things – objects, people or less tangible achievements – whose pursuit becomes the driving force of a narrative. The archaeologist's search for a famous tomb, lost city

or priceless artefact is one of the most straightforward examples of this theme: for example, the search for the philosopher's stone in the 2014 horror movie *As Above, So Below* or the hidden city of Hamunaptra in the 1999 version of *The Mummy*. The focus on the quest-narrative or the MacGuffin can distract from the trajectory of the character of the archaeologist him or herself. They might be driven to madness or death by their obsessive pursuit of the MacGuffin, or enjoy success and adulation and, in the process, get the girl or the boy.

Themes in popular culture archaeology

Across the full spectrum of popular culture archaeology and archaeologists, from board games to television, there are a number of recurring themes that reflect fundamental aspects of the popular understanding of archaeology and the archaeologist:

The archaeologist as detective: At times this is literal, where an archaeologist solves crimes either independently of the police or in collaboration. The television series *Bones* offers a particularly lively version of this theme, with a team of specialists bringing archaeological, physical anthropological and other skills to bear on criminal investigations. *Bones* also depicts another common theme in the archaeologist-detective: the exasperated professional detective forced to work alongside the unpredictable, brilliant maverick. This relationship type often includes a romantic or sexual dimension, as in the sparring between archaeologist academic Dr Ruth Galloway and police detective DCI Harry Nelson in the novels of Elly Griffiths (e.g. 2009). More generally, the theme of the archaeologist-as-detective focuses on the common activities of problem-solving and uncovering hidden or lost information through the careful, painstaking examination and recording of evidence.

The archaeologist as explorer or adventurer: This character has been a staple of popular fiction from the works of H. Rider Haggard through to his modern successors such as Clive Cussler and Wilbur Smith (Jones 2014; Murray 1993). These fictional archaeologists brave human, natural and supernatural perils in their quests to recover lost treasures or raise sunken cities. The exotic or glamorous locations of these adventures are part of their allure, and early examples drew upon popular fascination in Europe and America with the newly acquired imperial possessions in Africa and the Far East. Many nineteenth- and twentieth-century European archaeologists in these places were colonial administrators or other staff, conducting antiquarian studies in their spare

time, and this is also reflected in some of the fiction from the era. The character Bernice Summerfield from the novelisations of *Doctor Who* is a future-archaeologist whose adventurous exploits spawned their own series of books and other features. The *Indiana Jones* movies and the *Tomb Raider* franchise are certainly the best-known examples of this theme, embodying numerous common traits including racist and colonialist attitudes, violence and hinting repeatedly at the overlap between the archaeologist-adventurer and the lesser-known but equally significant character: the archaeologist-spy (e.g. Allen 2013).

The archaeologist as tomb-raider: At the darkest corner of popular culture archaeology lies the archaeologist-as-transgressor against god(s), ancestors, decency, private property and, most commonly, the sanctity of the tomb. This morally questionable aspect of popular archaeology is a powerful one: just as we condemn the curious scholar breaking the seals of the mausoleum, we long to stare over their shoulder. The popular horror writings of M.R. James and others including E.F. Benson often portray the hapless antiquarian whose blinkered fascination with the past leads them to unleash ancient horrors, with some sense that they deserve their horrid ends (such as the melting faces of the Nazis in *Raiders of the Lost Ark*) (Moshenska 2012). The tomb-raiding archaeologist is on a blind quest for knowledge and will stop at nothing to achieve their aims. The *National Treasure* movies starring Nicolas Cage are interesting in this respect, as they repeatedly invoke archaeological themes of material, symbolic and cultural transgression while the characters rarely (until the latter part of the second film) conduct anything that resembles archaeological research.

The archaeologist as bookworm or bumbling eccentric: Here the stereotype of the archaeologist melds comfortably into the common view of the generic 'professor' as socially inept, ill-kempt, head-in-the-clouds and, problematically, almost always male. Examples include Indiana Jones's friend and colleague Marcus Brody, famously capable of getting lost in his own museum; and Jones's father Henry Senior, whose unflappability in the face of peril and near-certain death owes much to his stubborn refusal to engage with reality. Evie Carnahan played by Rachel Weisz in the 1999 film *The Mummy* embodies many of the characteristics of this stereotype, including stubbornly intellectual goals (even when faced with priceless treasures), an interest in texts and antiquities that far exceeds her concern for her own wellbeing, and the dazed, unworldly cluelessness of a scholar dragged against their better judgement from the warm embrace of her library. Here it is worth noting that Evie is presented as a librarian (and proud of it), and the character

Case study 11.1: Pimpernel Smith

Professor Horatio Smith is a perfect popular culture archaeologist who manages to embody any number of the relevant stereotypes, including some that might appear mutually exclusive. *Pimpernel Smith* (1941) was a popular film directed by, co-produced by and starring Leslie Howard, best known for his role in *Gone with the Wind*. The plot is an adaptation of the Scarlet Pimpernel, with the action moved from Revolutionary France to Nazi Germany, and the rescues focusing on prominent anti-Nazis (including concentration camp inmates) rather than the French aristocracy. Howard's Professor Horatio Smith is to most appearances a bumbling and unworldly academic, viewed affectionately but not taken too seriously by his team of British and American students whom he takes on an excavation inside Nazi Germany. Smith obtains permission for his work by convincing the Nazis that his excavations will find evidence for the Aryan origins of the German people and nation. In fact, his expedition and eccentric persona are merely covers for his true aims: to rescue people, including a famous musician, from the Nazis, and to transport them across the border to safety.

The Pimpernel is a well-known figure, shrouded in mystery and hunted by the Gestapo. It is only when Smith is shot and wounded by the Germans (while disguised as a scarecrow in a field) that his students realise his true identity and promise to assist him in his most dangerous rescue, including staging a breakout from a concentration camp. Already under suspicion, Smith and his students ship the finds from their excavations out of the country, but the Nazis intercept them and search the packing cases for refugees, finding only artefacts. Smith is captured by the Gestapo but escapes, and his final victory is his revelation that the artefacts he recovered are, in fact, definitive proof *against* the Nazis' beliefs in Aryan German origins. In Peter Hiscock's analysis of the supernatural in archaeological films, he observed that the Pimpernel Smith story

> is full of heroism, risk, and tension, as the archaeologist outwits archetypically nasty and incompetent Nazis, but it takes place in a purely natural world. It would be easy to claim that the fictional world of Horatio Smith was a template for the race against Nazis represented in *Raiders of the Lost Ark* or *Last Crusade* ... yet

Jones does not inhabit the natural world of Smith. The world(s) of *Raiders of the Lost Ark*, and indeed all of the Jones and Croft films, are supernatural. (Hiscock 2012: 160)

Horatio Smith combines both key stereotypes of the archaeologist as academic bumbler and as swashbuckling adventurer, defying Nazis long before Indiana Jones. The focus on the archaeological scholarship within the narrative is also remarkable, bringing the propaganda value of prehistory into popular consciousness. The impacts of *Pimpernel Smith* were remarkable and far-reaching: aside from its public popularity and official approval from the British government, it is generally acknowledged to have been the inspiration for Swedish diplomat Raoul Wallenberg's campaign to rescue thousands of Hungarian Jews from the Holocaust. Leslie Howard died in 1943 in mysterious circumstances when his airliner was shot down by German aircraft over the Bay of Biscay.

perhaps embodies more of the drearily sexist stereotypes of this profession: the sensibly dressed, glasses-wearing young woman who will, in the course of the narrative, undergo a makeover, become glamorous and fall in love.

The anti-archaeologist

Finally, it is worth looking at the popular culture archaeologist through the penetrating and revealing lens of their adversaries: the popular culture anti-archaeologist or archaeological villain. We can learn much about what the stereotype archaeologist *is*, from seeing what he or she is most definitely *not*.

First amongst the anti-archaeologists are the looters: those who seek treasure for money rather than for intellectual ends (or the glory that accompanies them). In the *National Treasure* franchise Nicolas Cage's treasure hunter Ben Gates is driven in his search by patriotism and a sense of historical injustice, while his nemeses Ian Howe and Mitch Wilkinson are far more mercenary (and in Howe's case, a foreigner!). Closely linked to the looter character is the archaeologist-gone-bad, the dark mirror image of the hero: novelist Clive Cussler confronts his hero Dirk Pitt with a near-endless stream of such characters, while in *Raiders*

of the Lost Ark, Indiana Jones enjoys a thoroughly stereotypical 'we are not so unlike, you and I' conversation with the Nazi-collaborating French archaeologist René Belloq (Jones 2014). Belloq is an interesting example of this character type, demonstrating in his first on-screen encounter with Jones that he has a superior knowledge of local language and engagement with the local community, making Jones appear a mere looter in comparison.

The most troublesome of the anti-archaeologists are the dead themselves, and here we should consider the implications: a modern archaeologist even mildly concerned with professional ethics will take the rights of the dead (and their living descendants) into account in all their work, but the stereotype archaeologist of popular culture will scythe through skeletons and sarcophagi without a moment's hesitation. Little wonder then, that the dead sometimes rise up to take their revenge, most often grisly (if not thwarted in time). This includes virtually all films involving Egyptian mummies, with a few glorious exceptions, such as the friendly mummified nuclear physicist who assists Adèle Blanc-Sec in the eponymous 2010 film.

One of the grisliest examples of the dead taking their revenge occurs in the M.R. James short story *A Warning to the Curious* (the title alone gives a good clue) in which the keen excavator Paxton retrieves an Anglo-Saxon crown from a burial mound, despite the feeble despairing wails of its ghostly resident. Paxton is haunted, and ultimately brutally murdered, by this revenant: but what makes the story unusual is that the ghost in question is not that of an Anglo-Saxon king, but rather of William Ager, last in a long line of hereditary guardians of the crown, and at this point only a few years dead (James 2007; Moshenska 2012). James' story crosses over from the theme of the dead as anti-archaeologist to a far more troubling one: the guardian of the past.

In many respects the 1999 edition of *The Mummy* follows the very common pattern that Membury rather drily summarised as: 'find treasure map, lose map to men who wear black hats and spit a lot, get map back, find loot and finally an ending involving romance between members of the expeditionary party' (2002: 13) The complicating factor is the presence of the Ardeth Bay of the Medjai, an ancient secret society devoted to guarding the City of the Dead and keeping the evil mummy Imhotep from returning to life. The Medjai initially attack the archaeologists, but eventually they work together to defeat the mummy. In this way the Medjai play a similar role to the Brotherhood of the Cruciform Sword in *Indiana Jones and the Last Crusade* (1989), whose

Case study 11.2: The ghost stories of M.R. James

Cursed artefacts, accidentally summoned monsters, demonic abbots and luckless antiquarians: amongst scholars and connoisseurs of ghost stories, the thirty-odd works of Montague Rhodes James are commonly regarded as amongst the finest of their kind. A respected medievalist and museum curator, James spent the majority of his life at King's College, Cambridge (rising from student to Provost) and then served as Provost of Eton College until his death in 1936 (Moshenska 2012). Aspects of his scholarly work on medieval manuscripts and the biblical apocrypha remain authoritative, but his best-known legacy is his fiction, which was heavily influenced by his scholarship (Cox 1983). James' archaeological work is less well known, but as a student he took part in excavations in Cyprus in 1887–8 with his friends Ernest Gardner and D.G. Hogarth, both of whom went on to impressive careers in archaeology (Hogarth et al. 1888). James was not at home in the field, preferring to focus on the philological aspects of the project, and his scholarly interests soon moved from the Classical to the purely medieval (Lubbock 1939).

Years later James was involved in the remarkable excavation of the chapterhouse of the Abbey at Bury St Edmunds. Working on a manuscript source, James found a description of the burial places of the medieval abbots of Bury, including the famous Abbot Samson, and proposed an excavation to investigate. In the winter of 1902–3 the excavation took place within the ruins of the abbey, and the six bodies of the abbots were found buried in a line, just as the manuscript had described. James' involvement in this excavation was more managerial and fairly peripheral, but he reported the findings in a letter to the *Times* (James 1903). Ruined abbeys and dead abbots were to feature in several of James' ghost stories.

James' ghost stories began as Christmas entertainment for his students, colleagues and friends: sitting in his rooms at King's College he would extinguish all but one candle, then proceed to read his latest story to an appreciative audience. Later the stories were published in a series of short collections, and finally in 1931 as a collected edition (James 2007).

The archaeologists in James' stories tend to come to bad ends. The antiquary Mr Baxter in *A View From a Hill* wants to see into the past, so he boils the bones of hanged men, gathered from an ancient gibbet site, and pours the liquor into a pair of binoculars. With these magical

powers of vision Baxter records and describes archaeological sites in his district: a startlingly mundane achievement, brought to an abrupt end when he is dragged from his home and murdered violently by the ghosts of the men whose graves he disturbed. Some time later his binoculars, brought by accident into a church by the innocent narrator, are rendered useless by the power of religion. Similarly the unfortunate excavator Paxton in *A Warning to the Curious* (see main text) is harassed and finally murdered by a vengeful ghost, even after he has returned the stolen artefact to the site where he excavated it. Some of James' antiquarian and archaeological protagonists survive with just a bad fright. Professor Parkins in *Oh, Whistle, and I'll Come to You, My Lad* finds a silver whistle while poking around an archaeological site as a favour for a colleague. Blowing the whistle summons a creature formed from bedsheets that pursues him around his own hotel room, until the whistle is thrown into the sea. The site where the whistle was discovered bears a strong resemblance to Bury Abbey, the site of James' earlier excavations (Moshenska 2012).

The protagonists of James' stories are for the most part firmly within the bumbling eccentric stereotype of the popular culture archaeologist, a role that James himself fit rather well: there is generally agreed to be a degree of wry self-portrait in many of the stories. What links the ghost stories to so much of popular culture archaeology is the idea that archaeologists are in some indefinable way transgressing, and that by exploring the past they disturb things best left hidden and buried – and for that, they must be punished (Moshenska 2012).

ancient sacred duty is the guardianship of the Holy Grail against pillaging archaeologists and adventurers.

Conclusion: so what?

What does it imply about the popular culture archaeologist if his or her adversary is purely concerned to keep the treasure in the ground? First and foremost, that the idea of archaeologists as stewards or guardians of archaeological heritage – the 'It belongs in a museum!' principle – has barely impacted upon popular culture and consciousness. The popular culture archaeologist does not leave parts of the site unexcavated for future generations, nor do they put in place management plans to

prevent damage through development or farming. Does it matter that this vast and vital dimension of archaeological work – based around *not* digging stuff up – has virtually no public profile? Undoubtedly yes.

The stereotype of the popular culture archaeologist presents a challenge to public archaeology. Swashbuckling colonialist adventurers or dotty professors are increasingly alien to an increasingly young, female, postcolonial and technologically oriented profession. Today's high-profile popular archaeologists who defy the stereotypes include TED prizewinner Sarah Parcak, whose work traces heritage destruction from satellite images, and Somali archaeologist and public intellectual Sada Mire, who works at the interface of heritage and human rights. For public archaeologists trying to engage with younger and more diverse audiences, the stereotypical popular culture archaeologist is a problem to be overcome: the longer it lingers in popular consciousness the harder it will be to dislodge.

12
Archaeology and nationalism

Ulrike Sommer

Introduction

Archaeology is closely related to the state both organisationally and ideologically. It needs state funds for excavations, teaching and research institutions; in return, it can provide tangible remains from the past. However, the relation between the artefacts uncovered and any type of group identity of their makers is far from straightforward. In this chapter I am going to analyse the development of origin myths and the way archaeology became entangled in origin narratives.

One of the ways to naturalise a nation state is by comparing it to a human body which has an origin (birth), a family and ancestors, a character and some kind of home. By implication, a nation is assumed to have the same characteristics: a point of origin, ancestors, a national character and history, and a territory (cf. Kołakowski 1995). In the nineteenth century, the claim that a specific ethnic group (people) had been in existence since time immemorial was frequently used to boost a claim to political independence or the 'unification' of several different territories. A long history seemed to demonstrate the coherence and stability of a group and could also be taken to presage a long and glorious future. I would argue that many statements about the national past are in reality political statements about the present and the future.

Myths of origin

Records of the past take various forms and can be created for a wide variety of reasons: legal (property rights, rights of inheritance, seniority), chronological (year lists, king lists, lists of consuls and eponyms; cf. Sommer 2015) or for entertainment (epic poetry, historical novels). Of interest here are narratives about the past that have been constructed for political purposes, especially origin myths and, in the broadest sense, genealogical accounts that justify the seniority of different groups and lineages and thus the social position of specific groups.

The best-known origin myth is probably the Old Testament, describing both the origin of humankind in general (Genesis, with the second version also demonstrating the seniority of man over woman) as well as the Israelites' exodus from Egypt. Virgil's *Aeneid* is another origin tale that was very influential in the Western world. The pattern presented by these accounts was imitated in numerous medieval tales about the origin of peoples like the Getae, Lombards, Danes and Hungarians, but a very similar pattern is also found in origin tales from outside of Europe and the Judaeo-Christian world, for example, those of the Turks or the Mexica (Prehm 1996; Sommer 2009): see Table 12.1.

Table 12.1: Typical pattern of origin myths, with the Romans, Mexica, Hebrews and Lombards as examples

	Romans	Hebrews	Mexica	Lombards
Named point of origin	Troy	Egypt	Aztlán	Skandza
Divine guidance	Venus	Jahwe	Huitzilipochtli	Freya
Charismatic leader(s)	Aeneas	Moses	Ténoch	Alboin
Carry holy objects with them	Lares and penates	Ark of covenant	tlaquimilolli	
Cross a boundary	(Hades)	Desert	Lake/sea	Big wood
Named by a God	-	Jahwe	Huitzilipochtli	Woden
Finds promised land (divine sign)	-	Milk and honey, grapes	Eagle eats snake	View from Monte Maggiore
Conquers the natives and establishes rule	Italy	Israel	Mexico	Lombardy

Conquest is the prevalent pattern in origin myths from antiquity and the Middle Ages. The conquerors arrive from a mythical homeland far away, often fleeing famine or a stronger enemy, and subdue the natives, who are killed off or forced into servitude. This conquest establishes a legal title to the land they now inhabit. Even peoples without any recorded migrations adopted tales of foreign descent, often from the heroes of Troy (MacMaster 2014: 11–2), as autochthony was implicitly linked to a subservient status.

In medieval times, the length of a person's genealogy could be used to determine their rank, especially when people from several different countries met. In analogy, the length of documented history could be taken to indicate the rank of a nation. At the Council of Basel in 1434, for example, the length of national history was used to determine the seating arrangements, which led, unsurprisingly, to some serious quarrels (Heimpel 1994) and a renewed interest in origin narratives. Chronologies could only be established by counting the number of generations, or by a link to classical or biblical sources, which had themselves already been joined together by Annius of Viterbo ('Berossos').

In the context of national resistance against foreign rule, the length of time an ethnic group had been settled in an area could also gain importance. The Czechs thus emphasised that they were the original inhabitants of Bohemia and Moravia, and the Germans only later invaders (Klápště 2007). Similar claims were advanced by the Welsh, the Bretons, the Irish and the Romanians of Transylvania. A compilation such as Geoffrey of Monmouth's *Historia regum Britanniae* (History of the Kings of Britain; Thompson 1999), the *Lebor Gabála Érenn* (Book of Conquests; Macalister 1938) or Geoffrey Keating's *Foras feasa ar Éirinn* (History of Ireland; Comyn 1902) were at least partly written as a national re-ascertainment against the Norman conquerors.

As long as the biblical world view reigned supreme, all peoples had to have migrated to their future homelands from Mount Ararat, the mountains of Asia, India or secondary *vaginae genitorum* like the North Pontic steppes. Renaissance scholars such as the Swede Olaus Rudbeck (1678) would even try to trace the route taken and calculate the duration of the peregrination. Jacob Grimm formalised this model of consecutive east–west migrations, each linked to a language and a specific material culture (Figure 12.1). Older peoples were constantly being forced out to the very boundaries of Europe. Finns or Basques were thus frequently identified as the creators of Megalithic monuments, perceived at the time as the oldest human remains. Later on they were often seen as descended from Palaeolithic hunters and gatherers.

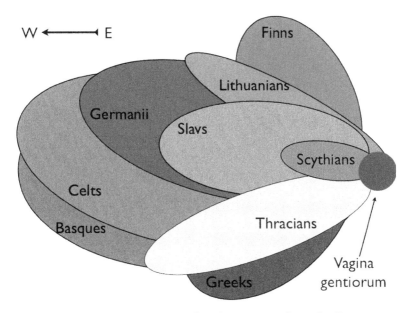

W ←——— E

Finns

Lithuanians

Germanii

Slavs

Scythians

Celts

Basques

Thracians

Greeks

Vagina
gentiorum

Figure 12.1: Consecutive migrations into Europe from the East,
according to J. Grimm (1846).

There was never an origin myth for the whole of the German
peoples, only learned inventions about the origin of single tribes,
variously linked to the Trojans, Armenians, Macedons (the *Annolied*;
Roediger 1895) or Celts (Boians). When Tacitus' Germania was redis-
covered around 1455, it was first used to show how uncultivated the
Germanic tribes had been before the civilising influence of the Catholic
Church, but it was soon adopted by German humanistic scholars as a
true description of the simple but heroic German mentality (Münkler
and Grünberger 1994). Tacitus (*Germania* 1.5) describes the Germanic
tribes as aboriginal, 'unspoilt by any admixture of foreigners', as the
country was so inhospitable that nobody else wanted to live there.
A rather negative account was thus turned into a matter of national
pride, allowing the Germans to claim to be the only autochthonous
people of Europe. After the wave of revolutions across Europe in 1848,
emerging nationalist intellectuals increasingly adopted this claim of
aboriginality, and length of possession of a specific territory replaced
length of history as the source of national pride. This went hand in
hand with a different idea of the nation. While before, history and
national culture had been maintained by the aristocracy or a thin layer
of educated bourgeoisie, now, increasingly, the common people were

regarded as a part of the nation too – or fought to be recognised as such by force of arms.

Folklore and mythology

With the increasing professionalisation of historians from the beginning of the eighteenth century onwards, many medieval accounts of early national history were recognised as fabrications. Scholars instead turned to the common people, who were supposed to have preserved memories of the national past, but also myths and legal traditions that went right back to the origin of the nation, or even beyond. The Brothers Grimm collected folk tales (Grimm and Grimm 1812–15) and interpreted them as memories of Germanic mythology (Grimm 1835), comparable to the Scandinavian *Edda*, which was also dated to the prehistoric past. Other nations followed suit, with more (Lönnrot's 1835 *Kalevala* for the Finns) or less (Macpherson's *Ossian*, 1760) success. Excavated structures and artefacts could only be integrated into this type of narrative if they were believed to have been produced by the ancestors of the group in question.

Ethnic purity is a concept linked to nineteenth-century racism. Few ancient or medieval origin myths lay any claim to ethnic homogeneity. Livy describes the foundation of Rome as follows:

> It had been the ancient policy of the founders of cities to get together a multitude of people of obscure and low origin and then to spread the fiction that they were the children of the soil. In accordance with this policy, Romulus opened a place of refuge … A promiscuous crowd of freemen and slaves, eager for change, fled thither from the neighbouring states. (Livius, *The History of Rome*, 1/18)

Many of the medieval origin tales also tell of the absorption of other groups. The Lombards reputedly freed slaves to swell their numbers, the Magyars incorporated the Adygean Kabardians, Cumans and Ruthenians (Rady 2009: chapter 10) and, in the case of the Alemanni, even the ethnonym proclaims their mixed origin (all – or any – men; Agathias 1975: 1, 6). Dynasties or noble houses acted as 'crystallising points' for people of widely different origin (Sneath 2007; Wenskus 1977). The 'Admonitions' of King Stephen of Hungary emphasise the importance of attracting foreigners (Hatházi and Szende 2003: 388; Nemerkényi 2004).

The dynastic tales and later learned inventions were addressed to the aristocracy and never became part of popular knowledge. It was only after the formation, or rather creation (Anderson 1983), of modern nations and the increasing spread of literacy and education after 1789 that national histories were compiled and publicised: in books, but also in museums, art and primary education. This creation of a national history was often a highly contested affair, and specific ancestors were often linked with specific political parties (see case study 12.3). In other cases, the aristocratic genealogies were adopted for the whole people (see case study 12.1; see also Sneath 2007: chapter 10).

Case study 12.1: Hungary

Hungarian is the only language of the numerous early medieval nomadic migrants/invaders from Central Asia to achieve the status of a majority language in Europe, and one of the few to survive at all. Others, like the languages of the Huns, Sarmatians, Avars, Bulgars, Cumans, Jazygians and Pechenegs became extinct by the nineteenth century at the latest.

The history of Hungary is normally presented very much as the history of the Magyars, and the history of the Magyars in Hungary starts in AD 996 with the invasion of the seven Hungarian tribes under Arpad (Figure 12.2). In 985, Vajk (István), the future king, converted to Catholicism, firmly linking the country to Western Europe. The Magyars emphasised their identity as conquerors, ignoring the culture of the indigenous peasants and retaining their own language, with Latin adopted as the language of learning and the courts. After the cruel suppression of the peasants' rising of György Dózsa in 1514, the peasants were reduced to serfdom until 1848. The Hungarian aristocracy proved useful in repulsing the Ottomans, leading to an uneasy co-operation with the Hapsburg Empire, even if they were seen as unreliable and 'naturally inclined to revolution and disquiet' (O'Reilly 2001: 79).

Attempts to implement German as vernacular under Emperor Joseph II met with strong Magyar opposition. Consequently, the rise of Magyar ethnic nationalism gradually led to attempts to include the peasantry in the nation. The Hungarian Academy of Sciences, intended to advance the use of the Hungarian language, was founded in 1825 by private donations. Major-scale Magyarisation started in

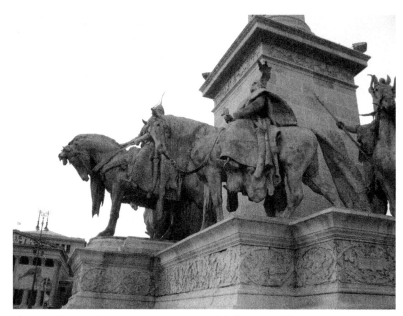

Figure 12.2: The seven Hungarian Chieftains, Millenium Monument,
by Albert Schickedanz and György Zala 1898–1927, Hősök tere (Place
of Heroes), Budapest (Photograph U. Sommer).

1867, after the Austro-Hungarian Compromise and the establishment
of the Hungarian nation. Of the languages spoken on the Hungarian
territory, most Slavonic languages as well as Romanian and Romani
were suppressed; others, like Turkish, Cuman and Jazygian, disap-
peared completely.

 Both the anonymous twelfth-century *Gesta Hungarorum* (Rady
2009) and Simon Kézai's *Gesta Hunnorum et Hungarorum* of 1280
(Veszprémy and Schaer 1999) cast the Magyars as descendants of
Attila's Huns. This narrative remained dominant among the aristoc-
racy until the beginning of the twentieth century (Fodor 1998: 29),
even when the image of the Huns and other Eastern peoples changed
from glorious conquerors to Asiatic savages during the nineteenth
century (cf. Lindenschmitt 1846).

 There was an active antiquarian research in the Kingdom of
Hungary in the nineteenth century, but the archaeology of the
Magyars was held back by the difficulties of distinguishing between
Sarmatian, Hunnic, Avaric and Magyar finds. On the other hand,

the Roman town of Aquincum (*civitas Atthile regis*) and the massive burial mounds in Százhalombatta (now dated to the Hallstatt period) were mentioned in the Hungarian chronicle, the latter as the burial place of the Hunnic kings (Vékony 2003: 16). Other archaeological sites were also linked to the Magyar past in popular traditions; that way, Roman and prehistoric sites could easily be integrated into the national ethnic history.

The archaeology of the Conquest Period only gathered pace during the official preparations of the nine-hundredth anniversary of the Arpádic conquest in 1896, which was celebrated on a massive scale in the context of rising nationalism inside the Austro-Hungarian Empire, which was also, of course, directed against Hungarian domination in Croatia, Slovakia and Transylvania. József Hampel's (National Museum) massive corpus of Migration Period burials (Hampel 1905; Szilágyi 1900) finally offered the possibility of differentiating between the different steppe peoples (Mesterházy 2003).

The relation between the Hungarian language and those of the Finns and Lapps had already been discovered in the sixteenth century by József Torkos. In the 1840s, first attempts were made to found a Finno-Ugrian chair at Budapest University. Antal Reguly (1819–1858) collected linguistic material, folklore and material culture in the Urals (Papay 1966), and an intensive research into the Siberian origins of the Hungarian people began. The Hungarian National Museum in Budapest (founded in 1802) still displays a large Ugric ethnographic collection. However, these 'poor, primitive fishermen' (Molnár 2001: 8) were never as popular as the heroic Huns, while any linguistic or cultural connection to the Turks, the arch-enemy since the Ottoman conquest of the sixteenth century, was fiercely denied.

Traditional Hungarian history thus started with the conquests of Arpád. There were attempts to archaeologically identify all the areas mentioned in the *Gesta* and the letter by the Dominican Monk Julianus (Fodor 1998), and maps of the Magyar homelands, with putative locations of Etelköz, Levédia and *Magna Hungarica* even survive in modern history books (cf. Molnár 2001: Map 1). Up to the Second World War, research into the migration period was almost completely confined to aristocratic cemeteries. In contrast, in the People's Republic of Hungary after 1949, 'the research of the life and archaeological remains of the Slavs and the "working people" became a compulsory exercise' (Mesterházy 2003: 323). There was also a joint Hungarian–Russian expedition looking for proto-Magyar finds in

Siberia (Erdély 1977). The graves of commoners were now identified as mainly Slavic, a view roundly rejected after 1989. In the overview of Hungarian archaeology from 2003 (Ministry of National Cultural Heritage 2003), Cumans, Jazygians (Hatházi and Szende 2003: 391), Muslims, Armenians, Jews, French, Italians and Walloons are mentioned, as well as Saxons (Hatházi and Szende 2003: 346, map), but there is no mention of Slavs.

The popular *Hereditas* series on Hungarian Archaeology, edited by the Hungarian Academy of Sciences, starts with a volume on the Neolithic (Kalicz 1970). There is no attempt to link Hungarian prehistory to a specific ethnic group here; modern territorial borders are used to define 'Hungarian prehistory', although in Hungarian publications sites now outside the national borders are routinely referred to by their old Hungarian name. During the refugee crisis that began in 2015, the Christian European identity of Hungary, as well as its cultural and ethnic homogeneity, was emphasised by the Prime Minister Viktor Orbán in a distinctly xenophobic way, even if this identity is not at all supported by historical or archaeological facts.

Hungary thus offers an example of a European settler nation that managed to maintain both an ethnic link to the past that was transferred from the aristocracy to the whole people, and a territorial view, in which the national prehistory includes all finds on the present (and sometimes past) Hungarian territory, which helps to anchor Hungary firmly in (Central) Europe (Renfrew 1996: 133–7).

Using archaeology

Historians also started to use archaeological finds to illustrate the texts of ancient authors. From the 1860s onwards, with the demise of the biblical timeframe and the slow acceptance of 'deep' prehistory, prehistoric peoples started to become part of historical narratives. The discovery of the Swiss Pile Dwellings in 1853–4 created quite a stir, and scholars started to look for similar structures all over Europe. Walled fortifications were another prehistoric or early historic feature of a more military type that captured the public imagination (Grunwald 2012).

Direct descent is, however, only one of the ways in which narratives about the past or remains of the past can be given meaning in the present. Anthony Smith (1986) has introduced the useful distinction between ethnic nationalism, based on descent, and civic nationalism,

Case study 12.2: Switzerland

Switzerland is quite a young country, founded as a federal state in 1848. It united people speaking at least four different languages (German, French, Italian and Raetoromanic, with strong local dialects not readily understandable for outsiders), different religions (Calvinist and Catholic), and who had been part of different countries or Empires before the unification. It is thus a nation based on a common idea – *Ideennation* (Kreis 1998) – not on descent or religion. The rich mercantile towns in the lowlands contrasted strongly with the often bitterly poor intramontane valleys, where communities could only exist by continuous economic migration. Even today, the *Röstigraben*, the boundary between Alemannic- and French-style cooking and language, is a defining trait of the country, while the Italian-speaking citizens of Grisons often feel that they are ignored or looked down upon.

The new national state had great difficulty in creating a national history. The civil wars after the Reformation and the 1847 Sonderbund War (Roca 1998–2017) had left divisions between the different parts of the country. The Old Confederacy (1300–1798), united by the opposition to the Habsburg empire (Wilhelm Tell) had only included the German-speaking parts of the country. The Helvetians, a Celtic tribe famous for being defeated by Caesar (*de bello Gallico*) were only located in the Mittelland. Their history, trying to emigrate into present-day France but being forced to return to their homeland by the Romans, did not make for a good national narrative either (Kaeser 1998), even if there are some heroic nineteenth-century paintings celebrating Helvetian victories (Marchal 1991).

The story has been frequently told: In 1853–4, during a very dry winter, schoolchildren discovered artefacts on the lakeshore in Obermeilen on Lake Zurich, and their teacher informed Ferdinand Keller, founder and president of the Zürich Antiquarian Society. Similar finds were then discovered on many other lakes, and the first report (Keller 1854) appeared the same year (Kaeser 2004; Leuzinger 2012; Menotti 2004; Ruoff 1992) (Figure 12.3). News about the well-preserved finds and the prehistoric pile dwellings they came from quickly spread all over Europe and led to the so-called 'pile-dwelling fever' (Helbling-Gloor 2004). Antiquarians everywhere started to look for similar remains, sometimes successfully, sometimes misidentifying late Bronze Age or early medieval fortifications. John

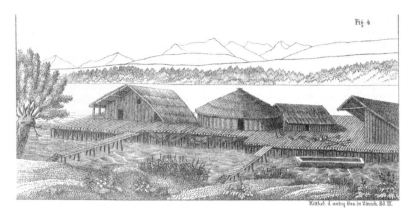

Figure 12.3: Possible reconstructions of the Obermeilen pile dwellings, based on ethnographic analogies (Keller 1854).

Lubbock included the discoveries in his *Prehistoric Times* (1865), which helped to popularise them even further, as did their inclusion in the Swiss exhibits at the World Exhibition in Paris, in 1867 (Gramsch 2007: 24) and finds from pile dwellings were subsequently acquired by many major European Museums.

The pile dwellings fulfilled a lot of the requirements for a satisfying Swiss national past. The language or ethnicity of their makers was unknown, thus avoiding any problem with the different groups making up Switzerland. Located in the pre-montane Alpine area of the German as well as the French-speaking part of the country, they displayed a high degree of sophistication. They lived in well-organised, orderly, clean and small independent villages that, as their location showed, kept out of conflict but were able to defend themselves if necessary. This resonated with the policy of neutrality adopted by Switzerland in 1815. The pile-dwellers were farmers; they did not show obvious social stratification, but indicated a high level of civilisation, unknown in surrounding areas (Gramsch 2007). As later research showed, their remains were also quite variable, which chimed with the self-description of Switzerland as manifold, or multicultural, to use a modern term (Gramsch 2007: 80). The pile-dwellers were soon depicted in numerous rather romantic paintings (cf. Schlichtherle 1986: 12–7), and were also celebrated in novels (Vischer 1879 etc.; see Von Arburg 2010), public pageants

(Zimmermann 1991), later on in films, and found their place in children's books and schoolbooks (Helbling-Gloor 2004).

From the beginning, the investigation of the pile dwellings had included a strong scientific element, with the analysis of sediments, plant remains (Heer 1865) and animal bones. This tradition strongly influenced Swiss archaeology in general and led to the rapid acceptance of scientific techniques like dendrochronology, palynology and radiocarbon dating, which were to transform the whole practice of archaeology internationally (Delley 2015).

In neighbouring countries, especially in southwest Germany, pile dwellings provided a regional past that differed from the heroic but uncivilised Germanic tribes favoured especially by the adherents of Prussian domination. They are still very popular there, as demonstrated by a major exhibition in 2016 (Archäologisches Landesmuseum Baden-Württemberg, Landesamt für Denkmalpflege im Regierungspräsidium Stuttgart 2016). The circumalpine lakeside villages, including sites in Switzerland, Austria, France, Germany, Italy and Slovenia, became a UNESCO World Heritage site in 2011. They are thus a symbol of European as well as Swiss identity, fitting with the increasing inclusion of Switzerland in the EU. The pile dwellings could thus be used to illustrate national as well as transnational identity.

based on citizenship, common laws and shared aims, much in the spirit of Ernest Renan's (1882) nation as a constant plebiscite, which only exists as long there is a will to act together and to protect the nation. So, while a genealogical link to prehistoric ancestors will be sought by adherents of ethnic nationalism, other connections to the past are possible. The idea that the environment determined the physical and mental characteristics of the inhabitants was introduced by the ancient Greeks (Pseudo-Hippocrates; Littré 1881), but taken up by authors of the renaissance and enlightenment (Herder 1784–91; Montesquieu 1748). The modern inhabitants of Saxony could thus claim a link to the medieval Slavonic and Bronze Age Lusatian inhabitants of the region, who showed just the same mentality as themselves, without claiming any direct descent (Sommer 2001, 2004). In a far more developed framework, Gordon Childe (1958: 97) claimed that the specific topography and distribution of resources of Europe led to an economic development

that enabled Bronze Age smiths to stay free and independent, leading to the development of a progressive European metallurgy ultimately paving the path for the Industrial Revolution and the European hegemony of the nineteenth century (cf. Kienlin 1999).

A link to the past via a shared mentality can also be established to peoples living in a different area, however. Johann J. Winckelman, one of the founding figures of Classical archaeology claimed that German art could only achieve greatness by following the example of ancient Greece (Winckelman 1755, 1764), to which many German intellectuals felt a 'spiritual kinship' (cf. Marchand 1996). In the same way, members of the British upper class would feel connected to the Romans who had conquered and settled Britain (Hingley 2000). This is linked to the idea that a fixed civilised core and core values of civilisation are in turn upheld by different empires or peoples (*translatio imperii*), based on an interpretation of the Old Testament Book of Daniel (chapter 2). This ultimately passed into the philosophy of Hegel (Moldenhauer 1986), where the 'world spirit', a kind of increasing self-consciousness and self-realisation of mankind, moves from the Orient to Greece and Rome, and then to Germany. Any claim to the mantle of Greece (or Rome) is thus not only a matter of aesthetic judgment, but also an outright demand for political supremacy. Later on, the nascent Greek nationalism had to claw back the symbolic capital of the classical remains (Hamilakis 2007, 2008) from the Western powers that had appropriated it from the 'decadent and orientalised' modern Greeks.

Colonialism and conquest

The right of conquest provided a legal and moral title in medieval times, which was only problematised with the rise of modern nationalism. Even then, conquest could be justified by arguments of uneven development. While the occupation of the territory of another state might be seen as problematical, local 'savages' did not own the land they lived on, because they lacked a state or social structures that allowed an individual claim to property (Australia). In addition, the land was declared to be empty and uncultivated (the American wilderness; cf. Schama 1995) or badly cultivated (the 'German East') and 'crying out for improvement'. The conquerors claimed a title by – their – blood, sweat and tears. In this case, local archaeological remains tended to be erased or used to demonstrate the lowly cultural state of the previous inhabitants.

Another strategy was to claim that the conquest was in reality a re-conquest. Archaeological finds could be used to demonstrate that a specific area had been settled by a specific ethnic group in the past. Kossinna (1919) used this to claim that Poland was 'an age-old Germanic homeland' (Figure 12.4), while in the 1930s, the Turks claimed that Anatolia had been settled by Turkish-speaking peoples from the Bronze Age onwards, and the Ottomans were simply the last Turkish tribe to arrive in an area already settled by their relatives (cf. Tanyeri-Erdemir 2006). If this was not possible, at least the locals could be characterised as newcomers as well. The ruins of Great Zimbabwe (Fontein 2006: 3–18) or the Mounds of Cahokia in the Mississippi delta (Feder 2002: 149–76) were interpreted as the work of some vanished advanced race totally unrelated to the present-day 'savages'.

So, is archaeology inescapably entangled with the nationalist project (Atkinson et al. 1996; Díaz-Andreu 2007; Díaz-Andreu and Champion 1996, Kohl and Fawcett 1995, Kohl et al. 2007), or is a non-nationalist archaeology possible? There is, indeed, a long tradition of international archaeology (Delley 2016, Kaeser 2004) and of archaeology striving to trace the development of mankind in general. M.A. Kaeser (2011) has claimed that an evolutionist view, transcending national borders, but looking instead on the progress of all mankind, escaped the ethnicist paradigm. Unfortunately, it led to the use of archaeology to demonstrate the advanced state of individual nations, and it also introduced the idea of uneven development. 'Present-day savages' (Klemm 1858; Lubbock 1865; Nilsson 1868; Worsae 1843) could be used to explain (European) prehistoric finds, because these peoples had remained at a primitive stage of development or were even seen as the remnants of prehistoric populations (Sollars 1911). Thus some evolutionists justified colonialism and the extermination of populations like the Tasmanians (Sollars 1911), and denied the existence of any independent history of 'primitive' peoples (Wolf 1997).

The politics of identity

At present, there is widespread agreement that ethnic groups or peoples are mainly defined by their self-identification as a people and by perceived common interests. In other words, they are political groups. While authors used to argue that peoples were defined by common descent, language, history, culture and religion, constructivist scholars argue that it is rather the *belief* in a common descent, language, history,

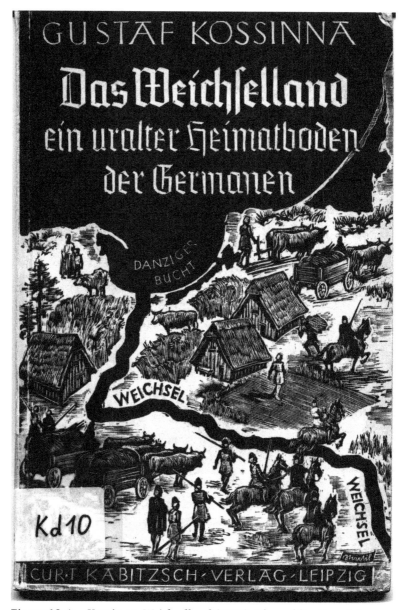

GUSTAF KOSSINNA

Das Weichselland

ein uralter Heimatboden
der Germanen

DANZIGER-
BUCHT

WEICHSEL

WEICHSEL

Kd10

CURT KABITZSCH·VERLAG·LEIPZIG

Figure 12.4: Kossinna, *Weichselland* (1919). The publication claims
that the Vistula area (Polish since the Versailles treaty of 1919) is 'age-
old Germanic homesoil'. The illustration shows Bronze Age settlers
working the fields and migrating further east.

culture and religion that characterises an ethnic group. Creating gene-
alogies and tales about a common descent is simply an idiom, a way of
speaking about dynastic and political relationships (Sneath 2007). The
resulting genealogies can be extremely malleable and are constantly
adapted to the political present (cf. Leach 1970: 164–72). Ethnography
has shown that ethnic groups can form rather rapidly (see, for example,
Cohen 1969 on Hausa groups in Nigeria), but they also rapidly acquire
a common culture and a common ideology. A common past can be part
of that package. Even if evidence of direct biological descent exists, this
does not prove the continuity of an ethnic group.

Anthony Smith has argued that ethnic groups are the driving force
for the formation of both past and present nations (Smith 1986, 1991,
2000, 2004), but this view has come under heavy criticism (Connor
1993). Most authors would agree that the modern state originated
with the French Revolution and is inextricably connected to moder-
nity. Ancient states and Empires were almost always multi-ethnic, and
united by the ruling dynasty rather than any feeling of common descent
or, indeed, of common purpose. A modern nation state, and especially
groups aspiring to national independence, would often construct a deep
national past to support their claims. North Italians could hark back to
the Etruscans, Austrians to the Celts (Koch 1857), Bohemians to early
medieval Slavonic tribes (Palacky 1836). In Poland, J. Kostrzewski
(1913; Kostrzewski et al. 1939) argued for a Slavonic origin of the Bronze
Age Lusatian culture, and the waterlogged settlement of Biskupin as the
origin of modern Poland (Piotrowska 1997/8). The construction of a
national history went hand in hand with the construction of a national
language and a national culture (Anderson 1983, Weber 1976).

Archaeology and history

Archaeological finds would now be used to illustrate past greatness
(Kossinna 1912). While there is some awareness that historiography
presents a particular and partisan view of some selected past events,
archaeological remains, by their very nature, seem to be objective and
unbiased. In fact, the historian J.G. Droysen differentiated between (writ-
ten) sources, created in order to remember the past, and remains and
monuments, which came into existence for other purposes (Rothacker
1925). The latter, he claimed, were objective testimonials of the past,
unbiased by personal interest or political and social circumstances. In a
contemporary context, Jan Assmann, a well-known German professor of

cultural studies, claims that literary texts have a subtext, which allows alternative and even oppositional interpretations, while landscapes and objects project a single, unambiguous message (Assmann, J. 1991). This view still dominates public perception, as well, even if anybody who has bought a car beyond their means to impress the neighbours knows this is not actually true.

Ian Hodder (1982) has demonstrated how material culture is actively and consciously used to reproduce, manipulate or challenge social relations, and modern material culture studies (Miller 1997) offer numerous instructive examples. Even before the advent of modern archaeology, artefacts and landscapes had been used to demonstrate the truth of religious tales (Halbwachs 1941; Schnapp 1996) and to fix them more firmly in the collective memory. While the modern state came into existence as an effective mechanism for administrating and ruling its subjects, there were also attempts to turn it into a transcendent idea, in a dialectic between modernisation and mythicisation (Assmann, A. 1996: 44). Since the late eighteenth century, modern professional historiography developed a body of methods to vet the veracity and validity of their sources (*Quellenkritik*), and the old origin myths were debunked as bad fakes. The nascent national myths, however, could be immunised against any formal criticism by linking them to collective memory (Assmann, A. 1996: 44). Nationalists came to use the authority of material remains to substantiate claims often unrelated to the past cultural context of the finds in question, integrating them into a narrative structure that owed nothing to archaeological interpretation, but lent the force of material, objective evidence to an origin tale of the nation. The seeming authenticity and mystique of finds emerging directly from the native soil, the fertile female body of the homeland, draws on metaphors connecting the soil, the human body and the unconscious (Freud 1899) with myths and deeply buried ancestral (or racial) memories (Drewermann 1983). Excavating is linked to collectively remembering a remote, 'deep' past (Benjamin 1984: 486; cf. Ebeling n.d.).

In connection with archaeological finds, it was (and is) easy to avoid complicated questions about the nature and duration of ethnic groups and the connection between consecutive archaeological cultures. Archaeologists are not normally good at communication with outsiders, especially when the theoretical background of the discipline is concerned. All too often, they seem happy to conform to the public perception as somewhat dumb treasure hunters, perhaps aided, in turn, by their perception of the public as gullible and stupid (Holtorf 2005).

Challenging nationalist narratives

A national narrative, once established, is normally hard to displace (see case study 12.3). It can become incorporated into another narrative, or the appraisal of individual events may be changed (Sommer 2002), but it is rarely abandoned entirely. In the case of the deep past, it is not enough to deconstruct the narrative; the concepts underpinning it – race, ethnic group, group identity – also have to be challenged. This calls for skills not normally included in the archaeological curriculum: the critical analysis of texts and historical circumstances. It is therefore often claimed that this analysis should be the domain of historians or philosophers of science. However, historians are often ignorant of the methods – and, indeed, the development of archaeology as a scholarly subject and its institutions (Eberhardt and Link 2015). The unravelling of national origin tales and their ideological underpinnings is thus one of the core subject matters of public archaeology.

Case study 12.3: France

Medieval traditions linked the origin of the French royal house to the Trojan Aeneas via the eponymous 'Francus' (Pomian 1992). Annius of Viterbo (Borgia 2013) created a link to Noah via a long line of Gaulish kings, many of them simply created from ethnonyms or place names (Asher, 1993; Dubois 1972). While this rather transparent fraud (Grafton 1990) maintained a long popularity in France (Stephens 2004: 219), the French aristocracy tended to trace their roots to the Frankish invaders of the fifth century (de Boulainvilliers 1727), whose story had been recorded by Gregory of Tours (in his *Decem libri historiarum* or *Historia Francorum*; Krusch and Levison 1951) in the classic ethnogenetic pattern (cf. Geary 2002). This also created a 'racial' contrast to the autochthonous Gaulish or Celtic peasantry that was emphasised at least since the peasant risings of the *Grande Jacquerie* of 1358. At the time of the conflict between the kings and the *Parlements* during the rule of Louis XIV and Louis XV, the aristocracy would refer to traditional Germanic rights and freedoms against the claims of the absolutist kings. Montesquieu famously referred to the freedom at home in the virgin forests of Germany (Cohler et al. 1989; Montesquieu 1748).

During the French Revolution, Emmanuel Joseph Sieyès used this origin myth in a very effective anti-aristocratic rhetoric, asking to dispatch 'to the forests of Franconia all those families that cling to the absurd pretension of having sprung from a race of conquerors and of having inherited the right of conquest', and claiming that 'the nation, thus purged, will be able to take consolidation in being reduced to the belief that it consists solely of descendants of the Gauls and Romans' (cited after Pomian 1992). This view was taken up by Republican historians like Michelet, Thierry and Guizot. Thus, it was the Gauls, or a mixture of Gauls and Romans, that were seen as the 'genuine' French people during the First Republic and beyond (Effros 2012: 5). The prehistorian Gabriel de Mortillet was to trace this 'ethnic' conflict between aristocrats and common people even deeper into prehistory: in his *Formation de la Nation française* (1897), he traces the aristocrats to dolichocephalic Palaeolithic hunters and gatherers, and the peasants to brachycephalic Mediterranean immigrants of the Neolithic period.

The link between Celts and the Republic proved so strong that it actually held back archaeological research into the early medieval period (Effros 2012). In contrast, Celtic studies were promoted by Napoleon Bonaparte, but especially by Napoleon III, who financed excavations in Alesia and Bibracte, among others. Vercingetorix, king of the Arverni, who had united the tribes of Gaul against Caesar, became the national hero, immortalised in numerous monuments and paintings (Dietler 1994), while the political right referred to Jeanne d'Arc and Clovis, the first Christian king of France. The analogy between Vercingetorix and Napoleon III became especially poignant after Sedan. Pomian (1992) has documented the popularity of the Celts during the late nineteenth century in all walks of life, doubtlessly also promoted by increasing anti-Prussian sentiment. In addition, the Celtic past linked Northern and Southern Occitan France, as well as Brittany.

After the Nazi invasion of France, Marshal Petain served as head of state of Vichy France between 1940 and 1944, and tried to use the defeat of Vercingetorix and the amalgamation of Gaul into the Roman Empire as a tool to popularise the submission of France to Hitler's Germany (Karlsgodt 2012: 126–8). The coins of Vichy France bear Vercingetorix' double axe on the obverse (Figure 12.5), but Petain's

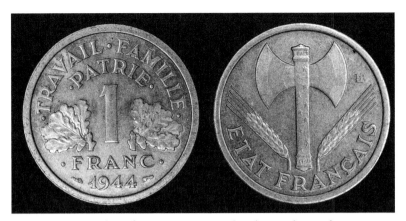

Figure 12.5: Vichy 1 franc coin, 1944. The obverse bears the motto of the Petain-regime, 'work, family, fatherland'; the reverse shows the double axe of the Gaulish king Vercingetorix between two wheat-sheaves (Photograph S. Laidlaw).

propaganda does not seem to have been very successful, and certainly did not hurt the continuing popularity of the Gauls after the war.

After a rather unsuccessful attempt at popularising the Francs as 'wayleaders of Europe' in a joint French–German project (Welck 1996), the Celts (Moscati 1991) have since served far more success-fully as an ethnic root of European unity (Gramsch 2005). Bibracte, where the Gaulish federation was formed in 52 BC, the projected burial site of French president François Mitterand, has become an international centre of late Iron Age research. At the same time, Goscinny and Uderzo's Asterix has become the symbol of stubborn local resistance (Kovacs and Marshall 2015: 114). France, a terri-torial unit well established since the late Middle Ages, thus illus-trates how different ethnic groups and events were firmly linked to opposing political parties. It also illustrates the staying power of a narrative once established under radically different political circumstances.

Edward Said (1985), analysing novels, has differentiated between origins and beginnings. For him, origins are divine, mythical and privileged. In contrast, beginnings are 'secular, humanly produced and ceaselessly re-examined' (Said 1985: xix). Beginnings are related to a specific situation and intention, and specific human actions. Archaeology thus has very much to say about beginnings, but not about origins, national or otherwise. Looking at different beginnings, we can develop and strengthen the methodology to deconstruct narratives about origins. This is a big responsibility, because, as Shanks and Tilley (1987: 40) have argued, 'Choosing a past … is choosing a future.'

13
The market for ancient art

David W.J. Gill

Introduction

Archaeological material, sometimes described as 'antiquities', surfaces on the market through different sources: auction houses and specialised galleries, as well as through the Internet. A study of the market needs to consider how materials move from closed archaeological contexts to their final resting place in public and private collections. It also seeks to explain the impact of collecting on the extant archaeological record, and to explore the ethics of collecting. Yet anyone working in this area needs to be sensitive to the names of famous collections and collectors. They need to be aware of the potential for modern creations to be inserted into the corpus. And supporting documentation is not always what it seems to be.

The importance of studying the market

A study of the market can be seen as tangential to archaeology. The world of high art and glamorous auction houses can seem very distant from an archaeological excavation in rural Anatolia. Yet the passionate desire to collect 'ancient art' by wealthy individuals creates a market and thus provides an incentive for those who think that by ransacking archaeological sites they will find the collectable object. This is why Ricardo Elia, in a review of a study of Early Bronze Age sculptures

from the southern Aegean but now in a private collection in Athens (Renfrew 1991), formulated the phrase that 'Collectors are the real looters' (Elia 1996: 61). The desire to collect and to possess Cycladic marble figures has encouraged the widespread looting of cemetery sites in the islands of the southern Aegean to the extent that some 85 per cent of the figures in the corpus have no known archaeological context (Gill and Chippindale 1993). In the case of the Cyclades, the extent of looting is well illustrated by the removal of large numbers of fragmentary Cycladic figures in what is now known as the 'Keros Haul' (Sotirakopoulou 2005; see also Gill 2007; Sotirakopoulou 2008). This looting has a material impact on the surviving archaeological record as contexts that have survived perhaps thousands of years are lost and groups are broken up.

This leads to a far more serious but subtle consequence for archaeology. Destruction through looting leads to a loss of knowledge that cannot be regained. In the case of Cycladic sculptures the lack of context has meant that archaeologists have turned to attribution studies and thereby attempted to identify individual hands of named sculptors often named in honour of contemporary collectors, such as 'the Goulandris sculptor' (Getz-Gentle 2001; Getz-Preziosi 1987). The same is true for the study of Athenian figure-decorated pottery, where attribution studies can be seen to dominate the approach (Robertson 1992). It is well known that Athenian pots were placed in Etruscan graves, perhaps as substitutes for drinking vessels in more valuable materials (Gill and Vickers 1995; Vickers and Gill 1994). These rock-cut tombs have allowed pots to survive relatively intact, in contrast with the fragments that are found in the excavation of urban or sanctuary sites (e.g. Moore 1997; Moore and Philippides 1986). One such example is the Athenian red-figured calyx-krater (a shape associated with mixing water and wine) showing the removal of the dead hero Sarpedon from the field of Troy by personifications of Sleep (Hypnos) and Death (Thanatos), alluding to Homer's *Iliad* Book XVI. A reflection of the knowledge that resides in the krater itself demonstrates how much knowledge has been lost (Gill 2012b). Although it seems likely that the pot was found in the Etruscan cemetery at Cerveteri, knowledge about the actual context and the other contents of the tomb are lost. Yet the krater became celebrated as it contained the Greek 'signature' of the presumed decorator Euphronios (Bothmer 1987; Exhibition catalogue 1990). This has formed the focus for a discussion of the painter rather than the contexts in which the works attributed to this individual have been found.

The sources for the market

One of the questions to ask when viewing archaeological material in a gallery, or flicking through the pages of a sale catalogue, is: How has this material reached this place? Have objects resided in 'private' collections for generations, or are they fresh from unknown archaeological contexts? The Sarpedon, or Euphronios, krater emerged from its Etruscan tomb through looting and then left Italy for Switzerland, where it was conserved, supplied with a misleading Lebanese collecting history, and sold to New York's Metropolitan Museum of Art for $1 million (Meyer 1974). A parallel story can be explored for an Athenian red-figured cup also decorated by Euphronios and 'signed' on the outer edge of the foot (Silver 2009). The source of such material is well illustrated by the cup linked to Onesimos and Euphronios that was acquired by the J. Paul Getty Museum (Sgubini 1999; Williams 1991). The initial parts of the cup were purchased from the 'European Art Market' in 1983, and a further fragment donated from the collection of Dietrich von Bothmer, a senior curator of Greek art at New York's Metropolitan Museum of Art, in 1984 (Walsh 1984: 246 no. 73; 1985: 169, no. 20). Additional fragments were purchased from the 'European Art Market' in 1985 (Walsh 1986: 191, no. 47). The base was inscribed with an Etruscan dedication that showed it had once been offered to the deity Hercle (Heurgon 1989). The sanctuary of Hercle was identified by Italian archaeologists at Cerveteri in 1993. It is significant that two further fragments of the cup were supplied by Giacomo Medici, an Italian handler of antiquities, in 2005, and another piece was seized in 2008 from an individual at Cerverteri. Further fragments seem to have been identified in the Bothmer collection and have been returned to Italy (Gill 2012a: 79).

This last cup that surfaced in a fragmentary condition via the 'European Art Markct' as well as from the collection of the distinguished museum curator Dietrich von Bothmer raises several issues. It is probably safe to assume that the cup was found in the sanctuary at Cerveteri, though probably in a fragmentary state. Who dispersed the fragments? When and where did Bothmer make his acquisition? Such questions are important as it seems that complete pots have been broken, and the parts distributed and then reunited. In some cases a fragment was donated to a museum and then the fitting fragments were sold to the institution (see Gill and Chippindale 2007). The case of the krater attributed to the Berlin painter and acquired by the J. Paul Getty Museum reveals a similar story of acquisition, with fragments derived from a number of

sources including Bothmer (Gill 2012a). It is perhaps significant that the missing fragments of an Athenian red-figured amphora attributed to the Berlin painter were supplied by J.R. Guy (Gill 2012a: 81). This same amphora was photographed undergoing restoration and this raises the question of how the fragments became separated. Why did the bulk of the amphora end up in New York, whereas some of the fragments entered Guy's private collection? These issues gain renewed significance when it is realised that Guy donated a major collection of fragments to Harvard (Paul 1997). Part of the Bothmer collection has been returned to Italy, and associations with pieces in Italy have been made (Tsirogiannis and Gill 2014).

It seems possible that some of this material came from the looting of archaeological sites in Etruria. A similar picture is emerging from the cemeteries of southern Italy, where graves are being opened to provide the market with Apulian pots (Elia 2001). Elia has demonstrated that some 31 per cent of the corpus of Apulian pots surfaced in the period between 1980 and 1992. This topic can be explored by the acquisition of pots attributed to the Darius painter (Gill 2009b: 79–82). Many of these pots have surfaced in recent years (Gill and Chippindale 2006, 2008). This includes a major funerary group, including three kraters attributed to the Darius painter, that was acquired by Berlin in 1984.

Other examples of looting include the hoard of Lydian silver plate that was acquired by New York's Metropolitan Museum of Art (Bothmer 1984; Özgen and Öztürk 1996). This hoard appears to have been found in a funerary mound in central western Turkey, an area now known to have been the subject of major looting (Roosevelt and Luke 2006). Another example from Turkey consists of the terracotta architectural fragments from a temple that surfaced on the market during the 1960s (Thomas 1964/5).

Sometimes the original location of the artwork can be revealed by other activity. The upper part of a marble statue showing a Weary Herakles (exhausted by his labours) was acquired by the north American private collectors Shelby White and Leon Levy, and then displayed in Boston's Museum of Fine Arts (Bothmer 1990: 237–8, no. 172). The lower part of the statue was found during the excavation of the Roman city of Perge in southern Turkey. The upper part of a funerary stele or marker was acquired by White and Levy (Bothmer 1990: 124–6, no. 97). Although it had been placed stylistically in western Turkey, the bottom half of the stela was found in a rural cemetery in eastern Attica, the territory of the city of Athens (Gill 2009b: 89–91). A more impressive group of life-size bronze sculptures were looted from the *sebasteion*, or room

associated with the imperial cult, at Bubon in Turkey. Subsequent excavations have recovered the inscribed bases for the statues showing how they were displayed. Among the works identified include a Lucius Verus in the White–Levy collection (Bothmer 1990, 240–1, no. 174; Mattusch 1996: 331–9, no. 50), a Marcus Aurelius in Cleveland (Christman 1987; Kozloff 1987; Mattusch 1996: 146, fig. 4, 345, figs. 2–3), and a head of Caracalla in the Fordham University Collection that may fit the statue in Houston Museum of Fine Arts (Cavaliere and Udell 2012: 264–7, no. 80).

In Britain one of the most important cases was the looting of a series of Romano-British bronzes from the settlement site of Icklingham in Suffolk (Browning 1995). These bronzes were sold through the New York market to White–Levy (Mattusch 1996: 262–3, no. 31). White–Levy have retained the bronzes although White has indicated that she will bequeath them to the British Museum. There was renewed interest in the bronzes when James Cuno cited the case as part of his defence of the encyclopaedic museum (Cuno 2008: 21–2; Gill 2009a).

Some objects that appear on the market do appear to have been derived from old collections. These items may have been acquired on the Grand Tour and have subsequently passed through other collections and dealers. However, such objects normally have documented collecting histories.

Metal detecting

Metal detecting is a popular hobby in the United Kingdom. Enthusiasts can subscribe to a voluntary code of conduct and need to gain permission to search on the land of others. The discovery of major hoards and finds encourages the seeking of further archaeological material and there are indications that finds are under-reported (Gill 2010c). These finds include material such as the Hoxne treasure (Bland and Johns 1993), the Roman coin hoard from Frome (Moorhead et al. 2010), and the Staffordshire hoard (Leahy and Bland 2009).

One of the most celebrated cases was the reported discovery of a Roman cavalry parade helmet just outside the Cumbrian village of Crosby Garrett in May 2010 (Breeze and Bishop 2013). The helmet was in 33 significant fragments, with 34 smaller pieces in close proximity. The helmet was taken in fragments to Christie's in London, arriving in early June, and in the space of a few months the piece was made ready for display and sale. Some three months later, the finder (or possibly finders) allowed officers from the Portable Antiquities

Scheme to inspect the hole where it was claimed that the helmet had been found. Although the Tullie House Museum in Carlisle wanted to purchase the piece, the helmet was purchased by an anonymous individual for £2.2 million. There is concern that vital information relating to the burial and context of the helmet has been lost, and the speedy preparation for sale meant that there was no detailed scientific analysis.

In East Anglia, metal detecting threatened to damage the important Anglo-Saxon site at Rendlesham, not far from the burial mounds at Sutton Hoo, Suffolk. Excavations have revealed what appear to be an important palace site ('vicus regius') with commercial links to continental Europe. The dig enlisted help of metal detectorists to make a survey of the surrounding area of Rendlesham to ensure that further information was not lost through unrecorded detection.

Creative accounts

One of the issues that has emerged from a study of the market is that reported find-spots and collecting histories – sometimes erroneously called 'provenance' (Gill 2010a) – can sometimes be adjusted. For example, objects returned to Italy from Boston's Museum of Fine Arts and the J. Paul Getty Museum had collecting histories that seem to have been fabricated or at least placed in collections that are known to have existed (Gill and Chippindale 2006, 2007). The Egyptian head of Amenhotep III had been placed in the fictitious collection assigned to Thomas Alcock (Tokeley 2006), which raises issues about the reliability of unauthenticated information. For example, the St Louis Egyptian mummy mask has two parallel collecting histories (Gill 2009b: 94). While both agree that it was excavated at Saqqara, the story given to the museum by the vendor was that it was given to the excavator and then taken to Europe, where it passed through a series of private collections. In contrast, the Egyptian view is that it was placed in an archaeological store at Saqqara, documented in a move to Cairo, and at some point stolen.

In the case of the 'Leutwitz Apollo' (also known as the 'Cleveland Apollo') that was acquired by the Cleveland Museum of Art there is a disjuncture between the reported collecting history and the documented past (Bennett 2013; Gill 2013b). Fragments of the bronze statue were reported to have been seen by a Romanian researcher (studying in Berlin) at Leutwitz in Germany in 1994, and it is known to have been in the gallery of a dealer in Geneva in 2003. But it was subsequently claimed that the statue was on the Leutwitz estate in the 1920s and

1930s, and that it was damaged as Soviet forces swept through the area in 1945. Yet there is no documentation to support this account and it must, for the moment, remain pure speculation.

Fakes

The case of fabricated histories for genuine objects is a reminder that such collecting histories can be applied to objects that appear to have been of modern manufacture. In the case of the Getty kouros, it was suggested that the statue had been acquired in the 1930s, a detail apparently confirmed in a 1952 letter from the classical archaeologist Ernst Langlotz to the owner, Jean Lauffenberger (Getty Museum 1993). However, the postal code used for the letter did not come into use until 1972, suggesting that the supporting documentation had been fabricated. Supporting documentation needs to be authenticated as part of the due diligence process when an object is acquired.

The acquirers

Antiquities come onto the market to be sold. While in Britain there are long-established guidelines for the acquisition of archaeological material, created by the Museums Association, North American museums do not seem to have been bound by the same ethical concerns. Even the adoption of the 1970 UNESCO Convention by North America did not appear to make an impact on acquisitions, as a study of south Italian pottery has shown (Gill and Chippindale 2008). This is particularly true for the J. Paul Getty Museum that opened in 1974 in Malibu in a reconstruction of the Villa of the Papyri. The museum wanted to build up a collection of classical objects and developed links with a number of suppliers (Felch and Frammolino 2011). It should be noted that this was taking place in the period after the 1970 UNESCO Convention on the Means of Prohibiting and Preventing the Illicit Import, Export and Transfer of Ownership of Cultural Property, which had been formulated to respond to the growing problem of looting around the world. It is clear from the antiquities that were returned from the museum that they included objects acquired during the 1970s (Gill 2010d; Gill and Chippindale 2007). It is even more significant that the returns contained a large number of the objects highlighted in the publication of *Masterpieces of the J. Paul Getty Museum: Antiquities* (Getty Museum 1997; Gill 1998). Even

the new catalogue for the Getty contains a terracotta head of Hades that has had to be returned to Italy.

The Getty return included a number of objects that had been derived (either as gifts or sold on) from the collection formed by Barbara and Lawrence Fleischman (Exhibition catalogue 1994). The collection had been displayed in a travelling exhibition arranged by the Cleveland Museum of Art; a study of the collecting histories for the collection had suggested that some 92 per cent of the collection had no stated find-spots (Chippindale and Gill 2000: 474). This in itself had suggested that there were questions to be raised about the objects. However, the raids in the Geneva Freeport provided documentary and photographic evidence that allowed the Italian authorities to make a reasonable claim (Watson and Todeschini 2006). The Getty return also included material that had passed through the collection of Maurice Tempelsman, among which were marble objects from an apparent villa complex in southern Italy.

Another newly formed collection in North America was the San Antonio Museum of Art. The problem facing a new collection is how to source the objects that a curator might want to display. Do you identify a potential benefactor with a ready-formed collection? Do you search the gallery brochures and auction-house catalogues? Or do you engage an 'ancient art consultant' who will identify the material that needs to be acquired? For the San Antonio collection, a study of the pottery collection indicated that some 86 per cent of the pots had surfaced after 1973 (Chippindale and Gill 2000: 479; Shapiro et al. 1995); many of them had come from the collection of Gilbert Denman. However, it became clear that some 15 per cent of the pots (19) had been acquired a year or less before they were acquired by the museum. Indeed some 43 per cent of the pots were only acquired five years or less before they were acquired by the museum. This suggests that Denman was forming a collection on behalf of the museum. Much of this took place during the curatorship of Carlos Picón (see also Mead 2007). It is now known that pots in San Antonio appear in the seized photographic archives and this suggests that there are likely to be future returns to Italy (Tsirogiannis 2012).

A further newly established North American museum is the William D. and Jane Walsh Collection at Fordham University (Cavaliere and Udell 2012). By the time that the catalogue was published one of the objects, an Etruscan hut urn, had already been returned to the Italians. Fordham additionally attracted attention when it acquired a series of

late antique mosaics that appear to have been derived from churches in Syria.

Looking beyond North America the formation of the Miho Museum in Japan has also caused controversy (Watson and Todeschini 2006). The collection contains objects that can be identified from the seized photographic archives such as the marble *oscilla* (Miho Museum 1997: no. 66). So far there has been no response to Italian requests for their return. However, in 2010 Operation Andromeda recorded 15 million euros' worth of antiquities (Gill 2010b: 75). These were linked to Japanese dealer Noryioshi Horiuchi, who is reported to have supplied antiquities to the Miho Museum.

Private individuals also actively seek to form collections that will either be dispersed or be donated as a group to a museum, thus memorialising their name. This may have been the case with the collection formed by Shelby White and Leon Levy (Bothmer 1990; see also White 2005). Some 93 per cent of the objects from the collection had no stated find-spot, and 84 per cent had surfaced after 1973 (Chippindale and Gill 2000: 472–3). Among the pieces was a Roman wall-painting fragment that came from the same wall as other fragments in the Fleischman collection (Gill 2009b: 81–3). All three fragments have now been returned to Italy. Shelby White was dismissive of the study of the collecting history of her collection (Mead 2007), but subsequent to her statements she had to return a number of key pieces from her collection to Italy (Gill 2010d), and this was followed by further objects to Greece including a bronze krater that featured on the cover of a loan exhibition catalogue (Chi and Gaunt 2005). The strengthened acquisition policies of North American museums may make it more difficult for private individuals to donate recently formed collections from objects that do not have authenticated collecting histories.

There are also tax benefits for those donating objects to museums. So, say that a pot fragment is purchased cheaply but then is attributed to a name pot-painter, or even linked to other fragments in a public collection, the donation can gain such value that the donor has made a clear profit. Bruce McNall, who ran the Summa Gallery in Beverley Hills, has explained how the system works (McNall 2003: 45).

A typical deal might involve three fragments of a Greek vase that I had acquired through Bob Hecht for, say, $100,000. A customer would buy them from me for $200,000. Frel would have them appraised as if they had been restored, which would make them

Case study 13.1: Fragments

Small sherds of Greek pottery are commonplace on Greek domestic and sanctuary sites. It is rare for complete vessels to emerge from the pile of fragments unless a pot had been dropped down a well. Thus fragments are the common publication of excavations such as the Athenian Agora (Moore 1997; Moore and Philippides 1986) and the rural site known as the Dema House in Attica (Jones et al. 1962), or sanctuaries such as the temple of Aphaia on Aegina (Williams 1983, 1993) and the Greek sanctuaries of Naukratis in the Nile Delta (Venit 1988). Fragments of pots have formed the backbone of collections and there has been much effort expended to identify joining fragments (Beazley 1933).

At one level collections of pot fragments could be considered to be above suspicion; a selection of sherds from different regions could be seen as an essential tool in a museum attached to a university. So, for example, the University of Cambridge developed and holds a collection of representative Greek sherd material to help with undergraduate and postgraduate teaching. However, it is now clear from specific cases of returned objects to Italy that pots were broken into fragments and these pieces were sold to the museum over a number of years. This was the case for the Attic red-figured krater attributed to the Berlin painter that was acquitted by the J. Paul Getty Museum (Gill 2012a). A parallel would be the Attic amphora, also attributed to the Berlin painter, that was acquired by New York's Metropolitan Museum of Art (Gill 2009b: 98). The amphora was completed by fragments donated by J. Robert Guy. The pot has now been returned to Italy.

Guy was the owner of a large collection of Greek pottery fragmentary that was acquired by Harvard University (Paul 1997). The collecting histories of the fragments are not documented and they have now appeared in the debate relating to cultural property (Cuno 2008; see also Gill 2009a). The issue of fragments have again been highlighted by the return of part of Dietrich von Bothmer's collection, which had been acquired by the Metropolitan Museum of Art where he had been a curator (Gill 2012a). The museum has declined to give details of what has been returned, but further fragments have been linked to objects now in Italy (Tsirogiannis and Gill 2014). It is not clear how Bothmer acquired the fragments or why they were linked to objects that had already been returned to Italy.

worth $500,000. Done correctly – and it was always done correctly – I would profit on the sale. My customer would get more money back from the Internal Revenue Service in taxes than he or she had laid out for the purchase. And Jiri would add something to the Getty's collection.

It is unclear how far this system was used across institutions, but the potential for creating profitable transactions is clear.

The impact of the Medici Conspiracy

In 1995 a raid on the premises of Giacomo Medici in the Geneva Freeport provided the Italian authorities with evidence of the organised movement of antiquities from Italy via Switzerland (Watson 1997; Watson and Todeschini 2006). The raid recovered not only substantial numbers of objects but also a photographic dossier, mostly of Polaroids, showing the objects that had been handled. These photographs sometimes showed objects in an uncleaned or broken state prior to restoration.

Research on these archives have identified objects in a range of North American museums. Objects have been returned from Boston's Museum of Fine Arts, the Cleveland Museum, the J. Paul Getty Museum, New York's Metropolitan Museum of Art and the Princeton University Art Museum (Gill 2010d).

Not all museums have waited for the Italian authorities to approach them. Maxwell Anderson investigated a number of objects in the Dallas Museum of Art where the collecting histories had raised questions (Gill 2013a). A series of objects were returned to Italy, and a Roman mosaic to Turkey. Anderson has a long and distinguished history of trying to find an alternative to acquiring antiquities. At Emory University he introduced the EUMILOP scheme to mount major exhibitions of loan material from archaeological collections in Italy and Sicily as a deliberate response to the problem of looting (Anderson and Nista 1988, 1989; Wescoat and Anderson 1989; see also Butcher and Gill 1990). It is ironic that the same museum, but with different curatorial emphasis, has been linked to the loan of material that has had to be returned to Greece (Chi and Gaunt 2005).

The adverse publicity surrounding all these returns from major museums has meant that the Association of Art Museum Directors (AAMD) has introduced a more rigorous policy relating to acquisitions, including the posting of images of new acquisitions on the AAMD's Object Registry. The AAMD policy has a major loophole when it comes to

the loan of material from third parties. The criteria for accepting loans do not require the same level of rigour for checking the collecting histories as does acquisitions to the permanent collections.

The scale of the market

It is claimed that the market for antiquities is third in value after drugs and weapons, however it is hard to substantiate this claim. A snapshot was given in the 2000 British Parliamentary Inquiry on Cultural Property and Illicit Trade (Gill and Chippindale 2002). Estimates submitted to the report included $4.5 billion (based on Interpol data), and a more modest £150 million to £2 billion (from the Museums Association) (Gill and Chippindale 2002: 51–3). Jerome Eisenberg estimated in 1995 that the annual 'turnover in classical, Egyptian and Near Eastern antiquities' was in the region of $200–$300 million (Eisenberg 1995: 215).

The objects seized during a raid in the Geneva Freeport were worth some £25 million (Gill and Chippindale 2002: 52). The 29 warehouses relating to Robin Symes and his deceased partner Christos Michaelides were valued at $250 million (Watson 2006: 94; see also Tsirogiannis 2012). Operation Andromeda seized some 15 million euros' worth of antiquities on a raid in Switzerland (Gill 2010b: 75).

In 1996 Sotheby's closed its London department of antiquities following a damaging scandal (Gill 1997; Watson 1997). There were 35 sales of antiquities in the New York department between 1998 and 2013 (normally in June and December), which generated just over $411 million: the annual income per year ranged from $6 million (in 2006) to $112 million (in 2007). The sale of 2007 was in part dominated by the sale of the Guennol Lionees for $57 million. Christie's have performed in an equally strong way: since 1999 there have been 33 sales in New York, worth just over $221 million. This ranges from $4.5 million (in 1999) to $42.7 million (in 2010). The London market for Christie's in the same period (1999–2010) was worth just under £40 million.

Conclusion

Concerns about the market for ancient art have been raised consistently since at least the 1970s. In the opening editorial of the *Journal of Field Archaeology* in 1974, James Wiseman wrote about the inclusion

Case study 2: The Minneapolis krater

One of the first objects to be identified from the Medici Polaroid photographs was an Attic red-figured volute krater (Abbe 2005). This wine-mixing vessel was decorated with a scene showing Dionysos along with his followers of Maendads and Satyrs. It had been acquired by the Minneapolis Institute of Arts in 1983 from London-based dealer Robin Symes (Padgett 1983–6 [1991]). The krater had been acquired on the recommendation of Michael Conforti, now the Director of the Sterling and Francine Clark Institute in Williamstown (MA). Padgett reported that the krater had been in two anonymous private collections prior to its acquisition: one in Switzerland and the other in London. He also claimed that its collecting history could be traced back to the period just before the 1970 UNESCO Convention.

The Polaroid photograph of the krater is recognisably that of the Minneapolis krater. It is shown covered in mud but in a near complete state. This suggests that it had been buried (and protected) in a tomb, and that it had been removed illegally. The fact that it was photographed using Polaroid technology provides a *terminus post quem* of 1972 for its emergence from its archaeological context.

The krater was attributed to the Methyse painter. Other works attributed to this artist have been found in Italy, from Spina at the mouth of the Po Valley, to Camarina on Sicily.

The Minneapolis Institute claimed to have started an enquiry into the acquisition in 2006 but nothing seemed to emerge. However, in December 2010, Kaywin Feldman, the then director of the Institute, commented on the case of the Egyptian mummy mask in the St Louis Art Museum. At the time of the comment Feldman was also the president of the Association of Art Museum Directors, a body that had recently adapted its policy towards antiquities. Michael Conforti had also made a public statement about the need for museums to return objects to their countries of origin if new evidence came to light.

The statement by Feldman, and the earlier one by Conforti, made it impossible for Minneapolis to retain the krater given the evidence provided by the Polaroid that indicated that the anonymous Swiss collection appeared to have been the stock of Giacomo Medici.

of a regular column on 'The Antiquities Market' (Wiseman 1974). This column was one of the ways that archaeologists documented the damage that was being sustained to the archaeological record. Analyses of material passing through auction houses highlighted the lack of information about collecting histories and find spots (Chippindale et al. 2001). The evidence that has emerged from the 'Medici Conspiracy' has now made museums wary of acquiring objects that do not have a properly documented collecting history. In spite of this, some auction houses continue to offer objects that passed through the hands of Medici (Gill and Tsirogiannis 2011; Tsirogiannis 2013). The highlighting of recently surfaced material through the use of social media, and in particular through the research blog 'Looting Matters' (Gill 2014), has helped to lessen the amount of recently surfaced material that has emerged on the market.

Acknowledgements

I would like to thank my colleagues Christopher Chippindale and Christos Tsirogiannis for their input to this research over a number of years. Christopher M. Hall encouraged me to use a blog to comment on the antiquities market. Noah Charney has invited me to write a regular column for the *Journal of Art Crime* and some of the ideas are drawn from the essays that have appeared there.

References

Abbe, M. 2005. Italy claims Minneapolis museum holds looted vase. *Star Tribune* (9 November, 2005).

Acar, E. 2005. *Turkish lawyers file suit against British Museum Halikarnassos mausoleum*. *Turkish Weekly* (3 August). Available at www.turkishweekly.net/news/16555/turkish-lawyers-file-suit-against-british-museum-halikarnassos-mausoleum.html [last accessed 10 October 2016].

Ackroyd, P. 1989. *First Light*. London: Hamish Hamilton.

Adams, J.L. 2010. Interrogating the equity principle: The rhetoric and reality of management planning for sustainable archaeological tourism. *Journal of Heritage Tourism* 5(2): 103–23.

Addyman, P. 2001. Antiquities without archaeology in the United Kingdom. In N. Brodie, J. Doole and C. Renfrew (eds.) *Trade in Illicit Antiquities: The Destruction of the World's Archaeological Heritage*. Cambridge: McDonald Institute Monographs, 141–4.

Agathias, Ιστορίαι. 1975. *Agathias: Historiarium*. Frendo, J.D. (ed.). Berlin: DAFBS.

AIM. 2010. *The Economic Value of the Independent Museum Sector*. Available at www.aim-museums.co.uk/downloads/2cef984a-dd70-11e1-bdfc-001999b209eb.pdf [last accessed 10 October 2016].

Ainsworth, A. 2009. *Gloucester's itinerant diggers*. *Past Horizons* 8: 26–7. Available at http://en.calameo.com/read/0000627291767a39589d5 [last accessed 10 October 2016].

Aitchison, K. 2010. United Kingdom Archaeology in Economic Crisis. In N. Schlanger and K. Aitchison (eds.) *Archaeology and the Global Economic Crisis: Multiple Impacts, Possible Solutions*. Tervuren, Belgium: ACE/Culture Lab Editions, 25–30.

Aitchison, K. 2012. *Breaking New Ground: How Professional Archaeology Works* [e-book]. Sheffield: Landward Research Ltd.

Aitchison, K. and Rocks-Macqueen. D. 2013. *Archaeology Labour Market Intelligence: Profiling the Profession 2012–13*. Sheffield: Landward Research Ltd.

Aitchison, K. 2012. *Breaking New Ground: How Archaeology Works*. [e-book] Landward Research. Available at www.amazon.co.uk/Breaking-New-Ground-archaeology-ebook/dp/B007U5SAKK [last accessed 21 June 2013].

Akdemir, Ö. 2008. *Yitik kentin kedisi! Evrensel* (1 February). Available at http://ozerakdemir.blogspot.co.uk/2012/11/yitik-kentin-kedisi-arsiv-haber.html [last accessed 10 October 20162016].

Alberge, D. 2012. *Turkey turns to human rights law to reclaim British Museum sculptures. The Guardian* (8 December). Available at www.theguardian.com/culture/2012/dec/08/turkey-british-museum-sculptures-rights [last accessed 10 October 2016].

Allen, S.H. 2013. *Classical Spies: American Archaeologists with the OSS in World War II Greece*. Ann Arbor, MI: University of Michigan Press.

Alphan, M. 2015. *New Turkey has positions only for theologians. Hürriyet Daily News* (5 January). Available at www.hurriyetdailynews.com/new-turkey-has-positions-only-for-theologians--.aspx?pageID=449&nID=76479&NewsCatID=507 [last accessed 10 October 2016].

Anderson, B. 1983. *Imagined Communities*. London: Verso.

Anderson, M.L. and L. Nista, L. 1988. *Roman Portraits in Context: Imperial and Private Likenesses from the Museo Nazionale Romano*. Rome: De Luca Edizioni d'Arte.

Anderson, M.L. and L. Nista, L. (eds.) 1989. *Radiance in Stone: Sculptures in Colored Marble from the Museo Nazionale Romano*. Rome: De Luca Edizioni d'Arte.

Anderson, C. 2004. *The Long Tail. Wired* (October). Available at www.wired.com/2004/10/tail/?pg=1&topic=tail&topic_set= [last accessed 16 November 2015].

2006. *The Long Tail: Why the Future of Business is Selling Less of More*. New York: Hyperion.

Appleyard, B. 2013. Why should it be free? *Sunday Times Culture Magazine* 7 (April), 6–7.

Archaeology Forum. 2005. *Archaeology Enriches Us All*. York: York Archaeological Trust. Available at www.archaeologyuk.org/archforum/enriches.pdf [last accessed 10 October 2016].

Archäologisches Landesmuseum Baden-Württemberg/Landesamt für Denkmalpflege im Regierungspräsidium Stuttgart (eds.) 2016. *4.000 Jahre Pfahlbauten*. Ostfildern: Thorbecke.

Arts & Business, Arts Council England, Museums, and Libraries & Archives. 2011. *Digital Audiences: Engagement with Arts and Culture Online*. Available at www.aandbscotland.org.uk/documents/2012-05-28-13-11-39-10-Digital-audiences-for-arts-and-culture-november2010.pdf [last accessed 10 October 2016].

Ascherson, N. 2000. Editorial. *Public Archaeology* 1(1): 1–4.

Asher, R.E. 1993. *National Myths in Renaissance France, Francus, Samothes and the Druids*. Edinburgh: Edinburgh University Press.

Assmann, A. 1996. *Erinnerungsräume. Formen und Wandlungen des kulturellen Gedächtnisses*. Munich: Beck.

Assmann. J. 1991. *Das kulturelle Gedächtnis: Schrift, Erinnerung und politische Identität in frühen Hochkulturen*. Munich: Beck.

Atalay, S. 2006. Indigenous archaeology as decolonizing practice. *The American Indian Quarterly* 30(3): 280–310.

Atkinson, J.A., Banks, I. and O'Sullivan, J. (eds.) 1996. *Nationalism and Archaeology*. Glasgow: Cruithne Press.

Australia ICOMOS (International Council on Monuments and Sites). 2000. *The Burra Charter: Revised*. Available at www.icomos.org/australia [last accessed 10 October 2016].

Badran, A. 2011. The excluded past in Jordanian formal primary education: The introduction of archaeology. In K. Okamura and A.Matsuda (eds.) *New Perspectives in Global Public Archaeology*. New York: Springer, 197–215.

Bailey, S.J. and Falconer, P. 1998. Charging for admission to museums and galleries: A framework for analysing the impact on access. *Journal of Cultural Economics* 22(2–3): 167–77. DOI: 10.1023/A:1007506019008.

Bakhshi, H. 2012. The impact of the 'valuing culture' debates in the UK: 2003–2011. *Cultural Trends* 21(3): 213–14.

Banks, K.M., Giesen, M.J. and Pearson, N. 2000. Traditional cultural properties vs. traditional cultural resource management. *CRM-Washington* 23(1): 33–5.

Bassett, K. 1993. Urban cultural strategies and urban regeneration: A case study and critique. *Environment and Planning* 25: 1773–88.

Baxter, J.E. 2009. *Archaeological Field Schools: A Guide for Teaching in the Field*. Walnut Creek, CA: Left Coast Press.

Beazley, J.D. 1933. *Campana Fragments in Florence*. London: Oxford University Press.

Beck, A. and Neylon, C. 2012. A vision for open archaeology. *World Archaeology* 44(4): 479–97. DOI: 10.1080/00438243.2012.737581.

Belfiore, E. 2012. 'Defensive instrumentalism' and the legacy of New Labour's cultural policies. *Cultural Trends* 21(2): 103–11.

Bender, B. 1998. *Stonehenge: Making Space*. Oxford: Berg.

Benjamin, W. 1984. Berliner Chronik. In H. Schweppenhäuser and R. Tiedemann (eds.) *Walter Benjamin: Gesammelte Schriften, Bd. VI: Fragmente, Autobiographische Schriften*. Frankfurt: Suhrcamp, 465–519.

Bennett, M. 2013. *Praxiteles: The Cleveland Apollo*. Cleveland Masterwork Series, vol. 2. Cleveland, OH: The Cleveland Museum of Art.

Benson, E.F. 2012. *Night Terrors: The Ghost Stories of E.F. Benson*. Ware: Wordsworth.

Bent, J.T. 1892. *The Ruined Cities of Mashonaland: Being a Record of Excavation and Exploration in 1891*. London: Longmans, Green and Co.

Bevan, A. 2012. Value, authority and the open society: Some implications for digital and online archaeology. In C. Bonacchi (ed.) *Archaeology and Digital Communication: Towards Strategies of Public Engagement*. London: Archetype Publications, 1–14.

Bevan, A., Pett, D., Bonacchi, C., Keinan-Schoonbaert, A., Lombraña González, D., Sparks, R., Wexler, J. and Wilkin, N. 2014. Citizen archaeologists: Online collaborative research about the human past. *Human Computation* 1(2): 183–97.

Bewley, R. and Maeer, G. 2014. Heritage and economy: Perspectives from recent Heritage Lottery Fund research. *Public Archaeology* 13(1–3): 240–9.

Beyleveld, D. 1991. *The Dialectical Necessity of Morality: An Analysis and Defence of Alan Gewirth's Principle of Generic Consistency*. London: The University of Chicago Press.

Bilefsky, D. 2012. *Seeking return of art, Turkey jolts museums*. New York Times (30 September; 1 October), A1. Available at www.nytimes.com/2012/10/01/arts/design/turkeys-efforts-to-repatriate-art-alarm-museums.html [last accessed 10 October 2016].

Bitgood, S. 2010. *An Attention-Value Model of Museum Visitors*. Washington, DC: Center for the Advancement of Informal Science Education. Available at http://informalscience.org/images/research/VSA_Bitgood.pdf [last accessed 10 October 2016].

Bland, R. and C. Johns, C. 1993. *The Hoxne Treasure: An Illustrated Introduction*. London: British Museum Press.

Bland, R.F. 1996. Treasure Trove and the case for reform. *Art, Antiquity and the Law* 1: 11–26.

1998. The Treasure Act and the proposal for the voluntary recording of all archaeological finds. *The Museum Archaeologist* 23: 3–19.

2005a. A pragmatic approach to the problem of portable antiquities: The experience of England and Wales. *Antiquity* 79(304): 440–7.

2005b. Rescuing our neglected heritage: The evolution of the government's policy on portable antiquities in England and Wales. *Cultural Trends* 14(4): 257–96.

2008. The development and future of the Treasure Act and Portable Antiquities Scheme. In S. Thomas and P. Stone (eds.) *Metal Detecting and Archaeology*. Woodbridge: The Boydell Press, 63–86.

2013. Response: The Treasure Act and Portable Antiquities Scheme. *Internet Archaeology* 33. Available at http://dx.doi.org/10.11141/ia.33.8 [last accessed 10 October 2016].

Bloom, B., Mesia, B.B. and Krathwohl, D.R. 1964. *Taxonomy of Educational Objectives*, 2 volumes. New York: David McKay.

Bonacchi, C. 2012a. Introduction. In C. Bonacchi (ed.) *Archaeology and Digital Communication: Towards Strategies of Public Engagement*. London: Archetype Publications, xi–xix.

2012b. *Communicating Archaeology: From Trends to Policy. Public Perceptions and Experience in a Changing Media Environment*. Unpublished PhD thesis, UCL.

2013. Audiences and experiential values of archaeological television: The case study of 'Time Team'. *Public Archaeology* 12(2): 111–25.

2014. Understanding the public experience of archaeology in the UK and Italy: A call for a 'sociological' movement in public archaeology. *European Journal of Post-Classical Archaeologies* 4: 377–440.

Bonacchi, C. and Galani, A. 2013. *'Culturally engaged? A people-centred approach to understanding digital cultural engagement on social media platforms*. Unpublished report, UCL.

Bonacchi, C. and Moshenska, G. 2015. Critical reflections on digital public archaeology. *Internet Archaeology* 40.

Bonacchi, C., Bevan, A., Pett, D. and Keinan-Schoonbaert, A. 2015a. Crowd- and community-fuelled archaeology: Early results from the MicroPasts project. In F. Giligny, F. Djindjian, L. Costa, P. Moscati and S. Robert (eds.) *CAA2014, 21st Century Archaeology: Concepts, Methods and Tools. Proceedings of the 42nd Annual Conference on Computer Applications and Quantitative Methods in Archaeology, Paris*. Oxford: Archaeopress, 279–88.

2015b. Experiments in crowd-funding community archaeology. *Journal of Community Archaeology and Heritage* 3(2): 184–98. DOI: http://dx.doi.org/10.1179/2051819615Z.00000000041.

Bonacchi, C., Furneaux, C. and Pett, D. 2012. Public engagement through online TV channels: A way forward for the audiovisual communication of archaeology? In C. Bonacchi (ed.), *Archaeology and Digital Communication: Towards Strategies of Public Engagement*. London: Archetype, 50–65.

Bones. 2005–. [Television series]. Hart Hanson, producer. 20th Century Fox Television.

Borgia. R. 2013. *Berosi sacerdotis chaldaici Antiquitatum libri quinque*. Ex editione anni 1498 (Venetiis) usque ad ed. anni 1659, recognovit Roberto Borgia. Available at https://www.academia.edu/4865078/Berosi_sacerdotis_chaldaici_Antiquitatum_libri_quinque_recognovit_Roberto_Borgia_2013 [last accessed 16 June 2017].

Bothmer, D. von. 1984. *A Greek and Roman Treasury*. New York: Metropolitan Museum of Art.

1987. *Greek Vase Painting*. New York: The Metropolitan Museum of Art.

Bothmer, D. von. (ed.) 1990. *Glories of the Past: Ancient Art from the Shelby White and Leon Levy Collection*. New York: Metropolitan Museum of Art.

de Boulainvilliers, H. 1727. *Histoire de l'ancien gouvernement de la France*. Amsterdam: La Haye.

Bowitz, E. and Ibenholt, K. 2009. Economic impacts of cultural heritage: Research and perspectives. *Journal of Cultural Heritage* 10: 1–8.

Boytner, R. 2014. Do good, do research: Why the two must meet to maximize economic gain. *Public Archaeology* 13(1–3): 262–77.

Bradley, R. 2006. Bridging the two cultures: Commercial archaeology and the study of prehistoric Britain. *Antiquaries Journal* 86: 1–13.

Bradley, A., Geary, K. and Sutcliffe, T-J. 2015. Two roads: Developing routes to professional archaeological practice. *The Historic Environment: Policy and Practice* 6(2): 98–109.

Brake, M.L. and Weitkamp, E. (eds.) 2009. *Introducing Science Communication: A Practical Guide*. Basingstoke: Palgrave Macmillan.

Bray, W. 1981. Archaeological humour: The private joke and the public image. In J.D. Evans, B. Cunliffe and C. Renfrew (eds.) *Antiquity and Man: Essays in Honour of Glyn Daniel*. London: Thames & Hudson, 221–9.

Breeze, D.J., and M.C. Bishop, M.C. (eds.) 2013. *The Crosby Garrett Helmet*. Pewsey: The Armatura Press.

Brekmoe, L. 2015. Community archaeology in Norway. In M. Nevell and N.Redhead (eds.) *Archaeology for All, Community Archaeology in the Early 21st Century: Participation, Practice, and Impact*. Salford Applied Archaeology Series Volume 2. Salford: Centre for Applied Archaeology, University of Salford, 67–70.

Brindle, T. 2014. *The Portable Antiquities Scheme and Roman Britain*. British Museum Research Publication 196. London: The British Museum.

British Museum. 2014. *The Portable Antiquities Scheme Annual Report 2013*. Available at https://finds.org.uk/documents/annualreports/2013.pdf [last accessed 10 October 2016].

Brodie, N., Kersel, M.M., Luke, C. and Tubb, K.W. (eds.) 2006. *Archaeology, Cultural Heritage, and the Antiquities Trade*. Gainesville, FL: University Press of Florida.

Browning, J. 1995. A layman's attempts to precipitate change in domestic and international 'heritage' laws. In K.W. Tubb (ed.), *Antiquities Trade or Betrayed: Legal, Ethical and Conservation Issues*. London: Archetype, 145-9–9.

Burke, H., Lovell-Jones, C. and Smith, C. 1994. Beyond the looking-glass: Some thoughts on sociopolitics and reflexivity in Australian archaeology. *Australian Archaeology* 38: 13–22.

Butcher, K. and D.W.J. Gill, D.W.J. 1990. Mischievous pastime or historical science? *Antiquity* 64: 946-5–50.

Caesar, C.I. *Commentariorvm de Bello Gallico*. Available at www.thelatinlibrary.com/caesar/gall1.shtml [last accessed 16 June 2017].

Campbell, S. 2013. Metal detecting, collecting and portable antiquities: Scottish and British perspectives. *Internet Archaeology* 33. Available at http://dx.doi.org/10.11141/ia.33.1 [last accessed 10 October 2016]

Carman, J. 2002. *Archaeology and Heritage: An Introduction*. London: Continuum.
 2005. *Against Cultural Property: Archaeology, Heritage and Ownership*. London: Duckworth.

Carver, M. 1996. On archaeological value. *Antiquity* 70: 45–56.
 2011. *Making Archaeology Happen: Design versus Dogma*. Walnut Creek, CA: Left Coast Press.

Casey, B., Casey, N., Calvert, B., French, L. and Lewis, J. 2008. *Television Studies: The Key Concepts*. London: Routledge.

Castells, M. 2010. *The Rise of the Network Society*. Oxford: Wiley-Blackwell.

Castells, M., and Cardoso, G. (eds.) 2005. *The Network Society: From Knowledge to Policy*. Washington, DC: Johns Hopkins Center for Transatlantic Relations.

Caton-Thompson, G. 1931. *The Zimbabwe Culture*. Oxford: Oxford University Press.

Cavaliere, B. and J. Udell, J. (eds.) 2012. *Ancient Mediterranean Art: The William D. and Jane Walsh Collection at Fordham University*. New York: Fordham University Press.

Çelik, Ö. with Evers, M. and Knöfel, U. 2013. *Museum wars: Ankara demands artifacts from Berlin. Der Spiegel* (14 March). Available at www.spiegel.de/international/germany/dispute-heats-up-between-germany-and-turkey-over-contested-artifacts-a-888398.html [last accessed 10 October 2016].

Cengiz, O.K. 2013. *Turkish academia and the Armenian Genocide. Al-Monitor* (22 December). Available at www.al-monitor.com/pulse/originals/2013/12/turkey-armenia-genocide-academic-research-media-exposure.html [last accessed 10 October 2016].

Chatterjee, H., Vreeland, S. and Noble, G. 2009. Museopathy: Exploring the healing potential of handling museum objects. *Museum and Society* 7(3): 164–77.

Chi, J. and J. Gaunt., J. 2005. *Greek Bronze Vessels from the Collection of Shelby White & Leon Levy.* Atlanta, GA: Michael C. Carlos Museum, Emory University.

Childe, V.G. 1933. Is prehistory practical? *Antiquity* 7(28): 410–18.

1958. *The Prehistory of European Society.* Harmondsworth: Penguin.

Chippindale, C. and D.W.J. Gill, D.W.J. 2000. Material consequences of contemporary classical collecting. *American Journal of Archaeology* 104: 463-5–511.

Chippindale, C., D.W.J. Gill, D.W.J., E. Salter, E. and C. Hamilton,. C. 2001. Collecting the classical world: First steps in a quantitative history. *International Journal of Cultural Property* 10: 1-3–31.

Chirikure, S., Manyanga, M., Ndoro, W. and Pwiti, G. 2010. Unfulfilled promises? Heritage management and community participation at some of Africa's cultural heritage sites. *International Journal of Heritage Studies* 16(1–2): 30–44.

Christman, B. 1987. Technical study: The emperor as philosopher. *Bulletin of the Cleveland Museum of Art* 74: 100-1–13.

CIFA. 2010. *Strategic Plan 2010–2020: Summary Document.* Reading: Chartered Institute for Archaeologists.

CIFA. 2014. *Standard and Guidance for Archaeological Field Investigations.* Reading: Chartered Institute for Archaeologists.

CIFA. 2015. *Chartered Institute for Archaeologists Yearbook and Directory 2015.* Reading: Chartered Institute for Archaeologists.

Clark, K. 2004. Why fund heritage? The role of research in the Heritage Lottery Fund. *Cultural Trends* 13(4): 65–85.

Cock, M., Caspari, A. and Campbell, K. 2011. *On Air, Online and Onsite: The British Museum and BBC's 'A History of the World'.* Available at www.museumsandtheweb.com/mw2011/papers/on_air_online_and_onsite_the_british_museum_an.html [last accessed 10 October 2016].

Cohen, A. 1969. *Custom and Politics in Urban Africa: A Study of Hausa Migrants in Yoruba Towns.* Berkeley, CA: University of California Press.

Cohler, M.C., Miller, B.C. and Stone, H.S. (eds.) 1989. *Montesquieu: The Spirit of the Laws.* Cambridge: Cambridge University Press.

Colley, S. 2014. Social media and archaeological communication: An Australian survey. *Archäologische Informationen* 36: 65–80.

Colwell-Chanthaphonh, C. and Ferguson, T.J. 2006. Memory pieces and footprints: Multivocality and the meanings of ancient times and ancestral places among the Zuni and Hopi. *American Anthropologist* 108(1): 148–62.

Colwell-Chanthaphonh, C. and T.J. Ferguson. 2006. Trust and archaeological practice: Towards a framework of virtue ethics. In C. Scarre and G.Scarre (eds.) *The Ethics of Archaeology: Philosophical Perspectives on Archaeological Practice.* Cambridge: Cambridge University Press, 115–30.

Comyn, D. (ed.) 1902. *The History of Ireland by Geoffrey Keating, DD.* London: Irish Texts Society.

Conference on the Future of Archaeology (CFA). 1943. *Conference on the Future of Archaeology held at the University of London, Institute of Archaeology, August 6th to 8th, 1943.* Occasional Paper 5. London: Institute of Archaeology.

Connor, W. 1993. *Ethnonationalism: The Quest for Understanding.* Princeton, NJ: Princeton University Press.

Cooper, A. 2012. The drivers, impact and value of CASE: A short history from the inside. *Cultural Trends* 21(4): 281–9.

Cooper, G.H. 1921. *Ancient Britain: The Cradle of Civilization.* San Jose, CA: Hillis-Murgotten.

Corbishley, M. 2011. *Pinning Down the Past: Archaeology, Heritage, and Education Today.* Woodbridge: Boydell.

Corbishley, M. and Jorayev, G. 2014. Politics, archaeology and education: Ancient Merv, Turkmenistan. In S. Thomas and J. Lea (eds.) *Public Participation in Archaeology.* Woodbridge: The Boydell Press, 119–28.

Corbishley, M., Fordham, J., Walmsley, D. and Ward, J. 2008. Learning beyond the class-room: Archaeological sites and schools. *Conservation and Management of Archaeological Sites* 10(1): 78–92.

Cornwall Archaeological Unit (CAU). 2017. Commercial services. Available at www.cornwall.gov.uk/environment-and-planning/cornwall-archaeological-unit/commercial-services [last accessed 19 June 2017].

Council of Europe. 2005. *Council of Europe Framework Convention on the Value of Cultural Heritage for Society* (The Faro Convention). Council of Europe Treaty Series 199. Available at http://conventions.coe.int/Treaty/EN/Treaties/Word/199.doc [last accessed 10 October 2016].

Cox, M. 1983. *M.R. James: An informal portrait*. Oxford: Oxford University Press.

Cracknell, S. and Corbishley, M. (eds.) 1986. *Presenting Archaeology to Young People*. CBA Research Report No 64. York: Council for British Archaeology. Available at http://archaeologydataservice.ac.uk/archives/view/cba_rr/rr64.cfm [last accessed 10 October 2016].

Cremo, M.A. and Thompson, R.L. 1993. *Forbidden Archeology: The Hidden History of the Human Race*. San Diego, CA: Bhaktivedanta Institute.

Crompton, J.L. 2006. Economic impact studies: Instruments for political shenanigans? *Journal of Travel Research* 45: 67–82.

Cuno, J. 2008. *Who Owns Antiquity? Museums and the Battle over Our Ancient Heritage*. Princeton, NJ: Princeton University Press.

Daniel, G. 1965. *The Cambridge Murders*. London: Penguin.

Däniken, E. von 1968. *Chariots of the Gods? Unsolved Mysteries of the Past*. New York: Putnam.

Darvill, T. 1995. Value systems in archaeology. In M.A. Cooper, A. Firth, J. Carman and D. Wheatley (eds.) *Managing Archaeology*. New York: Routledge, 40–50.

Dawkes, G. 2015. Pocock's Field, Eastbourne, East Sussex: A marsh side settlement from prehistoric to Tudor period. *Archaeology South-East Newsletter* 2: April 2015.

Day, D.H. 1997. *A Treasure Hard to Attain: Images of Archaeology in Popular Film, with a Filmography*. Lanham, MD: Scarecrow Press.

DCLG. 2010. *Planning Policy Statement 5: Planning for the Historic Environment*. London: The Stationery Office.

⸻ 2012. *National Planning Policy Framework*. London: The Stationery Office.

DCMS. 2001. *The Historic Environment: A Force for Our Future*. London: Department for Culture, Media and Sport. Available at www.tourisminsights.info/ONLINEPUB/DCMS/DCMS.htm [last accessed 10 October 2016].

⸻ 2008. *The Treasure Act 1996, Code of Practice (2nd revision). England and Wales*. London: Department for Culture, Media and Sport. Available at www.gov.uk/government/uploads/system/uploads/attachment_data/file/77532/TreasureAct1996CodeofPractice2ndRevision.pdf [last accessed 1 March 2015].

Delley, G. 2015. *Au-delà des chronologies: Des origines du radiocarbone et de la dendrochronologie à leur intégration dans les recherches lacustres suisses*. Vol. 53. Hauterive: Office du patrimoine et de l'archéologie de Neuchâtel.

⸻ 2016. Internationalism and lake-dwelling research after the Second World War. In G. Delley, M. Díaz-Andreu, F. Djindjian, A. Guidi and M.-A. Kaeser (eds.) *History of Archaeology: International Perspectives*. Oxford: Archaeopress, 71–8.

Department of the Environment (DoE) 1990. *Planning Policy Guidance Note 16: Archaeology and Planning*. London: HMSO.

Dhanjal, S., Flinn, A., Lockyear, K. and Moshenska, G. 2015. Dig where we stand. In K. Lockyear (ed.) *Archaeology in Hertfordshire: Recent Research*. Hatfield: University of Hertfordshire Press, 326–34.

Díaz-Andreu, M. 2007. *A World History of Nineteenth-Century Archaeology*. Oxford: Oxford University Press.

Díaz-Andreu, M. and Champion, T. (eds.) 1996. *Nationalism and Archaeology in Europe*. London: UCL Press.

Dietler, M. 1994. 'Our ancestors the Gauls': Archaeology, ethnic nationalism, and the manipulation of Celtic identity in modern Europe. *American Anthropologist* 96(3): 584–605.

Dixon, R.B. 1913. Some aspects of North American archaeology. *American Anthropologist* 15: 549–66.

DNH. 1996 *Portable Antiquities: A Discussion Document*. London: Department of National Heritage. Available at www.archaeologyuk.org/conservation/portant/research (accessed March 2015)

Dobat, A.S. 2013. Between rescue and research: An evaluation after 30 years of liberal metal detecting in archaeological research and heritage practice in Denmark. *European Journal of Archaeology* 16(4): 704–25.

Dobinson, C. and Denison, S. 1995. *Metal Detecting and Archaeology in England*. York and London: English Heritage and Council for British Archaeology.

Dobson, D., Fox, A., Hawkes, J. and Eates, M.E. 1944. *Preliminary Report of the Sub-Committee on Archaeology and Education for Submission to the Executive Committee of the Council for British Archaeology*. London: Council for British Archaeology.

Doeser, J., Dhanjal, S., Hinton, A. and Orton, C. 2012. *Diversifying Participation in the Historic Environment Workforce: A Report Commissioned by the Council for British Archaeology Diversifying Participation Working Group*. London: UCL Centre for Applied Archaeology. Available at http://new.archaeologyuk.org/Content/downloads/4291_Research_Bulletin_Number_2_final_resized.pdf [last accessed 10 October 2016].

Dowdall, K.M. and Parrish, O.O. 2002. A meaningful disturbance of the earth. *Journal of Social Archaeology* 3(1): 99–133.

Drewermann, E. 1983. *Tiefenpsychologie und Exegese 1: Die Wahrheit der Formen. Traum, Mythos, Märchen, Sage und Legende*. Munich: DTV.

Dubois, Cl.-G. 1972. *Celtes et gaulois au XVIe siècle*. Paris: Vrin.

Duesterberg, S. 2015. *Popular Receptions of Archaeology: Fictional and Factual Texts in 19th and Early 20th Century Britain*. Bielefeld: Transcript Verlag.

Duineveld, M., Van Assche, K. and Beunen, R. 2013. Malta's unintentional consequences: Archaeological heritage and the politics of exclusion in the Netherlands. *Public Archaeology* 12(3): 139–54.

Dümcke, C. and Gnedovsky, M. 2013. *The Social and Economic Value of Cultural Heritage: Literature Review*. Available at http://addict.pt/wp-content/uploads/2014/05/EENC-CDümcke-MGnedovsky-Cultural-Heritage-Literature-Review-July-2013.pdf [last accessed 10 October 2016].

Dunn, S., and Hedges, M. 2012. *Crowd-Sourcing Scoping Study: Engaging the Crowd with Humanity Research*. London: Centre for e-Research, Department of Digital Humanities, King's College London. Available at www.nottingham.ac.uk/digital-humanities-centre/documents/dunn-and-hedges-crowdsourcing.pdf [last accessed 10 October 2016].

Eberhardt, G. and Link, F. (eds.) 2015. *Historiographical Approaches to Past Archaeological Research*. Berlin: Edition Topoi.

Ebeling, K. n.d. *Ausgraben und Erinnern: Benjamins archäologisches Denkbild*. Available at www.archive-der-vergangenheit.de/vorlesung/text/denkbild_1024.html [last accessed 17 June 2017]

Economist. 2012. *Of marbles and men. The Economist* (19 May). Available at www.economist.com/node/21555531 [last accessed 10 October 2016].

ECORYS. 2012. *The Economic Impact of Maintaining and Repairing Historic Buildings in England*. Available at http://closedprogrammes.hlf.org.uk/aboutus/howwework/Documents/Historic_Buildings_Study_Ecorys_2012.pdf [last accessed 10 October 2016].

ECOTEC. 2008. *Economic Impact of the Historic Environment in Scotland: A Final Report by ECOTEC for the Historic Environment Advisory Council for Scotland*. Birmingham: ECOTEC.

ECtHR (European Court of Human Rights). 2001. *Streletz, Kessler and Krenz v. Germany – applications nos. 34044/96, 35532/97 and 44801/98* [22 March 2001]. Strasbourg: European Court of Human Rights.

Edwards, A., Housley, W., Williams, M., Sloan, L. and Williams, M. 2013. Digital social research, social media and the sociological imagination: Surrogacy, augmentation and re-orientation. *International Journal of Social Research Methodology* 16(3): 245–60.

Effros, B. 2012. *Uncovering the Germanic Past: Merovingian Archaeology in France 1830–1914*. Oxford: Oxford University Press.

eftec. 2005. *Valuation of the Historic Environment: The Scope for Using Results of Valuation Studies in the Appraisal and Assessment of Heritage-Related Projects and Programmes. Final Report*. Report to English Heritage, the Heritage Lottery Fund, the Department for Culture, Media and Sport and the Department for Transport.

Eisenberg, J.M. 1995. Ethics and the antiquity trade. In K.W. Tubb (ed.), *Antiquities Trade or Betrayed: Legal, Ethical and Conservation Issues*. London: Archetype, 215-2–21.

Elia, R.J. 1996. A seductive and troubling work. In K.D. Vitelli (ed.), *Archaeological Ethics*. Walnut Creek, CA: Altamira, 54-6–62.

2001. Analysis of the looting, selling, and collecting of Apulian red-figure vases: A quantitative approach. In N. Brodie, J. Doole, and C. Renfrew (eds.), *Trade in Illicit Antiquities: The Destruction of the World's Archaeological Heritage*. Cambridge: McDonald Institute, 145-5–53.

English Heritage. 1991. *Management of Archaeological Projects*. London: English Heritage.

1999. *The Heritage Dividend: Measuring the Results of English Heritage Regeneration 1994–1999*. London: English Heritage.

2000. *Power of Place: The Future of the Historic Environment*. London: English Heritage. Available at www.english-heritage.org.uk/publications/power-of-place [last accessed 10 October 2016].

2006. *Heritage Counts: The State of England's Historic Environment*. London: English Heritage.

2007. *Valuing Our Heritage: The Case for Future Investment in the Historic Environment*. London: English Heritage.

2013. *Heritage Works: The Use of Historic Buildings in Regeneration*. Available at www.english-heritage.org.uk/publications/heritage-works [last accessed 10 October 2016].

Enterprise LSE. 2010. *The Economic Impact of ICT. SMART N. 2007/0020. Final Report* (January). Available at http://ec.europa.eu/information_society/newsroom/cf/dae/document.cfm?doc_id=669 [last accessed 10 October 2016].

Erbil, Ö. 2014a: *Harvard mezunu arkeolog mobbinge isyan etti: Namert korkaklar! [Harvard graduate archaeologist rebelled against mobbing: Craven cowards!]* Radikal (19 September). Available at www.radikal.com.tr/turkiye/harvard_mezunu_arkeolog_mobbinge_isyan_etti_namert_korkaklar-1213607 [last accessed 10 October 2016].

2014b: *Harvard diplomalı arkeolog, Artuklu Üniversitesi'ndeki görevinden alındı [Harvard-certified archaeologist removed from her post at Artuklu University]*. Radikal (19 September). Available at www.radikal.com.tr/turkiye/harvard_diplomali_arkeolog_artuklu_universitesindeki_gorevinden_alindi-1213711 [last accessed 10 October 2016].

2014c: *Arkeoloji bölümüne ilahiyatçı başkan [Theologian head of archaeology department]*. Radikal (26 December). Available at www.radikal.com.tr/turkiye/arkeoloji_bolumune_ilahiyatci_baskan-1259354 [last accessed 10 October 2016].

Erdély, I. 1977. *Les anciens Hongrois et les ethnies voisines á l'est*. Studia Archaeologica Vol. 6. Budapest: Akademia Kiadó.

Ertani, E. 2013. *TTK Ermeni meselesini araştıran öğrencileri fişlemiş [Turkish Historical Society (TTK) indexed students who researched the Armenian issue]. Agos* (12 December). Available at www.agos.com.tr/tr/yazi/6174/ttk-ermeni-meselesini-arastiran-ogrencileri-fislemis [last accessed 10 October 2016].

Espenshade, C., Jolley, R. and Legg, J. 2002. The value and treatment of Civil War military sites. *North American Archaeologist* 23(1): 39–67.

European Commission. 2011. *Digital Competence in the Digital Agenda: Digital Agenda Scoreboard 2011*. Available at https://ec.europa.eu/digital-agenda/sites/digital-agenda/files/digitalliteracy.pdf [last accessed 10 October 2016].

Evans, C. 1989. Digging with the pen: Novel archaeologies and literary traditions. *Archaeological Review from Cambridge* 8(2): 186–211.

1995. Archaeology against the state: Roots of internationalism. In P.J. Ucko (ed.) *Theory in Archaeology: A World Perspective*. London: Routledge, 312–26.

2006. Engineering the past: Pitt Rivers, Nemo and *The Needle*. *Antiquity* 80: 960–9.

Evans, J. 1975. *Archaeology as Education and Profession*. London: Institute of Archaeology.

Exhibition catalogue. 1990. *Euphronios, peintre à Athènes au VIe siècle avant J.-C.: Musée du Louvre, Paris, 18 septembre-3-31 décembre 1990*. Paris: Éditions de la Réunion des musées nationaux.

Exhibition catalogue. 1994. *A Passion for Antiquities: Ancient Art from the Collection of Barbara and Lawrence Fleischman*. Malibu, Calif. A: J. Paul Getty Museum in association with the Cleveland Museum of Art.

The Extraordinary Adventures of Adèle Blanc-Sec. 2010. [Film]. Luc Besson, dir. EuropaCorp.

Fagan, B. 2003. 'Come, let me tell you a tale'. In B. Cripps, R. Dickau, L.J. Hartery, M. Lobb, L. Nicholls and T. Varney (eds.) *Archaeology into the New Millennium: Public or Perish*. Calgary: Archaeological Association of the University of Calgary, 2–5.

2005. *Writing Archaeology: Telling Stories about the Past*. Walnut Creek, CA: Left Coast Press.

Farid, S. 2014. From excavation to dissemination: Breaking down the barriers between archaeology and the public. In P. Stone and Z. Hui (eds.) *Sharing Archaeology: Academe, Practice and the Public*. Abingdon: Routledge, 117–32.

Faulkner, N. 2000. Archaeology from below. *Public Archaeology* 1(1): 21–33.

Feder, K.L. 1984. Irrationality and popular archaeology. *American Antiquity*, 49(3): 525–41.

2002. *Frauds, Myths and Mysteries: Science and Pseudoscience in Archaeology*. London: McGraw Hill.

Feder, K. 2002. *Frauds, Myths and Mysteries: Science and Pseudoscience in Archaeology*, 4th edition. London: McGraw-Hill Mayfield.

Felch, J. and R. Frammolino,. R. 2011. *Chasing Aphrodite: The Hunt for Looted Antiquities at the World's Richest Museum*. New York: Houghton Mifflin Harcourt.

Fell, H.B. 1976. *America B.C.: Ancient Settlers in the New World*. New York: Quadrangle.

Fiske, A. 1991. *Structures of Social Life: The Four Elementary Forms of Human Relations*. New York: The Free Press.

Flatman, J. 2011. *Becoming an Archaeologist: A Guide to Professional Pathways*. Cambridge: Cambridge University Press.

2012. Conclusion: The contemporary relevance of archaeology – archaeology and the real world? In M. Rockman and J. Flatman (eds.) *Archaeology in Society: Its Relevance in the Modern World*. London: Springer, 291–303.

Fodor, I. 1998. L'origine du peuple hongrois et la conquête de la Patrie. In I. Fodor, L. Revesz, M. Wolf, I.M. Nepper, C. Morigi Govi and J-Y. Marin (eds.) *L'an mil et la Hongrie: naissance d'une nation européenne*. Milano: Skira, 29–35.

Fontein, J. 2006. *The Silence of Great Zimbabwe: Contested Landscapes and the Power of Heritage*. London: UCL Press.

Fowler, P. 2006. Archaeology in a matrix. In J. Hunter and I. Ralston (eds.) *Archaeological Resource Management in the UK: An Introduction*. Stroud: Sutton Publishing, 1–10.

Freud, S. 1899. Über Kindheits- und Deckerinnerungen. In *Monatsschrift für Psychiatrie und Neurologie: Über Deckerinnerungen: Gesammelte Werke I*. Frankfurt: Fischer Verlag, 531–54.

Fulford, M. 2011. The impact of commercial archaeology on the UK heritage. In J. Curtis, M. Fulford, A. Harding and F. Reynolds (eds.) *History for the Taking? Perspectives on Material Heritage*. London: British Academy, 33–53.

Gardner, A. 2012. Strategy games and engagement strategies. In C. Bonacchi (ed.) *Archaeologists and the Digital: Towards Strategies of Engagement*. London: Archetype, 38–49.

Gardner, H. 1983. *Frames of Mind: The Theory of Multiple Intelligences*. New York: Basic Books.

1999. *Intelligence Reframed: Multiple Intelligences for the 21st Century*. New York: Basic Books.

Garduño Freeman, C. 2010. Photosharing on Flickr: Intangible heritage and emergent publics. *International Journal of Heritage Studies* 16(4–5): 352–68. DOI: 10.1080/13527251003775695.

Geary, P. 2002. *The Myth of Nations: The Medieval Origins of Europe*. Princeton, NJ: Princeton University Press.

Gere, C. 2009. *Knossos and the Prophets of Modernism*. Chicago, IL: University of Chicago Press.

Gero, J.M. 2000. *Why and whither WAC? World Archaeological Bulletin* 12. Available at http://web.archive.org/web/20020928024951/http://www.wac.uct.ac.za/bulletin/wab12/Gero.html [last accessed 10 October 2016].

Getty Museum. 1993. *The Getty Kouros Colloquium, Athens, 25-2–27 May 1992*. Athens and Malibu, CA: Nicholas P. Goulandris Foundation / Museum of Cycladic Art / J. Paul Getty Museum.

1997. *Masterpieces of the J. Paul Getty Museum: Antiquities*. Los Angeles: J. Paul Getty Museum.

Getz-Gentle, P. 2001. *Personal Styles in Early Cycladic Sculpture*. Madison, WI: The University of Wisconsin Press.

Getz-Preziosi, P. 1987. *Sculptors of the Cyclades: Individual and Tradition in the Third Millennium BC*. Ann Arbor, MI: The University of Michigan Press.

Gewirth, A. 1978. *Reason and Morality*. London: University of Chicago Press.

1982. *Human Rights: Essays on Justification and Applications*. London: University of Chicago Press.

Gill, D.W.J. 1997. Sotheby's, sleaze and subterfuge: Inside the antiquities trade. *Antiquity* 71: 468-7-71.

1998. Review of Masterpieces of the J. Paul Getty Museum: Antiquities (Los Angeles 1997). *Bryn Mawr Classical Review.*

2007. Review of Peggy Sotirakopoulou, *The Keros Hoard: Myth or Reality? Searching for the Lost Pieces of a Puzzle.* Athens: N.P. Goulandris Foundation – Museum of Cycladic Art, 2005. *American Journal of Archaeology* 111: 163-6-5.

2009a. Electronic review of James Cuno, *Who Owns Antiquity? Museums and the Battle Over Our Ancient Heritage* (Princeton University Press, 2008). *American Journal of Archaeology* 113: 104.

2009b. Looting matters for classical antiquities: Contemporary issues in archaeological ethics. *Present Pasts* 1: 77-1–104.

2010a. Collecting histories and the market for classical antiquities. *Journal of Art Crime* 3: 3-1–10.

2010b. Context matters. Greece and the U.S.: reviewing cultural property agreements. *Journal of Art Crime* 4: 73-7-6.

2010c. The Portable Antiquities Scheme and the Treasure Act: Protecting the archaeology of England and Wales? *Papers from the Institute of Archaeology* 20: 1-1–11.

2010d. The returns to Italy from North America: An overview. *Journal of Art Crime* 3: 105-0-9.

2012a. Context matters: Fragmented pots, attributions and the role of the academic. *Journal of Art Crime* 8: 79-8-84.

2012b. The material and intellectual consequences of acquiring the Sarpedon krater. In P. K. Lazrus and A. W. Barker (eds.), *All the King's Horses: Essays on the Impact of Looting and the Illicit Antiquities Trade on Our Knowledge of the Past.* Washington, DC: Society for American Archaeology, 25-4–42.

2013a. Context matters: Dallas Museum of Art takes the initiative. *Journal of Art Crime* 9: 79-8–84.

2013b. Context matters: The Cleveland Apollo goes public. *Journal of Art Crime* 10: 69-7–75.

2014. Looting Matters: Blogging in a research context. In D. Rocks-Macqueen and C. Webster (eds.), *Blogging Archaeology.* Sheffield: Landward Research Ltd, 44-5–59, 246-6–67.

Gill, D.W.J. and C. Chippindale. C. 1993. Material and intellectual consequences of esteem for Cycladic figures. *American Journal of Archaeology* 97: 601-5–59.

2002. The trade in looted antiquities and the return of cultural property: A British parliamentary inquiry. *International Journal of Cultural Property* 11: 50-6–64.

2006. From Boston to Rome: Reflections on returning antiquities. *International Journal of Cultural Property* 13: 311-3–31.

2007. From Malibu to Rome: Further developments on the return of antiquities. *International Journal of Cultural Property* 14: 205-4–40.

2008. South Italian pottery in the Museum of Fine Arts, Boston acquired since 1983. *Journal of Field Archaeology* 33: 462-7–72.

2011. Polaroids from the Medici Dossier: Continued sightings on the market. *Journal of Art Crime* 5: 27-3–33.

Gill, D.W.J. and M. Vickers, M. 1995. They were expendable: Greek vases in the Etruscan tomb. *Revue des études anciennes* 97: 225-4–49.

Gimbutas, M. 1974. *Gods and Goddesses of Old Europe.* London: Thames & Hudson.

1989. *The Language of the Goddess: Unearthing Hidden Symbols of Western Civilization.* London: Thames & Hudson.

Girard, L.G. and Nijkamp, P. (eds.) 2009. *Cultural Tourism and Sustainable Local Development.* Aldershot: Ashgate.

Global Heritage Fund. 2010. *Saving Our Vanishing Heritage: Safeguarding Endangered Cultural Heritage Sites in the Developing World.* Palo Alto, CA: Global Heritage Fund.

Goddard, I. and Fitzhugh, W.W. 1978. Barry Fell re-examined. *The Biblical Archaeologist* 41(3): 85–8.

Gonzalez-Tennant, E. 2010. Community centered praxis in conflict archaeology: Creating an archaeology of redress with the 1923 race riot in Rosewood, Florida. *SAA Archaeological Record* 10(4): 60–1.

Goonesekere, S. 1998. *A Rights-Based Approach to Realizing Gender Equality.* New York: United Nations Division for the Advancement of Women (UNDAW). Available at www.un.org/womenwatch/daw/news/savitri.htm [last accessed 10 October 2016].

Goskar, T. 2012. Wessex archaeology and the web: Amesbury archer to Archaeocast. In C. Bonacchi (ed.) *Archaeology and Digital Communication: Towards Strategies of Public Engagement.* London: Archetype Publications, 25–37.

Gould, P.G. and Burtenshaw, P. 2014. Archaeology and economic development. *Public Archaeology* 13(1–3): 3–9.

Grafton, A. 1990. Invention of tradition and traditions of invention in Renaissance Europe: The strange case of Annius of Viterbo. In A. Grafton and A. Blair (eds.) *The Transmission of Culture in Early Modern Europe*. Philadelphia, PA: University of Pennsylvania Press, 8–38.

Graham, B., Ashworth, G.J. and Tunbridge, J.E. 2000. *A Geography of Heritage: Power, Culture and Economy*. London: Arnold.

Gramsch, A. 2005. Archäologie und post-nationale Identitätssuche. *Archäologisches Nachrichtenblatt* 10(2): 185–93.

Gramsch, A. 2007. 'Schweizerart ist Bauernart': Mutmaßungen über Schweizer Nationalmythen und ihren Niederschlag in der Urgeschichtsforschung. In S. Grunwald, J.K. Koch, U. Sommer and S. Wolfram (eds.) *Artefact, Festschrift für Frau Professor Dr. Sabine Rieckhoff zum 65. Geburtstag*. Bonn: Habelt, 71–85.

Gray, C. 2007. Commodification and instrumentality in cultural policy. *International Journal of Cultural Policy* 13(2): 203–15.

Green, B. and Gregory, T. 1978. An initiative on the use of metal detectors in Norfolk. *Museums Journal* 77(4): 161–2.

Greer, S. 2010. Heritage and empowerment: Community-based Indigenous cultural heritage in northern Australia. *International Journal of Heritage Studies* 16(1–2): 45–58.

2014. The Janus view: Reflecting on the community-based approach to archaeological research and heritage in northern Cape York. *Journal of Community Archaeology and Heritage* 1(1): 56–68.

Greer, S., Harrison, R. and McIntyre-Tamwoy, S. 2002. Community-based archaeology in Australia. *World Archaeology* 34(2): 265–87.

Griffiths, E. 2009. *The Crossing Places*. Boston, MA: Houghton Mifflin Harcourt.

Grima, R. 2002. Archaeology as encounter. *Archaeological Dialogues* 9(2): 83–9.

Grimm, J. 1835. *Deutsche Mythologie*. Göttingen: Dieterich'sche Buchhandlung.

Grimm, W. and Grimm, J. 1812–15. *Kinder- und Hausmärchen*. Berlin: Realschulbuchhandlung.

Gruber, E., Heath, S., Meadows, A., Pett, D., Tolle, K. and Wigg-Wolf, D. 2013. *Semantic web technologies applied to numismatic collections*. In G. Earl, T.Sly, A. Chrysanthi, P. Murrieta-Flores, C. Papadopoulos, I. Romanowska and D. Wheatley (eds.) 2013. *Archaeology in the Digital Era: Papers from the 40th Annual Conference of Computer Applications and Quantitative Methods in Archaeology (CAA), Southampton, 26–29 March 2012*. Amsterdam: Amsterdam University Press.

Grunwald, S. 2012. '… to ransack the wall would give trouble and would waste time': Hillfort archaeology in Saxony in the 19th century. In O.W. Jensen (ed.) *Histories of Archaeological Practices: Reflections on Methods, Strategies and Social Organisation in Past Fieldwork*. Stockholm: Historiska muséet, 175–89.

Gui, M. and Argentin, G. 2011. Digital skills of Internet natives: Different forms of digital literacy in a random sample of northern Italian high school students. *New Media and Society* 13(6): 963–80.

Guinness, A. 2014. Are they being served? Delivering relevant training for the next generation of community archaeologists and their future employers. *Journal of Community Archaeology and Heritage* 1(2): 118–36.

Halbwachs, M. 1941. *La Topographie légendaire des Èvangiles en Terre Sainte*. Paris: Presses Universitaires de France.

Hall, M. 1995. Great Zimbabwe and the Lost City: The cultural colonization of the South African past. In P.J. Ucko (ed.) *Theory in Archaeology: A World Perspective*. London: Routledge, 29–45.

2004. Romancing the stones: Archaeology in popular cinema. *European Journal of Archaeology* 7(2): 159–76.

Hall, R.N. 1909. *Prehistoric Rhodesia*. London: Unwin.

Hampton, M.P. 2005. Heritage, local communities and economic development. *Annals of Tourism Research* 32(3): 735–59.

Hancock, G. 1995. *Fingerprints of the Gods: The Evidence of Earth's Lost Civilization*. New York: Crown Publishers.

2005. Underworld: Confronting Yonaguni. In P. Peet (ed.) *Disinformation Guide to Ancient Aliens, Lost Civilizations, Astonishing Archaeology and Hidden History*. San Francisco, CA: Disinformation Books, 125–48.

Hansen, D. and Fowler, J. 2008. Protect and present: Parks Canada and public archaeology in Atlantic Canada. In J. Jameson and S.Baugher (eds.) *Past Meets Present: Archaeologists*

Partnering with Museum Curators, Teachers, and Community Groups. New York: Springer, 321–38.

Hamilakis, Y. 2007. *The Nation and its Ruins: Antiquity, Archaeology, and National Imagination in Greece*. Oxford: Oxford University Press.

— 2008. Decolonising Greek archaeology: Indigenous archaeologies, modernist archaeology, and the post-colonial critique. In D. Damaskos and D. Plantzos (eds.) *A singular Antiquity*. Athens: Benaki Museum, 273–84.

Hampel, J. 1905. *Alterthümer des frühen Mittelalters in Ungarn*. Braunschweig: Friedrich Viehweg und Sohn.

Hardy, S.A. 2013. *The facts in the ground: Archaeological resistance during Occupy Gezi*. International State Crime Initiative (3 August). Available at http://unfreearchaeology.word-press.com/2013/08/10/turkey-occupy-gezi-park-archaeology-resistance [last accessed 10 October 2016].

— 2015. Virtues impracticable and extremely difficult: The human rights of subsistence diggers. In A. González-Ruibal and G.Moshenska (eds.) *Ethics and the Archaeology of Violence*. London: Springer, 229–39.

Hargittai, E. 2002. Second-level digital divide: Differences in people's online skills. *First Monday* 7(4) (1 April. Available at http://firstmonday.org/article/view/942/864 [last accessed 10 October 2016].

Harris, T. 2012. Interfacing archaeology and the world of citizen sensors: Exploring the impact of neogeography and volunteered geographic information on an authenticated archaeology. *World Archaeology* 44(4): 580–91. DOI: 10.1080/00438243.2012.736273.

Harrison, R. 2010. Exorcising the 'plague of fantasies': Mass media and archaeology's role in the present; or why we need an archaeology of now. *World Archaeology* 42(3): 328–40.

Harrold, F.B. and Eve, R.A. 1995. *Cult Archaeology and Creationism*. Iowa City: University of Iowa Press.

Harvey, J.H. 1940. *The Heritage of Britain*. London: The Right Review.

Hatházi, G. and Szende C. 2003. Ethnic groups and cultures in medieval Hungary. In *Hungarian Archaeology at the Turn of the Millennium*. Budapest: Ministry of National Cultural Heritage, 388–97.

Hauser, K. 2007. *Shadow Sites: Photography, Archaeology, and the British Landscape 1927–1955*. Oxford: Oxford University Press.

Hawkes, J. 1982. *Adventurer in Archaeology: The Biography of Sir Mortimer Wheeler*. New York: St Martin's Press.

Haythornthwaite, C. 2009. *Crowds and communities: Light and heavy work of peer production*. In C. Haythornthwaite and A.Gruzd (eds.) *Proceedings of the 42nd Hawaii International Conference on System Sciences*. Los Alamitos, CA: IEEE Computer Society. Available at www.ideals.illinois.edu/handle/2142/9457 [last accessed 10 October 2016].

Heaton, M. 2014. Constructing archaeology: The application of construction management practices to commercial archaeology in Britain. *The Historic Environment: Policy & Practice* 5(3): 245–57.

Heer, O. 1865. *Die Pflanzen der Pfahlbauten*. Zurich: Zürcher und Furrer.

Hein, G. 1995. The constructivist museum. *Journal for Education in Museums* 16: 21–3. Available at www.gem.org.uk/pubs/news/hein1995.html [last accessed 10 October 2016].

Heimpel, H. 1994. Sitzordnung und Rangstreit auf dem Basler Konzil: Skizze eines Themas. In J. Helmrath and H. Müller (eds.) *Studien zum 15. Jahrhundert. Festschrift für Erich Meuthen*. Munich: Oldenbourg, 1–9.

Hennessy, K. 2015. *Digital returns, hybrid futures*. Segundo Congreso Internacional El Patrimonio Cultural y las Nuevas Tecnologias, 12–16 October 2015, Mexico City, Mexico. Available at www.youtube.com/watch?v=BQvrrvZx86c [last accessed 10 October 2016].

Henry, P. 2004. The Young Archaeologists' Club: Its role within informal education. In D. Henson, P. Stone and M. Corbishley (eds.) *Education and the Historic Environment*. London and New York: Routledge, 89–99.

Henson, D. (ed.) 1997. *Archaeology in the English National Curriculum.*. York: Council for British Archaeology.

— 2000. Teaching the past in the United Kingdom's schools. *Antiquity* 74: 137–41.

— 2004. Archaeology and education: An exercise in constructing the past. In P. Gonzalez (ed.), *Comunicar el passat: Creació i divulgació de l'arqueologia i de la història*. Barcelona: Universitat Autònoma de Barcelona, 5–16.

2004. Archaeology in schools. In D. Henson, P. Stone and M.Corbishley (eds.) *Education and the Historic Environment*. London: Routledge, 23–32.

2005. Teaching our common humanity. *British Archaeology* 82: 44.

2008. Putting people in their place: The link between citizenship and heritage. *Journal of Education in Museums* 29: 28–36.

2009. In my view: The true end of archaeology? *Primary History* 51: 7–8.

2012. Does archaeology matter? In G. Moshenska and S.Dhanjal (eds.) *Community Archaeology: Themes, Methods and Practices*. Oxford: Oxbow, 120–7

Henson, D., Bodley, A. and Heyworth, M. 2006. The educational value of archaeology. In J.-C. Marquet, C. Pathy-Barker and C.Cohen (eds.) *Archaeology and Education: From Primary School to University*. British Archaeological Reports International Series (BAR S) 1505. Oxford: Archaeopress.

Henson, D., Stone, P.G. and Corbishley, M. (eds.) 2004. *Education and the Historic Environment*. London: Routledge.

Helbling-Gloor, B. 2004. Die Pfahlbauern in Schulbuch und Jugendliteratur. In Antiquarische Gesellschaft in Zürich (ed.) *Pfahlbaufieber. Von Antiquaren, Pfahlbaufischern, Altertümerhändlern und Pfahlbaumythen*. Mitteilungen der Antiquarischen Gesellschaft Zürich 71. Zurich: Chronos, 187–201.

Herder, J.G. 1784–91. *Ideen zur Philosophie der Geschichte der Menschheit*. Riga: Johann Friedrich Hartknoch.

Heritage Lottery Fund. 2010. *Investing in Success: Heritage and the UK Tourism Economy*. London: Heritage Lottery Fund. Available at www.hlf.org.uk/investing-success-heritage-and-uk-tourism-economy [last accessed 10 October 2016].

Heurgon, J. 1989. Graffites étrusque au J. Paul Getty Museum. In *Greek Vases in the J. Paul Getty Museum 4*. Malibu, CA: J. Paul Getty Museum, 181-6–6.

Hewison, R. 2012. The benefits of the valuing culture debate, 2003–2011. *Cultural Trends* 21(3): 209–10.

Hingley, R. 2000. *Roman Officers and English Gentlemen: The Imperial Origins of Roman Archaeology*. London: Routledge.

Hill, G.F. 1936. *Treasure Trove in Law and Practice*. Oxford: Clarendon Press.

Hiscock, P. 2012. Cinema, supernatural archaeology, and the hidden human past. *Numen* 59: 156–77.

Historic England. 2015a. *Management of Research Projects in the Historic Environment: The MoRPHE Project Managers' Guide*. London: Historic England.

2015b. *The Historic Environment in Local Plans: Historic Environment Good Practice Advice in Planning Note 1*. London: Historic England.

Hodder, I. 1982. *Symbols in Action: Ethnoarchaeological Studies of Material Culture*. Cambridge: Cambridge University Press.

2010. Cultural heritage rights: From ownership and descent to justice and well-being. *Anthropological Quarterly* 83(4): 861–82.

Hogarth, D.G., James, M.R., Elsey Smith, R. and Gardner, E.A. 1888. Excavations in Cyprus, 1887–88: Paphos, Leontari, Amargetti. *Journal of Hellenic Studies* 9: 147–271.

Holden, J. 2004. *Capturing Cultural Value: How Culture has Become a Tool of Government Policy*. London: Demos. Available at www.demos.co.uk/files/CapturingCulturalValue.pdf [last accessed 10 October 2016].

2006. *Cultural Value and the Crisis of Legitimacy: Why Culture Needs a Democratic Mandate*. London: Demos. Available at www.demos.co.uk/files/Culturalvalueweb.pdf [last accessed 10 October 2016].

Hole, B. 2012. A call for open scholarship in archaeology. In C. Bonacchi (ed.) *Archaeology and Digital Communication: Towards Strategies of Public Engagement*. London: Archetype Publications, 114–26.

Holtorf, C. 2005. Beyond crusades: How (not) to engage with alternative archaeologies. *World Archaeology* 37(4): 544–51.

2005. *From Stonehenge to Las Vegas: Archaeology as Popular Culture*. London: Altamira.

2007. *Archaeology is a Brand! The Meaning of Archaeology in Contemporary Popular Culture*. Oxford: Archaeopress.

Honey, P. and Mumford, A. 1982. *Manual of Learning Styles*. London: P. Honey.

Hoppenstand, G., 2000. Elizabeth Peters: *The Last Camel Died at Noon* as lost world adventure pastiche. In R.B. Browne and L.A. Kreiser Jr. (eds.) *The Detective as Historian: History and Art in Historical Crime Fiction*. Madison, WI: University of Wisconsin Press, 293–305.

Hooper-Greenhill, E. 2007. *Museums and Education: Purpose, Pedagogy, Performance.* London: Routledge.

Housley, W., Procter, R., Edwards, A., Burnap, P., Williams, M., Sloan, L., Rana, O., Morgan, J., Voss, A. and Greenhill, A. 2014. Big and broad social data and the sociological imagination: A collaborative response. *Big Data & Society* 1(1). DOI: 10.1177/2053951714545135.

Howe, J. 2006. *The rise of crowdsourcing. Wired* (June). Available at www.wired.com/2006/06/crowds [last accessed 10 October 2016].

Howell, R. (ed.) 1994. *Archaeology and the National Curriculum in Wales.* Cardiff: Council for British Archaeology, Cadw and National Museum of Wales.

Huggett, J. 2012. Lost in information? Ways of knowing and modes of representation in e-archaeology. *World Archaeology* 44(4): 538–52. DOI: 10.1080/00438243.2012.736274.

Hürriyet Daily News. 2013. *Turkish history body 'profiling' scholars working on Armenian issue: Report. Hürriyet Daily News* (13 December). Available at www.hurriyetdailynews.com/Default.aspx?pageID=549&nID=59490&NewsCatID=338 [last accessed 10 October 2016].

ICOMOS. 1964. *International Charter for the Conservation and Restoration of Monuments and Sites* (The Venice Charter) Available at www.icomos.org/charters/venice_e.pdf [last accessed 10 October 2016].

 2008. *The ICOMOS Charter for the Interpretation and Presentation of Cultural Heritage Sites.* Available at http://Icip.Icomos.Org/Downloads/ICOMOS_Interpretation_Charter_ENG_04_10_08.pdf [last accessed 10 October 2016].

 2013. *The Burra Charter: The Australia ICOMOS Charter for Places of Cultural Significance.* Available at http://Australia.Icomos.Org/Publications/Charters [last accessed 10 October 2016].

Indiana Jones and the Last Crusade. 1989. [Film]. Steven Spielberg, dir. Lucasfilm.

Jackson, K. and Stamp, J. 2002. *Pyramid: Beyond Imagination. Inside the Great Pyramid of Giza.* London: BBC.

James, M.R. 1903. Discoveries at Bury St. Edmunds. *The Times,* 9 January 1903, p. 9.

 2007. *Collected Ghost Stories.* Ware: Wordsworth Editions.

Jameson, J.H. 2003. Purveyors of the past: Education and outreach as ethical imperatives in archaeology. In L.J. Zimmerman, K.D. Vitelli and J. Hollowell-Zimmer (eds.) *Ethical Issues in Archaeology.* Walnut Creek, CA: Alta Mira Press, 153–62.

 2004. Public archaeology in the United States. In N. Merriman (ed.) *Public Archaeology.* London: Routledge, 21–58.

Jeater, M. 2012. Smartphones and site interpretation: The Museum of London's Streetmuseum applications. In C. Bonacchi (ed.) *Archaeology and Digital Communication: Towards Strategies of Public Engagement.* London: Archetype Publications, 66–82.

Jeffery-Clay, K.R. 1998. Constructivism in museums: How museums create meaningful learning environments. *Journal of Museum Education* 23(1): 3–7.

Jeppson, P. and Brauer, G. 2008. Archaeology for education needs: An archaeologist and an educator discuss archaeology in the Baltimore County public schools. In J. Jameson and S.Baugher (eds.) *Past Meets Present: Archaeologists Partnering with Museum Curators, Teachers, and Community Groups.* New York: Springer, 231–48.

Jóhannesdóttir, S. and Ingason, U. 2009. *The Kids' Archaeology Program, Iceland: Goals and Activities.* NABO. Available at www.nabohome.org/projects/kap/fornleifaskolibarnanna1.pdf [last accessed 10 October 2016].

Jokilehto, J. 1999. *A History of Architectural Conservation.* Oxford: Butterworth-Heinemann.

 2007. Conservation concepts. In J. Ashurst (ed.) *Conservation of Ruins.* Oxford: Butterworth-Heinemann, 3–9.

Jones, J.E., L.H. Sackett, L.H. and A.J. Graham., A.J. 1962. The Dema house in Attica. *Annual of the British School at Athens* 57: 75-1–114.

Jones, B. 1984. *Past Imperfect: The Story of Rescue Archaeology.* London: Heinemann.

Jones, D. 2012. *Turkey seeks to retrieve its lost artifacts. Deutsche Welle* (26 September). Available at www.dw.de/turkey-seeks-to-retrieve-its-lost-artifacts/a-16257174 [last accessed 6 April 2016].

Jones, S.P. 2014. *The Clive Cussler Adventures: A Critical Review.* Jefferson, NC: McFarland.

Kador, T. 2014. Public and community archaeology: An Irish perspective. In S. Thomas and J. Lea (eds.) *Public Participation in Archaeology.* Rochester, NY: Boydell & Brewer, 35–48.

Kaeser, M.-A. 1998. Helvétes ou lacustres? La jeune confédération suisse á la recherche d'ân-cestres opérátionels. In U. Altermatt, C. Bosshardt-Pfluger and A. Tanner (eds.) *Die Konstruktion einer Nation. Nation und Nationalisierung in der Schweiz, 18.–20. Jahrhundert.* Zuurich: Chronos, 75–86.

 2004. *Les Lacustres: Archéologie et Mythe National.* Lausanne: Presses Polytechniques et Universitaires.

 2011. Archaeology and the identity discourse: Universalism versus nationalism: Lake-dwelling studies in 19th century Switzerland. In A. Gramsch and U. Sommer (eds.) *A History of Central European Archaeology: Theory, Methods and Politics.* Budapest: Archaeolingua, 143–60.

Kalicz, N. 1970. *Clay Gods: The Neolithic and Copper Age in Hungary.* Budapest: Corvina.

Kangert, N. 2013. *Arheoloogia ja kogukond Rôuge, Padise ja Salme juhtumite näitel Magistritöö.* Unpublished master's dissertation, University of Tartu. Available at www.arheo.ut.ee/docs/MA13_Kangert.pdf [last accessed 10 October 2016].

Karlsgodt, E. 2012. *Defending National Treasures: French Art and Heritage under Vichy.* Stanford, CA: Stanford University Press.

Kasiske, A. 2013. *Archaeology strains German-Turkish relations. Deutsche Welle* (27 April). Available at www.dw.de/archeology-strains-german-turkish-relations/a-16772755 [last accessed 10 October 2016].

Kaul, I., Grunberg, I. and Stern, M.A. 1999. Defining global public goods. In I. Kaul, I. Grunberg and M.A. Stern (eds.) *Global Public Goods: International Cooperation in the 21st Century.* New York and Oxford: Oxford University Press, 2–19.

KD (Kypriaki Dimokratia). 2013. *O peri tis diadikasias typopoiisis ton geografikon toponymion tis Kypriakis Dimokratias Nomos tou 1998 (66(I)/1998) [On the procedure for the standardisation of the geographical toponyms of the Republic of Cyprus: Law of 1998].* Lefkosia: Vouli ton Antiprosopon. Available at www.cylaw.org/nomoi/enop/non-ind/1998_1_66/full.html [last accessed 6 April 2016].

Keller, F. 1854. Die keltischen Pfahlbauten in den Schweizerseen. *Mitteilungen der Antiquarischen Gesellschaft Zu-rich* 9(3): 65–100.

Kiddey, R. and Schofield, J. 2011. Embrace the margins: Adventures in archaeology and home-lessness. *Public Archaeology* 10(1): 4–22.

Kienlin, T. 1999. *Vom Stein zur Bronze: zur soziokulturellen Deutung früher Metallurgie in der englischen Theoriediskussion.* Rahden/Westf.: Leidorf.

King, T.F. 1983. Professional responsibility in public archaeology. *Annual Review of Anthropology* 12: 143–64.

 2004. *Cultural Resource Laws and Practice,* 2nd edition. Walnut Creek, CA: AltaMira Press.

 2012. Forum: Is public archaeology a menace? *AP: Online Journal in Public Archaeology* 2: 5–23.

 2013. *Cultural Resource Laws and Practice,* 4th edition. Lanham, MD: Rowman & Littlefield.

Kinghorn, N. and Willis, K. 2008. Valuing the components of an archaeological site: An application of choice experiment to Vindolanda, Hadrian's Wall. *Journal of Cultural Heritage* 9: 117–24.

Kitchin, R. 2013. Big data and human geography: Opportunities, challenges and risks. *Dialogues in Human Geography* 3(3): 262–7. DOI: 10.1177/2043820613513388.

 2014. Big data, new epistemologies and paradigm shifts. *Big Data & Society* 1(1). DOI: 10.1177/2053951714528481.

Klápště, J. 2007. Die Archäologie des Mittelalters im Spannungsfeld verschiedener Identitäten: Das Fallbeispiel Böhmen. In S. Rieckhoff U. and Sommer (eds.) *Auf der Suche nach Identitäten: Volk – Stamm – Kultur – Ethnos.* Internationale Tagung der Universität Leipzig vom 8.–9. Dezember 2000. British Archaeological Reports International Series S1705. Oxford: Archaeopress, 166–74.

Klemm, G. 1858. *Allgemeine Culturgeschichte der Menschheit.* Leipzig: Teubner.

Knudson, R. 1984. Ethical decision making and participation in the politics of archaeology. In E.L. Green (ed.) *Ethics and Values in Archaeology.* London: The Free Press, 243–63.

Koch, M. 1857. *Keltische Forschungen.* Leipzig: Voigt & Günther.

Kohl, P. 1998. Nationalism and archaeology: On the constructions of nations and the reconstructions of the remote past. *Annual Review of Anthropology* 27: 223–46.

Kohl, P. and Fawcett, C.P. (eds.) 1995. *Nationalism, Politics, and the Practice of Archaeology.* Cambridge: Cambridge University Press.

Kohl, P., Kozelsky, M. and Ben-Yehuda, N. (eds.) 2007. *Selective Remembrances: Archaeology in the Construction, Commemoration and Consecration of National Pasts*. Chicago, IL: University of Chicago Press.

Kołakowski, L. 1995. *Is God happy? Selected Essays*. London: Penguin.

Kolb, D. 1984. *Experiential Learning: Experience as the Source of Learning and Development*. Englewood Cliffs, NJ: Prentice Hall.

Kossinna, G. 1912. *Altgermanische Kulturhöhe*. Würzburg: Kabitzsch.

1919. *Das Weichselland, ein uralter Heimatboden der Germanen*. Danzig: Kafermann.

Kostrzewski, J. 1913. *Wielkopolska w czasach przedhistorycznych*. Poznan: Fiszer i Majewski.

Kostrzewski, J., Jakimowicz, R. and Krukowski, S. 1939. *Prehistoria ziem polskich*. Krakow: Polska Akademia Umiejętności.

Kovacs, G. and Marshall, C.W. 2015. *Son of Classics and Comics*. Oxford: Oxford University Press.

Kozloff, A.P. 1987. Bubon: a re-assessment of the provenance. *Bulletin of the Cleveland Museum of Art* 74: 130-4–43.

Kreis, G. 1998. Schweiz: Nationalpädagogik in Wort und Bild. In M. Flacke (ed.) *Mythen der Nationen, ein europäisches Panorama*. Berlin: Deutsches Historisches Museum, 446–75.

Krusch, B. and Levison, W. (eds.) 1951. *Gregorii episcopi Turonensis. Libri Historiarum X*. Monumenta Germanicae Historiae, Scriptores rerum Merovingicarum I. Hannover: Hahn.

Kuklick, H. 1991. Contested monuments: The politics of archaeology in southern Africa. In G.W. Stocking (ed.) *Colonial Situations: Essays on the Contextualization of Ethnographic Knowledge*. Madison, WI: University of Wisconsin Press, 135–69.

Labadi, S. 2008. *Evaluating the Socio-Economic Impacts of Selected Regenerated Heritage Sites in Europe*. European Cultural Foundation. Available at http://openarchive.icomos.org/1238/1/Sophia_Labadi_2008CPRA_Publication.pdf [last accessed 10 September 2016].

Lafrenz Samuels, K. 2008. Value and significance in archaeology. *Archaeological Dialogues* 15(1): 71–97.

Lake, M. (ed.) 2012. Open archaeology. Special issue of *World Archaeology* 44(4).

Lampe, S. 2014. The scope and potential for community archaeology in the Netherlands. In S. Thomas and J.Lea (eds.) *Public Participation in Archaeology*. Woodbridge: The Boydell Press, 49–59.

Lang, C. 2000. *Developing an Access Policy*. London: Museums and Galleries Commission.

Leach, E.R. 1970. *Political systems of Highland Burma: A Study of Kachin Social Structure*. London: London School of Economics.

Leahy, K. and R. Bland,. R. 2009. *The Staffordshire Hoard*. London: The British Museum Press.

Letsch, C. and Connolly, K. 2013. Turkey wages 'cultural war' in pursuit of its archaeological treasures. *The Guardian* (21 January). Available at www.theguardian.com/world/2013/jan/21/turkey-cultural-war-archaeological-treasure [last accessed 6 April 2016].

Leuzinger, U. 2012. Informing the public: Bridging the gap between experts and enthusiasts. In F. Menotti and A. O'Sullivan (eds.) *The Oxford Handbook of Wetland Archaeology*. Oxford: Oxford University Press. DOI: 10.1093/oxfordhb/9780199573493.013.0051

Lewis, M. 2012. Leaden dolls, books and seals: Fresh insights into post-medieval material culture provided by finds recorded though the Portable Antiquities Scheme. In H. Harnow, D. Cranstone, P. Belford and L. Høst-Madsen (eds.) *Across the North Sea: Later Historical Archaeology in Britain and Denmark, c. 1500–2000 AD*. Odense: University Press of Southern Denmark, 93–103.

Lipe, W. 2009. Archeological values and resource management. In L. Sebastian and W. Lipe (eds.) *Archaeology & Cultural Resource Management: Visions for the Future*. Santa Fe, NM: SAR Press, 41–63.

Lindenschmitt, L. 1846. *Die Räthsel der Vorwelt, oder: Sind die Deutschen eingewandert?* Mainz: Seifert'sche Buchdruckerei.

Lister, M., Dovey, J., Jiddings, S., Grant, I. and Kelly, K. 2009. *New media: A Critical Introduction*. New York: Routledge.

Littré, E. (ed.) 1881. *Hippocrates: On Airs, Waters, and Places*. London: Wyman.

Livingstone, S. and Das, R. 2009. *The End of Audiences: Theoretical Echoes of Reception amidst the Uncertainties of Use. Conference Proceedings: Transforming Audiences 2, 3–4 September 2009, London, UK*. Available at http://eprints.lse.ac.uk/25116 [last accessed 16 November 2015].

Livius, T. *The History of Rome*. Available at http://mcadams.posc.mu.edu/txt/ah/Livy/ [last accessed 18 June 2016].

Lock, G. and Molyneaux, B. (eds.) 2006. *Confronting Scale in Archaeology: Issues of Theory and Practice*. New York: Springer.

Lönnrot, E. 1835. *Kalewala*. Helsingburg: J.C. Frenckellin ja Poika.

Lubbock, J. 1865. *Prehistoric Times, as Illustrated by Ancient Remains and the Manners and Customs of Modern Savages*. London: Williams and Norgate.

Lubbock, G. 1939. *A Memoir of Montague Rhodes James*. Cambridge: Cambridge University Press.

Lucas, G. 2006. Changing configurations: The relationship between theory and practice. In J. Hunter and I. Ralston (eds.) *Archaeological Resource Management in the UK: An Introduction*. Stroud: Sutton Publishing, 15–22.

Luckhurst, R. 2012. *The Mummy's Curse: The True History of a Dark Fantasy*. Oxford: Oxford University Press.

Luke, C. and Kersel, M. 2013. *US Cultural Diplomacy and Archaeology: Soft Power, Hard Heritage*. London: Routledge.

Macalister, R.A.St. 1938. *Lebor Gabála Érenn*. London: Irish Texts Society.

MacDonald, C. and Burtness, P. 2000. Accessing educational systems in Canada and the United States. In K. Smardz and S.Smith (eds.) *The Archaeology Education Handbook: Sharing the Past with Kids*. Walnut Creek, CA: AltaMira Press, 42–53.

Macklin, G. 2008. The two lives of John Hooper Harvey. *Patterns of Prejudice* 42(2): 167–90.

MacMaster, Th.J. 2014. The origin of origins: Trojans, Turks and the birth of the myth of Trojan origins in the medieval world. *Atlantide* 2: 1–12.

Macpherson, J. 1760, *Fragments of Ancient Poetry, Collected in the Highlands of Scotland, and Translated from the Galic or Erse Language*. Edinburgh: Hamilton and Balfour.

Maddison, D. and Mourato, S. 2001. Valuing different road options for Stonehenge. *Conservation and Management of Archaeological Sites* 4(4): 203–12.

Manley, J. 1999. Old stones, new fires: The local societies. In J. Beavis and A. Hunt (eds.) *Communicating Archaeology*. Oxford: Oxbow, 105–12.

Marchal, G.P. 1991. Höllenväter – Heldenväter – Helvetier. *Archäologie der Schweiz* 14(1): 5–13.

Marchand, S. 1996. *Down from Olympus: Archaeology and Philhellenism in Germany, 1750–1970*. Princeton, NJ: Princeton University Press.

Marshall, Y. 2002. What is community archaeology? *World Archaeology* 34(2), 211–9.

Mason, R. (ed.) 1999. *Economics and Heritage Conservation: A Meeting Organised by the Getty Conservation Institute. December 1998. Getty Center, Los Angeles*. Los Angeles: The Getty Conservation Institute.

2008a. Assessing values in conservation planning: Methodological issues and choices. In G. Fairclough, R.Harrison, J.H. Jameson Jnr and J.Schofield (eds.) *The Heritage Reader*. London: Routledge, 99–124.

2008b. Be interested and beware: Joining economic valuation and heritage conservation. *International Journal of Heritage Studies* 14(4): 303–18.

Matsuda, A. 2004. The concept of 'the Public' and the aims of public archaeology. *Papers from the Institute of Archaeology* 15: 66–76.

Matsuda, A. and Okamura, K. 2011. Introduction: New perspectives in global public archaeology. In K. Okamura and A.Matsuda (eds.) *New Perspectives in Global Public Archaeology*. New York: Springer, 1–18.

Matthews, O. 2012. *Turkey's archaeology blackmail*. *Newsweek* (9 April). Available at www.newsweek.com/turkeys-archaeology-blackmail-64037 [last accessed 6 April 2016].

Matthews, W.J. 2003. *Constructivism in the classroom: Epistemology, history, and empirical evidence*. *Teacher Education Quarterly* Summer: 51–64. Available at http://eric.ed.gov/?q=matthews+-constructivism+classroom&id=EJ852364 [last accessed 24 September 2013].

Mattusch, C.C. 1996. *The Fire of Hephaistos: Large Classical Bronzes from North American Collections*. Cambridge, (MA): Harvard University Art Museums.

McDavid, C. 2002. Archaeologies that hurt; descendants that matter: A pragmatic approach to collaboration in the public interpretation of African-American archaeology. *World Archaeology* 34(2): 303–14.

2004. From 'traditional' archaeology to public archaeology to community action: The Levi Jordan plantation project. In P.A. Shackel and E.J. Chambers (eds.) *Public Archaeology as Applied Anthropology*. London: Routledge, 35–56.

2011. *Considering public archaeology in the long run: Capacity building, sustainability, and (sometimes) closing things down*. SHA Blog, edited by T. Brock. Available at www.sha.org/blog/index.php/2011/12/considering-public-archaeology-in-the-long-run-capacity-building-sustainability-and-sometimes-closing-things-down [last accessed 3 November 2013].

2013. Community archaeology. In C. Smith (ed.) *Encyclopedia of Global Archaeology*. New York: Springer.

McEwan, C., Silva, M. and Hudson, C. 2006. Using the past to forge the future: The genesis of the community site museum at Agua Blanca, Ecuador. In H. Silverman and E. Shackel (eds.) *Archaeological Site Museums in Latin America*. Gainesville, FL: University Press of Florida, 187–216.

McGimsey, C.R. 1972. *Public Archaeology*. London: Seminar Press.

McLoughlin, J., Sodagar, B. and Kaminski, J. 2006. Economic valuation methodologies and their application to cultural heritage. In J. McLoughlin, J. Kaminski and B.Sodagar (eds.) *Heritage Impact 2005: Proceedings of the First International Symposium on the Socio-Economic Impact of Cultural Heritage*. Budapest: EPOCH, 8–27.

McNall, B. 2003. *Fun While It Lasted: My Rise and Fall in the Land of Fame and Fortune*. New York: Hyperion.

McQuail, D. 2005. *McQuail's Mass Communication Theory*. London: SAGE.

Mead, R. 2007. Den of antiquity: The Met and the antiquities market. *The New Yorker* (April 9, 2007): 52-6–61.

Meighan, C.W. 1994. Burying American archaeology. *Archaeology* 47(6): 64, 66, 68. Available at http://archive.archaeology.org/online/features/native/debate.html [last accessed 6 April 2016].

Menotti, F. (ed.) 2004. *Living on the Lake in Prehistoric Europe: 150 Years of Lake-dwelling Research*. London: Routledge.

Membury, S. 2002. The celluloid archaeologist: an X-rated expose. In M. Russell (ed.) *Digging Holes in Popular Culture: Archaeology and Science Fiction*. Oxford: Oxbow Books, 8–18.

Merriman, N. (ed.) 2004. *Public Archaeology*. London: Routledge.

1991. *Beyond the Glass Case: The Past, the Heritage and the Public in Britain*. Leicester: Leicester University Press.

Meskell, L. 1995. Goddesses, Gimbutas and 'New Age' archaeology. *Antiquity* 69: 74–86.

Mesterházy, K. 2003. The archaeological Research of the Conquest Period. In *Hungarian Archaeology at the Turn of the Millennium*. Budapest: Ministry of National Cultural Heritage, 321–5.

Meyer, K.M. 1974. *The Plundered Past*. London: Hamish Hamilton.

Miéville, C. 2009. *The City and the City*. Macmillan, London.

Miho Museum. 1997. *Miho Museum: The South Wing*. Kyoto: The Miho Museum.

Miller, D. 1997. *Material Cultures: Why Some Things Matter*. London: UCL Press.

Ministry of National Cultural Heritage (ed.) 2003. *Hungarian Archaeology at the Turn of the Millennium*. Budapest: Department of Monuments of the Ministry of National Cultural Heritage.

Moldenhauer, E. (ed.) 1986. *Georg Wilhelm Friedrich Hegel Werke, Band 12: Vorlesungen über die Philosophie der Geschichte*. Frankfurt: Suhrcamp.

Molnár, M. 2001. *A Concise History of Hungary*. Cambridge: Cambridge University Press.

Montesquieu, C. 1748. *The Spirit of the Laws. De l'Esprit des loix ou du Rapport que les loix doivent avoir avec la constitution de chaque gouvernement*. Geneva: Barrillot & fils.

Moore, M.B. 1997. *Attic Red-Figured and White-Ground Pottery*. The Athenian Agora, vol. 30. Princeton, NJ: American School of Classical Studies at Athens.

Moore, M.B., and M.Z.P. Philippides., M.Z.P. 1986. *Attic Black-Figured Pottery*. The Athenian Agora, vol. 23. Princeton, NJ: American School of Classical Studies in Athens.

Moorhead, S., A. Booth, A. and R. Bland, R. 2010. *The Frome Hoard*. London: The British Museum Press.

Morgan, C. and Eve, S. 2012. DIY and digital archaeology: What are you doing to participate? *World Archaeology* 44(4): 521–37.

de Mortillet, G. 1897. *Formation de la nation française: textes, linguistique, palethnologie, anthro-pologie*. Paris: F. Alcan.

Moscati, S. 1991. *I Celti*. Milan: Bompiani.

Moshenska, G. 2006. The archaeological uncanny. *Public Archaeology* 5(2): 91–9.

2008. The Bible in stone: Pyramids, lost tribes and alternative archaeologies. *Public Archaeology* 7(1): 5–17.

2009a. What is public archaeology? *Present Pasts* 1: 46–8.

2009b. Beyond the viewing platform: Excavations and audiences. *Archaeological Review from Cambridge* 24(1): 39–53.

2012. M.R. James and the archaeological uncanny. *Antiquity* 86(334): 1192–201.

2013. Reflections on the 1943 'Conference on the Future of Archaeology'. *Archaeology International* 16: 128–39.

2013. The archaeological gaze. In A. González-Ruibal (ed.) *Reclaiming Archaeology: Beyond the Tropes of Modernity.* Abingdon: Routledge, 211–19.

Moshenska, G. and Dhanjal, S. (eds.) 2012. *Community Archaeology: Themes, Methods and Practices.* Oxford: Oxbow.

2012. Introduction: Thinking about, talking about, and doing community archaeology. In G. Moshenska and S.Dhanjal (eds.) *Community Archaeology: Themes, Methods and Practices.* Oxford: Oxbow, 1–5.

Moshenska, G. and Schadla-Hall, T. 2011. Mortimer Wheeler's theatre of the past. *Public Archaeology* 10(1): 46–55.

Münkler, H. and Grünberger, H. 1994. Nationale Identität im Diskurs der deutschen Humanisten. In H. Berding (ed.) *Nationales Bewußtsein und Kollektive Identität.* Studien zur Entwicklung des kollektiven Bewusstseins in der Neuzeit. Frankfurt: Suhrcamp.

The Mummy. 1999. [Film] Stephen Sommers, dir. Alphaville.

Murray, T. 1990. The history, philosophy, and sociology of archaeology: The case of the Ancient Monuments Protection Act (1882). In V. Pinsky and A. Wylie (eds.) *Critical Traditions in Contemporary Archaeology: Essays in the Philosophy, History and Socio-Politics of Archaeology.* Cambridge: Cambridge University Press, 55–67.

1993. Archaeology and the threat of the past: Sir Henry Rider Haggard and the acquisition of time. *World Archaeology* 25(2): 175–86.

Myerscough, J. 1988. *The Economic Importance of the Arts in Britain.* London: PSI.

National Treasure. 2004. [Film]. Jon Turteltaub, dir. Walt Disney Pictures.

National Trust and Accenture. 2006. *Demonstrating the Public Value of Heritage.* London: The National Trust.

Naughton, J. 2006. Our changing media ecosystem. In E. Richards, R. Foster and T.Kiedrowsky (eds.) *Communications: The Next Decade. Section 1: Trends and Challenges.* N.p.: Ofcom. Available at http://stakeholders.ofcom.org.uk/binaries/research/research-publications/comms10full.pdf [last accessed 16 November 2015].

Ndlovu, N. 2009. Access to rock art sites: A right or a qualification? *The South African Archaeological Bulletin* 64(189): 61–8.

Nemerkényi, E. (ed.) 2004. *Latin Classics in Medieval Hungary: Eleventh Century.* Budapest: Central European University Press.

Nevell, M.D. 2014. Community archaeology at the University of Salford: 2009 to 2013. *The Museum Archaeologist* 35: 17–21.

Nijkamp, P. 2012. Economic valuation of cultural heritage. In G. Licciardi and R.Amirtahmasebi (eds.) *The Economics of Uniqueness: Investing in Historic City Cores and Cultural Heritage Assets for Sustainable Development.* Washington, DC: The World Bank, 75–106.

Nilsson, S. 1868. *The Primitive Inhabitants of Scandinavia: An Essay on Comparative Ethnography, and a Contribution to the History of the Development of Mankind: Containing a Description of the Implements, Dwellings, Tombs, and Mode of Living of the Savages in the North of Europe During the Stone Age.* London: Longmans, Green and Co.

Nissinaho, A. and Soininen, T.-L. 2014. Adopt a Monument: Social meaning from community archaeology. In S. Thomas and J. Lea (eds.) *Public Participation in Archaeology.* Woodbridge: The Boydell Press, 175–81.

Noble, V.E. 2007. When the legend becomes fact: Reconciling Hollywood realism and archaeological realities. In J.M. Schablitsky (ed.) *Box Office Archaeology: Refining Hollywood's Portrayals of the Past.* Walnut Creek, CA: Left Coast Press, 223–44.

O'Brien, D. 2010. *Measuring the Value of Culture: A Report to the Department for Culture, Media & Sport.* London: DCMS. Available at www.gov.uk/government/uploads/system/uploads/attachment_data/file/77933/measuring-the-value-culture-report.pdf [last accessed 20 July 2013].

O'Donnell, N. 2014. *Parthenon sculpture loan to Russia: Legal and diplomatic fallout could be far-reaching. Art Law Report* (9 December). Available at www.artlawreport.com/2014/12/09/parthenon-sculpture-loan-to-russia-legal-and-diplomatic-fallout-could-be-far-reaching [last accessed 6 April 2016].

O'Reilly, W. 2001. Divide et impera: Race, ethnicity and administration in early 18th-century Habsburg Hungary. In G. Hálfdánarson and A.K. Isaacs (eds.) *Nations and Nationalities in Historical Perspective.* Pisa: Plus, 77–104.

O'Reilly, T. 2005. *What is Web 2.0*. Available at http://oreil.ly/13vrGTD [last accessed 16 November 2015[.

Ofcom (Office of Communications). 2010. *The International Communications Market 2010: Internet and Web-based Content*. Available at http://stakeholders.ofcom.org. uk/binaries/research/cmr/753567/icmr/Section_5_Internet.pdf [last accessed 16 November 2015].

Office of Travel and Tourism Industries. 2012. *Profile of Overseas Travelers to the United States: 2011 Inbound*. Washington, DC: US Department of Commerce, International Trade Administration.

Opoku, K. 2011. *Queen-Mother Idia and others must return home: Training courses are no substitutes for looted treasures*. Modern Ghana (16 March). Available at www.modernghana. com/news/320680/1/queen-mother-idia-and-others-must-return-home-trai.html [last accessed 6 April 2016].

——— 2012. *Nigeria must tell holders of looted artefacts that the game is over. Modern Ghana* (12 October). Available at www.modernghana.com/news/423670/1/nigeria-must-tell-holders-of-looted-artefacts-that.html [last accessed 6 April 2016].

Orange, H. 2013. *Public Engagement in Commercial Archaeology: UK Survey 2013*. Available at https://figshare.com/authors/Hilary_Orange/529529 [last accessed 16 June 2017].

Ost, C. and Van Droogenbroeck, N. 1998. *Report on Economics of Conservation: An Appraisal of Theories, Principles and Methods*. Available at www.icomos.org/en/what-we-do/disseminating-knowledge/publicationall/other-publications/116-english-categories/resources/publications/314-report-on-economics-of-conservation [last accessed 14 April 2013].

Oxford Archaeology. 2009. *Nighthawks & Nighthawking: Damage to Archaeological Sites in the UK & Crown Dependencies caused by Illegal Searching and Removal of Antiquities*. Available at http://historicengland.org.uk/images-books/publications/nighthawks-nighthawking [last accessed 19 September 2016].

Oxford Economics. 2013. *The Economic Impact of UK Heritage Tourism Economy*. Available at www.hlf.org.uk/economic-impact-uk-heritage-tourism-economy [last accessed 7 November 2014].

Özgen, I. and J. Öztürk, J. 1996. *The Lydian Treasure: Heritage Recovered*. Istanbul: Republic of Turkey, Ministry of Culture General Directorate of Monuments and Museums.

Özgül, B. 2013. *2015'e fişleyerek hazırlanıyorlar. Taraf* (13 December). Available at http://web. archive.org/web/20150220020427/http://arsiv.taraf.com.tr/haber-2015-e-fisleyerek-hazirlaniyorlar-141992 [last accessed 6 April 2016].

Pace, A. (ed.) 2000. *The Ħal Saflieni Hypogeum: 4000 BC–2000 AD*. Malta: National Museum of Archaeology.

Padgett, J.M. 1983-8–86 [1991]. An Attic red-figure volute-krater. *Minneapolis Institute of Arts Bulletin* 66: 66-7-77.

Palacky, F. 1836. *Geschichte von Böhmen*. Prag: Kronberg und Weber.

Palmer, N.E. 1993. Treasure Trove and title to discovered antiquities. *International Journal of Cultural Property* 2(2): 275–318.

Papay, J. 1966. Anton Regoly (1819–1855). In T.A. Sebeck (ed.) *Portraits of Linguists: A Biographical Source Book for the History of Western Linguistics, 1746–1963*. Volume 1. Bloomington, IN: Indiana University Press, 268–310.

Parker Pearson, M. and Pryor, F. 2006. Visitors and viewers welcome? In J. Hunter and I. Ralston (eds.) *Archaeological Resource Management in the UK: An Introduction*. Stroud: Sutton Publishing, 316–27.

Parks, S. 2010. The collision of heritage and economy at Uxbenká, Belize. *International Journal of Heritage Studies* 16(6): 434–48.

Patterson, T.C. 1995. *Towards a Social History of Archaeology in the United States*. Fort Worth, TX: Harcourt Brace.

Patterson, T.C. and Kohl, P.L. 1986. Archaeology Congress. *Science* 231(4736): 319.

Pauketat, T.R. and Loren, D.D. 2005. Alternative histories and North American archaeology. In T.R. Pauketat and D.D. Loren (eds.) *North American Archaeology*. Oxford: Blackwell Press, 1–29.

Paul, A.J. 1997. Fragments of antiquity: Drawing upon Greek vases. *Harvard University Art Museums Bulletin* 5: 1-8–87.

Paulus Diaconus. *Historia Langobardorum*. Available at www.thelatinlibrary.com/pauldeacon/ hist1.shtml [last accessed 26 June 2017].

Paynton, C. 2002. Public perception and 'pop archaeology': A survey of current attitudes toward televised archaeology in Britain. *The SAA Archaeological Record* 2(2): 33–6, 44.

Pearson, V. (ed.) 2001. *Teaching the Past*. York: Council for British Archaeology, Creswell Heritage Trust and English Heritage.

Perring, D. 2015a. Involving the public in archaeological fieldwork: How heritage protection policies do not always serve public interests. In P. Stone and Z. Hui (eds.) *Sharing Archaeology: Academe, Practice and the Public*. London: Routledge, 167–79.

2015b. My historic environment. *The Historic Environment: Policy and Practice* 6(2): 192–4.

2016. Working for commercial clients: The practice of development-led archaeology in the UK In P. Florjanowicz (ed.) *EAC Occasional Paper No 11: When Valletta meets Faro: The Reality of European Archaeology in the 21st Century. Proceedings of the International Conference, Lisbon, Portugal, 19–21 March 2015*. Namur, Belgium: Europae Archaeologia Consilium, Association Internationale Sans But Lucratif (AISBL), pp. 95–104.

Perry, P. and Beale, N. 2015. The social web and archaeology's restructuring: Impact, exploitation, disciplinary change. *Open Archaeology* 1(1): 153–65. DOI: 10.1515/opar-2015-0009.

Pett, D. 2010. The Portable Antiquities Scheme's database: Its development for research since 1998. In S. Worrell, G. Egan, K. Leahy, J. Naylor and M. Lewis (eds.) *A Decade of Discovery: Proceedings of the Portable Antiquities Scheme Conference 2007*. London: David Brown Book Company, 1–18.

2012. Use of social media within the British Museum and the museum sector. In C. Bonacchi (ed.) *Archaeology and Digital Communication: Towards Strategies of Public Engagement*. London: Archetype Publications, 83–102.

2014. Linking portable antiquities to a wider web. In T. Elliott, S. Heath and J.Muccigrosso (eds.) *Current Practice in Linked Open Data for the Ancient World*. New York: Institute for the Study of the Ancient World, New York University.

Phillips, T., Gilchrist, R., Hewitt, I., Le Scouiller, S., Booy, D. and Cook, G. 2007. *Inclusive, Accessible, Archaeology: Good Practice Guidelines for Including Disabled Students and Self-Evaluation in Archaeological Fieldwork Training*. Higher Education Academy Subject Centre for History, Classics and Archaeology: Guides for Teaching and Learning in Archaeology 5.

Piccini, A. 2007. *A Survey of Heritage Television Viewing Figures*. York: Council for British Archaeology. Available at http://new.archaeologyuk.org/Content/downloads/4300_Research_Bulletin_Number_1_final.pdf [last accessed 7 September 2016].

2007. Survey of Heritage Television Viewing Figures. *CBA Research Bulletin* 1: 2–10.

Picknett, L. and Prince, C. 2003. Alternative Egypts. In S. MacDonald and M.Rice (eds.) *Consuming Ancient Egypt*. London: UCL Press, 175–94.

Pimpernel Smith. 1941. [Film]. Leslie Howard, dir. British National Films.

Piotrowska, D. 1997/8. Biskupin 1933–1996: Archaeology, politics and nationalism. *Archaeologia Polona* 35–6: 255–85.

Planel, P. 1996. Education and excavation. *The Field Archaeologist* 26: 22–3.

Pomian, K. 1992. Francs et Gaulois. In P. Norá (ed.) *Lieux de Mémoire III/1: Conflits et partages*. Paris: Gallimard, 42–105.

Prehm, H.J. 1996. Die Wanderung der Mexi'ca': Erzählung einer Wirklichkeit oder wirklich nur eine Erzählung? *Archäologische Informationen* 19: 39–49.

Provins, A., Pearce, D., Ozdemiroglu, E., Mourato, S. and Morse-Jones, S. 2008. Valuation of the historic environment: The scope for using economic valuation evidence in the appraisal of heritage-related projects. *Progress in Planning* 69: 131–75.

Pyburn, K.A. 2009. Practising archaeology as if it really matters. *Public Archaeology* 8(2–3): 161–75.

Rady, M. 2009. The Gesta Hungarorum of Anonymus, the anonymous notary of King Béla: A translation. *Slavonic and East European Review* 87(4): 681–727.

Raiders of the Lost Ark. 1981. [Film]. Steven Spielberg, dir. Lucasfilm.

Rasmussen, J.M. 2014. Securing cultural heritage objects and fencing stolen goods? A case study on museums and metal detecting in Norway. *Norwegian Archaeological Review* 47(1): 83–107.

Reid, P. 2012. Performance or participation: The relationship between local communities and the archaeological domain. In G. Moshenska and S.Dhanjal (eds.) *Community Archaeology: Themes, methods and practices*, Oxford: Oxbow Books, 18–27.

Reichs, K. 1997. *Déjà Dead*. London: William Heinemann.

Renan, E. 1882. *Qu'est-ce qu'une nation?* Paris: Lévy.

Renfrew, C. 1991. *The Cycladic Spirit: Masterpieces from the Nicholas P. Goulandris Collection*. London: Thames & Hudson.

Renfrew, C. 1996. Prehistory and the identity of Europe, or don't let's be *beastly* to the Hungarians. In S. Jones, C. Gamble and P. Graves-Brown (eds.) *Cultural Identity and Archaeology: The Construction of European Communities*. London: Routledge, 125–37.

Reynolds, F. 2011. *Saved for the nation: Cultural tourism today*. In J. Curtis, M.Fulford, A.Harding and F.Reynolds (eds.) *History for the Taking? Perspectives on Material Heritage. A Report Prepared for the British Academy*. Available at www.britac.ac.uk/publications/history-taking [last accessed 10 September 2016].

Richardson, L. 2013. A digital public archaeology? *Papers from the Institute of Archaeology* 23(1). Available at http://doi.org/10.5334/pia.431 [last accessed 8 September 2016].

2013. A digital public archaeology? *Papers from the Institute of Archaeology* 23(1): 1–12. DOI: http://doi.org/10.5334/pia.431.

Richardson, L.J. 2014. The Day of Archaeology: Blogging and online archaeological communities. *European Journal of Post-Classical Archaeologies* 4: 421–46.

2014a. *Public Archaeology in a Digital Age*. Unpublished PhD thesis, UCL.

2014b. Understanding archaeological authority in a digital context. *Internet Archaeology* 38. Available at http://dx.doi.org/10.11141/ia.38.1 [last accessed 8 September 2016].

2014c. The Day of Archaeology: Blogging and online archaeological communities. *European Journal of Post-Classical Archaeologies* 4: 421–46.

Ridge, M. 2013. From tagging to theorizing: Deepening engagement with cultural heritage through crowdsourcing. *Curator: The Museum Journal* 56(4): 435–50.

2014. *Crowdsourcing Our Cultural Heritage*. Farnham: Ashgate.

Robbins, K. 2013. Balancing the scales: Exploring the variable effects of collection bias on data collection by the Portable Antiquities Scheme. *Landscapes* 14(1): 54–72.

The Portable Antiquities Scheme: A Guide for Researchers. Available at https://finds.org.uk/research/advice [last accessed 19 September 2016].

2012. *From Past to Present: Understanding the Impact of Sampling Bias on Data Recorded by the Portable Antiquities Scheme*. Unpublished PhD thesis, University of Southampton.

Robertson, M. 1992. *The Art of Vase-Painting in Classical Athens*. Cambridge: Cambridge University Press.

Roca, R. 1998–2017. Sonderbund. *Historisches Lexikon der Schweiz*. Bern: Stiftung Historisches Lexikon der Schweiz.

Roediger, M. (ed.) 1895. *Das Annolied. Monumenta Germaniae Historia, Deutsche Chroniken I, 2*. Hannover: Hahn.

Roosevelt, C.H., and C. Luke, C. 2006. Looting Lydia: The destruction of an archaeological landscape in western Turkey. In N. Brodie, M. M. Kersel, C. Luke, and K. W. Tubb (eds.), *Archaeology, Cultural Heritage, and the Antiquities Trade*. Gainesville, FL: University Press of Florida, 173-8–87.

Rothacker, E. (ed.) 1925. *Droysen, Grundriß der Historik, nach der dritten und letzten Auflage 1882*. Halle: May Niemeyer.

Rountree, K. 2002. Re-inventing Malta's Neolithic temples: Contemporary interpretations and agendas. *History and Anthropology* 13(1): 31–51.

2003. The case of the missing goddess: Plurality, power, and prejudice in reconstructions of Malta's Neolithic past. *Journal of Feminist Studies in Religion* 19(2): 25–43.

Rowe, S. and Stewart, L. 2014. *Rainford's Roots: The archaeology of a village*. Liverpool: National Museums of Liverpool.

Rudbeck, O. 1678. *Atland eller Manheim*. Uppsala: Henricus Curio.

Ruijgrok, E.C.M. 2006. The three economic values of cultural heritage: A case study in the Netherlands. *Journal of Cultural Heritage* 7: 206–13.

Ruoff, U. 1992. *Leben im Pfahlbau*. Solothurn: Aare Verlag.

Russell, M. 2002. 'No more heroes any more': The dangerous world of the pop culture archaeologist. In M. Russell (ed.) *Digging Holes in Popular Culture: Archaeology and Science Fiction*. Oxford: Oxbow Books, 38–54.

Rypkema, D., Cheong C. and Mason, R. 2011. *Measuring Economic Impacts of Historic Preservation: A Report to the Advisory Council on Historic Preservation*. Available at www.achp.gov/docs/economic-impacts-of-historic-preservation-study.pdf [last accessed 3 September 2012].

Said, E. 1985. *Beginnings, Intention and Method*. New York: Columbia University Press.

Sagan, C. 1997. *The Demon Haunted World: Science as a Candle in the Dark*. London: Headline.

Saville, A. 2000. Portable antiquities and excavated finds in Scotland. *Institute of Field Archaeologists Yearbook and Directory of Members*. Reading: Institute of Field Archaeologists, 31–2.

Schadla-Hall, T. 1996. What are we groping for? *MDA Information* 2(4).

1999. Editorial: Public archaeology. *European Journal of Archaeology* 2(2): 147–58.

2004. Community archaeology in Leicestershire: The wider view beyond the boundaries. In P. Bowman and P. Liddle (eds.) *Leicestershire Landscapes*. Leicestershire Museums Archaeological Fieldwork Group Monograph No. 1. Leicester: Leicestershire Museums Archaeological Fieldwork Group, 1–7.

2004. The comforts of unreason: The importance and relevance of alternative archaeology. In N. Merriman (ed.) *Public Archaeology*. London: Routledge, 255–71.

2006. Public archaeology in the twenty-first century. In R. Layton, S. Shennan and P.Stone (eds.) *A Future for Archaeology: The Past in the Present*. London: UCL Press, 75–82.

Schama, S. 1995. *Landscape and Memory*. New York: Vintage.

Scheyvens, R. 2002. *Tourism for Development: Empowering Communities*. Harlow: Pearson.

Schlichtherle, H. 1986. *Archäologie in Seen und Mooren*. Stuttgart: Theiss.

Schmidt, P. 2014. Rediscovering community archaeology in Africa and reframing its practice. *Journal of Community Archaeology and Heritage* 1(1): 37–55.

Schnapp, A. 1996. *The Discovery of the Past: The Origins of Archaeology*. London: British Museum Press.

Schofield, J., Carman, J. and Belford, P. 2011. *Archaeological Practice in Great Britain: A Heritage Handbook*. New York: Springer.

Schwyzer, P. 2007. *Archaeologies of English Renaissance Literature*. Oxford: Oxford University Press.

Selvakumar, V. 2010. The use and relevance of archaeology in the post-modern world: Views from India. *World Archaeology* 42(3): 468–80.

Selwood, S. 2002. The politics of data collection: Gathering, analysing and using data about the subsidised cultural sector in England. *Cultural Trends* 12: 13–84.

2006. Great expectations: Museums and regional economic development in England. *Curator* 49(1): 65–80.

Sgubini, A.M.M. 1999. *Euphronios epoiesen: Un dono d'eccezione ad Ercole Cerite*. Rome: L'Erma di Bretschneider.

Shanks, M. 1992. *Experiencing the Past: On the Character of Archaeology*. London: Routledge.

2012. *The Archaeological Imagination*. Walnut Creek, CA: Left Coast Press.

Shanks, M. and McGuire, R.H. 1996. The craft of archaeology. *American Antiquity* 61(1): 75–88.

Shanks, M. and Tilley, C. 1987. *Social Theory and Archaeology*. Cambridge: Polity.

Shapiro, H.A., C.A. Picón, C.A. and G.D. Scott, G.D.. (Editors.) 1995. *Greek Vases in the San Antonio Museum of Art*. San Antonio, TX: San Antonio Museum of Art.

Shermer, M. 1997. *Why People Believe Weird Things*. New York: Freeman.

Silberman, N.A. 2015. *Remembrance of Things Past: Collective Memory, Sensory Perception, and the Emergence of New Interpretive Paradigms. 2nd International Conference on Best Practices in World Heritage: People and Communities. Mahon, Menorca. April 2015*. Available at http://works.bepress.com/neil_silberman/51 [last accessed 12 June 2015].

Silver, V. 2009. *The Lost Chalice: The Epic Hunt for a Priceless Masterpiece*. New York: William Morrow.

Simpson, F. and Williams, H. 2008. Evaluating community archaeology in the UK. *Public Archaeology* 7(2): 69–90.

Simon, N. 2010. *The Participatory Museum*. Available at www.participatorymuseum.org/read [last accessed 16 November 2015].

Simpson, F. 2010. *The Values of Community Archaeology: A Comparative Assessment between the UK and US*. Oxford: Archaeopress.

Simpson, F. and Williams, H. 2008 Evaluating community archaeology in the UK. *Public Archaeology* 7(2): 69–90.

Sismondo, S. 2010. *An Introduction to Science and Technology Studies*, 2nd edition. Chichester: Wiley Blackwell.

Skeates, R. 2010. *An Archaeology of the Senses: Prehistoric Malta*. Oxford: Oxford University Press.

Smardz, K. and Smith, S. (eds.) 2000. *The Archaeology Education Handbook: Sharing the Past with Kids*. Walnut Creek, CA: AltaMira Press.

Smith, A.D. 1986. *The Ethnic Origins of Nations*. Oxford: Basil Blackwell.

1991. *National Identity*. Reno, NV: University of Nevada Press.

2000. *The Nation in History: Historiographical Debates about Ethnicity and Nationalism*. Cambridge: Polity.

2004. *The Antiquity of Nations*. Cambridge: Polity.

Smith, G.E. 1929. *The Migrations of Early Culture*. Manchester: Manchester University Press.

Smith, L. and Waterton, E. 2009. *Heritage, Communities and Archaeology*. London: Duckworth.

Sneath, D. 2007. *The Headless State: Aristocratic Orders, Kinship Society, and Misrepresentations of Nomadic Inner Asia*. New York: Columbia University Press.

Snowball, J.D. 2008. *Measuring the Value of Culture: Methods and Examples in Cultural Economics*. Berlin: Springer.

Sollars, W.J. 1911. *Ancient Hunters and their Modern Representatives*. London: Macmillan.

Sommer, U. 2001. 'Hear the Instruction of thy Father, and forsake not the Law of thy Mother': Change and persistence in the European Early Neolithic. *Journal of Social Archaeology* 1(2): 244–70.

2002. Die Darstellung der Vorgeschichte in sächsischen Geschichtsbüchern des 19. Jahrhunderts. In C. Friedrich, H.-M. Moderow and H.-W. Wollersheim (eds.) *Die Rolle von Schulbüchern für Identifikationsprozesse in historischer Perspektive*. Leipziger Studien zur Erforschung von regionenbezogenen Identifikationsprozessen 5. Leipzig: Akademie, 133–60.

2004. Die Lausitzer Kultur: Germanen, Illyrer oder Sorben? Ethnische Deutungen der sächsischen Vorgeschichte im 19. und frühen 20. Jahrhundert. In B. Gediga (ed.) *Archäologie – Kultur – Ideologie*. Vorträge der internationalen Tagung in Biskupin, 20.-22.6. 2002. Wrocław: Polska Akademia Nauk, 57–72.

2009 'Der Vorwelt Räthsel' – Daker, Kelten, Skythen und Geten. In S. Grunwald, J.K. Koch, U. Sommer and S. Wolfram (eds.) *Artefact, Festschrift für Frau Professor Dr. Sabine Rieckhoff zum 65. Geburtstag*. Bonn: Habelt, 219–32.

2015. Zeit, Erinnerung und Geschichte. In S. Reinhold and K.P. Hofmann (eds.) Zeichen der Zeit. Archäologische Perspektiven auf Zeiterfahrung, Zeitpraktiken und Zeitkonzepte (Themenheft). *Forum Kritische Archäologie* 3: 25–59.

Sotirakopoulou, P. 2005. *The Keros Hoard: Myth or Reality? Searching for the Lost Pieces of a Puzzle*. Athens: N.P. Goulandris Foundation – Museum of Cycladic Art.

Sotirakopoulou, P. 2008. The Keros Hoard: Some further discussion. *American Journal of Archaeology* 112: 279-9–94.

Southport Group. 2011. *Realising the Benefits of Planning-led Investigation in the Historic Environment: A Framework for Delivery*. Reading: Institute for Archaeologists.

Speight, S. 2002. Digging for history: Archaeological fieldwork and the adult student 1943–1975. *Studies in the Education of Adults* 34(1): 68–85.

2003. Localising history 1940–1965: The extra-mural contribution. *Journal of Educational Administration and History* 35(1): 51–64.

Stephens, W. 2004. Pope Noah ruled the Etruscans: Annius of Viterbo and his forged Antiquities. *MLN* 119(1): 201–23. DOI: 10.1353/mln.2004.0152

St Hilaire, R. 2012a: *Seize and send v. investigate and indict: Focusing on cultural heritage criminal investigations and prosecutions*. Cultural Heritage Lawyer (5 March). Available at http://culturalheritagelawyer.blogspot.co.uk/2012/03/seize-and-send-v-investigate-and-indict.html [last accessed 6 April 2016].

2012b: *Cracking down on antiquities trafficking by changing Homeland Security's 'seize and send' policy*. Cultural Heritage Lawyer (10 December). Available at http://culturalheritagelawyer.blogspot.co.uk/2012/12/cracking-down-on-antiquities.html [last accessed 6 April 2016].

Starr, F. 2010. The business of heritage and the private sector. In S. Labadi and C. Long (eds.) *Cultural Heritage and Globalisation*. London: Routledge, 147–69.

Stone, P.G. and MacKenzie, R. (eds.) 1990. *The Excluded Past: Archaeology in Education.*. London: Routledge.

Stynes, D.J. 1997. *Economic Impacts of Tourism: A Handbook for Tourism Professionals*. Available at https://msu.edu/course/prr/840/econimpact/pdf/ecimpvol1.pdf [last accessed 10 September 2016].

Sustainable Trust. 2014. *The Restoration of Carwynnen Quoit: A Monument Like No Other*. Redruth: The Sustainable Trust.

Sutcliffe, T.J. 2014. Skills for the future: An introduction to the Community Archaeology Bursaries Project. *Journal of Community Archaeology and Heritage* 1(2): 107–17.

Swain, H. 2007. *An Introduction to Museum Archaeology*. Cambridge: Cambridge University Press.

Sydney Morning Herald. 1929. *Zimbabwe ruins. Sydney Morning Herald* (6 August), 11. Available at: http://trove.nla.gov.au/ndp/del/article/16573218 [last accessed 6 April 2016].

Szilágyi, S. 1900. *A magyar honfoglalás kútföi*. Budapest: *Magyar* Tudomanyos Akademia.

Tacitus, P.C. *Germania*. Available at https://sourcebooks.fordham.edu/source/tacitus1.html [last accessed 18 June 2016].

Tanyeri-Erdemir, T. 2006. Archaeology as a source of national pride in the early years of the Turkish Republic. *Journal of Field Archaeology* 31(4): 381–93.

Tarlow, S. 2006. Archaeological ethics and the people of the past. In C. Scarre and G. Scarre (eds.) *The Ethics of Archaeology: Philosophical Perspectives on Archaeological Practice*. Cambridge: Cambridge University Press, 199–216.

Thiering, B. and Castle, E. (eds.) 1972. *Some Trust in Chariots*. Toronto: Popular Library.

Thomas, N. 1964/65. Recent acquisitions by Birmingham City Museum. *Archaeological Reports*: 63-7-70.

Thomas, R. 2007. Development-led archaeology in England. In K. Bozóki-Ernyey (ed.) *European Preventive Archaeology: Papers of the EPAC Meeting, Vilnius 2004*, 33–42. Available at https://rm.coe.int/16806a5717 [last accessed 16 June 2017].

Thomas, G. 2001. Strap-ends and the identification of regional patterns in the production and circulation of ornamental metalwork in Late Anglo-Saxon and Viking-Age Britain. In M. Redknap, N. Edwards, S. Youngs, A. Lane and J. Knight (eds.) *Pattern and Purpose in Insular Art: Proceedings of the Fourth International Conference on Insular Art held at the National Museum and Gallery, Cardiff 3–6 September 1998*. Oxford: Oxbow, 39–49.

Thomas S. 2010. *Community Archaeology in the UK: Recent findings*. [presentation] York: Council for British Archaeology. Available at http://new.archaeologyuk.org/supporting-community-archaeology-in-the-uk [last accessed 10 October 2016].

2012. Archaeologists and metal-detector users in England and Wales: Past, present and future. In R. Skeates, C. McDavid and J.Carman (eds.) *The Oxford Handbook of Public Archaeology*. Oxford: Oxford University Press, 60–81.

2012. Searching for answers: A survey of metal-detector users in the UK. *International Journal of Heritage Studies* 18(1): 49–64.

2014. Making archaeological heritage accessible in Great Britain: Enter community archaeology. In S. Thomas and J. Lea (eds.) *Public Participation in Archaeology*. Woodbridge: The Boydell Press, 23–33.

2015. Community archaeology in the UK: Looking ahead. In M. Nevell and N.Redhead (eds.) *Archaeology for All, Community Archaeology in the Early 21st Century: Participation, Practice, and Impact*. Salford Applied Archaeology Series Volume 2. Salford: Centre for Applied Archaeology, University of Salford, 159–62.

Thomas, S., Henson, D., Johansen, L. and Terry, W. 2014. *Young People and Archaeology: A Report by the Council for British Archaeology*. CBA Research Bulletin 3. York: Council for British Archaeology.

Thompson, A. (ed.) 1999. *Geoffrey of Monmouth: History of the Kings of Britain*. Ontario: In Parenthesis Publications.

Throsby, D. 2001. *Economics and Culture*. Cambridge: Cambridge University Press.

2012. Heritage economics: A conceptual framework. In G. Licciardi and R.Amirtahmasebi (eds.) *The Economics of Uniqueness: Investing in Historic City Cores and Cultural Heritage Assets for Sustainable Development*. Washington, DC: The World Bank, 45–74.

Tilley, C. 1989. Excavation as theatre. *Antiquity* 63: 275–80.

2004. *The Materiality of Stone: Explorations in Landscape Phenomenology*. Oxford: Berg.

Timothy, D.J. and Boyd, S.W. 2003. *Heritage Tourism*. Harlow: Pearson.

Timothy, D.J. and Nyaupane, G.P. 2009. *Cultural Heritage and Tourism in the Developing World: A Regional Perspective*. London and New York: Routledge.

Tobias, S. and Duffy, T.M. 2009. *Constructivist Instruction: Success or Failure?*. New York: Routledge.

Tokeley, J. 2006. *Rescuing the Past: The Cultural Heritage Crusade*. Exeter: Imprint Academic.

Tong, J., Evans, S., Williams, H., Edwards, N. and Robinson, G. 2015. *Vlog to Death: Project Eliseg's Video-Blogging. Internet Archaeology* 39. Availabe at http://dx.doi.org/10.11141/ia.39.3 [last accessed 8 September 2016].

Towse, R. (ed.) 2011. *A Handbook of Cultural Economics*, second edition. Cheltenham: Edward Elgar.

Trigger, B.G. 1984. Alternative archaeologies: Nationalist, colonialist, imperialist. *Man* 19(3): 355–70.

2006. *A History of Archaeological Thought*. Cambridge: Cambridge University Press.

Tsirogiannis, C. 2012. *Unravelling the Hidden Market of Illicit Antiquities: The Robin Symes—Christos Michaelides Network and Its International Implications*. Unpublished PhD Dissertation, Cambridge University.

2013. Something is confidential in the state of Christie's. *Journal of Art Crime* 9: 3-1–19.

Tsirogiannis, C. and D.W.J. Gill, D.W.J. 2014. 'A fracture in time': A cup attributed to the Euaion painter from the Bothmer collection. *International Journal of Cultural Property* 21: 465-8–80.

Ucko, P.J. 1968. *Anthropomorphic Figures of Predynastic Egypt and Neolithic Crete with Comparative Materials from the Prehistoric Near East and Mainland Greece.*. London: Andrew Szmidla.

1987. *Academic Freedom and Apartheid: The Story of the World Archaeological Congress*. London: Duckworth.

UCL. 2015. Archaeology South-East: History of the unit. Available at https://www.ucl.ac.uk/archaeologyse/about-ase/about-ase-history-of-the-unit [last accessed 16 June 2017].

UN (United Nations). 1948. *The Universal Declaration of Human Rights*. New York: United Nations. Available at www.un.org/en/documents/udhr [last accessed 6 April 2016].

1966a: *International Covenant on Civil and Political Rights*. New York: United Nations. Available at www.ohchr.org/en/professionalinterest/pages/ccpr.aspx [last accessed 9 September 2016]

1966b: *International Covenant on Economic, Social and Cultural Rights*. New York: United Nations. Available at www.ohchr.org/en/professionalinterest/pages/cescr.aspx [last accessed 9 September 2016]

UNESCO. 2013. *The Operational Guidelines for the Implementation of the World Heritage Convention*. Available at http://Whc.Unesco.Org/En/Guidelines [last accessed 12 June 2015].

UNFPA (United Nations Population Fund). 2005. *Human Rights Principles*. New York: United Nations Population Fund. Available at www.unfpa.org/resources/human-rights-principles [last accessed 6 April 2016].

UNSRCR (United Nations Special Rapporteur on Cultural Rights). 2016. *Report of the Special Rapporteur in the Field of Cultural Rights* [A/HRC/31/59, 3rd February 2016]. Available at http://ap.ohchr.org/documents/dpage_e.aspx?si=A/HRC/31/59 [last accessed 10 September 2016].

UNWCHR (United Nations World Conference on Human Rights). 1993. *Vienna Declaration and Programme of Action*. Available at www.ohchr.org/EN/ProfessionalInterest/Pages/Vienna.aspx [last accessed 9 September 2016].

Van den Dries, M.H. 2014. Community archaeology in the Netherlands. *Journal of Community Archaeology and Heritage* 1(1): 69–88.

Van Deursen, A. and Van Dijk, J. 2010. Internet skills and the digital divide. *New Media & Society* 13(6): 893–911.

Vázquez Chamorro, G. and Día Migoyo, G. (eds.) 2001. *Crónica mexicana de Hernando Alvarado Tezozómoc*. Madrid: Dastin.

Vékony, G. 2003. History of archaeological fieldwork. In: *Hungarian Archaeology at the Turn of the Millennium*. Budapest: Ministry of National Cultural Heritage, 15–22.

Venit, M.S. 1988. *Greek Painted Pottery from Naukratis in Egyptian mMuseums*. American Research Center in Egypt Catalogs, vol. 7. Winona Lake, IN: Eisenbrauns and ARCE.

Venturini, T. and Latour, B. 2010. *The social fabric: Digital traces and auali-quantitative methods*. In *Proceedings of Future En Seine 2009*. Cap Digital. Available at www.medialab.sciences-po.fr/publications/the-social-fabric-digital-traces-and-quali-quantitative-methods [accessed 22 November 2015].

Vergil, *Aeneis*. Available at www.thelatinlibrary.com/vergil/aen1.shtml [last accessed 18 June 2017].

Veszprémy, L. and Schaer, F. (eds.) 1999. *Simonis de Kéza Gesta Hungarorum. Simon of Kéza: The Deeds of the Hungarians*. Budapest: Central European University Press.

Vickers, M. and D.W.J. Gill, D.W.J. 1994. *Artful Crafts: Ancient Greek Silverware and Pottery*. Oxford: Clarendon Press.

Von Arburg, H.-G. 2010. Nation aus dem Sumpf, Pfahlbaugeschichten oder literarische Konstruktionen eines anderen 'Mythos Schweiz'. In J. Barkhoff and V. Heffernan (eds.) *Schweiz schreiben: zu Konstruktion und Dekonstruktion des Mythos Schweiz in der Gegenwartsliteratur*. Berlin: Walter de Gruyter, 117–38.

Waddell, L.A. 1924. *The Phoenician Origins of Britons, Scots and Anglo-Saxons*. London: Williams and Norgate.

Wallace, J. 2004. *Digging the Dirt: The Archaeological Imagination*. London: Duckworth.

Walker, D. 2014a. Antisocial media in archaeology? *Archaeological Dialogues* 21 (2): 217–35.

2014b. Decentering the discipline? Archaeology, museums and social media. *AP Online Journal in Public Archaeology* 1: 77–102.

Walker, M. and Saitta, D.J. 2002. Teaching the craft of archaeology: Theory, practice and the field school. *International Journal of Historical Archaeology* 6(3): 199–207.

Walsh, J. 1984. Acquisitions/1983. *The J. Paul Getty Museum Journal* 12: 225-2–7, 29-30, 32-3316.

1985. Acquisitions/1984. *The J. Paul Getty Museum Journal* 13: 157-5–9, 61-2258.

1986. Acquisitions/1985. *The J. Paul Getty Museum Journal* 14: 173-2–286.

1997. *Sotheby's: The Inside Story*. London: Bloomsbury.

2006. Convicted dealers: What we can learn. In N. Brodie, M. M. Kersel, C. Luke, and K. W. Tubb (eds.), *Archaeology, Cultural Heritage, and the Antiquities Trade*. Gainesville, FL: University Press of Florida, 93-7–7.

Waterton, E. and Smith, L. 2010. The recognition and misrecognition of community heritage. *International Journal of Heritage Studies* 16(1–2): 4–15.

Watson, P. and C. Todeschini., C. 2006. *The Medici Conspiracy: The Illicit Journey of Looted Antiquities from Italy's Tomb Raiders to the World's Great Museums*. New York: Public Affairs.

WCED (World Commission on Environment and Development). 1987. *Our Common Future*. Oxford: Oxford University Press. Available at www.un-documents.net/our-common-future.pdf [last accessed 12 June 2015].

Weber, E. 1976. *Peasants into Frenchmen: The Modernization of rural France, 1870–1914*. Stanford, CA: Stanford University Press.

Welck, K. 1996: *Die Franken – Wegbereiter Europas*. Mainz: Zabern.

Wenskus, R. 1977. *Stammesbildung und Verfassung, das Werden der frühmittelalterlichen gentes*. Cologne: Böhlau.

Wescoat, B.D., and M.L. Anderson,. M.L. 1989. *Syracuse, the Fairest Greek City: Ancient Art from the Museo Archeologico Regionale 'Paolo Orsi'*. Roma, Italiae: De Luca edizioni d'arte.

Wetherall, D.M. 1994. From Canterbury to Winchester: The foundation of the institute. In B. Vyner (ed.) *Building on the Past: Papers Celebrating 150 Years of the Royal Archaeological Institute*. London: Royal Archaeological Institute, 8–21.

Wheeler, R.E.M. 1955. *Still Digging: Interleaves from an Antiquary's Notebook*. London: Michael Joseph.

1956. *Archaeology from the Earth*. Harmondsworth: Penguin.

White, S. 2005. Building American museums: The role of the private collector. In K. Fitz Gibbon (ed.), *Who Owns the Past? Cultural Policy, Cultural Property, and the Law*. New Brunswick, NJ: Rutgers University Press / American Council for Cultural Policy, 165-7–77.

Wilkening, T. and Kremer, M. 2007. *Protecting Antiquities: A Role for Long-Term Leases?* Working Paper, Harvard University. Available at www.tomwilkening.com/images/Kremer_Wilkening_Protecting_Antiquities.pdf [last accessed 14 April 2013].

Williams, D. 1983. Aegina, Aphaia-Tempel. V. The pottery from Chios. *Archäologischer Anzeiger*: 155-8–86.

1991. Onesimos and the Getty Iliupersis. In M. True (ed.), *Greek Vases in the J. Paul Getty Museum 5*. Occasional Papers on Antiquities, vol. 7. Malibu, CA: J. Paul Getty Museum, 41-6–64.

1993. Aegina, Aphaia-Tempel XVI: The Laconian pottery. *Archäologischer Anzeiger*: 571-9–96.

Williams, D. 1997. *Late Saxon Stirrup-Strap Mounts.* CBA Research Report 111. York: Council for British Archaeology.

Williams, H. 2013. *Mapping Falklands fighting to tackle veterans' trauma. BBC News,* 10 July 2013. Available at www.bbc.co.uk/news/uk-scotland-glasgow-west-23250478 [last accessed 3 November 2013].

Williams, S. 1991. *Fantastic Archaeology: The Wild Side of American Prehistory.* Philadelphia, PA: University of Philadelphia Press.

Wilson, P. and Harrison, M. 2013. Three years on from 'The Nighthawking Survey': Innovations in heritage protection. *Internet Archaeology* 33 DOI: http://dx.doi.org/10.11141/ia.33.7.

Wilson, T. 1894. *Swastika: The Earliest Known Symbol and Its Migrations; with Observations on the Migration of Certain Industries in Prehistoric Times.* Washington, DC: The Smithsonian Institute.

Winckelmann, J.J. 1755. *Gedanken über die Nachahmung der griechischen Werke in der Malerei und Bildhauerkunst.* Dresden and Leipzig: Walther.

 1764. *Geschichte der Kunst des Alterthums.* Dresden: Walther.

Winterton, S. 2014. From the Army Medical Centre to Operation Nightingale: My entry into archaeology. *Journal of Community Archaeology and Heritage* 1(3): 245–7.

Wiseman, J. 1974. Editorial Comment. *Journal of Field Archaeology* 1: 1-2–2.

Wolf, E.R. 1997. *Europe and the People Without History.* Berkeley, CA: University of California Press.

Woodward, C. 2009. *The mystery of Bosnia's ancient pyramids. Smithsonian Magazine.* Available at: www.smithsonianmag.com/history/the-mystery-of-bosnias-ancient-pyramids-148990462/?no-ist [last accessed 20 September 2016].

World Bank. 2001. *Cultural Heritage and Development: A Framework for Action in the Middle East and North Africa.* Washington, DC: World Bank. Available at https://publications.worldbank.org/index.php?main_page=product_info&products_id=21933 [last accessed 7 November 2014].

Worrell, S., Egan, G., Naylor, J., Leahy, K. and Lewis, M. (eds.) 2010. *A Decade of Discovery: Proceedings of the Portable Antiquities Scheme Conference 2007.* Oxford: Archaeopress.

Worsae, J.A. 1843. *Danmarks Oldtid oplyst ved Oldsager og Gravhøie.* Copenhagen: Klein.

Wylie, A. 2002. *Thinking from Things: Essays in the Philosophy of Archaeology.* London: University of California Press.

Yapı. 2010. *Yasak kent Allianoi [Allianoi, the forbidden city]. Yapı* (9 April). Available at www.yapi.com.tr/haberler/yasak-kent-allianoi_78438.html [last accessed 6 April 2016].

Yaraş, A and Aşkın, N. 2010. *Allianoi'yi kurtaracak proje ve parası hazırdı [The project and money to save Allianoi was arranged]. Habertürk* (15 December). Available at www.haberturk.com/kultur-sanat/haber/581447-allianoiyi-kurtaracak-proje-ve-parasi-hazirdi [last accessed 6 April 2016].

Yeğinsu, C. 2013. *Turkey's new spin on human rights: They can be used to recover art. The International Business Times* (14 January). Available at www.ibtimes.com/turkeys-new-spin-human-rights-they-can-be-used-recover-art-1004248 [last accessed 6 April 2016].

Yu-Min Lin, A., Huynh, A., Lanckriet, G. and Barrington, L. 2014. Crowdsourcing the unknown: The satellite search for Genghis Khan. *PLoS ONE* 10(3). DOI: e0121045DOI: 10.1371/journal.pone.0114046.

Zimmerman, L.J., Vitelli, K.D. and Hollowell-Zimmer, J. (eds.) 2003. *Ethical Issues in Archaeology.* Oxford: Altamira.

Zimmermann, K. 1994. Kelten und Helvetier im Spiegel historischer Festumzüge. *Archäologie der Schweiz* 14(1): 37–45.

Index

Hungarian Academy of Sciences 171
Hungarian National Museum, Budapest 173
Hungary 171–4
hyperdiffusionism 124, 126, 130

Iceland 24
Icklingham, Suffolk 191
ICOMOS *see Charter for the Interpretation and Presentation of Cultural Heritage Sites*
Imperial Fascist League 130
Indiana Jones (film franchise) 11, 159
Indiana Jones and the Last Crusade (film, 1989) 162, 164
Indiegogo 64
indigenous communities 25–6
Institute of Archaeology, Iceland 24
Institute of Archaeology, University College London 4–5, 44
interdisciplinarity 11–12
International Union of Prehistoric Protohistoric Sciences (IUPPS) 102
Internet 71
 web archives 79–81
 websites 73, 79, 136–7, 153–4
Investing in Success (HLF, 2010) 39
Italy 99
IUPPS *see* International Union of Prehistoric Protohistoric Sciences

J. Paul Getty Museum 189, 192, 193–4, 196, 197
James, Montague Rhodes 157, 159, 162, 163–4
 Oh, Whistle, and I'll Come to You, My Lad 164
 A View From a Hill 163–4
 A Warning to the Curious 162, 164
Jeanne d'Arc 184
job creation 37, 40
Johns, C. 191
Jones, B. 139
Jones, J.E. 196
Jones, S.P. 158, 162
Jordan 22
Joseph II, Emperor 171
Journal of Field Archaeology 198–9
Julianus (Dominican Monk) 173

Kaeser, M.-A. 175, 179
Kalevala 170
Kalicz, N. 174
Karlsgodt, E. 184
Keating, Geoffrey, *Foras feasa ar Éirinn* 168
Kelland, Kate 127–8
Keller, F. 175
Kersel, M. 22
Kézai, Simon, *Gesta Hunnorum et Hungarorum* 172, 173
Kickstarter 73
Kiddey, R. 24
Kids' Archaeology Programme 24
Kienlin, T. 178
King, T.F. 139
Klápště, J. 168
Klemm, G. 179

Koch, M. 181
Kohl, P. 179
Kołakowski, L. 166
Kolb, David 46–7
Kossinna, G. 179, 181
Kostrzewski, J. 181
Kovacs, G. 185
Kozloff, A.P. 191
Krusch, B. 183

Langlotz, Ernst 193
Lauffenberger, Jean 193
Leach, E.R. 181
Leahy, Diana 111
Leahy, K. 111, 191
Learning Outside the Classroom 57–8
Lebor Gabála Érenn 168
Leese, Arnold 130
Leutwitz Apollo (aka Cleveland Apollo) 192
Leuzinger, U. 175
Levison, W. 183
Levy, Leon 190, 191, 195
Lewis, Carenza 58
leylines 131
Lindenschmitt, L. 172
Link, F. 183
Linked Open Data 120
Littré, E. 177
Livy (Titus Livius), *The History of Rome* 170
Lombards 167, 170
Lönnrot, E., *Kalevala* 170
looting 188
Louvre Museum, Paris 100
Lovrenovic, Dubravko 134
Lubbock, G. 163
Lubbock, John 179
 Prehistoric Times 175–6
Lucas, G. 149
Luckhurst, R. 157
Luke, C. 22, 190

Macalister, R.A.St. 168
McDavid, C. 16
MacDonald, C. 22
McGimsey, Charles 7
MacGuffinn 157–8
Macklin, Graham 130
MacMaster, Th.J. 168
McNall, Bruce 195
Macpherson, J., *Ossian* 170
Maddison, D. 35
Magyars 171–4
Malta 73
 Hağ Qim Neolithic Temples 75
 Hal Saflieni Hypogeum, Paola 81–2
Marchal, G.P. 175
Marchand, S. 178
Marcus Aurelius 191
Mardin Artuklu University, Turkey 101
marginalised communities 24–5
marketing/branding 37, 41
Marshall, C.W. 185
Marshall, Y. 15
Masterpieces of the J. Paul Getty Museum: Antiquities (1997) 192